P9-DYZ-422

Early Childhood Art

Please remember that this is a library book,
and that it belongs only temporarily to each
person who uses it. Be considerate. Do
not write in this, or any, library book.

WITHDRAWN

Early Childhood Art

Third Edition

Barbara Herberholz
University of California, Davis

Lee Hanson
*Curriculum Coordinator: Art
and Gifted Education
Chula Vista City School District
Chula Vista, California*

wcb
Wm. C. Brown Publishers
Dubuque, Iowa

Copyright 1974, 1979, 1985 by Wm. C. Brown Company Publishers. All rights reserved

Library of Congress Catalog Card Number: 84–70558

No part of this publication may be reproduced, stored in a
retrieval system, or transmitted, in any form or by any means,
electronic, mechanical, photocopying, recording, or otherwise,
without the prior written permission of the publisher.

Printed in the United States of America
10 9 8 7 6 5 4 3 2 1

2 03249 01

Contents

Foreword

This third edition of *Early Childhood Art* brings a fresh perspective and new insights to the subject of the aesthetic/art education of the young child. Building on the solid foundation of earlier works, authors Barbara Herberholz and Lee Hanson enrich this publication with discerning analyses of current trends in comprehensive arts education, timely examples from exemplary art projects across the nation and solid strategies developed to implement emerging common frameworks for art instruction with a significant place in the total curriculum.

The book is organized in a logical and practical manner. The presentation of research focused on aesthetic education in the early years is followed by a philosophical base for educating children in art as a separate discipline and as an avenue to other learning. Explicit examples define four components of art in early childhood: (1) aesthetic perception, (2) creative expression, (3) aesthetic judgment and valuing of art, and (4) heritage of art. Photographs and illustrations of children's art animate the text in every section, and each chapter abounds with down-to-earth methods for connecting the child's natural growth and development with appropriate learning experiences.

A blueprint is offered here for the art education of young children from pre-school through third grade, a critical span of time for the establishment of the youngster's aesthetic beginnings and foundations. The art tasks described in this book are planned to elicit creative problem-solving and aesthetic responses through heightened awareness of how to see, feel and know about art. The artistic experiences and sequences outlined in the book serve as a detailed map, a practical plot plan for the development of children's art skills, aesthetic perception, original expression and learning attitudes. Adults in charge of children's art education will find in these pages well-tested methods that allow for individual art expression in a variety of media, along with a firm conceptual basis, research-backed approaches to high quality aesthetic experiences, a background for study of art heritage and emphasis on children's original thinking in art production.

In this revised edition of a classic text for pre-school and elementary teachers and teachers-to-be, the authors relate recent developments in the arts and general education, and provide a substantial rationale for art as basic in a balanced program of instruction. Aesthetic education attends to the refinement of all of the senses and is basic to all learning. Art as a second language for all children—a visual language rich in symbolism and metaphor and uniquely non-verbal—is a vital part of the growth of the intellect and the development of intelligence. The new focus on excellence in education in the United States can well accomodate a significant position for art instruction at all grades and for every child. Recent research supports the role of art in the total educational process, as well as in the fostering of reading and language development. Across the country there is a long overdue shift away from methods of teaching art in which the end product is predetermined by the adult who dictates step-by-step copying, use of patterns or prepared outlines, to methods that stress visual prob-

lem-solving, aesthetic perception and interaction of children with artists and original works of art. There is an emphasis now on art experiences which begin in early childhood that will contribute to the individual's understanding of the visual aspects of one's environment and will lead to a desire on the person's part to improve and protect that environment. Guidelines for an art program of quality are provided in the chapter on Art Education and the Early Years, and concepts of interdisciplinary approaches are introduced here as well.

It is estimated that less than ten percent of all students study any kind of visual art in high school. Even in a climate of educational reform it appears that the majority of students in American schools will have few opportunities to study art beyond the middle school level. It is urgent, then, that the elementary program be one that clearly opens avenues to the child's awareness and valuing of his own art productions, and that also leads the child to an awareness of the rich heritage of the art world, including the art of many cultures—his own and other's.

This work describes ways and means of introducing the very young child to artists, galleries, original works of art and fine reproductions. Ways of talking with children about works of art are dealt with in great detail, and attention is called to artmobiles, mini-museums and art-in-a-trunk programs that incorporate the four components of art instruction in a visual tangible form as these have been developed in several cities. There is a description of twenty-one "aesthetic games" for visual and perceptual growth, an expansion of an effective teaching device outlined in earlier editions. Ideas presented are intended to stimulate teachers to become involved in the invention and making of other art games in formats of their own design. In addition to games that familiarize children with great works of art and involve them in guided practice in using elements and principles of art, other strategies are described for the visual involvement of young children viewing original art in museum or artist studio settings.

The chapter on Artistic Development in the Early Years plots the types of graphic expressions considered normal for different age levels and advocates a qualitative developmental sequence of art lessons. This section has been enlarged to include methods of identifying and meeting the needs of the artistically talented, and approaches to the effective teaching of art to handicapped and educationally disadvantaged learners in special education programs. The role of the teacher as the child progresses through several stages of learning and a variety of learning modes is extremely important. Numerous details are given as to conversation, comments and motivations that are appropriate for encouraging the child's art expression.

A supportive role on the part of parents is essential if such growth is to occur, and suggestions are made in the chapter on Avenues to Aesthetic Growth for teacher/parent contacts. A complete model is presented for a parent volunteer docent program which has proved exemplary in a large California school district, with sample activities provided for the training of parent volunteers in art appreciation.

A new section on planning art programs for children in special education is included. Also new in this revised edition is a large section on Art Learning Stations.

It is generally accepted that originality, sensitivity, fluency, and flexibility are important aspects of creative thinking and production in art. Unusual responses and unique configurations showing originality and sensitivity are the result of a child's vivid perceptual experiences and a high level of ability in imagining and building fantasies. A child who is fluent in art uses many ideas and symbols to communicate. The outpouring of his ideas is endless and delightful, and he or she will create many more visual images than the rigidly oriented child will produce within the same time span. The young child who is flexible changes his symbols and responses easily and confidently and is stimulated when encouraged by a variety of in-depth encounters with art materials. Early childhood years are formative; and the education program is deficient if it is not rich in input and conducive to the development of the child's visual thinking and creative powers.

Additions have been made to each of the art production chapters to assure that children will have diversified and repeated experiences in all areas—both two and three dimensional. Individual and group projects are included. By using the types of art tasks described in this book, children are encouraged to hazard guesses, test their ideas, and enjoy the delights of discovery. While aimed at fostering specific cognitive and expressive skills, these tasks appeal to the child's natural curiosities, his desire to explore, experiment, and communicate ideas in a beautiful visual way.

Throughout the text, multi-cultural crafts are related to the materials and expression of young children. In this edition, the interrelationship of culture and crafts with folk art is stressed. Design craftsmanship is rooted in the artistic heritage of peoples, reflects the direct and honest expression of a people's everyday life. Folk art is, in fact, akin to child art in which materials and subject matter are often similar. A chapter on Celebrations turns the focus away from stereotypes and toward original and unique art expression closer to historical backgrounds and cultural origins of holidays. New materials and techniques are incorporated—techniques that are particularly appropriate in the early years. Ranging from making paper and creating baker's clay murals, to making edible puppets and jewelry, making group wall hangings with fabric crayons, weaving, stitchery, printing with tape, designing gifts and participating in celebrations, projects in this revised edition will aid the classroom teacher in exploring and using in depth a number of art activities.

To see the world through the eyes of children is perhaps one of the greatest rewards for the adult in charge of structuring and facilitating the child's artistic encounters. This book urges teachers to experience again, with the children under their direction, the delight of visual discovery, ideation, aesthetic involvement and emotional response to the world of art. This ongoing, never-ending process of self-awareness, fulfillment in creative expression and renewal keeps us all "young in art".

Audrey Welch
Art Specialist
Glendale Schools

1 Art Education and the Early Years

If we hope for our children that they will become full human beings and that they will move toward actualizing the potentialities that they have, then, as nearly as I can make out, the only kind of education in existence today that has any faint inkling of such goals is art education.

ABRAHAM MASLOW
The Farther Reaches of Human Nature

In a society tending more and more to be technological, complex, and mass-oriented, the arts have the responsibility of fostering and preserving an individual's human identity and self esteem. Young children reflect the experience of beauty, so that when they engage in art production and view works of art by others, they come to a better understanding of themselves and the world around them. The main objective of art education should be to bring children in contact with and give them a better understanding of visual culture.[1]

Aesthetic education is essential and is designed to enrich a person's life by increasing his capacity to use his senses joyfully in experiencing his environment. Such aesthetic encounters are for all children; and the values of an educational experience such as this are best transmitted through the schools, since these are the institutions that provide for personal development and the transmission of cultural heritage. The results of aesthetic education should enable students to make personal choices relative to life and to be responsible for what they reject or prize in our society.[2]

Most recent trends in elementary curriculum have placed an emphasis on 'arts education' or 'comprehensive arts', a policy which reaches out to all children, not just the gifted or talented few. This approach, strives to have the visual and performing arts function not only as an independent subject area but as infused in other subject matter. According to Webster, *infuse* implies the introducing into one thing a second that gives life, vigor or new significance.

Since art education represents fundamental ways of knowing, it must be recognized as basic to education. Art and the other subject matter areas can nourish one another. The slogan "All the arts for every child" is emerging as the key for curriculum development, since the arts invest teaching and learning with a more human quality than do the 3 R's alone.

Art and the Development of Language

Recent research supports the role of art in the total education process, as well as in the fostering of reading and language development. Clyde Martin observed that children who have been asked to talk about their paintings almost always make very high scores on language sections on readiness tests. This indicates that giving form to ideas through painting aids children in language growth. Rhoda Kellog has observed that spontaneous child art is a stimulating mental process which correlates with success in learning to read.[3]

Art's Influence on Test Scores

Wilson Riles, recently state superintendent of Public Instruction in California, stated that as school districts drop arts education to balance budgets, whole groups of children are deprived of this source of refreshment, inspiration, and fulfillment. As tragic as that loss is, Riles points out that there is even a greater loss: the learning of those basic skills that school board members and taxpayers prize may well be hindered by the absence of aesthetic stimulation.[4]

In Oakland, California in 1972, Stan Cohen noted in the arts centered school that children in grades 4–6 advanced in reading an average of 1.26 years in six months (or twice the normal rate), and advanced an average of .75 year during the same period in arithmetic (or 1½ times the normal rate.[5])

In Columbus, Ohio, schools that participated in the special ARTS IMPACT program[6] (in which the arts were central to the core curriculum) reading and mathematics scores increased substantially during the six years in which the program was in effect. A dramatic achievement was noted in the fourth year when 79% of the sixth graders that year scored at grade level or above in reading vocabulary, 65% higher than the previous year's sixth grade, of whom only 14% had scored at grade level or above. In arithmetic computation, the increase was 56%; arithmetic concepts, 65%; reading comprehension, 41% and arithmetic application 25%. When the arts are introduced, the school environment becomes alive, while total learning is improved.

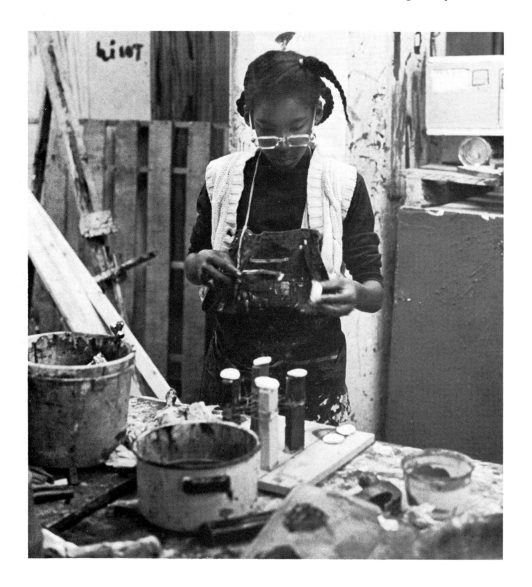

At present, over 3,000 students in New York City are participating in the Learning to Read Through the Arts program. Like this student who is constructing a sculptural piece, students participating in LTRTTA keep a journal of their art experiences.

Connecticut's Mead school places strong emphasis on the arts for children who are preschoolers, through sixth grade, with children spending as much as half of their time in art classes and the other half with math, sciences, and other subjects. The results have been gratifying. In 1976–77 each grade was performing at Standard Achievement Test norms or above in every subject.[7] With five considered grade level, one finds in scanning the test scores, almost all sixes and sevens and several eights, but only a couple of fives. Most recent scores showed spelling gains to be normal and above, whereas before the children were below grade level.

Another link between art and reading achievement can be found in the Learning to Read Through the Arts program, formed in 1975 as an outgrowth of a pilot program initiated five years earlier at the Guggenheim Museum. The program is designed to foster and stimulate learning through the arts for children who are performing below grade level in reading and/or mathematics and for whom the more traditional methods of education have not proven effective. Over 10,000 children from most of the thirty-two districts in New York City have participated; year after year, nationally normed tests indicate that the majority of participating students demonstrate dramatic increases in reading scores at each grade level.

In 1979, forty-seven percent of the students entering the program had scores in the lowest quartile on the pretest. On the post-test, only six percent of the students' scores were in the lowest quartile. Independent evaluators commissioned by the New York City Board of Education have concluded that these significant gains can be attributed directly to the program.[8] Further recognition of the program's success came about when the National Right to Read Effort chose it as one of the twelve reading programs in the United States to be designated as exemplary, and this was validated by the Dissemination Review Panel of the United States Office of Education.

The New York State Department of Education, utilizing methodology developed under the Learning to Read Through the Arts program, launched Reading Improvement Through Art (R.I.T.A.) in 1975. This pilot project combined reading and art

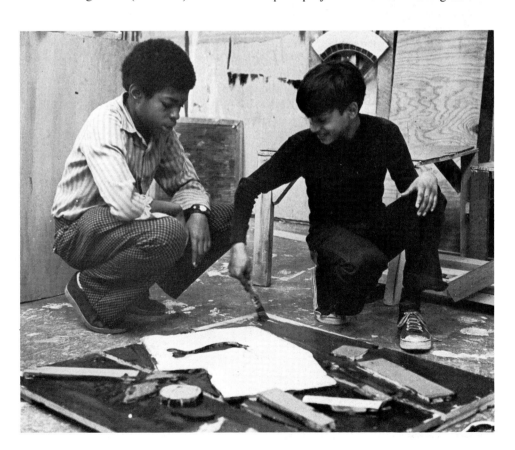

The learning to Read through the Arts program has been validated as an exemplary program on city, state and national levels. These two students are working on an art project at one of the five sites selected at LTRTTA centers in New York City.

experiences for high school students who were reading at least two grades below level. After three months of instruction (40 minutes per day), post-test results indicated that exceptional growth had taken place with the students (grades 9, 10, 11) showing a mean grade equivalent ranging from eight months to one year.[9]

Upon reviewing this and other exemplary programs, The Rockefeller Panel in its report on the arts stated that testing results bear out the hypothesis that learning capability in other subjects does increase when the arts are major components of the students' experiences.[10] Are such learning increases due to perceptual training, individual attention, internalized motivation or emotional satisfaction? A great deal of research is being conducted to try to answer this question.

Public Attitude toward Art Education

Despite evidence to the contrary, the belief is frequently encountered that any activity which takes away from reading, writing and arithmetic will interfere with the ability of children's reaching acceptable levels of proficiency. At present, we are at a time when proficiency in the basic skills is a priority, and the arts are frequently considered expendable by the general public.

Elliot Eisner of Stanford University, in a speech to the Multi-Arts Convention in 1977 in San Jose, California, noted a paradox, in that the arts don't fare well when budget cuts come, even though most parents give lip service to the importance of the arts. While attendance at museums and concerts has risen, parents see only the published test scores for math and reading, and do not consider that their children might also have low scores in imagination, in expression, aesthetic sensitivity, and in creativity.

A study of value assigned to various subject areas in the school curriculum was conducted by Lawrence Downey. In his study of the goals of American education, several thousand people from many walks of life, living in various parts of the country, were asked to rank order sixteen fields of study with regard to the extent to which they considered them expendable. Individuals were asked, "If the school budget had to be cut and subject areas had to be eliminated from the school curriculum, which of the following areas of study should be eliminated first, which last?" Out of the sixteen areas of study, aesthetic education was ranked fourteenth by the lay public and twelfth by educators.[11] It would seem that for many, the arts are not seen as "basic" to education.

Report on the Arts

National concern for the arts was evidenced in 1977 when a panel on Arts, Education, and Americans, composed of 25 businessmen, scientists, artists, and educators and chaired by David Rockefeller, Jr., issued a 330 page report, recommending the arts as basic to education.[12] The report, contains 98 recommendations addressed to government, teachers, arts specialists, school administrators, and parents.

This report called for reorganization of the United States Office of Education as a Cabinet-level department, and appointment of a special advisor for the Arts and Education, to serve the new Secretary of Education. It recommended that the Federal Council on the Arts and the Humanities carry out a ten-year strategy for arts in education, that each governor establish a cabinet-level position for the arts, and that every municipality form an arts commission concerned with education.

The report called for the schools to make creative work in the arts available for all students. It also recommended that in-service and academic programs be revised to provide teachers, arts specialists, and administrators with experience in a variety of arts and their correlation to each other and to other disciplines.

In *Coming to Our Senses,* the assertion is made that American education exaggerates the importance of words for transmitting information. Torrents of information are sent and received through our senses, and we use these senses to interpret and convey complexities of daily life. The Panel's report affirms therefore, that all our sensory languages need to be developed as well as verbal and written language, if words are to fulfill the deeper function and deliver both vivid and subtle messages. The Panel supports 'basic education,' but maintains that the arts are basic to individual development since more than any other subject they awaken all the senses—the learning pores. This report endorses a curriculum that puts 'basics' first because the arts are basic. The panel members do not advocate that reading be replaced by art, but they insist that the concept of literacy should be expanded beyond word skills alone.

Essential vs. Expendable

Possibly the wide gap between "art is expendable" (the public) and "art is basic" (the Panel) is due to differing concepts about what art education actually entails. According to Blanche Jefferson in her classic work, *Teaching Art to Children,*[13] there are six easily distinguishable methods of teaching art. Two of the listed methods use patterns and prepared outlines. In these activities, the child colors inside the lines that someone else drew (as with coloring books or workbooks) or uses shapes drawn or cut by another person in duplicating or assembling an object.

A third method of art instruction is called the "directed method" by Jefferson and entails the child's following a prescribed course set by the adult and controlled by the adult in a step-by-step procedure. A fourth method is copying or reproducing the likeness of an object, picture, or design, again under close adult supervision and with step-by-step directions.

Creative expression is only possible in two of the six methods of art instruction listed by Jefferson; these two involve art work produced from assigned topics or themes such as "on the playground" or "the circus" or art work based on the child's choices. In the latter activity, the child chooses the topic for the art work, the way it will be expressed, and the organization of it. "Adult direction" in these two methods takes the form of providing instruction in the use of materials, utilizing objects and words to stimulate ideas and visual images, and developing a supportive atmosphere which encourages experimentation and originality.

The first four methods discussed—patterns, prepared outlines, directed methods, and copy art—are considered "dictated art," that is, the end product is predetermined by the adult. The two methods of teaching art that allow for individual expression—thematic or self-directed art—are clearly distinguishable from the other methods since the content of each child's art work is different from that of others who also participated in the activity.

If the general public envisions dictated art as what is taught in the schools, then it is reasonable that it would have a low priority. But if art is viewed as being a quality aesthetic experience which stimulates creativity and problem-solving abilities, then clearly it is important—an essential "basic" in the total educational development of our young people.

An Art Program of Quality

The National Art Education Association, in stating why art is important for children, asserts that art brings the personal dimension of feeling, sensitivity, empathy and expression to the education program. The visual arts help involve children in perceiving the world, reacting to the things they see and feel, and in interpreting emotions, feelings, and insights through a variety of materials. Art experiences which begin in early

childhood will contribute to the individual's understanding of the visual aspect of his environment, and they should lead to a desire on his part to improve and protect them.

The NAEA also states that art in school is a body of knowledge, as well as a series of activities, organized to provide experiences that are related to specific goals. The sequence and depth of these experiences are determined by the nature of the art discipline, the objectives desired, and by the interests, abilities, and needs of children at different levels of growth.

An art program of quality should begin in preschool and sequentially progress through the educational levels, with experiences provided that are compatible with the intellectual, social, and aesthetic maturity of each student. The art program should provide experiences in

1. examining intensively both natural and man-made objects from many sources,
2. expressing individual ideas and feelings through use of a variety of art media suited to the manipulative abilities and expressive needs of the student,
3. experimenting in depth with art materials and processes to determine their effectiveness in achieving personal expressive form,
4. working with tools appropriate to the students' abilities, in order to develop manipulative skills needed for satisfying aesthetic expression,
5. organizing, evaluating, and reorganizing work-in-process to gain an understanding of the formal structuring of line, form, color, and texture in space,
6. looking at, reading about, and discussing works of art—painting, sculpture, constructions, architecture, industrial and handcrafted products—using a variety of educational media and community resources,
7. evaluating art of both students and mature artists, industrial products, home and community design,
8. seeing artists produce works of art in their studios, in the classroom, or on film,
9. engaging in activities which provide opportunities to apply art knowledge and aesthetic judgment to personal life, home, or community planning.[14]

Comprehensive Arts

Comprehensive arts education has evolved as an educational concept during the past ten years. This approach to arts education is based on a strong philosophical belief in "all the arts for all the children." In a comprehensive arts program, existing arts programs would be strengthened and expanded in order to reach larger numbers of children. The object is to present to all children an education in learning to look and listen with understanding, as well as performing and creating in studio activities.

Furthermore, ways to connect the arts with other curriculum areas are viewed as essential in developing a total school program. Ideally, this integration of subject matter would involve creative problem solving rather than the mere reinforcement of factual knowledge. For example, children would not be expected to duplicate pictures or designs in their study of American Indians, but would instead study symbols as a way people communicate ideas, would develop their own set of symbols to record an event in their own lives, and would draw upon the events and materials found in their own environment (as did the Indians and other groups of people). Utilized as motivation and enrichment, the arts provide tools for more effective learning.

In the comprehensive arts education approach, community resources in the arts are used in ways that meet the educational needs of the schools. Museums, and various performing groups in music, theater and dance are encouraged to work with the schools to build effective programs. The combination of school and community resources creates a support system for the incorporations of the arts into all areas of life.

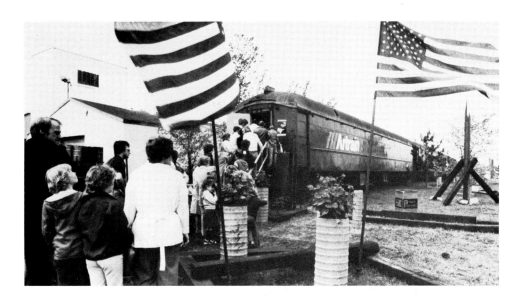

Galleries and a studio are brought to communities throughout the country as the Artrain travels the nation's railways. Originally the Freedom Train during the Bicentennial, the train has been converted in order to bring art and artist to various regions of the United States. (Photo courtesy of Artrain Incorporated).

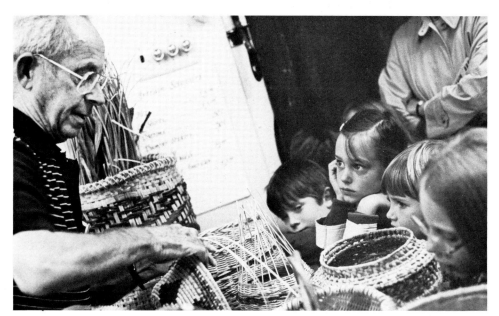

Artists and craftsmen from the host community as well as those traveling with the Artrain provide an opportunity for students and adults to see professionals at work. (Photo courtesy of Artrain Incorporated).

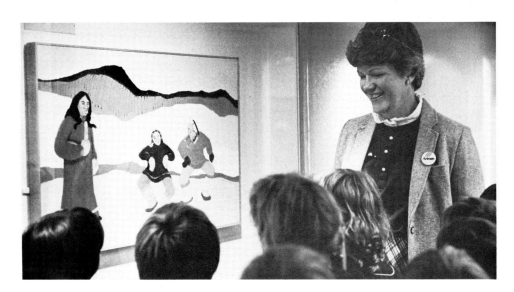

Artrain docents answer questions in the train's galleries while approximately 125 students view the collection every hour. (Photo courtesy of Artrain Incorporated).

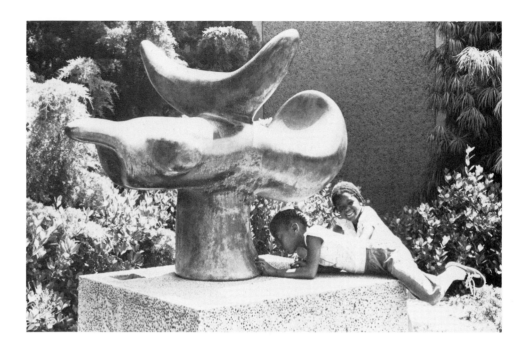

Students check to see the artist's name on this work by Miro in the Sculpture Garden of the San Diego Museum of Art.

Research in Brain Hemisphericity

In addition to stimulating cognition and affective learning, a group of neuropsychiatrists currently conducting research in bicameral brain functions has introduced the possibility that the arts are intrinsic in mental development.

Scientific research during the last 20 years has shown that the two halves of the brain have separate functions, and this hemisphericity is a possible cause of behavioral and learning differences. Neurologists have known for a long time that the left hemisphere of the brain controls movements on the body's right side while the right hemisphere controls movements on the left. Recently, however, researchers have found indications that the hemispheres are specialized in other ways.[15]

Robert E. Ornstein, one of the scientists involved in right brain/left brain research, states that the left hemisphere is predominantly involved with analytic thinking, especially language and logic; the right hemisphere by contrast, appears to be primarily responsible for our orientation in space, artistic talents and body awareness.[16] Ornstein is quick to point out that activities of the right and left hemispheres are not exclusive of one another; rather each is a specialist in its functions.

Evidence for this specialization has come about through study of people whose brains have been damaged in an accident or through illness. Investigations of hundreds of clinical cases have found that damage to the left hemisphere often interferes with language ability. Conversely, damage to the right hemisphere may not interfere with language at all, but may cause disturbances in spatial awareness, in musical ability, and in visual recognition of objects (such as faces, for example).

Roger Sperry of the California Institute of Technology and his associate Joseph Bogen have done extensive work on the functions of the two hemispheres. Bogen has conducted research in which electroencephalograms of normal people were taken while the individuals were thinking verbally and spatially. Ornstein reports that these experiments at Cal Tech have reaffirmed the conclusion that the brain does have specialized thought processes. He states that if a person does a verbal task, for example, often the alpha rhythm in his right hemisphere increases. If he works on a spatial problem, the alpha rhythm in his left hemisphere increases. Increased alpha production is a sign of decreased information processing; the brain appears to reduce the operation of the side not in use.[17]

Hemisphericity and Learning

If research in brain hemisphericity continues to substantiate some of the early theories, educators may have to investigate the implied insights into the learning-teaching process. The left hemisphere, which is the major controller of speech, reading and writing, is dominant for most people; it is also the hemisphere toward which education traditionally has been directed. The right hemisphere which excels in nonverbal skills appears to be responsible for the creative, intuitive, imaginative side of human personality. It is this hemisphere that many educators claim has been neglected in the schools. Marilyn Winzenz has stated that by ignoring creative, intuitive, visual, spatial aspects of the brain, those valuable thought processes may stagnate.[18]

Madeline Hunter further supports the idea that schools need to include educational strategies which focus on both right brain and left brain skills. She states that individuals may be born with a predisposition to use their right or left brains, and she points out that schools have been beaming most of their instruction through a left-brained input (reading and listening) and output (talking and writing) system, thereby handicapping all learners.[19] Hunter proposed that strategies must be used which utilize left-brained and right-brained input of information for students. Bogen supports Hunter's viewpoint and has stated that children who have been exposed only to the three R's may suffer from educational neglect because such a program educates mainly one (the left) hemisphere of the brain, leaving half of an individual's high-level potential unschooled.[20]

Art and the Neglected Hemisphere

Since art is largely a right-brain activity in the theory of hemisphericity, many advocates of educational programs with balanced left-brain/right-brain activities would place a greater emphasis on art than is currently being done in schools. Betty Edwards at the University of California at Los Angeles, author of *Drawing on the Right Side of the Brain,* has been doing research using art to unlock right-brain potential. Edwards used a pre- and post-test model with four treatment groups in a study designed to investigate whether an individual's realistic drawing capability is facilitated by instructional methods which tend to suppress symbolic and analytic perceptions of visual images (the left-hemisphere mode of processing) and tend to facilitate relational, visuospatial perceptions (the right-hemisphere mode). The hypothesis predicted that the relational instructions would elicit more realistic drawing. Drawings were scored by five art teachers, and the results of the analysis indicated significantly increased accuracy of perception and ability to draw realistically. Edwards states that the results of the study may also imply that training in art might be used as a means of teaching students to improve their perceptual skills and to utilize more fully their right-hemisphere capabilities.[21]

Two Ways of Knowing

Recent research has provided the educational field with substantial evidence that alternating modes of thinking during the school day can provide a definite stimulus in the learning environment. When these two halves or two ways of knowing cooperate and are not in conflict, the person has a better balance in his life activities. To live successfully in our constantly changing world, the child needs to establish early patterns of synthesizing the knowledge logically stored by the left brain into new solutions and relationships with the intuitive, gap-jumping, innovative thinking of the right hemisphere. Schools must provide a climate in which both sides of the brain are cherished and nourished. Some learning calls for logical, analytical thinking. However

computers and data banks can hold more information than one mind ever could; and it is here that the ability to think creatively and with feeling will be crucial in the child's future.

The flexibility necessary to think imaginatively about an idea or combination of ideas is largely a function of the intuitive, synthesizing right hemisphere. The analytical linear thinking of the left hemisphere is needed in the subsequent development of a project to a solution. Coping with difficulties that appear while solving a problem usually requires a return to the free-wheeling flexibility of the right hemisphere, while the final evaluation is largely a left hemisphere function.

Carl Sagan of Cornell University also subscribes to the idea of stimulating both sides of the brain to full potential. To Sagan, the process of genius involves a dominance of neither side of the brain, but rather a vision, or intuition, emanating from the right brain which is then confirmed by the logical left brain and expressed in language or mathematical symbols. Sagan postulates that no work of artistic or scientific genius has ever emanated first from the left brain, but was always first a vision of the right brain, collaborated and proved logically by the left brain.[22]

Creative thinking requires an unconscious switching from one side of the brain to the other; a child whose education has only equipped him to reiterate and reuse information will live less than a whole life. Arthur Koestler in *The Act of Creation*[23] documents statements of geniuses who testify as to the origins of their creative breakthroughs. Einstein, Coleridge, Faraday, Wiener, and others received their initial ideas not from logic but from kinesthetic or visual imagery. Intuitive leaps were described by all of them, leaps which followed immersion in the logical, factual background of problems. This sudden insight, springing forth as intuition from the subconscious was subsequently worked upon by the left hemisphere to verify it.

Both logic and metaphor, analytic and holistic thinking, must work together, *synergically,* for true creativity. Art has a great deal to do with the kind of thinking associated with the right hemisphere; therefore all children need opportunities to experience all of the arts as well as science, math, and language if they are to develop their full potential. Art places rich emphasis on visual imagery, touching the child's feelings and emotions, providing impetus for fluency, flexibility, uniqueness, and originality. Hence art, with its striving for synthesis, closure and cohesiveness, should play a vital part in developing both hemispheres of the brain, providing that balance that is imperative not only for survival but for abundant living.

Creative thinking involves both of these highly complex modes of knowing. Through art activities children are given the opportunity to use creative and intuitive approaches to solving problems. In school programs that are becoming increasingly oriented toward test scores related to science and the 3 R's, art can provide balance for the development of both halves of the brain.

The National Art Education Association has stated that while the sciences provide the means through which man survives, the arts are what make survival worthwhile.

Notes

1. "How the Public Schools Kill Dreams and Mutilate Minds," Atlantic, 1970, C. E. Silberman.
2. Aesthetic Education Program, *Aesthetic Education: A Social and Individual Need* (St. Louis, Mo.: CEMREL, Inc., 1973), pp. 4–5.
3. "Learning Partners—Art and Reading," *Texas Education Agency,* (Fine Arts Section, Division of Curriculum Development, Feb. 1975).
4. "Foreword," *Arts for the Gifted and Talented K–6,* California State Department of Education, p. V.
5. Ken O'Toole, "Art: Core of the Curriculum," *California School Boards,* June, 1975, pp. 20–21.

6. Arts Education Advocacy, a Project of the Alliance for Arts Education in cooperation with NAEA, MENC, ATA, NDA, NAESP, NASSP, CCSSO, AASA, and NSEA, 1977, p. 7.
7. Roger M. Williams, "Why Children Should Draw, the Surprising Link Between Art and Learning," *Saturday Review,* 3 September 1977, pp. 7–16.
8. Information Bulletin issued by the New York City Board of Education, 100 West 84th Street, New York City, 10024, September 1980.
9. Sylvia K. Corvin, "Art as a Tool for Learning," *School Arts,* March 1978, Vol. 77, No. 7, pp. 34–35, 51.
10. *Coming to Our Senses: The Significance of the Arts for American Education.* The Arts, Education and Americans Panel (New York: McGraw-Hill Book Co., 1977, p. 114.
11. Elliott Eisner, *Teaching Art to the Young: A Curriculum Development Project in Art Education,* (Palo Alto: Stanford University Press, November 1979), p. 4.
12. *Coming to Our Senses:,* Ibid., pp. 248–254.
13. Blanche Jefferson, *Teaching Art to Children,* Allyn & Bacon, 1969.
14. *The Essentials of a Quality Art Program: A Position Statement,* (Washington, D.C.: National Art Education Association, 1972), pp. 6–7.
15. Roger W. Sperry, "Left Brain—Right Brain," *Saturday Review,* 9 August 1975, p. 33.
16. Robert E. Ornstein, "Right and Left Thinking," *Psychology Today,* (May 1973):12:81.
17. Ibid., p. 92.
18. Marilyn Winzenz, "Reading Comprehension and Right/Left Brain Thinking," a paper presented at the annual meeting of the California Reading Association of the International Reading Association Eleventh Annual, (Anaheim, California: November 2–5, 1977).
19. Madeline Hunter, "Right-Brained Kids in Left-Brained Schools," *Today's Education,* 65, (Nov.–Dec., 1976), 4:47.
20. Joseph Bogen, *The Individualized Learning Letter,* 8, (February 15, 1979), 7:1.
21. Betty A. Edwards, "An Experiment in Perceptual Skills in Drawing," *Dissertation Abstracts International,* (November 10, 1979):xxxvii:1.
22. Richard Louv, "Which Side of Your Brain Are You On?" *San Diego Magazine,* April 1979, p. 207.
23. Arthur Koestler, *The Act of Creation: A Study of the Conscious and Unconscious in Science and Art,* (New York: The MacMillan Co., 1964), p. 32.

Components of Art in Early Childhood 2

"It is important that pupils, as a part of general education learn to appreciate, to understand, to create, and to criticise with discrimination those products of the mind, the voice, the hand, and the body which give dignity to the person and exalt the spirit of man."

. . . American Association of School Administrators

Boys and girls in the awakening formative years of early childhood have special developmental needs. These include perceptual, emotional, aesthetic, and creative implications which can best be fostered through an art program that incorporates four principal components or behavioral categories: (1) aesthetic perception, (2) creative expression, (3) aesthetic judgment and valuing of art, and (4) heritage of art.[1]

A school program that has meaning and is dynamic must include all four of these components. They are not separate entities. Rather they are interrelated, and knowledge of and experience with each of them enriches and nourishes the others. A sequential and developmental art program for early childhood, which is based upon the four components of art, recognizes that not every child is destined to become an adult artist, but that art can enrich the present and future life of every child by giving him satisfaction and joy. Through a personal involvement in art, positive attitudes are developed, an appreciation, understanding and enjoyment of art are stimulated, and a capacity for thinking and expressing oneself creatively are advanced.

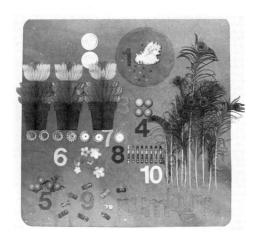

Five feet square, this felt-covered bulletin board infuses math with visual/tactile perception and good design. (Designed by Nancy and Wally Remington for pre-school classroom at Inverness Day School, Carmichael, Ca.)

Creative Characteristics

Except for differences in terminology, researchers are generally in agreement on the characteristics of the creative person. Charles Schaefer's list of the ten characteristics of the creative child states the attributes in a clear and simple manner; Schaefer further states that these characteristics are evident from the earliest years and inevitably include:

1. A sense of wonder and heightened awareness of the world.
2. Openness to inner feelings and emotions
3. Curious, exploratory, adventuresome spirit
4. Imagination, the power of forming mental images of what is not actually present to the senses or of creating new images by combining previously unrelated ideas.

A

B

C

A. Rock polisher produces smooth, sculpture-like forms from ordinary pebbles. The colors, patterns, shapes, and surface qualities invite the child to examine them.

B. Early childhood is a time for many intake experiences; and art is a means of activating the child's sensibilities.

C. Created by a sculptor, this "limbic system" installed in the San Francisco Exploratorium is in the shape of a multicolored bubble and reflects a child's image into infinity.

5. Intuitive thinking, the solving of problems without logical reasoning.
6. Independent thinking, the desire to find things out for himself rather than accepting them on authority
7. Personal involvement in work, total absorption in meaningful activities.
8. Divergent thinking, thought patterns which seek variety and originality, that propose several possibilities rather than seeking one right answer
9. Predisposition to create rather than considering how things are supposed to be or always have been expressed
10. Tendency to play with ideas, to mentally toy with the possibilities and implications of the idea.[2]

Paul Torrance also states that the creative behavior of pre-primary children is characterized by the spirit of wonder and magic; most healthy young children have this spirit unless they have been victims of neglect, harshness, lack of love, coercive punishment, or sensory deprivation.[3] It is natural for children to be creative, and the characteristics of creativity can be kept alive as children mature if they are regularly involved in quality art experiences. These experiences when based on the four art components (interrelated through meaningful, sequential instruction) stimulate attitudes and awareness that are the foundation of both the creative thought process and the quality art program.

The relationship between creativity and the production of art is shown in the chart which follows, developed by Dr. Ronald Silverman and printed in the newsletter for the California Art Education Association.[4] In his column, Silverman points out that interpretive skill and creative skill are equally important in the production of a work of art, and that each relates directly to the goals and objectives of a program in visual arts education.

Aesthetic Perception

What we know of the world we take in through our senses. The refinement and sharpening of the senses, then, become paramount in the development of the individual. A research group in Germany, described in *Time Magazine,* Sept. 17, 1973, looking for ways to stimulate the learning process of babies, designed a plexiglass crib and achieved remarkable results. The 38 infants who were raised in these transparent cribs could see much more of what was going on around them and interact with it. Their mental development was much faster than that of a control group. At 18 months children in the experimental group were measurably more intelligent than two-year-olds who had been placed in traditional cribs.

Young children are enthusiastic, curious, and eager participators interested in exploring everything around them. The quality and quantity of that exploration must not be left solely to chance. Rather, the teacher should lead, guide, and direct the child. He should whet his appetite for perceptual experiences so as to aid him in becoming better able to recognize and discriminate art elements in both natural and man-made objects. Thus the child should become more skillful in recalling observations, better able to understand, describe, and to make use of colors, textures, lines, and shapes. Design is found everywhere in the world, but it may go unnoticed until the individual becomes aware of it.

If perception is basic to all learning, if selective viewing is a desirable kind of behavior, and if conceptualization comes after sensory experiences, then it becomes imperative that the teacher set the stage so as to keep all the young child's senses alive and free from atrophy. While we cannot always decipher when an aesthetic experience has occurred or cannot always cause one to happen, we can provide the paths for numerous visual and tactile experiences. If left to his own devices, a child is not apt to discover these by himself.

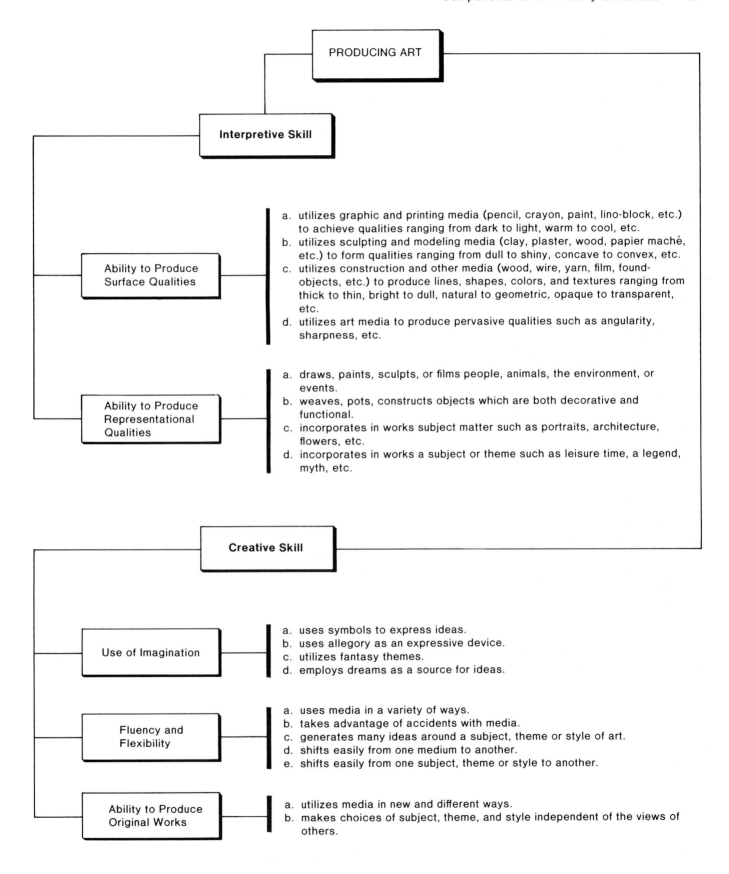

PRODUCING ART

Interpretive Skill

Ability to Produce Surface Qualities

a. utilizes graphic and printing media (pencil, crayon, paint, lino-block, etc.) to achieve qualities ranging from dark to light, warm to cool, etc.
b. utilizes sculpting and modeling media (clay, plaster, wood, papier maché, etc.) to form qualities ranging from dull to shiny, concave to convex, etc.
c. utilizes construction and other media (wood, wire, yarn, film, found-objects, etc.) to produce lines, shapes, colors, and textures ranging from thick to thin, bright to dull, natural to geometric, opaque to transparent, etc.
d. utilizes art media to produce pervasive qualities such as angularity, sharpness, etc.

Ability to Produce Representational Qualities

a. draws, paints, sculpts, or films people, animals, the environment, or events.
b. weaves, pots, constructs objects which are both decorative and functional.
c. incorporates in works subject matter such as portraits, architecture, flowers, etc.
d. incorporates in works a subject or theme such as leisure time, a legend, myth, etc.

Creative Skill

Use of Imagination

a. uses symbols to express ideas.
b. uses allegory as an expressive device.
c. utilizes fantasy themes.
d. employs dreams as a source for ideas.

Fluency and Flexibility

a. uses media in a variety of ways.
b. takes advantage of accidents with media.
c. generates many ideas around a subject, theme or style of art.
d. shifts easily from one medium to another.
e. shifts easily from one subject, theme or style to another.

Ability to Produce Original Works

a. utilizes media in new and different ways.
b. makes choices of subject, theme, and style independent of the views of others.

A

B

C

A. Seven piece tangram puzzle originated in China in 1800's and involves arranging a square, parallelogram and five triangles into silhouettes of people, animals, and objects. Manipulations aid child in developing concepts of size, shape, symmetry, and similarity.

B. Colored wooden shapes to fit and arrange in box frame give children experiences in color and space.

C. A set of plastic bracelets was used to create a teaching toy. Bracelets are graded in value and child must stack them on round wooden post in light to dark arrangement.

Creative people are perceptually very aware of their environment. They are visually observant of the world, and they know how things feel to the touch. They listen to sounds and are sensitive to the ways things smell and taste. They are able to take in information without prejudging it; they delay structuring it, trying to take in much information and to look at things from several points of view.[5] Imagination relies upon perception to be recharged and enhanced.

Art helps the child learn to recall visually as well as verbally. As the child becomes more visually aware he discovers the qualities of design—line, texture, color, form, and space. He becomes more sensitive to the qualities of design—unity, rhythm, balance, movement, and variety. This increased awareness of design enables the child better to understand the work of the adult artist, while providing him more satisfying experiences in his own visual expression.

As children mature they are able to perceive with more complexity and subtlety, the quality of this desirable behavior being affected by the amount and types of perceptual experiences to which they have been exposed. As it relates to artistic expression in early childhood, visual and tactile perception is twofold. It involves (1) the extent to which the child has developed the capacity to perceive and select, as each occasion demands, that which is significant, unusual, similar, contrasting, has more details, or is differentiated from a myriad scene or from a total encounter with his environment,

(2) the extent to which the child focuses on one part of his own picture or on the work of art by another person at a time, and does or does not perceive the more complex contextual relations within the entire configuration.

Tactile awareness implies not only the sense of touch but concept development and its related vocabulary enrichment. Children should engage in exploratory investigations that will encompass experiences such as curved, angular, flat, irregular, volume, mass, solid, round, and relief. They need to become acquainted with architecture, pottery, furniture, sculpture, mobiles, free forms, nature forms, utensils, and containers. Through working with both two and three dimensional materials they will model, shape, pinch, pull, form, gouge, build, adhere, and decorate.

Art gives the child new ways of seeing. Through looking at works of art and through discussions about his work—whether it be in the form of a motivational discussion before he draws or paints, or after he has completed a work of art—he brings into his world expanded ways of seeing. These include such concepts as close-up, magnified, transparent, bird's-eye view, worm's-eye view, silhouette, larger or smaller, thick or thin, negative or positive. Factors involving visual movement and repetition in art can be built upon; among these are art projects involving wheels, spirals, rhythm, and mobiles. Vocabulary and visual image relationships can be improved by exploring concepts such as 'move, swing, burst, curve, spin, curl, dance, twist, backward, forward, and flow.'

As the child matures, he will become aware of spatial relationships and detailed perception of objects. He will know more about overlapping shapes, dark colors in contrast with light colors, and bright versus dull. He will perceive things from above, inside and out.

Through heightened perceptual experiences the child often discovers in both new and familiar things a beauty and honesty that one whose senses are dulled might dismiss or overlook. Sensory encounters give wings to the child's imagination and at the same time enable him to relate and react to the real world around him. In addition, the visual world and experiences in art provide ways of thinking in visual images. Through personal involvement in quality art activities, the child's increasing perceptual powers continue to develop and provide the mental images needed for creative thinking and problem solving. According to Paul Torrance, a child must have a rich store of imagery in order to go very far in developing creative powers. This quality is apparently as essential in the scientific discoverer, inventor, and creative writer as well as in the artist.[6]

Creative Expression

Art production is a creative process for the child; it is an avenue through which all kinds of experiences are expressed in a nonverbal way. An involvement with art tasks provides experiences for young children that can be derived in no other way. When the very youngest child picks up a crayon or brush, he has taken one of the first steps involved in the creative act, that of selecting and making a decision. As he matures he will develop meaningful artistic expressions involving his personal feelings, his cognitive awareness, and his sensory impressions, using them to convey and communicate with himself and others. If the environment is warm, supportive, and receptive, he will enjoy and freely incorporate moods and original concepts in all sorts of subject matter by using many kinds of art materials.

Expression implies having the skill and power to state clearly what one is thinking, feeling, or perceiving in a unique and individual way. The greater coherence, the more compact and perfect the organization, the greater the aesthetic whole. Prior to expression comes perceiving, searching, discriminating, selecting, and enjoying the visual world. Art production is a way of perceiving and expressing our own uniqueness.

A

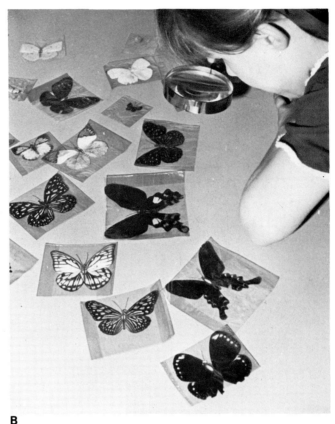

B

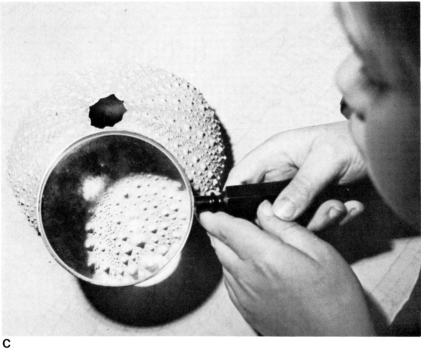

C

A, B, and C. The child's visual language expands if he is surrounded with materials and an encouraging and many-faceted atmosphere. "Come touch, come see" should be bywords in the early years.

Two of the leading specialists commenting on Piaget, an outstanding authority on the general intellectual development of children, believe that the leading argument for teaching Piaget's theory is that young children learn best from concrete activities.[7] Since Piaget believes that it is advisable to permit children to absorb experiences in

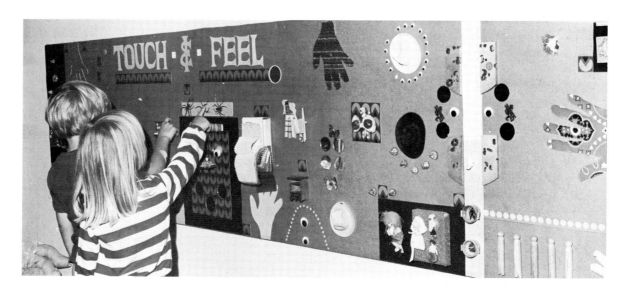

Felt covered bulletin board in pre-school invites small children to touch and feel a variety of appealing objects. Small round mirrors catch their own reflections.

their own ways and at their own rates, teachers must provide a rich environment that will permit a maximum number of concrete activities. But they must keep at a minimum those situations in which the children are shown exactly how to structure such experiences.

Situations in which children are unable to fall back on preconceived ideas and in which they explore in previously undiscovered areas are of educational value.[5] The art program in early childhood should be so designed as to promote the child's own personal production of concepts, develop his skills in painting, drawing, cutting, gluing, modeling, constructing, weaving, printmaking, and so on. Art productions in both two and three dimensions are important, closely related, and they reinforce each other. Each makes its own valuable contribution to the artistic growth of the child.

Paul Torrance lists three fundamental attributes which seem to characterize learning activities that facilitate creative behavior and motivate learning. These include the incompleteness or openness of the learning experience, the requirement to produce something and utilize it, and using children's questions (the "wanting to know") to capture the excitement of learning.[8] Creative expression in art also originates in open-ended problem-solving activities in which the child's creation is not pre-determined by adult dictates. The adult's role in the creative environment is to provide motivation and stimulation of ideas.

Very young children need exceedingly little stimulation to begin art production. They are eager to respond to the sensuous attraction of brightly colored paint and paper, and to the tactile appeal of modeling materials. They delight in cutting paper for the sake of cutting, and in pounding and squeezing pliable materials for the kinesthetic enjoyment it gives them. They may not always choose to recount an experience, but in the exploration of materials they will learn the skills that they will need when they do wish to communicate or tell a story about something that is important to them.

A

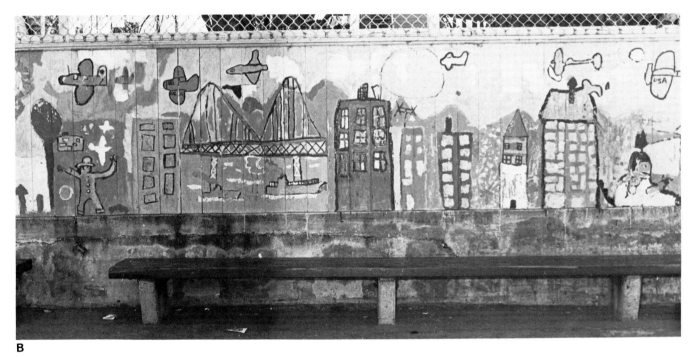

B

A. Through art the child takes from his world the ordinary and heightens his awareness by using it for subject matter. He accents its essence and finds delight in the sensuous beauty of paint. He communicates to others.

B. Children paint what they know and see around them. The entire length of the playground in this San Francisco school is bright with paneled murals painted by the children in the primary grades.

Aesthetic Judgment and Valuing of Art

Werner von Braun has said that 'we would all have dead souls if we had no aesthetic values'; and children early in life need to recognize and become familiar with different kinds of art. They will respond in their own way. They will have different feelings toward art than adults have. Beginnings are in early childhood. In sequential programs where art works of painters, architects, craftsmen and sculptors play an important role, it is feasible and desirable to build and expand upon the child's knowledge and judgment of some of the concepts of the role art plays in government, religion, events, genre, and business.

A

B

A. Bright colors in "The Purple Robe" by Henri Matisse are enjoyed by kindergarteners as they observe these small reproductions. Lamination assures protection and longer use.

B. Book, COLOR SEEMS, illustrates concepts of warm, cool, bright and dull, etc., and can be shared and discussed by teacher and children.

C. Albums are decorated with printed design and contain small reproductions of great works of art.

D. A small reproduction of Van Gogh's Starry Night is one of a number of great works of art that were made into badges by one third grade teacher. Children may choose one for wearing each day as they learn to recognize specific artists and their works.

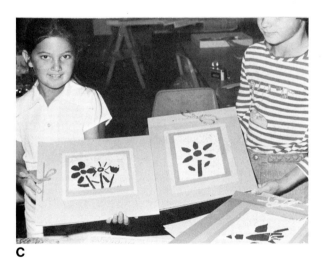

C

D

Looking and thinking and talking—all these are involved when aesthetic judgment is an aspect of the art program. In large or small groups, or on an individual basis, the teacher can guide the children in learning to analyze, select, appraise and evaluate. Children can begin to name, describe art elements, and principles, to recognize media and individual artists' works. Vocabulary development is important because words are needed to discuss, identify, clarify, compare, and interpret art works. This is true whether they are their own, their peers'; or adult artists'. They can begin to recognize some styles of art, some cultural expressions and movements in art such as realistic and abstract, primitive and contemporary.

Through many short discussions in which the child must formulate an answer the child gradually will develop criteria to evaluate aesthetic qualities. Thus he can support his personal choices, which may include liking, disliking, accepting, or rejecting.

If a child's life is devoid of the knowledge of art and its value as an important human endeavor, he is culturally handicapped. Becoming literate is one of the main goals of education. If children are encouraged to speak of their attitudes, feelings, and perceptions relative to a work of art, their educational landscape is not left devoid of a body of enriching and ennobling ideas related to the artistic contributions of man-

kind. Acquiring and using art terminology with an easy fluency is an important part of the child's visual learning. He responds to each aesthetic encounter with attitudes, judgments, and nonverbal feelings; and words can help in sharpening and directing his perceptions in regard to his own work and the works of others.

Elliot Eisner[9] distinguishes between aesthetic judgment and aesthetic preference with judgment conceived of a process whereby an individual not only appraises something that he sees in terms of its import, significance, and quality, but also has some basis for justifying that judgment. On the other hand aesthetic preference is a simple statement of like or dislike, approval or disapproval.

When children encounter a new work of art, verbalizing about it with familiar words can make for a non-threatening starting point. Preschool and kindergarten children can begin to use elementary art terms and add to their basic vocabulary every time they handle art materials or look closely at natural and man-made objects. They can talk about which works of art they like best and how the colors and images evoke in them feelings of happiness or anger. Even very young children are able to look at reproductions of art created by artists such as Picasso, Klee, Modigliani, Dali, Calder, Van Gogh, and Matisse and discuss concepts such as real and not real, simple and detailed, curved and straight, big and small, bright and dull. They can point out paintings that look like dreams, paintings that exaggerate what is real, as well as shapes, patterns and details in the works of art.

Pre-primary children can become consciously and critically aware of art that evidences pleasing relationships and well-developed elements or organization and richness. Through handling art materials and seeing original and reproduced items of fine art, they come to identify a variety of art forms such as painting, sculpture, ceramics, prints, and architecture.

If art materials are available only when each holiday rolls around and room decorations are needed, the child will never come to know art as the communicator of mankind's visions and aspirations. If the art period is held only sporadically when the teacher can find a few minutes for it after the "real" work of math and reading is done, the child will receive the wrong message as to the importance of art and its relationship to life.

Art must not be placed low on the scale of educational values by its neglect and misuse in the school program. Through frequent and regular encounters, young children should be brought to an awareness of the expressive qualities in visual forms and, at the same time, come to accept and respect the range of interests and abilities of other individuals.

Aesthetic judgment involves an awareness of our environment. Humanities stress this relation, and the relevance of art to society. We are concerned not only with clean air and water, green spaces, and protecting nature's balance, but with guarding against visual pollutants as well. A visually literate populace demands an aesthetic environment which includes good design qualities in homes and home furnishings, schools, city planning, and transportation, television and films.

Early childhood is the time for aesthetic beginnings and foundations.

Art Heritage

Man's history is vividly portrayed through art, and thus we can better understand ourselves by understanding our ancestors and their ways. Different places and different times have been expressed through art. In looking at primitive cultures, we realize that art cannot be separated from the everyday life of the tribe, a people in tune with nature and natural laws. Art has been valued by mankind from the very beginning of recorded history. Today, painters, sculptors, craftsmen of all kinds, photographers, film makers, industrial designers, fashion designers, architects, commercial artists, city planners, landscape architects, and environmental designers of all kinds influence our lives.

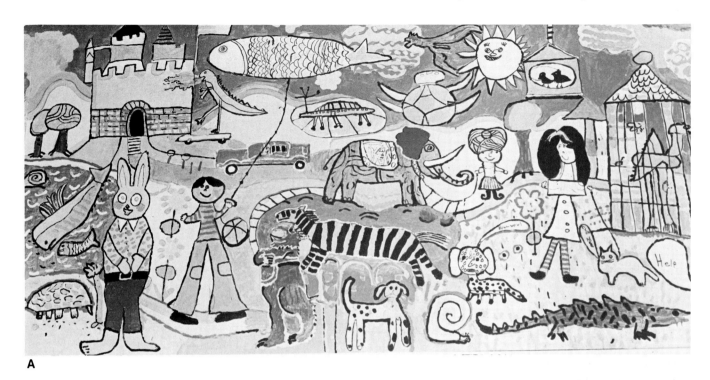

A

A. Many painting experiences
and follow-up discussions on
aesthetic concepts increase
children's skills and self-
judgment for future productions.
This large mural was painted by
second and third-grade children
for the Bryant Elementary
School Library in San Francisco.

B. Bronze dolphin by a
contemporary sculptor is being
explored as to its curving,
leaping form and its touch-
inviting surface. Six-year-old
children learned how metal was
melted like wax with a very hot
torch to form the undulating
texture that they loved to feel

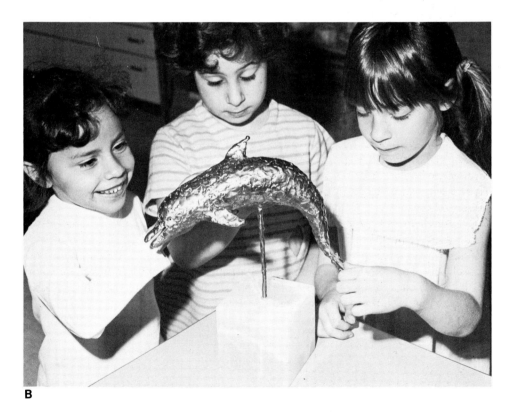

B

Through the visual arts, schools can provide behavioral experiences that will lead
to changes in which each child's ultimate potential is more likely to be reached. It is
the responsibility of the school to foster in the children a feeling of pride and appre-
ciation for the art heritages of all groups that participate in our society and that con-
tribute to its art.

While early childhood is a difficult period to teach the concept of historical time, children can view original works of art as well as reproductions. They are able to know that art has a long history and that mankind has always been engaged in the creation of visual images. If the teacher will expose the children to art from some of the major periods of art history, the idea will be born that there is no one single art form that is "correct" for all human beings. The children in these early years can come to know that at different periods of time art has taken different forms and served different purposes.[10] Within the contextual study of other cultures and times, some of the important artistic contributions of ethnic groups can be introduced, observing their similarities and differences and the purposes that prompted the artists to create them.

Notes

1. *Visual and Performing Arts Framework for California Public Schools, Kindergarten Through Grade Twelve,* (Sacramento, Calif.: California State Board of Education, 1982), pp. 5–7.
2. Charles E. Schaefer, *Developing Creativity in Children,* (Buffalo, N.Y.: D.O.K. Publishers, 1973). p.
3. Paul E. Torrance, *Creativity,* San Rafael, Calif.: Dimensions Publishers, 1973), p. 1.
4. Ronald Silverman, "Curriculum Coral," *Painted Monkey,* (Volume 8, No. 5, February 1983), p. 2.
5. Earl W. Linderman and Donald W. Herberholz, *Developing Artistic and Perceptual Awareness, 4th ed.,* (Dubuque, Ia.: Wm. C. Brown Company Publishers, 1978), pp. 5–6.
6. Paul E. Torrance, Ibid., p. 40.
7. Herbert Ginsburg and Sylvia Opper, *Piaget's Theory of Intellectual Development: An Introduction,* (Englewood Cliffs, N.J.: Prentice-Hall, Inc., 1969), p. 221.
8. Torrance, Ibid., p. 43.
9. Eisner Elliot, Instructional Monographs: *Ideas to Provoke the Thoughts and Actions of Education,* "The Nature of Aesthetic Education," Sacramento, California, Sacramento County, Superintendent Schools Office, 1968, p. 2.
10. Kenneth M. Lansing, *Art, Artists, and Education,* (New York: McGraw-Hill Book Co., 1969), pp. 357–59.

3 Reaching Out

Art is like a border of flowers along the course of civilization.

Lincoln Steffens

It is through early contact with art and artists that the child's attitudes and concepts form. The young child is ready to find and enjoy art in his community. This discovery can be facilitated in several ways.

Museums and Galleries

Most of the larger cities and towns in our country have a number of small galleries and a museum or two that offer exciting viewing potentials for field trips. Some museums have specially designed rooms or galleries for elementary school children.

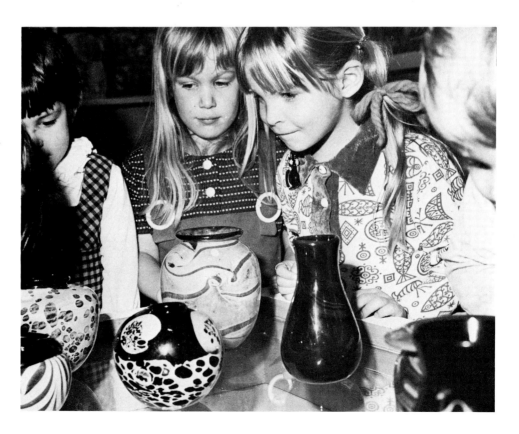

Preschoolers visited an art gallery and studied the swirling, contrasting patterns that the ceramist created on these pots.

Many have docents (tour leaders) who are particularly trained in helping children view with sensitivity and awareness and respond aesthetically and with imagination.[1] The youngest child will enjoy exploring and discovering, with only a little instruction on the part of the teacher. He will respond emotionally and vigorously to colorful paintings, huge sculptures, and decorative prints. Older children will benefit by some pretrip discussion and direction as to what they are likely to see, how the objects were made, by whom, and other details.

Many galleries have a rental room where a class may browse and collectively vote on which work of art they would like to borrow for a month or two. The rental

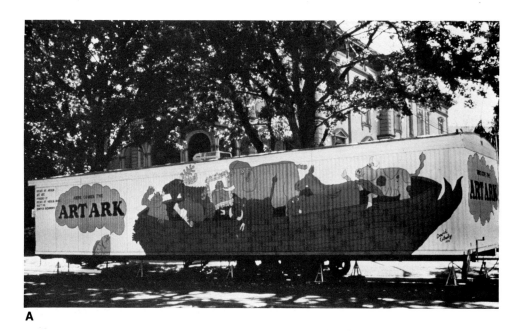

A

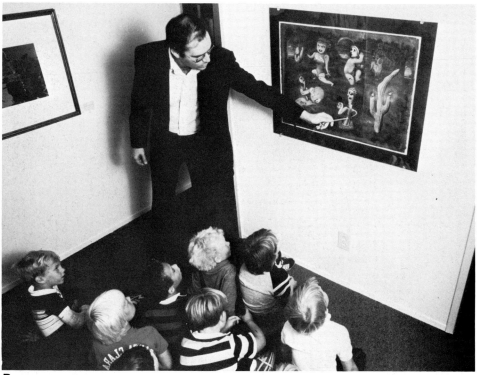

B

A and B. Crocker Art Museum, Sacramento, sends ART ARK for a week's visit to schools. Mobile unit is staffed with an artist who talks with small groups of children as they tour its interior and see original works of art. A-Photo by Chad Chadwick, © 1983; B-Photo by John Mees, © 1982.

fees on these paintings, prints, and drawings are minimal, and the children will profit by participating in the selection as well as in living with their choice for the allotted time.

In some parts of the country a traveling museum has been housed in a large trailer or mobile unit, enabling children to come in contact with original works of art even though they may live in areas somewhat distant from a museum or in school districts whose budgets for field trips have been cut. Proper planning insures that both teachers and children are prepared for the sojourn of the traveling unit, that they are escorted through the exhibit with a guide well-versed in talking with young children, and that adequate follow-up activities are provided for.

Art-in-a-Trunk

A similar concept to the traveling museum, but on a much smaller scale, is the Art-in-a-Trunk project. In Sacramento, California, community groups, clubs, leagues and businesses cooperated with the Junior League in sponsoring the assembling of eleven Art Trunks. Foot lockers were equipped with shelving, compartments, and wheels, then the interiors were transformed into a multi-media milieu for teaching art in kindergarten through the sixth grade. On loan to elementary schools the Art Trunks each have a theme. Some encompass multi-cultures, such as Arte de Mexico, African Art, Native American Art, and American Heritage. Other Trunks are cross-cultural and contain items related to Weaving, Puppetry, Toys, Art in Music, Man the Adorner: Jewelry, Design, and Birds and Beasts in Art.

The contents of each Art Trunk are structured around the following general categories:

1. Mini-museum: replicas, originals, folk art—from many cultures, countries and periods, incorporating a variety of materials.
2. Bulletin board visuals: photographs from books, magazines, etc., mounted on colored poster board and laminated. Holes are pre-punched for attaching with pins to bulletin board.

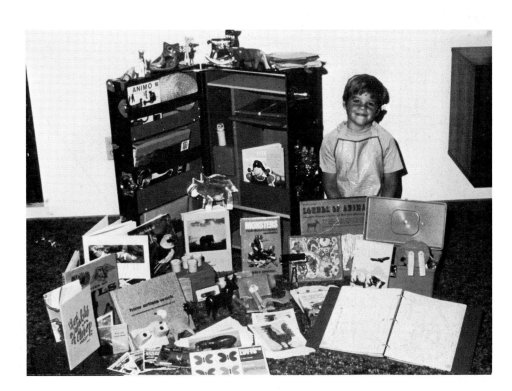

Birds and Beasts is the theme for this Art Trunk. Contents are geared for teaching art's four components using a multi-media milieu.

3. Stand-up visuals: zigzag fold-up display materials made of pages from books, magazines, calendars, etc., mounted on 9 × 12 inch colored poster board, laminated, and then taped at the sides. Also, plastic cubes with photos mounted on five sides.

4. Filmstrips with cassettes: some were purchased from commercial sources and others were created by local personnel from slides taken from private collections, local museums, and other sources.

5. Books: both children's and teachers' . . . reference, how-to books, related story books, descriptive, historical, detailed, etc.

6. Games and puzzles: crossword, matching, word-a-grams, acrostics, etc., for vocabulary and general concept development; manipulative puzzles and games, commercially purchased or created by committee members. Postcard puzzles, mounted on colored poster board, cut and placed in vinyl fold-up envelopes.

7. Project cards: written and visualized descriptions, directions, how-to-do-it's, etc., on 8½ × 11″ paper, mounted on colored poster board and laminated. Originals are kept in files to guard against loss. Schools are encouraged to make copies in order to make use of the ideas inspired by the visit of the Trunk.

8. Examples to accompany the project cards, mounted laminated and placed in vinyl packet with project card.

9. Tools for projects: brayers, looms, magnifying glass, baker's clay tools, and others.

10. Tape cassettes: introducing child to Trunk. Descriptive, explanatory, motivating. Also cassettes with stories, legends, folk tales related to the theme of the Trunk and made by members of committee.

11. Reproductions: sets of 20 of one print, 6″ × 9″ or in postcard form, laminated and placed in colored vinyl packets.

Smaller than the Art Trunks but highly concentrated and practical are Art Boxes. Filled with items related to such themes as Japanese Art, Masks around the World, and the Art of India, the boxes are a stimulant to the development of a unit. The boxes may contain such hands-on items as folk art, a filmstrip and cassette, brayers, games,

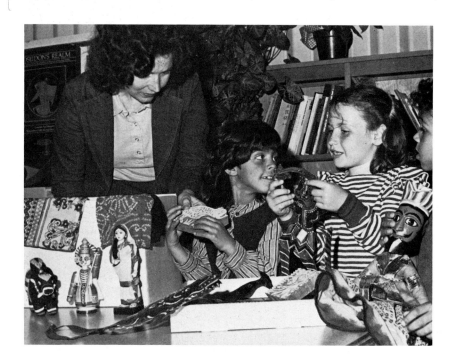

Items from India are examined from an Art Box that contains puppets, costumed dolls, fabrics, etc.

puzzle sheets, sets of reproductions, and are an open-ended tool to establish, implement and nourish art projects that are related to the Four Components. Art Boxes are easy to store, an exciting challenge to compile and assemble, and a joy for the creative and inventive teacher to use. Any single idea or concept can be embodied in an Art Box; and these can be geared to any age level and used repeatedly in many different ways.

Contacts with Artists in School and Community

A visit to the studio of a working artist has much to offer the young child. He comes into contact with an adult whose life is devoted to his art, and he sees him at work—producing paintings, sculpture, prints, or crafts in his own studio. He observes the artist using fascinating equipment, and he listens and watches as the artist explains the sequence of steps it takes to complete an object. Most artists' studios abound in finished objects as well as works in the making, and they are intriguing places for youngsters to visit. They can come to know and identify art as something that is a natural and vital part of adult endeavor and of a community's life. A unit on the "Community and Its Helpers" often includes visits to fire stations, post offices, and factories.

A trip to the studio of a metal sculptor introduces children to the beauty inherent in steel, copper, and brass when these materials are touched by the torch of a skilled and sensitive craftsman.

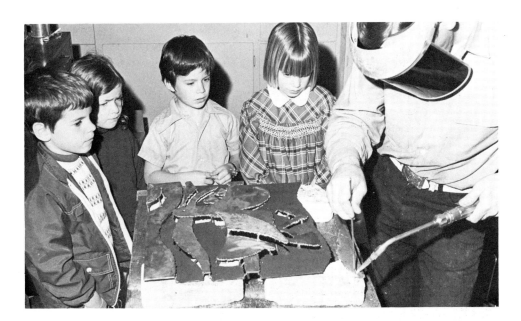

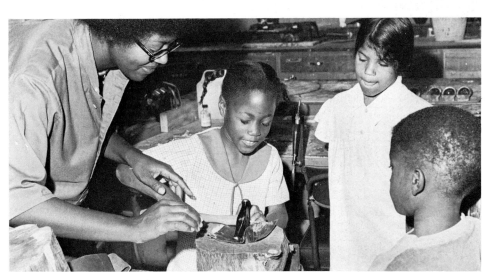

Visiting youngsters watched to see how jewelry can be made, and then they were given the opportunity to pound copper in a wooden mold.

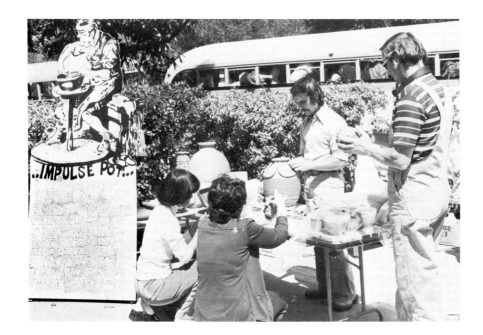

Art fairs and art-in-action events held in shopping centers and other locations are excellent resources for children to view artists at work. Here, a potter throws and decorates a pot and invites audience participation.

What better time than this to arrange a visit to the studio of an artist? To see a potter throwing a pot on a fast-spinning wheel, to watch a sculptor chisel a block of stone or wood and see a beautiful form emerge, to see a craftsman create jewelry with metal and heat, to watch a weaver make a shuttle fly back and forth on a loom, or a print-maker work on a silk screen—all these are "ah-inspiring" experiences indeed for the young child.

Many shopping centers hold 'art fairs' with dozens of artists and crafts persons not only exhibiting their work but participating in an art-in-action performance. These occasions offer opportunities for children to see sculptors welding, jewelers setting stones, wood carvers polishing sculpture, and potters throwing on a wheel.

Not only is it feasible and stimulating to take the child to art gallaries and artists' studios, but it is also highly recommended that artists be invited to come to the school. The teacher can enlist the help of guilds, leagues, museums, galleries, local Arts Councils and Artist-in-the-Schools programs to recruit resource people to visit the classroom. The photographs on page 31 show a woman from the Weaver's Guild who brought her spindle, fleece, and spinning wheel to a preschool and not only demonstrated her skill but let the children work at carding wool and try their hands at spinning. They watched with keen attention as she showed them how yarn may be spun on such a simple device as a stick inserted in an onion. She told them of the many sources of fleece and brought along samples from a number of animals for them to touch.

In a similar manner, an enamelist, linoleum block printer, painter, jewelry maker, or any number of kinds of artists could touch the children's lives in a memorable way through a classroom visit.

Folk Art: An Ethnic and Cultural Emphasis

Above the entrance to the International Museum of Folk Art in Santa Fe, New Mexico, are inscribed the words: "The art of the craftsman is a bond between the peoples of the world." Folk art comes to us from many ethnic and cultural groups. The people who have produced it were and are the common people of a nation or region. They modeled, constructed, carved, wove, stitched, and otherwise made objects for both utilitarian and nonutilitarian purposes. These visual arts are part of the record of mankind's achievements. They embody the values and beliefs of different cultures.

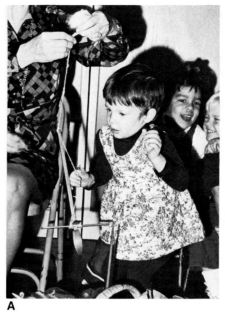

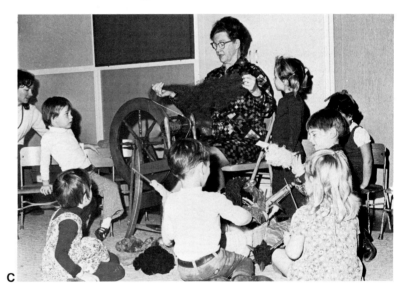

A. Three-year-old girl gives the demonstrator an assist and actually sees fibers become spun yarn on a drop spindle.

B. The ancient task of carding wool is experienced first-handed by this young boy.

C. Preschoolers examine several kinds of fleece used for spinning yarn on the wheel.

Through examining them the child can begin to have a feeling of the past as well as for the present. Folk art can involve children in learning something of our origins and of ourselves. Some of the ancient artifacts that we find in original, reproduced, or photographed form tell us of human necessities, beliefs, scenes, and customs of a vanishing way of life—a way of life that nourished man's soul and from which he felt the need to fashion beautiful things. Folk art celebrates the creative spirit of a people and preserves evidence of cultural traditions.

Alexander Girard in speaking about the Collection of Folk Art from the Girard Foundation makes a plea for the present-day evolving of customs and the shaping, in our own way, of contemporary objects of equivalent value, using new methods and materials. Folk art, he believes, should not be sentimentally imitated, but its creative spirit should nourish the human productive attitude of the present.[2]

Very young children can be introduced to the artistic heritage of many countries, peoples, and times, by seeing a number of items that have their origins in ethnic and cultural groups. They can come to know that art has always been an important and

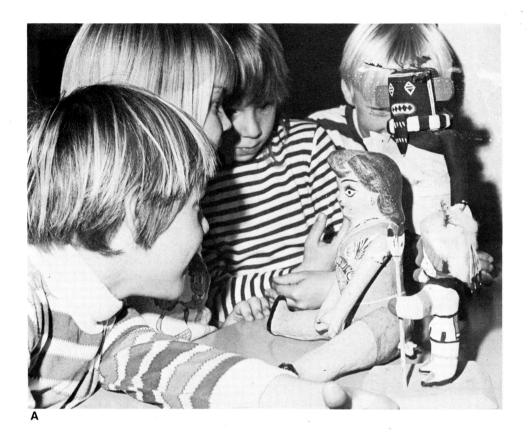

A

A. Papier-mâché doll from Mexico and Kachina dolls from the Southwest use familiar materials and arouse the interest of children everywhere. Through respect is born the desire to handle fine things with care.

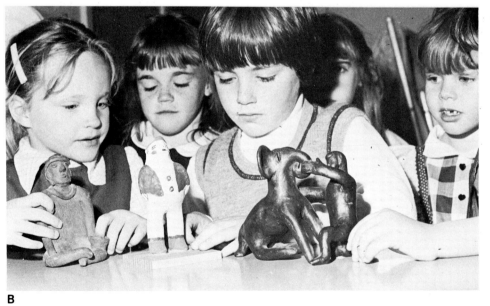

B

B. Mexican and Indian figures, both human and animal are modeled from clay. Six-year-old children are fascinated with their simplicity and tactile appeal. Folk art in the classroom inspires, stimulates, and conveys historical and cultural concepts

beautiful aspect of life for young and old alike. Folk literature, folk music, folk dance, and folk costumes have long been meaningful areas of exploration in the educational program. Children respond readily to the directness and simplicity of folk art and to its sometimes humorous, whimsical notes. In the early childhood classroom, folk art can serve to motivate an art production, be the focal point for a discussion of aesthetic considerations, or provide information about the way of life of another people.

Though the roots of various cultures differ widely, there is a pervasive similarity in most folk art, and at the same time there is a good deal of relatedness to child art. Its materials and subject matter are often familiar to children. Carved and modeled figures, both human and animal, masks, baskets, pots, dolls, toys, jewelry, textiles, and metal pieces usually portray an individual craftsman's response to a need—whether it be for beauty, function, or just plain delight. Such ethnic and cultural art, when brought into the classroom, seen in galleries or books, or viewed in films, bring to the children's eyes and hearts insight into the proud roots of many cultures. Throughout time these have given a high priority to fine craftsmanship and good design to all sorts of objects—whether they were made for everyday use, for religious or ceremonial purposes, or even for play.

Almost all art of ethnic origin makes use of a great deal of overall decoration, whether it is applied to a fabric, carved on an animal, painted on a clay pot, or hammered on a tin mask. While the motif is usually uncomplicated, it is often repeated over and over because the folk artist delights in rhythmic design rather than in the natural appearance of things. Many folk groups use their own legends, stories, religion, and everyday events as a basis for their craft work. In a similar manner children model and construct characters from their own favorite tales and from their immediate environment. Folk artists everywhere love to carve, model, and make small figures of both humans and animals, and children respond instinctively to this sort of sculpture with delight and interest.

While industrial growth and the emergence of city life have brought about a decline in this valuable art form, the last few years have witnessed new and revitalized interest in crafts and folk art. It appears from this trend that the need for being involved in craft and art production as well as for owning objects made by someone's hand is a very natural and human one. It can be fostered and nourished by introducing and enjoying folk art in the early childhood educational program.

Notes

1. *Art Education: Elementary* (Washington, D.C.: National Art Education Association, 1972), pp. 184–90.
2. Alexander Girard, *The Magic of a People* (New York: Viking Press, 1968), Introduction.

Avenues to Aesthetic Growth 4

Art is the difference between seeing and just identifying.

Jean Mary Norman

Any discussion of a work of art, whether it is an original in a museum, projected from a slide, filmstrip or film, or a reproduction[1] in the classroom should include information relating to both the subject matter or story and to the form, style and design of the work. Some works of art are purely visual without any story or objects that can be identified; in this instance it is difficult for the story-oriented individual to make any sense of it. This sort of painting or sculpture may easily be rejected by a child who was never been exposed to a perceptive discussion related to a totally non-objective work of art. While music without words may be tolerated, all art must 'look like something' for this individual. If pictures are viewed, visually analyzed, and reactions made with feeling and insight, the child's mind will tend to remain open and free to understand and enjoy all sorts of art, both now and in the future.

When young children view a work of art, whether it is contemporary or historical, original or reproduced, the teacher should give them some appropriate background information which is within their level of comprehension. Knowing about different kinds of art and artists, what artists think about and what they do, and how art is a part of everyday life are important aspects of this sort of aesthetic discussion in early childhood. Emphasis should be placed on the enjoyment of a work of art, the uniqueness of each piece and on the presentation of many kinds of art.

Interaction with Art

Children respond to works of art with a natural enthusiasm. However, the visual language that some artists use needs a degree of interpretation or decoding for fuller understanding. The information given the children should be brief; it may refer to the process and materials used in making a work of art, the subject matter depicted, the country of its origin, and a few interesting facts about the artist's life. Reference should be made to the structural and design elements that make the work especially interesting and to the expressive component inherent in the work. We should encourage young children to delay making a judgment about a work of art until they have considered several basic questions. These have to do with describing what they see, observing how the work of art was composed or put together, and thinking about what it was the artist was trying to say.[2]

Another concept suitable for discussion with young children is the idea that each artist is trying to do something different, something unique. The question we can ask is "What do you think the artist is trying to do?" In this way, young children's imag-

inations are stimulated as they explore the ideas and emotions that the artist might have wanted to communicate. A suitable evaluation question might be, "How close did the artist come to doing what he set out to do?"

Which works by adult artists appeal most to very young children? Generally speaking they like to see things that have something in common with their own work and lives. They love to see paintings and sculptures of children, both historical and contemporary; animals; people doing things; fantasy and imaginative types of subjects. Filmstrips showing great works of art, both old and from our time, have been produced, focusing on subject matter, materials, techniques, countries of origin, periods of time, and other aspects (see Source List on page 228).

Children are more apt to identify with works that have something in common with their own work, whether it be color, line, or subject matter. Works that make their curiosity tingle are good starting points. (Why did Chagall show people dancing on the ceiling?) Works that make art an adventure, that intrigue children enough that they want to use brushes and paint and tell us about their own points of view, are valuable.

Viewing the art work of others can lead to an important concept: art expresses many different ideas in many different ways. The child in today's world is bombarded with coloring books, plastic models, paint-by-number kits, and the ready-made, repetitive images of television and computer games. The emphasis is frequently on control, following directions, and imitating others in order to obtain the one "correct" or "best" solution. Even in school, there is only one "right" answer in an arithmetic problem, and no one wants a creative speller. With the invention of the camera, there is little reason for photographic likenesses; artists are free to create images which express their ideas, emotions, and experiences. In viewing the works by adult artists, it is possible to show the many ways people can express themselves; aesthetic encounters which compare and contrast art in this way can free the young artist to create expressive and subtle images reflecting his own unique spirit.

Although visits to art galleries and museums are ideal ways to view original art, these are sometimes limited by finances or availability. Student interest can still be stimulated by introducing them to artists through the use of art reproductions in the classroom. Many teachers find that setting aside a small bulletin board area for the classroom's 'Art Gallery' stimulates interest. Several reproductions from one artist may be hung at one time, or perhaps a number of small prints by artists who painted self-portraits or clowns or horses might be grouped together.

Details from small art prints can be used to make plastic covered badges. A badge kit is available from Nasco (See source list on page 228), and circles may be cut from small reproductions and encased in a pin form. Several dozen of these badges can be made and labeled on the backside with a felt marker as to the name of the artist or country of origin. The children can wear them or the teacher may wear a different one each day as a highly visible way of acquainting children with some famous works of art.

Getting Acquainted with Our Artistic Heritage

What mode is best utilized for introducing young children to their artistic heritage and how can the art program develop lasting attitudes and skills for aesthetic awareness? Appropriate visual materials, interesting conversation and commentary, and related hands-on activities enable children to actively participate in seeing, valuing, comparing, contrasting, and enjoying works of art from the past, present, and from around the world.

Reproductions of works by well-known artists should be displayed in the school. These are available, mounted and unmounted, from several sources (see list on page 228). Filmstrips and slides are other media that bring the works of the great masters into the lives of young children.

Commentary and questions should aim at having the children perceive and respond to four major areas of emphasis: (Example: "Coryell's Ferry," Joseph Pickett, Shorewood Print #832)

Describing the subject matter—observing details that the viewer actually sees.

"The river in this painting is shown during a spring flood. Large trees are being carried downstream. The houses are shown in great detail. Can you see all the windows? Can you find animals drinking from the river and see their reflections? How many ducks do you see on the river? Who can find the horse waiting for his rider on the hill? What is his rider doing? What shows us that the wind is blowing? Can you find the water wheel? Do you see the water rushing down the hillside carrying more trees?"

Identifying the elements and principles of art—concentration on color, shape, line, value, and texture, and how the artist has used these elements to create balance, unity, emphasis, contrast, pattern, movement and rhythm in the composition.

"What is the most important color in this picture? It is green, and it is shown in bright fresh tones that make us think of spring rains and stormy winds. It is accented with yellows and browns. Let's take a walk with our eyes and see where the artist's use of line takes us. Start at the upper left corner and move along the ridge to the left. Where does your eye go next? The artist knew how to lead our eyes through his painting. This gives it a feeling of unity. What shapes are the buildings and the windows? What shapes are the uprooted trees? Look at the texture of the rushing water. Compare it to the texture of the trees on the hillside. Is it the same or different? Do you have a feeling of balance when you look at the painting? What shapes give you this feeling?"

Responding to the feelings and emotions that the work of art evokes—its expressive content.

"Have you ever gone outside after a spring storm and seen trees bending in the wind and water running high in a river? Is a flood frightening? What do you think the man is doing? What do you think will happen next in this picture? Make up a story about it. The artist, Joseph Pickett, loved his hometown and wanted us to share his feelings about it."

Knowing some information about the artist—his/her life, style of working, and favorite subject matter.

"Joseph Pickett painted this picture about 100 years ago. He lived in Pennsylvania and taught himself how to paint. He worked as a carpenter, boat builder, storekeeper and at carnivals. He painted his hometown in all seasons and watned people to know every detail and all about the events that happened there. Pickett is classified as a 'primitive artist.' "

An art activity after this sort of discussion could be based on extending the concept that primitive artists like to include many details in their pictures so that people in the years to come will see an accurate record of how a place or persons looked and what events took place. The skill to be emphasized is one of observation. Pickett looked very carefully at Coryell's Ferry and painted about an exciting flood. The motivation should ask the children to remember some event that happened on their street or at their house . . . perhaps when workers repaired the street, put out a fire, cut down a tree, or towed away a wrecked car. The children would then draw a picture about it and include perhaps at least six important details that show where the event took place, what happened, and who was involved.

Sharpening the Discussion

The first impression a work of art makes oftentimes may begin the discussion. For different pictures or works of art, different questions are appropriate. If color appears to be the most important element, questions should focus on that; if line, then questions should center on this element. The following observations might be covered:

1. What is the most unusual or interesting thing about this picture?
2. Do you think the artist was more interested in colors, shapes, lines, and textures, or was he/she trying to convey to us a story/message?
3. What are the main part/parts of the picture, and how are they arranged (in the center, flat background, spiral, triangular, closeup, faraway.)
4. In discussing line, questions should point to such aspects as: are the lines smooth, flowing, delicate, jagged, stiff, weak, swirling? Do any lines express a mood or emotion? Is any line repeated regularly? Is any line varied in direction, length, color?
5. In discussing shape, questions should detail such aspects as, do the objects stand out from the background as solid shapes? Are they delicate or bold and strong? Are some shapes flat? Are any shapes distorted to show strength, grace or sorrow? Are any shapes repeated in several places? Is one shape the most important thing in the picture? Do some shapes in the picture appear to be farther away than others? Are things farther away as clear as those shapes that are closeup? Could any shapes be moved without losing a feeling of unity? Are some shapes overly crowded? Are some spaces lacking in form and uninteresting?
6. In discussing color, questions should detail such aspects as: in a quick glance, what is the overall effect of color in this work of art? Is it dull, bright, pale, intense, warm, cool, clashing, quiet, rich, dull, confused, bleak, sad? What color is dominant? Is it because of its brightness, or has it been the one most used? Is it centrally located, and are there many different shades and tints of that one color? Are the colors enclosed with definite lines? Do the colors contrast with those next to them? Do the colors gently blend together? Where are the colors repeated? Do any scattered spots of a color form a pattern? Do color repetitions lead your eye all over the picture? How would the picture look in black and white? Do the colors shimmer, sparkle, grow dim and hazy? Does the color help express a mood?
7. In discussing dark and light, questions should bring out such aspects as: where are the lightest parts of the picture? the darkest? Is there a strong constrast between them? Where is the light probably coming from, a lamp, moon, or the sun? Are there shadows in the picture? Are they soft with details in them, or dense and black? Are there shadows that are diffused and broken, such as sunlight through leaves? Do the lights and shadows look natural and real?
8. In discussing texture and pattern, questions point to such aspects as: how many different textures can you find? Are some textures soft, others shiny or rough? Where do you see pattern? Are the textures repeated in several places? How did the artist indicate the texture or pattern?

Utilizing Parent Volunteers

A regular monthly visit to the classroom by a parent volunteer who has been trained in making art appreciation presentations can enhance and supplement the classroom art program.[3] A museum docent is a person who is skilled in escorting groups of people through an exhibit, explaining and giving appropriate information. A parent volunteer, acting in the docent role, carries a mini-exhibit of great works of art in the form of mounted reproductions in a portfolio and spends about 30 minutes in the classroom.

Parent docent discusses
Picasso's "Three Musicians"
with youngsters.

Here is a suggested set of themes for a semester's portfolios. It is followed by a
sample lesson from Grade One.

KINDERGARTEN

Artists Make Pictures
Artists Paint Animals
Artists Paint Cowboys & Indians
Artists Have Fun with Sculpture: Calder and Moore

GRADE ONE

Artists Paint People at Play
Artists Use Color
Artists Paint the Circus
Artists Paint Self-Portraits (sample lesson follows)

GRADE TWO

Artists Paint Birds
Artists Paint Winter and Summer
Artists Use Line
American Folk Artists

GRADE THREE

Artists Paint Still Lifes
Artists Paint Trains
Artists Use Shape
Artists Paint Children

Artists Paint Self-Portraits (sample lesson)

A favorite subject for some artists is his or her own picture. An artist who draws a picture of himself must keep the same pose and the same facial expression as he moves his eyes back and forth from the mirror to the canvas. Some artists painted their own portraits many times during their lifetime, and we can see how they looked when they were young and when they were old. It is interesting to see how the artist sees himself and what feeling is portrayed. When an artist paints himself, it is called a self-portrait. Here are some paintings that some different artists have made of themselves.

Vincent Van Gogh (Shorewood Print #1285)
Van Gogh painted this portrait of himself at age 36. The background and his clothing are a light sea green, and his red hair and beard stand out sharply against it. He is wearing his everyday shirt and coat. He painted about 100 portraits over a three-year period, and many of them were of himself. He had difficulty getting models since he couldn't afford to pay them. Then too, he was a strange sort of man, and sometimes people didn't want to pose for him. When he painted this picture he had just had a quarrel with a friend, another artist named Gauguin. Can you see the swirling brushstrokes? They seem almost to be moving. His pose is called 'three-quarter.' This means it is not full frontal or profile and we can see one ear. He painted himself frowning with a tight unsmiling mouth and hard intense eyes that stare right out at us. He seems determined to try to be calm amid all the swirling motion around him. He was a lonely man and had a sad life. He is known for his pure bright colors and swirling thick brushstrokes.

Henri Rousseau (Shorewood Print #1319)
This happy scene shows Henri Rousseau standing near a ship decorated with flags. There is a clear bright sky with soft clouds and a balloon. The two tiny figures promenading by him are no larger than his shoes. Does Rousseau look as if he is almost floating off the ground? Describe how he is dressed. How did he show us that he is an artist? The button on his coat was mistakenly awarded to him once, but he wore it anyway. The names on the palette are of his two wives. Can you find his signature? What do you think the artist Rousseau was like? He was a friendly man who had no formal schooling as he grew up. He worked as a customs inspector for the government outside Paris. Artists liked his work very much but some critics laughed at him for the way he painted. He sometimes used a tape measure to measure the people he painted.

Albrecht Durer (Shorewood Print #524)
Albrecht Durer painted this portrait of himself about the time Columbus discovered America. He was 21 years old. He shows us that he is well-dressed in rich clothing and has an elaborate curly hair style. He is standing in front of a window and makes us feel that he had an elegant life. He was very skilled at showing differences of texture in clothing, skin and hair. He made many pictures of himself during his lifetime. He painted very realistically, telling a friend that other artists were so jealous of him that he couldn't attend a banquet for fear of being poisoned! He painted portraits of many rich and important people during his lifetime. Have you ever seen the picture he made of a rabbit? It is so real that you want to reach out and touch its fur.

Max Beckmann (Shorewood Print #525)
This painting was done fairly recently, about 1944, when the artist was 60 years old. He has a strong very masculine face. He studied his features very carefully and painted himself many times, even including his likeness in some of his other pictures anonymously. He painted himself in many different costumes, in different moods and from different angles. Try sitting in this position. His long fingers are an important part of the composition. His head tapers to a determined strong chin, and his mouth tightens to a line. We are almost forced to stare back at him. Can you see the light shining on

him and find the highlights? The expression on this self-portrait makes us wonder what he is thinking about. He was in World War I and was horrified at some of the things he saw. His portraits are often mysterious. (As a supplement, show Filmstrip/Cassette #301, "Self-Portraits," Wilton Art Appreciation Program.)

The teacher's responsibility is that of following up, reinforcing the concepts covered by the parent docent, and providing a hands-on art experience that is related to the theme of the presentation. Here is a sample lesson for "Artists Paint Self-Portraits."

Strategies for Visual Involvement

Maria Winkler and several teachers and museum personnel[4] have developed some strategies for involving children in looking at art whether the works of art are in a museum and are viewed as original works of art or whether they are brought into the classroom via a mounted reproduction. During a museum visit, children should be moved quickly to avoid fidgeting and boredom. They should keep together as partners, sitting down in front of the art work or holding onto a length of rope. They should know that they may touch the art with their eyes only. Some specific techniques suitable for working with young children include the following:

General Activities

1. Tap a child's shoulder with a 'magic wand,' to enable him/her to see something that no other person can see in a painting or to find some secret thing.
2. Look at the art from upside-down, faraway, very close.
3. Begin a story about the art work, with each person taking a turn and developing the story.
4. Rename the art work and tell your reasons.
5. Look at the art work for ten seconds, look away and try to remember and describe it in detail.
6. Be a salesman. In ten seconds sell the art work to the group.
7. Take turns using one word to describe the work.
8. What would you change or add if you had been the artist?

Focus on Abstract Works of Art

1. All children shut their eyes except for one child who describes the work and then the group guesses which work was described.
2. Decide which works match or belong together.
3. Choose a painting that you could hide inside.
4. Choose flavors for each color in a picture.
5. Have a detective search . . . who can find a triangle, a white roof, etc.
6. Which work is noisy or quiet?
7. Try to find a color that is used only once in a painting.
8. Pretend the painting is a maze and find a path from one side to the other.

Focus on Portraits (Try to have two or three for comparison such as Van Gogh's Postman, the Mona Lisa, and a Modigliani)

1. Look carefully at the face/faces and imitate their expressions. Do they look like anyone you know? Is the person probably a father, mother, or what? Give him/her a name.
2. What would the last few pages in this person's dairy say?

PARENT
DOCENT
PROGRAM

Grade 1
Artists Paint Self-portraits

ART Concepts and Skills: A self-portrait is a picture (or sculpture) that an artist makes of himself. Some artists made self-portraits many times during their lives.
Mixed media involves creating a work of art by combining several art materials.

You'll need:
black crayon or pen
mirrors
white manila and colored paper
scissors and paste
oil pastels or crayons
fabric scraps
wallpaper samples

Here's how:
1. With chalk lightly draw the left or right half of a large oval on a piece of colored paper that is close to your skin color. Fold it in half vertically. Cut it out. Unfold it. You have made a *symmetrical* oval. Fold it in half horizontally to find where to draw your eyes.
2. Cut out a neck and add it to the face.
3. Cut out the shoulders of your shirt or dress. Use fabric or wallpaper for this.
4. Cut out some hair from colored paper.
5. With small amounts of paste, adhere all the pieces in place on a large piece of white, manila or colored paper.
6. Use oil pastels or crayons and color in the features: eyes, nose, eyelashes, eyebrows, lips, ears, glasses, etc. Bear down on oil pastels to gain their full velvety glow. Working on top of a pad of newspapers makes it easier.
6. Think of a repeated pattern or design for the background.
7. You have mixed several media for your composition.

Motivation:
Look at your face in the mirror. Look at the location and size of each feature. Look at the shape of your eyes, nose, mouth. Look at the color and length of your hair. Find where your neck begins and ends. With your face very close to a mirror, close one eye and hold *very* still. Use a black crayon or felt pen and draw the outline oval of your face on the mirror as you look at your face. Now draw your eyes. They are located about half- way from the top of your head.

Vocabulary:
self-portrait features mixed media
symmetry oval horizontally composition
vertically

Spin-Off:
Try drawing your self-portrait with a soft lead pencil while you are looking in the mirror. Then draw it again a week later and compare the two drawings.

3. Let one child interview the portrait and another child pretend to speak for the portrait.
4. How are the portraits like or not like photographs?
5. Is the person in the portrait posing, and how can you tell? What do you think he/she was thinking about?
6. Would you like to sit next to this person on a bus ride? What would you talk about?
7. What kind of present would you choose for this person's birthday? What kind of present do you suppose this person would choose for you?
8. What does this person do for a living? Is he/she friendly and kind?

Focus on Sculpture

1. Create a group body sculpture or individual body positions in imitation of a piece of sculpture.
2. In a heavy rain, which sculpture would you choose for shelter?
3. Pretend you are an ant and crawl over the sculpture with your imagination. How would you explore it? How would it feel? Or pretend the sculpture is reduced to a very small size. Where would you keep it? What would you use it for?
4. Would you change any part of the sculpture?

Focus on Landscapes

1. What kind of weather do you think is indicated in this picture? How can you tell?
2. Would you like to visit or live there?
3. What time of year is it? time of day?
4. Shrink yourself and step into the landscape. Tell where you would walk first.

Games for Aesthetic and Perceptual Growth

The following games are examples of play activities designed to sharpen the child's perception, familiarize him with great works of art, and give him a working visual/verbal knowledge of some of the elements and principles of art.

Not exactly new as a teaching device, Friedrich Froebel[5] used the game technique in 1896 when he developed his gifts, which consisted of blocks, triangles, straws and other materials. The game approach can be a useful one for teaching art concepts. The competitiveness factor is minimal in the games described here; and art games can be an excellent activity for an individual child or small groups. They are easy enough that most children may play them alone and independently, thereby minimizing the teacher's role in judgment and direction.

The directions for the games listed here are not meant to be rigid; rather, it is hoped that the ideas presented will stimulate the adult himself to become involved in the creating and making of other art games. The teacher will need to collect a number of small reproductions of great works of art, as well as photographs showing pattern, color, texture, and closeups of natural objects. Commerical sources for fine arts prints are listed on pages 228–231, and one should not overlook small paper back books on art, calendars, museum catalogs, advertisements, and magazines, for they can provide valuable materials for the avid game maker.

If game cards are laminated or covered with clear contact paper, they will wear better. Plastic file boxes from office supply stores or variety stores are excellent for packing and storage. Brightly colored vinyl from yardage shops can be stitched on a machine, and the openings secured with an inch of velcro. This inexpensive vinyl ma-

terial can be made into envelopes, bags, and pouches which take up little storage space while protecting the contents. The vinyl should be sandwiched between two pieces of tissue or typing paper in order to slide easily and not stick under the pressure foot of the sewing machine.

Artcentration (Similar to Concentration).

Make a set of twelve pairs (or more) of mounted reproductions. One pair consists of two prints by the same artist. The pairs may be the same paintings by Picasso, Renoir, etc., or different paintings by Picasso, Renoir, or another artist. Or the pairs may be landscapes, still lifes, figures, abstractions, seascapes, architecture, ceramics, sculpture, or jewelry. Or the pairs may be matching textures, shapes, lines, or colors. To play the game, mix the cards and place them all face down on the table. The first child turns one card over and tries to find its mate by turning over one more card. If he is successful, he keeps the pair and tries again. If unsuccessful, he places the cards back in the same position, face down, and the next child turns one card over, then tries to find its mate in one more turn. (With very small children, start with four pairs of cards and increase the number as they become familiar with the art works and the artists' names.)

Art Squares

Cut five-inch squares of colored poster board. Cut small reproductions in half diagonally so you have two triangular pieces. Place all the blank squares on a table and arrange a matching pair of triangles on each side and glue them in place. Leave a few blank sides. Place a number—1, 2, 3, or 4 on one half of each matched pair of triangles. To play the game, place all the cards in a stack, face down. The first player draws the top card and places it in the middle of the table. He then draws again and places the second card alongside one of the sides of the first card. If he is able to match a pair, he scores the number printed on the matching set. If no triangles match up, he must play the card anyway, along a mismatched side. Second player continues, drawing the top card and adding it to the already placed squares. Players are not allowed

Art Squares can be played in several ways. Two triangles match to complete each picture.

to move any squares after they have been put in place. Blank sides may be placed anywhere, but no score is given. Plays in which a player is forced to place a card in a non-matching position do not score. When the last card is played, players add up their scores. Variation: Art Squares may be played as a jigsaw puzzle, with one or more players putting all the squares together, matching all sides and timing themselves.

Art Words

Using a group of photographs of zoo, farm, or jungle animals, have one child be 'it' and secretly choose one animal and describe it to the group as to its color, the shape of its ears, the size of its feet, the placement of its nose, and so on. This causes the child to look carefully at the animal and select its significant and characteristic details. He may then say, "I have four thick legs. My skin is wrinkled and rough. My ears are flat and roundish. Which animal am I?"

Arty-Knows

Cut small reproductions in half and mount them, domino-style on small rectangles of poster board. Use two different colors of beads for keeping score. Each child has a notebook ring to hold the beads as he scores. Make 18 'half-dominoes' and 15 'double dominoes' and four blank dominoes. Place all the beads on a large notebook ring to serve as the 'bank.' Place all the Arty-knows face down on the table, then each player selects four of them. First player chooses one card from the pile and places it face up in the center of the table. He then tries to play one of his cards in a matching position. If he plays a double card, he takes a black bead from the bank; if he plays a half card, an orange bead. He draws another card from the deck or 'gallery.' Play passes to the left. If a player can't play at all, he passes to the second player and retains his four cards. Blank ends of half cards may be joined to another blank end, but no beads are collected from the bank. A perpendicular joint may be made with a blank card

Arty-Knows, a form of dominoes, is made with small reproductions cut in half and mounted on poster board.

Bag of pairs of diverse textures challenges child to discriminate and select disc inside bag that matches disc on table beside him.

where two blanks have joined. When the gallery is empty and no more plays can be made, the player with the highest score wins. Orange beads equal one point; black, two points.

Bag of Textures

Cut discs, two each of a variety of textures, such as leather, vinyl, sheet plastic, cork, corduroy, velvet, sandpaper. Child reaches in the cloth bag without looking and tries to find matching pairs by touch. Child may be asked to describe the texture. Or one disc of each texture may be placed on the table and the child asked to reach in the bag and find its mate.

Circle-in-a-Picture

Cut close-up texture photos from a magazine, or take your own color photos of flowers, tree bark, seed pods, shells, tires, pebbles. Mount each on a piece of poster board. Use an X-acto circle cutter and make a round hole in the center of each one. Glue a small bead to the cut-out circle for a 'handle.' Glue the picture with the circle cut from its center to another piece of poster board. Gently whirl the discs in the center holes to find the correct locations. (This game could also be done with fine art reproductions.)

Color: Tint and Shade Cards

Collect cards of paint samples from the paint store. Child arranges each color from light to dark.

Match-it

Collect two or three postcards or small reproductions of works of each of about five to ten artists. Mix them all up and place them in a box or a fabric drawstring bag. The child takes them out and spreads them all out on a table. Then he is to pair or match up the two or three that are by the same artist. Two Van Gogh's have similar characteristics, colors, and style; and the child should be able to separate and differentiate them from two Rembrandt's, two Gauguin's, etc.

Matching Halves

Collect small reproductions or postcards, cut in half and mount them on small pieces of poster board to make a number of very simple puzzles. For the youngest child, about three or four prints may each be cut in half and all the cut halves mixed up and placed in a small box. Have him take out the pieces and put them together, matching top with bottom half.

Match the Paintings

Make a playboard with a single picture on the left in each row followed by four blank squares on its right. Select five or six different artists. Then mount four additional pictures by each artist on small squares of poster board. The child to play the game must perceive similarities and differences in various artists' styles and techniques by grouping all the paintings by one artist on the blank squares to the right of the example. A color dot on the reverse side of the cards matches a color dot by the picture to provide for a self-checking device.

Multi-Game Cards

Mount four works of art by one artist on four pieces of poster board. (Variation: Use four different textures, landscapes, portraits, sculptures. Or make sets of four values of one color.) Make twelve sets in this manner, giving a total of 48 cards.

Game #1. *Museum:* Four players. Shuffle and deal seven cards to each player and place the remainder in a center pile, called the Museum. First player asks another player to look for all the cards he has by one artist (or all landscapes or textures, etc.) If he has any, he must give them to the first player who then asks the same player for more cards of a set. If this player has none, the first player draws a card from the Museum. If he draws the card he asked for, he may ask the second player for cards. The next player repeats play as above. When a player collects a set of four cards, he places the set in front of him. The winner is the one who has the most sets of cards when play is over.

Game #2. *Old Master:* This game requires one additional card, one that reads 'Old Master.' Shuffle and deal cards to four players. Dealer then places on the table all the matching sets in his hand, if he has any. He then takes a card from the player's hand on his right. If it matches cards in this hand, he puts the set on the table. The player to his left then does the same, and the game proceeds until all the cards are matched, leaving the 'Old Master' card in the winning player's hand.

Game #3. *Paint Brush:* Use one set of four matching cards per player, and one paint brush for each player, minus one. Shuffle and deal four cards to each player. The object of the game is to collect four cards of one set. Each player selects one card he doesn't need and places it face down next to the player to his left. When all players have done this, players pick cards up on their right. Repeat play until one player has a set of four. He quickly grabs a paint brush from the center, and then each player grabs one. The player who doesn't get a brush loses.

Perceptual Recall

Have a tray of a number of small objects. Let the child look at the objects for a few minutes. Cover the tray. See how many of the objects the child can name. Vary the task by asking the child to name all the brown objects, or all the hard objects, or all the round ones. Or have one child leave the circle, then remove one or two objects; see if he can remember which ones are missing. Start with just a few objects and increase the number as the children become more skilled.

Postcard Puzzles

Collect postcards showing fine art reproductions, or purchase small reproductions and mount them on light weight poster board. Cut them in four, six, eight, or nine pieces. Mount an identical postcard for each puzzle on poster board, and on the backside write some interesting information about the art work and the artist. Make a convenient storage pouch from colored vinyl and stitch a pocket for each set of pieces.

See, Touch, and Tell

A natural object such as a seed pod, flower, or shell is passed from one child to another in a circle, with each child adding a word or phrase to describe it. A seashell, for instance, might be called 'big' by the first child; 'big and bumpy' by the second; 'big, bumpy, and pink' by the third; 'big, bumpy, pink, and curving' by the fourth and so on. This causes the child to observe and feel the object carefully, to use a word to describe it, and to remember the other descriptive words that have been used.

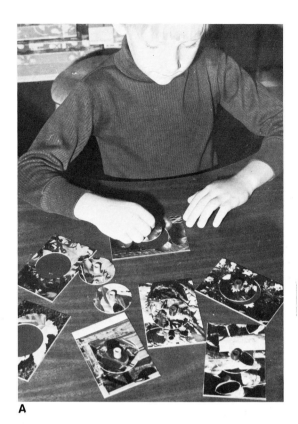

A

B

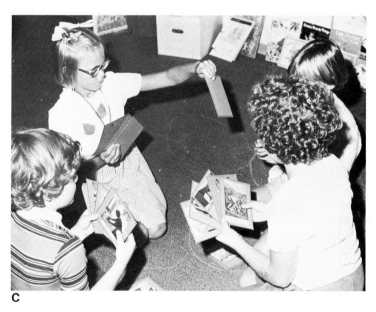

C

A. Close-up photographs of cactus, leaves, flowers, metal and such are made into puzzles by cutting circle from center of each and attaching a bead for a handle. Child must whirl circle in empty space until he matches correct position.

B. A set of five cards for each color goes from dark to light. Child may sort and match up sets in appropriate arrangement or create other tint and shade games.

C. Old Master and several other games can be placed with a pack of cards made up of sets of four cards by each artist.

Secret Guessing

Pass a small object around a circle with everyone blindfolded and have each child in turn feel it and silently guess what it is. When all the children have examined it, the teacher may call on them to see how many children guessed correctly.

Tactile Dominoes

Buy a set of regular dominoes and cover each half with different bits of textured materials such as: one = sandpaper; two = vinyl; three = cork; four = suede, five = felt; six = calico; blank = wood stripping. Dominoes are placed face down on the table, and each child draws five of them and stands them up in front of him. First player places one domino in the center of the table, and second player matches one of the ends with one of his dominoes. If he doesn't have a domino that matches, he draws from the pile until he can play. After he has played, the third player has a turn. Play continues until a player has used all of his dominoes and becomes the winner.

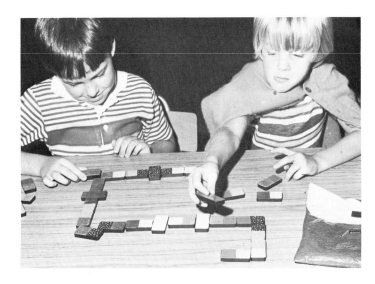

Tactile Dominoes with halves covered with sandpaper, suede, etc., enable children to see and feel differences and similarities in texture.

Tell About it

Have a number of reproductions of fine paintings, drawings or pieces of sculpture. Have three children leave the room. The first one to return is told which is the secret picture. He then must describe it to the second child when he returns, using descriptive art words that do not refer to its subject matter. The second child must remember what he has been told and repeat the description to the third child who was waiting outside the room and who must try to guess which is the secret picture. Many modifications of this game may be made according to the number and kind of reproductions available, and the interest and maturity of the children.

Three-Dimensional Jigsaw Puzzles

Use all six sides of six or nine wood cubes to mount six diffferent reproductions that have been cut into six or nine squares to fit the square sides of the cubes.

Touch and Guess

Players sit in a circle with one child blindfolded in the center. Other children take turns selecting an object from a tray for the child in the center to hold and guess what it is. Objects should include such things as a feather, a piece of sandpaper, a cube, a cylinder of wood, a nail, a bit of fur, a scrap of soft satin, a button, a paint brush, a rock, a wooden spoon. If the blindfolded child guesses correctly on the first attempt, the child who selected the item gets to become 'it.'

Verbal/Visual Match-it

Make sets of cards with small reproductions glued onto them. Make another set of cards with verbal descriptions of these reproductions written on them. (Or obtain twenty-five cent booklets from the Metropolitan Museum of Art and cut the pictures apart from the written descriptions and mount each separately.) Children may play at matching up the visual image with the verbal description. Or distribute the cards to the children and see how quickly they can find their verbal/visual mate. For children who have not yet learned to read, the teacher may distribute the visual cards and then read the verbal cards with the children listening to see if the description matches the card they are holding.

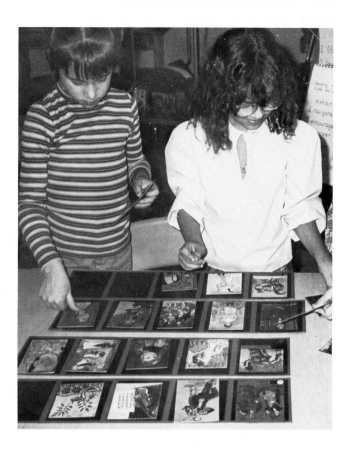

"Match the Paintings" game challenges children to find similar styles from mixed assortment of small prints.

Set of Visual Perception cards requires children to match sides and make designs. Two contrasting colors should be used in constructing a set of these cards. (See diagram below.)

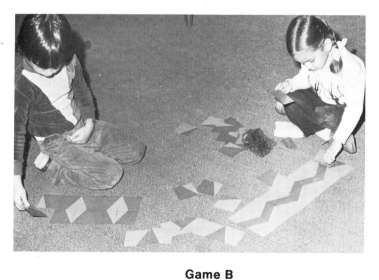

Game A **Game B**

Visual Perception Game

Make twelve three-inch squares each for Cards 1 and 2 for Game A and twelve three-inch squares each for Cards 1 and 2 for Game B. (See diagrams) Use two contrasting colors. Cards are the same on the back and front sides. Let the child play at matching and making configurations and forms. This game helps with figure-ground differentiations, visual closure, positioning, synthesizing and visual memory. Diagram shows designs for two separate sets of game cards.

Notes

1. A reproduction is a copy of a work of art considered important enough to be wanted by more people than just the owner of the original.
2. Charles D. Gaitskell and Al Hurwitz, *Children and Their Art, 2nd ed.,* (New York: Harcourt, Brace and World, Ind., 1970), pp. 422–24.
3. As developed and implemented in San Juan Unified School District, Carmichael, CA 95608: ARTS CONNECTIONS, a #1735 Exemplary Arts Project funded by the California Arts Council and the State Department of Education.
4. Maria Winkler and John Steinbacher, *The Innovative Docent: A Docent and Teacher Training Manual for the Visual Arts,* (Boise State University), 1975. Bonnie Baskin, *Games to Play in Museums,* (Berkeley: Museum of Art, University of California), 1976. (Mimeographed.); and Dolo Brooking and Leni Salkind, *Art-ful Boxes.* (Lawrence, Kansas: The University of Kansas Museum of Art), 1976.
5. Friedrick, Froebel, *Education of Man,* (New York: D. Appleton Co., 1896).

5 Artistic Development in the Early Years

There are children playing in the street who could solve some of my top problems in physics because they have modes of sensory perception that I lost long ago.

. . . J. Robert Oppenheimer

General Characteristics

Very young children all over the world begin at an early age to reveal certain developmental characteristics in their art products. General stages of growth appear to be quite universal and need to be identified, so that an environment for maximum growth can be designed. The adult's task is to provide the means through which the child's motor, affective, perceptual, cognitive, and aesthetic development will reach its fullest potential.[1]

Two points of view regarding artistic development in children have been prevalent. One holds that the child will unfold and manifest changes in his art work with the teacher merely providing the materials. The other maintains that the unfolding of the child's artistic self can be aided and abetted by direction and training.[2] Howard Gardner insists that a deeper understanding of both views can emerge and benefit from a developmental perspective. He notes that by age seven or eight, perhaps earlier, the child has an initial grasp on the major symbolic media of our culture. He is an incipient artist since he now has the raw materials to become involved in the artistic process, an idea of how symbols work in an aggregation of symbolic media, some knowledge of how to construe work, and some capacity to construct one himself.

The school curriculum in early childhood should provide a qualitative developmental sequence of art lessons. The result should be that when the child arrives later at a much more self-critical level, he will have developed skills at a sufficiently high level that he will not reject what he has done. In addition he will have a store of ideas and feelings he wishes to express. A developmental program in art, one that builds upon the child's own experiences, helps him to recall visually and verbally, to perceive, organize, define, clarify and reinforce his own thoughts and feelings. Such a program is based on experiences the child has had in earlier levels and should become the foundation for the level that follows.

The early childhood years are marked by the young child's eagerness to participate in art with enthusiasm and naturalness. He enjoys creating his own art. He likes looking at pictures, reproductions of works of art, and visiting galleries and museums. His own art expression progresses from scribbles into more organized forms and symbols, and is an important means of non-verbal communication. Art is a second language for all children. In grades one to three children become even more responsive and curious in reacting to visual/tactile experiences than they were in earlier years. They are

able to handle a greater variety of materials and tools—they can make prints, construct, model, paint, stitch, and weave. They can begin to talk about the art of others, make choices and express preferences, and understand the relationship of art to literature, social studies, and music. They learn about various cultures and times.

Children who have had paper, felt-pens, crayons, scissors, paint and modeling materials available at home will come to preschool or kindergarten more advanced in their artistic development than those who have not. Mental, emotional, and physical handicaps, social and cultural influences, also have a bearing upon a child's visual image development. Some children will pass quickly through the stages of growth in art; but the characteristic pattern of their artistic behavior remains very similar.

It is of paramount importance that this early period of development be fostered to its fullest, in order for the stage to be set for future growth and development. Without basic and supportive experiences with art materials the child will tend to be retarded in his artistic expression. He will not acquire a language of nonverbal symbols that will enable him to express his personalized vision of the world in an artistic form. If at this time adults encourage children to do copy work, use coloring books and forbid spontaneous scribbling, harm may be done to the child's development in learning as well as in art.[3]

Children gain pleasure not only in handling materials but in experiencing the thrill of discovery and the intense satisfaction of mastery. Through early manipulative and exploratory experiences the child develops concepts of searching, investigating, recording, selecting, building and determining. From relatively simple, limited and direct use of materials, the young child advances to more complex sophisticated involvement.

These manipulative experiences which begin in preschool may not seem of great significance as the adult views the final product. Yet it must be kept in mind that the child is establishing beginnings—beginnings in using the elements of art, in planning, executing, completing, and evaluating, in judging the wholeness or completeness of his composition, in correlating visual expression with other forms of expression, in demonstrating originality, self-confidence, and competency. The attitude the adult adopts when these early expressions begin has much to do with the child's later ability to communicate ideas, images, symbols, and feelings in his own unique and original way.

For the child artist as for the adult artist, art is more than a factual recording of an object. He is coming to grips with his own thoughts, feelings and perceptions, and these may involve fantasy, dreams, suspense, surprises, thrills, sorrow, fear, delight, wonder, anger, pleasure, joy or hate.

The Scribbler

The development of art in the young child actually originates in the years prior to formal instruction. Difficult as it may be to believe, the origin of aesthetic expression for even the greatest of artists can be found in the earliest scribbling of childhood.

Irregular Scribbling

The first marks the child makes, usually between his first and second year, are random scribbles and are most likely derived from the kinesthetic enjoyment of moving the arm and hand. At this stage the child really doesn't realize that he can make these marks do what he wants. He will show variation in these random marks in both length and direction. He may show some repetitive movements as he swings his arm back and forth, but the main principle involved is kinesthetic. Accidental results occur. The line quality varies. The crayon or drawing implements may be held in various ways, and the size of the marks and movements are in relation to the size of the child's arm.

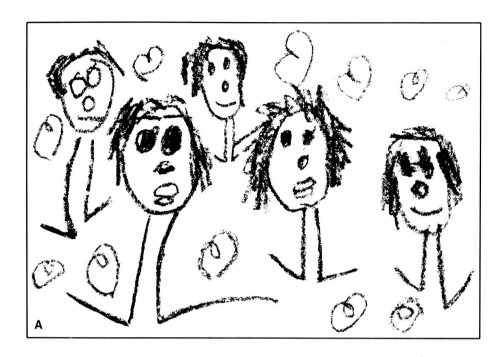

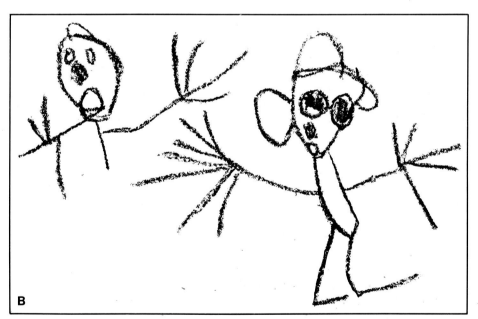

A and B. These two drawings, both done by children in the same kindergarten class, show differing stages of development. Although the faces in the first drawing are detailed, the legs and feet are the only parts of the body represented. A body, arms and figures appear in the second drawing; the child clearly has the concept of "many fingers," but an exact number has not been determined. Both drawings depict the children's families.

There is no intent by the child at this time to make representational symbols; rather his work shows a rather random haphazard grouping of marks. He enjoys scribbling, and it is important that he has the opportunity, materials, and place to engage in it. Chalk and chalk board, crayons, wide-tipped felt pens, pencils with strong blunt points that do not break easily—all these provide vehicles for the child to use for this kinesthetic activity.

Controlled Scribbling

Usually about six months after the child begins to scribble he develops some control and discovers that he can make the marks do what he wants them to do. He

These two drawings of a girl, drawn by the same child, show the development that occurs between the ages of three and six. Both drawings represent the human figure as seen by Kathleen at different ages; the development of a definite schema is evident in the later drawing.

becomes consciously aware of scribbling. While we may detect no difference in observing some of these scribbles and those of the previous disordered stage, this marks an important step in his artistic growth. He will begin to vary his motions. He will repeat some lines that give him particular satisfaction, and spend a longer time at this activity. He will make circular and longitudinal scribbles. He is mainly interested in the kinesthetic sensation and in mastering his movements.

Symbolic Scribbling

At about three and a half years of age, most children begin to name their scribbles, and with this a landmark in their development is reached, because the child's thought process has now changed from thinking kinesthetically to imaginatively. Until now he was principally involved in motions; now he has connected his motions to the world around him. While the actual drawings may appear much like those of the previous stage, the child's intent is different. He may start a drawing and say 'This is Daddy', or at least have some idea of what he is going to draw. He may call it something else when he is finished. He may talk the entire time that he is drawing, or he may announce what it is when he is finished. The next day, looking back at it, he may possibly call it something else; but he has established a visual relationship to the world with his drawings. He may revert back to manipulation of the medium if he has a new tool. If given baker's clay, salt ceramic, or clay, his thought processes are the same as with drawing and painting, in that he first will manipulate it—pound it, roll it, pinch it. His movements gradually become more controlled until the naming stage evolves and he begins squeezing little blobs of the modeling material and giving them names.

Since scribbling mainly involves muscular activity, gaining control and then establishing a relationship with the outside world, color does not play a very important role at this time. The colors the child chooses will be those he happens to like and not those that are related to the visual world. What is most important is that the child has an art medium that enables him to gain control of his lines. Therefore crayon, chalk, felt pens or paint should be of a contrasting color with the paper on which he is working, so that he can establish a visual relationship with what he is doing. He will begin learning the names of colors and showing preferences.

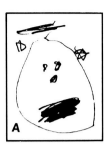

A. The circle as a symbol for a face can be seen in Bradley's early drawing (age three). Although the scribbles representing the hair and one ear are detached from the circle, details have been added to form a recognizable symbol for the human face.

B. Bradley's later drawing (age four) uses a rectangular shape for the body with two lines extending from it to form legs. Notice how scribbled circles are repeated to form symbols for eyes, the nose, buttons, and knees. Radial lines have been added for hair.

C. A third drawing shows a complex ensemble of figures—a clown, two trapeze artists and a tightrope walker. Drawn when Bradley was five years old, the picture represents his experiences and interests.

Communicating with the Scribbler

Joseph and Marilyn Sparling[4] focus on meaningful dialogues with scribblers. Instead of only providing the opportunity for activity and acting as an observer, they suggest a positive approach to increase communication skills. Their basic approach is that these beginners in art (1) need encouragement in the form of verbal approval and respect (2) need to be aware of their own creative process and product, and (3) need to perceive of their own thoughts and feelings. When children gain new names or labels for things, they have a way of reusing and recalling experiences. Skills in forming concepts have been shown to be linked to the acquisition of language, especially labeling.[5]

The Sparlings have some specific suggestions as to what to say to the scribbling child. First, the communication should be geared to the child's developmental level, since a comment appropriate for a child who is scribbling in a disordered manner is not adequate for a child who is controlling his crayon. Second, a comment should relate specifically to what the child has done. Generalized comments that show we have not really looked at the child or at what he is doing are often stereotyped phrases which provide no rich language stimulation.

In talking with the beginning scribbler, the adult could mention the child's movements, since the child at this stage is more fascinated with the kinesthetic process than by the marks he is making. These comments make the child more aware of his own movements, and motor coordination is an important task. The adult might comment on how fast the child's hand is moving back and forth, or how hard he is pressing on the crayon, or how big the child's movements are. If comments are directed toward how the child's work looks, the child will become more aware of the things he has created spontaneously. One could describe some of the marks—such as long curving

A, B, and C. These three drawings show one child's developing symbols at age 4 (figure A), age 5 (figure B), and age 6 (figure C). Nina's earliest drawing is a clear representation of a face. The head-feet symbol emerges a year later. This symbol continues and can be seen in Nina's picture of her family a year later. Notice how the eyes-nose are represented with three dots in a triangular configuration; this pattern is repeated in the body to represent nipples and belly buttons.

lines, or where they were placed on the page, or the colors used. The Sparlings also suggest that the adult touch or trace some of the lines with his/her finger to guarantee that the child knows what is being referred to.

If the adult will provide a language model, the children can become more conscious of their feelings during and after scribbling. Such comments will lead the children to verbalize their feelings independently. The adult will find clues to the child's feelings in his facial and body expressions and in his preferences. Comments on what a long period of time he has been working and how he must have enjoyed it will help the child know that we understand and value what he is feeling.

In the controlled stage of scribbling, comments should be directed toward the child's increased motor control and ability to devise a variety of movements. Because the child at this time is better able to repeat certain movements the adult might comment on how the child's hand is going around and around. Conversation directed at the way the scribble looks will help the child realize that he has made a particular mark many times, or has made a number of closed shapes and lines. The adult might call his attention to how he drew a small circle inside a big one and how hard that is to do. One might also refer to contrasting colors and values, describe different lines or shapes and how these marks relate to each other. Since the scribbler feels a great satisfaction at being able to control his marks, talk about his feelings should focus on this new accomplishment and how exciting it is.

When children begin to name their scribbles, a much richer opportunity for communication exists. Since the actual marks may not differ much from those done earlier, and since children frequently change their ideas and meanings by the time they complete a scribble, it is unwise for adults to try to guess or name an object in the child's

art work. Instead, adults should listen to the child's comments and build on the meaning to the child at that moment. When a child does name his work, the adult should pick up the clue and ask questions relating to both aesthetic and personal ideas. A child's comment about 'my big man' could be countered with questions about the shapes, colors, or repetition of lines, and also about the relationship of the child to the man, or the size or placement of the man. These comments concentrate the child's thinking in the direction he has begun, and have more meaning for him.

If a child is hesitant to talk about his work, the Sparlings suggest we encourage conversation by commenting on how much fun he seems to be having, and ask him whether he would like to tell about some of the things he has made. If the child doesn't respond, he may be at an earlier stage of scribbling or he may just be unwilling to converse. A positive or reassuring comment could be made about the 'nice lines going around the paper,' or that you're glad he's having fun. He should not be forced to comment; but with continued support, children will gradually want to converse about their work.

The Sparlings suggest remedial techniques to use with children who are reluctant to scribble. The adult may sit down with the child, use a crayon with him, and comment on how he is letting the crayon move all around the paper and how good it feels to do so, even with his eyes closed. Then he can suggest they try doing it together. The smallest efforts should be praised, and attempts made each day since it takes a while for the child's confidence to be built up if he has had an unhappy experience or is frightened of new experiences.

It is not necessary to comment every time the child scribbles. Some children enjoy humming and making other noises as they work. Other children stare into space while they are engaged in scribbling. It is best not to interrupt when the child is fully involved. But when he puts his crayon or brush down, or takes his attention from his work, the time is good for communicating. The adult should use the child's name, touch him, and sit at his level. The adult should avoid asking the child what he is drawing or whether an object in his work is a house, since these questions put the child "on the spot" and leave no room for creativity and further exploration. A comment might be directed at an especially bright color he has used, and the child asked if he would like to tell about something special in the drawing.

Sensitive and thoughtful comments directed to the scribbler will help children be more enthusiastic about expressing themselves through art. They will be more motivated to continue and expand their art work, while the general awareness that has been built up through language will enable the child to translate his art experiences into art concepts. This sort of awareness will be needed when the child reaches later stages in his development and is required to evaluate with aesthetic concepts his work and the works of others.

The Schema Emerges

At a specific point in the child's development, scribble lines evolve into rudimentary shapes. These early efforts contain both closed and open shapes in combination with linear marks.

Circles and Simple Configurations

Many of the child's scribbles are circular, and usually during the fourth or fifth year the child makes a remarkable discovery through this round shape: that he can make a closed round shape and repeat it at will, and that in this circle he sees a symbol which he can use to represent a number of objects that are of emotional significance to him in his world. He can add two lines, and the circle becomes his mother. This new configuration is sometimes referred to as the 'head-feet' symbol sometimes called the

Recording comments made by the child on his or her drawing provides an introduction to reading and the written symbol. The two examples shown here are "Smiling people on PSA, getting ready to land" by a child who is 4½, and "A crane lifting an 'E' to a weathervane on a church" by a six-year-old child.

Accuracy isn't essential in this whimsical drawing of an "ice skater with 35 buttons." Notice the number "35" on the right side of the drawing. The young artist has allowed long, wandering lines to enclose the figure in a box.

"polliwog" drawing[6] or the 'big head' symbol.[7] While different children arrive at this stage at various times in their development, most are using this symbol during their fourth and fifth years. They will repeat it, often modifying it, making it more elaborate and detailed by adding eyes, mouth, ears. They may add a number of radial lines and call it the sun, or four legs and a tail and make it a dog. Eventually many children draw a connecting line near the lower part of the two lines that are extending from the circle, making it into a body from which they may extend two more lines for arms and two for legs. The body is sometimes in a triangular shape, or sometimes it is another circle or oval with the legs and arms also drawn with ovals.

The child at this time will do a lot of verbalizing with himself or with an interested adult while he is drawing—recalling, reorganizing, fantasizing about some experience. In the end the result may be named something entirely different than it was originally intended to be. The child will use this rudimentary figure repeatedly to suit his needs, to communicate with himself and others about those experiences which have some important conceptual or emotional meaning to him. He will use it with drawing tools, with paint, and with modeling materials. It is very interesting to collect the drawings from one child over a period of time, from his initial scribbles through the development of a schema. Notes should be made on the backside as to comments made by the child, along with the date the drawing was made. It is also revealing to collect a group of drawings from a kindergarten class of children who are close in age, to see the wide range of artistic development.

A, B, C, and D. The developmental stages from symbolic scribbling to fully evolved schema are shown in these four drawings by Mia at ages three, four, five and six. The looped fingers and outstretched arms were repeated without variation for some time during the later stage.

Responding to Early Drawings

An adult should never 'correct' a young child's drawing or show him 'how to draw' or ask him to copy another drawing. Such interference is meaningless and damaging to the child's pursuit of self-discovery, to his artistic growth and to his personality. It makes him dependent on an adult when he needs to be building confidence in his own visual language, and learning to reach out, explore and communicate his own thoughts. A cliché of a boat or a stick figure 'taught' to the child of this age usually results in a clinging to that form, a stereotyped repetition that is locked in and halts creative growth.

Bruner[8] states that by the age of three or so, and through the primary grades, the child is probably functioning at the level of iconic representation, that is, he is primarily learning through actions, through visual and sensory experiences and organization. He also believes that the emotional attitudes concerning learning are begun at this age; he is in favor of a relaxed and playful attitude and approach on the part of the teacher. Bruner believes that the young child will be more encouraged to attempt things and be less upset by failure if he understands that the results of such activities are not as extreme as he may have hoped or feared that they would be.

The crude symbols made by the four or five year-old are a tangible clue to the child's thinking process and give the adult strong leads with which to communicate with him. The first head-feet representations may not be easily recognized without the child's naming of them; however, by kindergarten most children are making objects that are easily recognized as houses, trees, animals and people. Visual depiction of relative sizes and proportion is not the children's major concern at this time. Rather, they have an honest sense of logic that is naive and obvious, and which is perhaps quite realistic in the true sense of the word. A long, strong arm is needed to pull a wagon; hence that arm will appear longer in the picture. To depict oneself with a newly lost tooth requires drawing a huge mouth. A stubbed toe feels larger than it looks and may be drawn that way.

As the kindergartener matures, his schema shows more variations and details until, by age six, it is fairly elaborate. He draws it differently each time, depending upon the experience or feelings he may have at that moment. He is more interested in relating the drawing to the object than he is in relating the color to the object, and thus he may draw himself with green hair or make a red tree. He likes color and finds painting with tempera, drawing with colored chalk, and cutting with brightly colored pieces of paper most exciting. It is best not to criticize or correct his choices of colors as not 'right' for an object; he will discover the relationship himself as his work merges into a later stage of development. The adult should find ample opportunity, however, to develop and encourage this awareness through games (see pages 42–50), in motivations and in impromptu informal chats, e.g., 'what a bright red skirt Kim is wearing today . . . Maria's dog is as brown as a chocolate bar.'

When the child first begins drawing the head-feet symbol, his concepts of space have not developed beyond that of representing the objects in a random floating array. A symbol for 'mother' may be placed high on the page, the child's kitten lower, and perhaps a house may be placed off to the side. The objects are not related to one another in position or size, nor are they related to the ground. It is satisfaction enough for the child to be aware that he has created a symbol that is recognizable as a person, animal, or tree.

Although this is a time of development of verbal skills Lowenfeld[9] feels that there is no substantial reason for attempting to teach a child of this age to read, since he is not able to relate letters to form words and words to form sentences—skills learned later when the child has established his base line concept which is symptomatic of a higher level of seeing and understanding spatial relationships. Furthermore, if the child begins his reading instruction later he is better able to learn to read quickly and with less struggle, with the result that his attitude toward reading and learning in general is positive and eager.

A trip to a natural history museum motivated Jeff (age 5½) to make this detailed drawing of Indians, teepees, drums, campfires and smoke. Experiences not only help the child's perceptual growth but stimulate memory and other cognitive powers as well.

One of the key factors operating in the drawings of the beginning schematic child is that the symbols for various objects change frequently. The child is quite flexible in his depictions of a 'man' or a 'dog' and will make them with different forms and features each time he draws. The way they are depicted may relate to the experiences the child has had with that person or object, the keenness of the child's perception and overall awareness, his intellectual capacity (since a large number of details indicates a higher intelligence), and in general, more developed personality characteristics.

Topics for Drawing

The child of four and five years is self-centered, and the names he gives his drawings will usually have in them 'I, my, and me.' Motivations, therefore, should be structured around this sensitive area by extending the child's field of awareness and expression to specific topics. These should build upon the child's experiences for drawing topics, especially those that have to do with his bodily self—he has a new pair of dark glasses, he has a stomachache, he is blowing bubbles, he is jumping rope. Each motivation of this type emphasizes one bodily part, a part which at that particular moment is charged with emotional impact. The adult can use these moments to ask such questions as, "How do your dark glasses feel? What holds them up? Did you look at yourself in the mirror with them on?" Or . . . "Where is your stomach hurting? Show me how you blow bubbles. Do you puff your cheeks out? How do you hold the pipe . . ." Or "Where are your arms when you jump rope? Do you bend your knees?, etc."

Other topics more charged emotionally may also be used as topics for drawing—'When my kitten died, Saying goodbye to Grandma at the airport, My new baby brother,

I am eating birthday cake.' The adult may extend the child's idea by asking questions after the child has initiated an idea for drawing, or the adult may suggest drawing topics that are tuned into the child's experiences and recent happenings.

Motivations can help the child's perceptual growth, his cognitive powers, and his emotional relations: all discussions relative to drawing, painting, and modeling should incorporate several questions or points related to these three areas.[10] Motivations can help the child be more aware of things in his world; they can help him develop a flexible personality, think with imagination, originality and fluency, can help increase his ability to face new situations, to recognize and express both pleasant and unpleasant feelings in an acceptable manner.

Motivations can also include considerations as to where the child will place the objects on his paper, what shapes he will use, which colors will be best to use for his idea, etc.

Schematic and Spatial Concepts

The objects in the early drawings of children may not appear very realistic to the adult eye. However, these symbols represent the child's understanding of the world as he or she experiences it.

Symbols Emerge

By the time the child is six or seven years old he usually has developed a definite schema, that is, a symbol for a man, a house, a dog, a tree, and so on, which he repeats without variation unless some motivation or experience causes him to deviate. To prevent this symbol from becoming 'locked' in and stereotyped, it is imperative that the teacher endeavor to keep the child flexible in his thinking and thus in his depictions. The schema for a person at this age is generally made up of circles, rectangles, triangles, ovals, and lines. By constantly structuring experiences in which the child is made more aware of visual details and relationships, the teacher can help the child's growth. Not only should the motivations incorporate the self but should extend outward to include where and with whom the action took place.

Second grade class in Glendale, Ca. culminated unit on "Our Neighborhood," with this tightly filled baker's clay mural. Included are stores, homes, churches, their schools, cars, people and a number of other important parts of their environment organized on multiple base lines.

The child's spatial development is the most notable achievement at this stage of development. He begins to include the *base line,* a line drawn across the paper and upon which the objects are placed. This signifies that the child is now aware that there are other objects in the world and that they have a definite place on the ground and in relation to other people and things. He often puts a line across the top of the picture for the sky with 'air' in the middle.

Once again it is very important to make sure that the spatial schema does not become a rigid unyielding concept, since many ideas and experiences will be unfolding, which the child will want to draw but for which the base line will not suffice. Motivations that encourage base line deviations therefore are in order. Such deviations and their topics might include:

1. Bent or curved base line: Climbing a mountain. Going skiing.
2. Multiple base lines: Horses racing on tracks. Booths at the carnival. An orchard.
3. Elevated base line (placed near the top of the paper). Inside an ant hill. Under the sea.
4. Mixed plane and elevation (part of the objects are drawn as if we are looking down on them and others are drawn as if we are looking at them at eye-level.): Floating down the river on rafts. A parade on a building-lined street.
5. X-ray: Inside our apartment building. Inside a space ship. Inside me.
6. Fold-over: (A variation of the mixed plane and elevation in which some objects appear to be upside down but are, in a realistic manner, three-dimensional if the paper is 'folded' upright).

Exaggeration as an Expressive Quality

At this stage, when children draw a symbol for a person and the idea of expressing something that person is experiencing is important, they often exaggerate the part that is involved in the activity, or enrich it with many details. "I am throwing a ball" may show a much longer arm than is usually drawn. Or the child may change the shape he ordinarily gives to a symbol for a bodily part. A particular child may usually draw

An imaginative kindergarten student comments on this drawing:

"People are hanging in a dungeon. An elf is on top of the ladder locking them up with a key. The girl doesn't know how to tie her shoes and her Dad (the big guy on the wall) won't do it for her. The elf's boss is at the bottom of the ladder."

a circle to represent a hand; however, if the child is given a new ring or has had fingernail polish applied, the circle will disappear and in its place will probably appear a much more elaborate and detailed drawing for a hand. This shows us that the child is maintaining a degree of flexibility and is able to change his schema to meet the needs of what it is he is desirous of representing.

A rigid and inflexible child either responds by drawing the same schema over and over again regardless of the motivational topic, or he responds by stating, "I can't." In this case rather than 'draw for' the child and 'show him how' it would be much more advisable to have the child throw a ball himself and at the same time the adult should endeavor to make him more aware of how he moved his arm, how it felt, how far the ball went. Then the child might observe another child throwing a ball and see how he stood and moved when he threw the ball.

Children often become so emotionally involved in depicting an experience-idea that they omit a bodily part that at that particular time is unimportant. Ears may be left off a figure who is throwing a ball. However, a subsequent motivation might deal with drawing 'when I had an earache,' or 'my new pierced ears,' or 'whispering a secret in my ear.'

The exaggerations, changes of shape, concentration of details and omissions are all healthy and to be expected during the schematic period. If motivations are regularly and consistently given, motivations that are sensitively structured in themselves, the child's awareness will be gradually awakened and incorporated into his drawing. His symbols will be richer, more detailed, more aesthetically whole, and he will be able to use them, change them, and enrich them to depict all manner of experiences and ideas. Art indeed is a second language for all children, one whose vocabulary depends upon perceptual awareness, cognitive development, and emotional feelings that can be developed by sound motivational practice in these early years.

Occasionally, this student draws pictures looking down on people. Roasting marshmallows, sleeping and playing chess seem to be the activities in this Boy Scout camp-out. Jeff, age nine, has a remarkable ability to manipulate space in his mind's eye. This ability appeared earlier when he completed a picture of a baseball game, again looking from above, at the age of six.

Taking a close look at one's features while drawing sharpens child's perception while creating a self-portrait (above).

The exaggerated legs of this running figure dominates this drawing by Max (age 5). Children often become so involved with their experiences or ideas that they emphasize the parts that are involved in the activity and minimize or eliminate those parts that are not being used (right).

Characteristics of the Schematic Years

The child in the schematic years is an eager participant in group projects such as assembled mural-making and large boxy constructions. He likes to explore new materials and processes such as print making, stitchery, weaving, puppetry, and modeling techniques. Also, during the schematic period the child discovers and uses colors that are related to objects. Hair will no longer be purple and noses green. He is eager to classify and categorize things, to feel that he has a tangible hold on the world. However, most children are not yet ready to see and depict in their drawings fine gradations of green in one tree. The child's attention may be directed at warm, happy colors in his environment such as red, orange, yellow, and hot pink, and what things they may make him think of. He may also be introduced to cool, calm colors and think of images these tones of green, blue and purple evoke in him. The teacher may provide tints and shades and dulled colors of tempera and verbally name these colors for the child. As he becomes more deeply involved with their uses in his picture making and sees the manner in which red vibrates next to green, or the effect a great deal of a dull color has next to a single bright spot of orange, he will begin to mix and blend his own colors to suit his needs.

By the end of the third grade, the child should be able to express his own ideas creatively, confidently and without limitation, using a wide variety of materials. Gradually he should be able to place the figures and objects in different positions in his pictures and reveal a growing awareness of the entire painting area and its relation to

the different parts. Through repeated drawing and painting experiences, he will learn to vary the sizes and shapes of things, to use contrasting colors for emphasis, dark and light values for moods and wherever they are appropriate. By eight years, the schema for the human figures will have changed somewhat from being totally geometric symbolic representation to one that shows more specific characterizations. The child will use more details, including such items as hair, buttons, eyebrows and clothing patterns. Distant objects may sometimes be represented by placing them higher on the page. He is using more visually realistic proportions and may represent some spatial relations through the overlapping of forms. The base line may become the horizon line. Distant objects may be drawn smaller and some attempt may be made to show figures in action poses.

Teachers are sometimes disturbed and puzzled by the child who paints over a picture he has just completed. Such behavior is usually of an emotional nature; perhaps the child just happens to like that particular color very much, or in painting over his picture he may be showing some normal aggressive behavior. Unless these actions are part of a larger pattern of overtly abnormal behavior in other areas, they may be regarded as within the range of typical development and will probably soon be outgrown and left behind for more positive actions.

As some children reach six and seven years of age, they may show evidences of being critical of their own work and becoming dissatisfied when something doesn't look just as they want it to look. This is especially true if they have not had numerous perceptual encounters, have not participated in a variety of experiences with art materials, and if their artistic growth has been interfered with by coloring books or highly directed projects. The teacher can help by directing the children's attention to details and similarities, to shapes, to movements, and by encouraging them to look at and explore the environment more carefully, to try to relate and remember that which was of artistic and emotional significance.

Identifying the Artistically Talented

Perhaps the single characteristic which most typifies the artistically talented student is rapid progression through the various stages of art development. When compared to others of their age, artistically talented students consistently demonstrate abilities at extraordinary high levels. Adults familiar with the typical art work of students at various grade levels will frequently communicate on the "maturity" or "advanced ability" of the exceptionally talented child.

The classroom teacher is sometimes the first person to notice a student's unusual talents, but other students are usually aware of the exceptional talent of one of their peers. As may be expected, however, finding the exceptional and uniquely talented student is not an easy task unless there exists a basal program for art for all students. There are no standardized tests for art ability, and the most reliable means of identification is through looking at the accumulated body of work created by large groups of children.

In addition to advanced development in art production, there are other characteristics of highly talented students. Usually, they will show high interest in art activities; they take art work seriously and seem to find satisfaction in it. Frequently, the talented student has accumulated a sizeable amount of art work, and he or she may spend a great deal of time and energy in drawing (sometimes all over the pages of books, classwork, or any other available surface—much to the despair of his/her teacher). Talented students display ease and dexterity in creating art products, and they frequently use visual representation to communicate their experiences, ideas, and deepest feelings.

It is not advisable to offer the talented student a program that is oriented primarily toward media. The talented child needs some instruction in the use of new materials, but he rapidly moves beyond the manipulation of tools. A conceptual approach

One hot sunny day a family went to get a new lemon tree. There was only one lemon tree. That lemon tree looked beautiful, but it had no lemons on it.

A and B. The child in the schematic years enjoys expressing his own ideas both in pictures and in words. These two samples from child-made books demonstrate verbal and visual creativity at grades two and three.

A

The grandmother was in the kitchen cooking. Sheeba smelled the food and was hungry. Sheeba pulled on the grandmothers dress to tell her she was hungry and ripped her dress.

The whole family got mad at Sheeba and threw her out of the house. Sheeba was very sad because she no longer had a home.

B

to art experiences originates with an ideal and asks that the student use materials merely as a means to solve a problem.

Given encouragement, the talented student will show unusual and unique ideas and will be highly fluent in generating a variety of solutions. When given an open-ended problem to solve in art, talented students will frequently exhibit widely divergent

A

B

C

A, B, and C. Series of drawings by Emily at age 6 showing high degree of talent. Note complexity and variations in figure, overlapping, action, detail, composition, etc.

D, E, F, and G. Highly talented students frequently exhibit their ability at very young ages and progress rapidly through developmental levels. Examples of drawings at ages 7, 8, 9 and 10, show Victor Navone's exceptional talent at various stages of his early artistic growth. Victor is self-taught, and his work reveals his interest in exploring techniques and images.

art products. They are usually interested in other people's art work and under the right circumstances can appreciate and learn from the art work of others.

At times, talented students may repeat schema but it will be done with variations. At this stage, "theme and variation" will occur until the student has exhausted its

potential. No matter what the motivational topic, the child expresses a desire to explore his or her current set of images—such as monsters, ballerinas, horses, cars, outer space. As long as the child continues to be highly original and is willing to try out new materials, techniques and experiences, there is little reason for concern. As motivations help the talented child become more aware of things in the world, diverse images flow from the highly creative mind into the art products.

However, students who display talent will sometimes become locked into repeating certain images (their own or those of others) over and over again. This usually occurs when they have received a great deal of praise and recognition for having duplicated art work in the past. It takes a great deal of self confidence to take risks, to create original art work. With very young children, the teacher is a particularly strong influence and has the primary responsibility of providing a safe environment for originality. Just as there is an ideal environment for the growth and development of living things, there is an optimum environment in which children may best develop creatively.

This drawing by Joel Claunche, age 8 demonstrates the advanced artistic development of an exceptionally talented student. The work of art, entitled "Scoot Over," shows a variety of imaginative characters riding in an elevator.

The Creative Environment for Exceptional Talent

Psychological safety and freedom are necessary if people are to behave creatively. All children, but especially those who exhibit high levels of artistic ability, have a need to experiment and seek out their own symbolic expression. According to E. Paul Torrance, one of the leading authors in the field of creativity, children will reveal their intimate imagining only if they feel loved and respected. This is the essence of what

Torrance calls the creative relationship between a teacher and child.[11] For this reason, the classroom teacher is instrumental in developing the optimum environment for creative expression.

When the "significant adults" in a child's life are highly critical and judgmental, when uncertainty is reinforced by disapproval, creative and original art work diminishes. All too often, statements are made which are limiting, such as "Dogs aren't green," or "Don't be so messy." In addition to overt statements, students' self confidence can be undermined by constantly exposing them to art which utilizes patterns and prepared outlines. The message inherent in these activities is that the child is not able to create his or her own images, that the outcome must be predetermined by an adult.

Anne Wiseman states that parents and teachers hold the success of children in their tone of voice and generosity of understanding.[12] To awaken the creative potential of children, all artistic expression that shows sensitivity, uniqueness, and involvement needs to be acknowledged in ways that are positive and honest. Encouragement and motivation form the basis of the environment which stimulates individuals to the highest levels of their potential.

Exceptional Opportunities for Exceptional Talent

In addition to the creative environment so necessary for the artistic expression of all children, the highly talented student needs additional stimulation, opportunities to go beyond what is offered in the regular program. Partially, this can be provided by the classroom teacher. As a major influence in the child's life, the teacher need not be artistically talented but can provide the open-ended art activities necessary to develop the student's abilities; the art work of great artists can be discussed and used as models. In addition, opportunities for students to interact with professional artists provides in part for the needs of the exceptionally talented. Whether the artist is a visitor or the student visits the artist's studio, observing professionals functioning in the real world can have great impact.

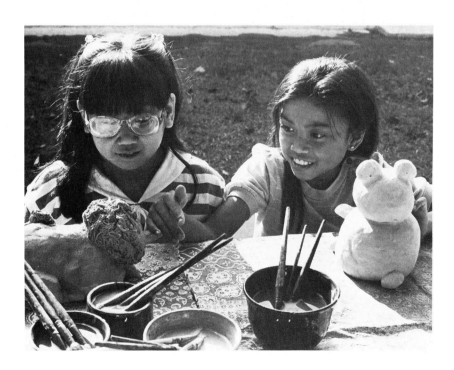

Two talented students discuss and compare their work as they experiment with clay, a new medium for them. Bringing students together so that they can interact and stimulate one another's creativity is one of the purposes of this program for highly talented students. Providing new materials also permits experimentation with techniques and ideas.

Talented peers can greatly influence a student who shows a high degree of ability in art. Students who are highly skilled, who have a great deal of "natural talent," frequently feel alone. Interacting with peers of comparable talents not only alleviates the feeling of isolation but can stimulate ideas and a realistic sense of ability. For this reason, grouping students who are exceptionally talented can have positive results—in personal development as well as in aesthetic production.

In a program designed to meet the needs of talented children, there should be opportunities for students to work in one area in depth. Thus a child who is interested in making pinch pots may be given the opportunity to create large ceramic animals or (with help from an adult) to experience the use of a potter's wheel. Still another child might be given the opportunity to draw a series of images on acetate to create his own filmstrip, create a pinhole camera, and participate in the development of his own contact prints. Since many of these activities are beyond the scope of the regular classroom program, after-school opportunities and Saturday morning classes can extend the range of the child's experience and compensate for the relatively limited challenge provided in the regular school program.

Acknowledging art work which represents the highest degree of a child's potential is also a powerful influence on the child's development. When outlets and audiences are provided for the student's most creative work, when pieces of art are valued and exhibited, meaning is given in the real-life world. Even at a very young age, children are sensitive to the unspoken message communicated when their art work is displayed for others to see. As value is given to their efforts, highly talented students will respond with images which are richer, more elaborate, and which consistently incorporate personal symbols depicting the enormous variety of experiences—both real and imagined—in these early years.

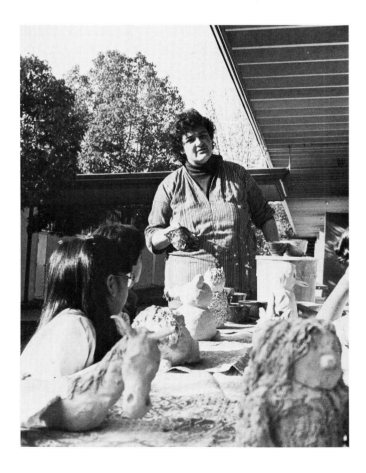

Artistically talented students are given the opportunity to work with professional artist Nancy Gordon in this Saturday morning class in Chula Vista, California. Providing opportunities to interact with professionals is one way to meet the needs of highly talented students.

Art and Special Education

Unlike highly talented students who advance rapidly through the various developmental stages, children with mental or physical handicaps have barriers which impede progression. Depending on the type of disability, the handicapped child will have problems and will encounter frustration in everyday life that other children will never experience. Not only can art activities ease of the frustrations of the handicapped learner, but they provide a profoundly valuable form of emotional expression while encouraging improved muscular control, increased perceptual awareness, and a sense of personal achievement. The creative activities found in art are particularly important for children with physical or mental handicaps. As with all other children, the emphasis in the aesthetic experience is on the development of the individual to his or her fullest potential. For this reason, if no other, the importance of art in the education of disadvantaged students cannot be overemphasized.

PL 94–142

Federal legislation (Public Law 94–142) has been passed to establish full educational opportunities for all handicapped children. Children who would previously have stayed at home or remained in private schools are now able to request public education. The law also states that the "least restrictive environment" must be provided and that handicapped children must be educated with non-handicapped children to the extent possible.

As art therapist Nancy Mayhew has pointed out, many children who are now integrated into regular classes—"mainstreamed"—for part of their day, experience deep anxiety and are fearful of the reactions of others in their environment. These physical and mental barriers decrease these children's ability to interact successfully

Creative activities found in art provide a means of expression while helping to improve muscular control and increased perception. Original drawings such as this one by Javier (age 10) demonstrate the potential that can be stimulated through the use of art in special education classes.

with their environment and cause social and emotional isolation. In working with these children, Mayhew has found that the art process serves as a psychological service to promote emotional and social growth which will in turn aid the learning process.[13] She sees art as also benefiting four general areas of special importance for the handicapped: language and communication skills, independent living skills, psycho-motor development, and social-emotional growth.

Zaidee Lindsay, a specialist in art for handicapped children, agrees with Mayhew's views and states that art activities can be used for developing manual dexterity and patterns of movement as well as encouraging social communicability and providing a means to restore confidence. In art experiences, the child is able to master his environment through control of tools and materials. In addition, art encourages observation, discrimination of color, shape, and texture. Last, but certainly not least, states Lindsay, it stimulates imagination.[14]

Appropriate Art Activities for Special Education

A discussion of appropriate creative activities for both the physically and mentally handicapped is difficult since there are numerous handicaps which offer a wide variety of obstacles to learning. However, the single factor which seems to be common to all disabilities is that most of the children in special education classes were placed there because they are unable to respond normally to outside stimuli. For this reason, development of perceptual and expressive skills is often delayed, distorted, or limited

This series of drawings of a bird and eggs was motivated by a nesting bird on the playground. The students, ages nine and ten, show remarkable awareness of their environment despite limitations caused by their disabilities. (Drawings from the Ann Daly Center, TMR class, Chula Vista, California).

due to the obstructions created by the disability. Many handicapped students may be helped to overcome these obstacles by introducing creative activities that stimulate physical and mental abilities, that increase awareness of the environment, and that offer alternate ways of communication.

Using a Toy An example of a simple art activity for young handicapped children, one that might be adapted to make it suitable for use with children of differing disabilities, utilizes a favorite toy or stuffed animal. A beloved Teddy bear, a toy truck, a tricycle, or a doll can offer unlimited possibilities for motivating sensory exploration and for stimulating perceptual awareness. Media selected for this activity will need to be suited to the individual child's abilities and limitations. Crayons may be awkward for children with severe physical handicaps since downward pressure is required, but colorful felt markers or sponges dipped in paints can provide flowing lines.

Before the actual art activity takes place, children may be encouraged to write letters or make up pictorial invitations asking their favorite toys to visit the classroom. When the toys and stuffed animals are present, all kinds of activities are possible: toys and children can participate in a parade to music; toys can be weighed and measured; the children might want to make up a book of drawings, stories and poems. After a drawing or painting experience in which the toys are used as models, an art exhibit can be created which displays the paintings and drawings as well as the actual toys themselves. Some children might be willing to dictate stories to adults, other children, or into tape recorders, and these stories can be a source of interest and entertainment for several days. All these activities provide ways to extend the art experience to make it even more meaningful.

Art Leads to Self Discovery In a paper presented at an international conference, speaker Gay Chapman described many similar art activities which developed specific skills. As Chapman points out, one of the great strengths of the art process is that the child with disabilities is able to set the learning pace and manipulate his own environment. This not only builds self confidence, but leads to self discovery. Art is one means of helping children with disabilities to confront and adjust to their handicaps.[15]

Enriching activities and a safe environment enable students to produce original art work. Jimmy's drawing captures the popcorn experience enjoyed by his TMR class in elementary school.

Focus on Abilities Rather Than Product Some teachers of the handicapped are tempted to provide activities which lead to more skillful-looking results. Dictated art, as described in Chapter One, presents little creative stimulation and does not provide the sense of fulfillment to be found in creating original art. Tracing, using patterns, and copying the work of others becomes manipulative busywork which fills the time but not the soul of the handicapped child. Teachers concerned with the fundamental learning process and the needs of their students will not find satisfaction in methods of instruction in which the focus is on the end product rather than on developing a child's abilities.

Chance Manipulation Activities which enable the student to produce original work derived by chance manipulation of materials is another method frequently found in special education classes. Although these experiences fail to provide creative stimulation, they can be introduced periodically for variety and can be used to promote increased awareness. For example, a string dipped in black tempera paint and dragged across a piece of white paper may provide the teacher an opportunity to discuss such concepts as dark and light, lines and shapes, curved and straight. Spots of red, yellow, and blue paint (primary colors) can be painted on a piece of paper that is then folded along a midline and rubbed on the outside so that the paint inside smears and mingles; when opened, the accidental design will be symmetrical, and some of the colors will have mixed to produce new ones (secondary colors). These phenomena can be discussed, and the mirror-image concept extended by holding a mirror up to an object so that half of it is mirrored or reflected in perfect symmetry.

Abilities of the Handicapped Child

Antusa Bryant and Leroy Schwann conducted a study to see if the design sense of retarded children could be improved. They developed and administered a test to assess sensitivities to five art elements—line, shape, color, value, and texture. Fifteen lessons of a half hour each were taught, and they discovered that children with substandard I.Q.'s (23–80) were able to learn art terminology by direct exposure to concrete objects which they were able to observe, examine, manipulate, verbalize about, react to, and put together in some artistic way. Their study also indicates that retarded children can get involved in producing original art which they understand and enjoy.[16]

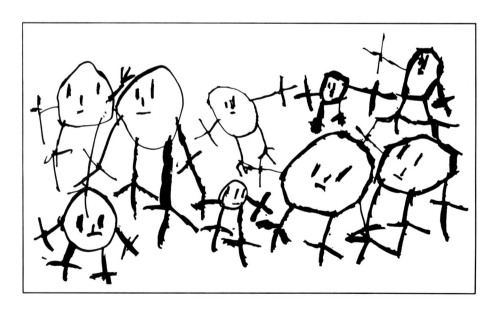

Although Saul (age 10) is autistic and mentally handicapped, he enjoys drawing and is willing to spend time and energy in creating detailed pictures. This drawing of his classmates shows his own unique statement about the world as he perceives it.

As with children in the regular school programs, it's essential that the abilities of the handicapped child not be underestimated. In working with children with disabilities, it becomes particularly important that the teacher look beyond labels and categories in order to provide the program best suited for the needs and abilities of the individual child. The methods and activities used in the regular art program are to a large extent also practical and effective when used with handicapped children. Teachers introducing art activities will need to adapt some of the art experiences; they will need to simplify, repeat directions, demonstrate, and divide the learning activity into manageable stages. But most of all, they will need to have the patience to step back and allow their students to experience their own creative potential. The results, while possibly not highly representational, are the tangible products of a process which has involved decision making, problem solving, and the manipulation of the physical world so as to create unique and personal visual statements.

Notes

1. *Art for the Preprimary Child,* (Washington, D.C.: National Art Education Association, 1972), pp. 59–73.
2. Elliot W. Eisner, ed., "Unfolding or Teaching: On the Optimal Training of Artistic Skills," Howard Gardner, *The Arts, Human Development, and Education,* (Berkeley, CA.: McCutchan Publishing Corp., 1976).
3. Rhoda Kellogg, *Analyzing Children's Art,* (Palo Alto, Calif.: National Press Books, 1969), p. 100.
4. Joseph and Marilyn Sparling, "How to Talk to a Scribbler," *Young Children,* Aug. 1973, 28, pp. 333–341.
5. H. H. Kendler and T. S. Kendler, "Effect of Verbalization on Discrimination Reversal Shifts in Children." *Science,* 1961, 134, 1619–1620.
6. Viktor Lowenfeld and Lambert W. Brittain, *Creative and Mental Growth, 6th ed.,* (New York: MacMillan Co., 1975), p. 155.
7. Kenneth Jameson, *Art and The Young Child,* (New York: Viking Press, 1968), p. 23.
8. Jerome S. Bruner, *Toward A Theory of Instruction,* (Cambridge, Mass.: Belknap Press of Harvard University, 1966), pp. 10–13.
9. Viktor Lowenfeld and Lambert W. Brittain, *Creative and Mental Growth, 6th ed.,* (New York: MacMillan Co., 1975), p. 208.
10. Donald and Barbara Herberholz, *A Child's Pursuit of Art,* (Dubuque, Iowa: Wm. C. Brown Company Publishers, 1967), p. 10.
11. E. Paul Torrance, *Creativity,* (San Rafael, Calif.: Dimensions Publishers, 1969), p. 43.
12. Ann Wiseman, *Making Things: The Handbook of Creative Discovering,* (Boston: Little and Brown, Publishers, 1973), p. 3.
13. Nancy Mayhew, "Expanding Horizons: The Practice of Art Therapy in a Special Education Setting," a paper presented at the American Art Therapy Association's Ninth Annual Conference, (Los Angeles, California, 1978), p. 5.
14. Zaidee Lindsay, *Art and the Handicapped Child,* (New York, N.Y.: Van Nostrand Reinhold Company, 1972), p. 9.
15. Gay Chapman, "Learning in a Friendly Environment: Art as an Instructor," a paper presented at the Council For Exceptional Children, 55th Annual International Convention, (Atlanta, Georgia, 1977), pp. 3–4.
16. Antusa P. Bryant and Leroy B. Schwan, "Art and Mentally Retarded Children," *Studies in Art Education,* Vol. 12, No. 3, (Spring 1971), p. 56.

Motivating for Artistic Expression 6

Every child is an artist. The problem is how to remain an artist once he grows up.

—Pablo Picasso

Innate Awareness

Art education practices are firmly founded on the fundamental philosophy that children have the innate capacity to transform their primary means of knowing—the experiences of feeling, thinking, and perceiving, into their own unique art forms. In attempting to retain and foster the precious human gift of discovery through art, leading art education authorities have emphasized the importance and basic value of motivations as the primary method of evoking art responses in the child.

Motivation that precedes an art production experience should engage the children in a visual analysis which includes emotions and cognitive functions in order that they become skilled in looking. They should come to know that every object, whether it is natural or manmade, has a form and characteristics that distinguish it from other objects. The overall shape of a lion is different from that of a peacock. The parts of the lion can be analyzed as to their thickness, thinness, angularity, the relative sizes of the parts as compared to other parts, and the relative position of these parts in relation to other parts.

The children's attention may be directed toward distinguishing lines in the animal, person, or object—such as smooth flowing tail feathers or sharp jutting antlers. The texture can be noted, and appropriate terminology used to describe its visual and tactile qualities—rough, shaggy, shiny, or bumpy. The gesture or bearing of the animal can be noted—it may be restful, tense, ready to jump, or running. The position of the animal, person, or plant form should be perceived during the discussion. Are the arms stretched to catch a ball, is the cowboy seated on a horse, is the beak of the toucan higher or lower than his body when he sits on the branch? Colors may be noted, how many places they are seen, how bright or dull, which color is predominant. Pattern involves repeated shapes, and children can become aware of bricks in a building and stripes on a zebra. Contrast between dark and light, large and small, and plain versus patterned can be observed.

"Observed" is a key word here. Frequently, children are directed to draw or paint pictures without any observation taking place. When this happens, the child draws upon his memory, and the result is as good, or as poor, as the stored image in the child's mind. Told to draw an elephant, for example, the child's memory may include a long trunk but all the other visual characteristics—the large ears, wrinkled skin, thick legs— all may be lost in the finished work of art. Direct observation of objects in the real world (or carefully looking at photographs of real world objects) provides experiences that can be stored and later used. Drawing or painting observed objects is also a way to increase perception and to store visual experiences which can be recalled for use at a later time.

Students use actual dolls, stuffed toys and other everyday objects in this draw-from-the-real-world lesson.

Students asked to draw what they remember must call upon a large bank of stored visual images.

In addition to images created from observation or memory, a third way of creating in art—the development of fantasy objects, creatures and environments—is based upon observation and recall. In this case, the imaginary creatures and objects are combinations, variations and distortions of those observed in the real world. A child's awareness of what *is* allows his mind to explore all the variations of what is *not* and

A third grade student calls upon his imagination in order to create robots in this pair of detailed drawings.

what *could* be. Providing many visual/tactile experiences and directing the child's observation is necessary in order to attain the high levels of perception required for creative and imaginative production in art.

Providing Options

As children become established in the base line stage of their art development, at about age six, they can think more of placement or environment that is necessary to deal with the theme or idea they are portraying. Second and third graders are ready to do some pre-planning for their pictures, that is, thinking of a point of view and where the objects will be placed on the paper. Will I draw it from the front, side, from below or above, from up close or faraway? It is good practice to have the child verbally describe the animal or subject he is going to draw or paint, striving to note as many of the above-mentioned factors as possible. With practice and perserverance, the child's skill in learning to look and looking to learn will be substantially increased.

It has been said that from impressions come expression. Motivations can help the child select the subject for his art and send him in the direction of making a complete statement of his thoughts, feelings, and perceptions. Regular experiences in painting and drawing will help him sort out pertinent details and eliminate unnecessary elements. Achieving of harmonious relationships within the work and correlation of contrast and balance can be brought about through verbal interchanges. Through these the child is made more aware and critical of why or why not his picture has conveyed what he wanted it to do.

Six and seven-year-old children are ready to widen the range of their experiences with art materials and to explore more challenging and intricate processes. They are eager to develop their skills in manipulating all sorts of materials, and the teacher will do well not to underestimate their capabilities. The child will by now probably tend to

A visit by a clown can provide strong motivational impetus for subsequent drawing and painting activities.

be less spontaneous and fluent in his art production, and hence the teacher should use many motivational channels to stimulate the children to keep open the doors of creative input.

A variety of motivational techniques provides opportunities for the adult to ask leading questions that will stimulate the child to look, feel, remember, and to engage in art production. This latter subsequently may be evaluated for evidence of behavioral change and artistic growth. Motivations set up by the teacher provide artistic problems for children to solve; during the production period that follows, children need to develop a critical eye and conscious judgment. The aesthetic choices and decisions made during the work process will ultimately result in a higher level of aesthetic literacy, and the teacher/child verbal interchange can better bring this about.

Photographic Materials for Visual Analysis

Visual materials (such as photographs, slides, films and filmstrips) on a variety of subjects provide fine resources for motivating precise observation as preparation for drawing, painting, and modeling. "Field trips" to all sorts or places all over the world can thus be brought directly into the classroom. Such visual aids not only provide the teacher with a rich abundance for visual stimulation and input, but present opportunities for language development as the children look, question, discuss, compare, contrast, and note specific shapes, colors, lines, and patterns.

Photographs may be collected from National Geographic magazines, photographic magazines, calendars, and books that deal with a single photographic subject. Such books are often found on sale tables in bookstores. After trimming the photos, the teacher should mount them on railroad board using spray adhesive available from art supply stores. This method of adhesion, in addition to being quick and easy, keeps

the photos flat and neat on the boards and avoids wrinkles and stains that may occur when paste or rubber cement is used. One piece of railroad board 22" × 28" may be cut into two pieces, and a number of photos may be grouped on each panel.

Clear envelopes for storing these panels may be made from plastic sheeting available in variety and hardware stores. Such packages are 'see-through' and protect the contents. They are easy to file and retrieve for frequent use. A piece of this sheeting cut 24 × 36 inches can be stitched on the sewing machine on each side to create an envelope that is 23 × 14 inches with a flap that is 23 × 8 inches. One envelope should be made for each set of panels, i.e., one for birds, one for horses, animals and their young, butterflies, buildings, trains, cars, faces, trees, people in action, fish, flowers, insects, dogs, cats, etc.

Studying visual materials dealing with birds prior to the art activity can increase the children's perceptual skills through directed observation. The discussion will help them note the different shapes of beaks and how different birds make use of their beaks; the lengths of different legs and necks; different sizes and shapes of bodies; the relationship of the size of a bird's head to the size of its own body; details that relate to the placement of the eyes, the position of the wings at rest and in flight; the different kinds of claws and tails, etc. The children should move in bird-like manners, swooping,

A

A, B, and C. Careful observation of photographs of birds, noting different sizes and shapes of bodies, beaks, wings, legs and tails, results in emergence of differentiated concepts when children undertake painting activities.

B

C

feeding, pecking, roosting, and nesting, thus insuring that different modes of sensory awareness—visual, auditory, and kinesthetic—are open to them. The importance of this approach which insures that all children's strongest modes of learning are addressed has been demonstrated by a study[1] in which it was found that 33% of individuals learn primarily in the visual mode, 24% are auditory learners, 14% are kinesthetic learners, and 29% learn in mixed modes.

In initiating a drawing or painting activity, if the teacher only tells the child to 'draw a bird' and uses no visual input devices, no directed observational opportunities, and no kinesthetic activity, the expression that is produced is usually symbolic, generalized, and lacking in any degree of emotion or self-identification. The left hemisphere is content to present a symbol to stand for 'bird,' taking out only small bits of information and using them to represent the whole thing. By alternating hemispheric involvement during a motivation, we call upon the desirable capabilities of the left hemisphere by having it analyze birds in a logical manner, using words to name, define, and describe, analyzing birds step-by-step and part-by-part. On the other hand, the characteristic modes of the right hemisphere increase the non-verbal awareness of birds with a minimal connection with words. The child is allowed to synthesize or put a bird together as he draws and paints, focusing on the likenesses between things, seeing where things are in relation to other things, and how different parts go together. By making the motivation open-ended and encouraging fluency of response, children are free to make metaphorical relationships, arriving at divergent conclusions based upon intuitive leaps of insight, hunches, feelings, and visual images.[2]

Such observational skills involving the child's thoughts, feelings, and perceptions can be increased through frequent short encounters with visual materials. These input skills establish a perceptual learning pattern or base that can be transferred to other media, that is, when the students view films, filmstrips, and slides on a variety of subjects, and when they observe real life objects that are either brought into the classroom or seen on field trips. These encounters build up within the child's mind a visual image 'bank' upon which his imagination may feed and find rich resources for expression. Subsequent art production can call upon him/her to review, recall, and visualize ideas, feelings, and experiences in his drawing, painting and modeling.

Actual Objects as Motivators

Acting it out and actual objects are extremely useful adjuncts for motivation. Through handling a saddle during a motivation, children will be eager to draw themselves horseback-riding. As an example of such an 'actual object' motivation, the following might serve. Given a saddle, and drawing and painting materials, the child could:

1. enjoy sitting on the saddle,
2. act out or pretend to ride horseback,
3. observe other children's body positions when they are sitting on the saddle and verbalize as to the placement of arms, legs,
4. discuss various situations and environments where people ride horses,
5. think of items of clothing he might be wearing when he rides and what sort of hat and boots he might have,
6. observe the shape of the saddle, the length of the stirrups,
7. imagine his picture on the paper, thinking of where he will place the different parts, what background he will use, which details,
8. draw or paint himself or another person horseback riding.

A **B**

A and B. Student sits in real saddle wearing over-sized boots and rides a make-believe horse while class observes and draws or paints. Live models with simple costumes and props assist in schema development by providing visual clues and emotional identification with real-life experience.

These considerations do not restrict the individual's creativity in that they do not preordain or control the child's response, nor do they specify how the child must draw or paint. The motivation or stimulus is provided, the main focus being on perception, motor and cognitive awareness, affective involvement, some preproduction planning, and subsequent art expression.

"Cowboy and Indian" Theme

The theme of "Cowboys and Indians" is one that relates well to the saddle-and-horseback motivation, and is one that great artists in America have loved to portray. A motivation can show how some of these artists have chronicled the adventure, the color, and the lives of these characters and have told us through their pictures, the way they dressed, their activities, and of the emotional encounters of battles and friendships between the two groups. Children can be shown a group of famous works of art on this theme to help them observe details, see action, and note differences in clothing that were of interest and that were recorded by some well-known artists. The following large reproductions from Shorewood (see Source List, p. 228) can be presented to the children, thereby reinforcing the Aesthetic Judgment and Art Heritage Components while relating the theme of "Cowboys and Indians" to their own art productions. (Allowing the children to copy or imitate any of the paintings is to be vigorously avoided.)

"North American Indians" (Currier and Ives) Shorewood #952 This engraving was made from drawings by the artist George Catlin by the Currier & Ives firm so that many people in the Eastern part of America could see what these native Americans looked like. Note differences in hairstyles, body adornment, clothing.

"The Scout" (Frederic Remington) Shorewood #856 We see a lone Indian on his horse searching the landscape for movement. What do you think he is looking for? Look for the lights of the settlement in the distance. The shaggy pony and the Indian look as if they are cold and lonely. What color makes you feel this? Do you think the

Indian is wondering if the people in the faraway houses are friends or enemies? Is it night or day? Remington worked as a ranch cook, shepherd, and cowpuncher. He painted many pictures of the West so people could know what life in this part of America was like in the 1800's.

"A Close Call" (William Leigh) Shorewood #991 This cowboy is charging through a rocky mountain canyon. Do you see him from the side or is he coming toward you? How can you tell that the horse is going fast? Does the horse look frightened? Can you see the cowboy's hat flying off his head? How is he dressed? Do you think he is chasing something or being chased?

"Questionable Companions" (H. W. Hansen) Shorewood #865 The artist named this picture "Questionable Companions." Why do you think he called it this? It shows a cowboy and an Indian talking as they ride over the prairie. The scenery is very realistic. We can see sagebrush, rocks, and shadows. Hansen was a German artist who moved to California and became a favorite of the people because he showed life in the West so very clearly and with such great feeling.

"Sun River War Party" (Charles Russell) Shorewood #966 In this painting, the artist shows a group of Indians riding their war ponies across the wind-swept prairie. Russell loved and respected the Indians and often painted about the battles they had with the settlers. Can you see the strong brushstrokes in the ground that is closest to you? Russell worked as a field hand and cowboy and was a self-taught artist.

"Turn Him Loose, Bill" (Frederic Remington) Shorewood #989 Do you think the title is good advice for this cowboy? Can you see the dust on the ground, the flying tail and mane, the powerful legs on the animal, and the cowboy quickly sliding off the saddle? Look at the expressions on the faces. Find the shadows. Do you feel close to the action? Remington was a football player and boxer at Yale. Later he went West in search of adventure and became a part of frontier life. He recorded Western scenes and became a very popular artist and illustrator. He was very proud of his ability to paint horses and left nearly 3000 works when he died in 1909.

After a lively discussion of this group of paintings on "Cowboys and Indians," the children will be ready to make visual statements of their own ideas about how these

A and B. Potato print face shapes were made by first graders before student wearing blanket and feather headdress modeled for the class for the oil pastel drawings to be completed.

A

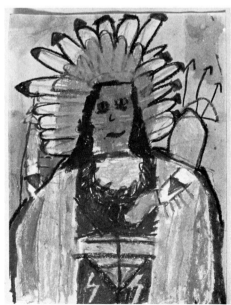

B

characters lived and how they dressed. As an example of a follow-up lesson that uses a group of fine works of art that has a theme-oriented base, the following is given: What kinds of work do cowboys do and what kinds of adventures do they have? (herd cattle, lasso strays, brand cattle, ride horses, make campfires, shoot rifles) What did Indians do? (Rode horses, hunted animals such as buffalo, herded sheep, shot bows and arrows, carried babies, gathered food, acted as scouts) What else? Describe their clothing in detail. Describe their headgear, footware. What did they carry?

We can make our own pictures about cowboys and Indians. Here's how: Cut a potato in half and drain the flat cut side on paper toweling to absorb moisture. It will be an oval shape. Brush water color paint or diluted tempera on the surface and try stamping it on scrap paper until you can make a good print. Now make one or several prints on a piece of manila paper. Let the prints dry. Then use crayons or oil pastels to draw the facial features and rest of the picture—the body and clothing of the cowboy and/or Indians. Show the hat, feathers, etc. Show what your cowboy/Indian is doing and where he is. Include a horse, buffalo, wagon, trees, rocks, etc.

Evoking Images with Words

In addition to the motivational structures just described (photographs, films, filmstrips, slides, field trips, actual objects, acting-it-out, and groups of theme-based works of art), highly imaginative responses can be produced by humorous songs and image-evoking poems. These devices may call upon the child to include several sequential events within one picture. The class can be asked to close their eyes while listening to the song or poem and to pretend that they have a TV set 'inside their heads' upon which to 'see' what the words and events are describing.

The song, "The Big Black Hat" by Rolf Harris (EPIC 45 rmp, 5–9596) describes a man who is dressed in a very strange way. The rhythm and melody are lively and easy to remember. After listening to the song, the children are asked to call upon their visual memory and tell how they would like to meet a man dressed in the manner described and whether or not they would be frightened, curious, or amused. Can they remember how he was dressed, starting with what he wore on his head? What sort of brim did the hat have? What kind of band? How do you imagine the man's moustache was shaped? What sort of glasses were on his nose? What was around his neck and what was attached to it and dragging on the ground? What is a 'sunshade?' What color was the man's sunshade, and where did he hold it? What sort of coat and shirt and trousers do you suppose he might have worn? Do you imagine that this strange man was tall or short—fat or thin? Do you think he had large feet or small—wore boots or shoes or sandals?

Edward Lear, who lived during the 19th century in England, was a master of limericks—those five-lined poems often humorous and always highly rich in evoking visual images. The people and other creatures in the limericks are often connected in odd and unexpected ways, giving cause for chuckles and giggles. For instance, each child who hears the following limericks will image different responses in illustrating what he/she sees while listening to the words:

There was an old man in a tree,
Whose whiskers were lovely to see:
But the birds of the air, pluk'd them perfectly bare,
To make themselves nests in that tree.

There was a young lady whose bonnet,
Came untied when the birds sat upon it;
But she said, "I don't care! all the birds in the air
Are welcome to sit on my bonnet."

There was an old man of Dunrose,
A parrot seized hold of his nose.
When he grew melancholy, they said, "His name's Polly,"
Which soothed that old man of Dunrose.

There was an old man with a beard,
Who said, "It is just as I feared!
Two owls and a hen, four larks and a wren,
Have all built their nests in my beard!"

Mother Goose rhymes, Aesop's fables, and numerous books of poems for children can be found which contain descriptive accounts of people, animals both real and imaginary, places, and events. It is best to avoid showing the children any illustrations that may accompany the poem in the book until after they have completed their drawings to avoid any efforts the children might make to copy the picture rather than to create images in their own way.

Acting It Out

Some motivations place a strong emphasis on requiring the child to strongly identify with another person or being with questions prefaced with "If you were a helicopter pilot, or a scarecrow, or a balloon man or a robot. . . ." These motivations call for the child to project his thoughts, feelings and perceptions into another person or object, placing himself in that person or being's position and imagining how he would feel, what he would see, and what he would think and do. Identifying with being a balloon man is an example. Students should be asked where they have seen balloon men and if they ever let go of the string on a balloon and watched it vanish in the distant sky. What colors are their balloons? How many shapes of balloons have they seen? How many balloons could they hold if they were selling them at a fair? Are their balloons on sticks or strings? Do they need one hand or two to hold all of them? Where do they put the money they are collecting? What kind of clothing would they wear? Would they get tired? How would they like to look up and see about 20 balloons over their heads? Children might then cut out a large number of circles from colored paper, paste them onto a piece of drawing paper, and finish the drawing with their crayons.

Becoming a grasshopper for a few minutes before drawing these insects calls upon the children to think how it would feel to be caught while hopping along and eaten by a big hungry bird. What shape is your body? What do you like to eat? Where would you hide from your enemies? Do you know that grasshoppers are musicians, rubbing their legs and wings together to make music? How would it feel to have three pairs of legs and have to tie shoestrings on six pairs of shoes? What position are your legs in when you hop? (Have children crouch down, elbows bent upward to simulate grasshopper legs). Hop! Hop! Now crawl along a juicy leaf and take a bite of it.

Fantasy and Humor

Fantasy and humor are also appealing focus points for a motivation that will charge the young child's mental batteries and aid him in pushing forward in his artistic expression. Fantasy themes can be fanciful, unreal, absurd, and dream-like. Humorous topics deal with caprice, wit, jests jokes and just plain funny situations. These might include The Mixed-Up animal I saw in my backyard, What I think I look like inside, Inside our TV set, Magic flowers, Underground tunnels for alligators, etc. Pretend and make-believe, weird visual connections, old ideas placed in fresh surroundings, and silly absurd situations help the child grow creatively and explore new tasks in individual visualized ways.

Evaluating the Results

As children become involved in art, if changes in artistic production are expected as an outcome of a series of motivations, then the evaluation of the artistic process and product becomes a significant area of concern.

In considering what aspects of an art production can be evaluated, Elliot Eisner has defined three areas.[3] The first of these is the degree of technical skill displayed in a child's work. This relates to determining the extent to which the child has demonstrated skill in handling and controlling a given material, because without the necessary skills, expression is bound to be stifled. If a child's paper has holes in it from being overworked with a brush on its surface, or if it has large puddles of paint that were not intended to be there, we can probably conclude that the child is having difficulty coping with the material. In early childhood we do not expect highly developed mastery or control of materials; however, an increasing capacity to master materials and a desire to develop skills are evidences suitable for evaluation.

The second aspect for evaluation deals with aesthetic and expressive areas of the child's work. In this, we look at the extent to which the child has organized his work and made the parts function, as well as what sort of expressive characteristics he has displayed. The third focus for Eisner's evaluation in the productive realm has to do with assessing the degree of creative imagination and ingenuity used in the work. Technical skill and an aesthetically pleasing form may be present, yet imaginative aspects and fresh insight may be at a minimum. Ideally, all three aspects work together and support each other.

For the preschool and kindergarten child, an impromptu and informal discussion as the completed art products are being hung about the room is probably critique enough. "John's painting makes me feel like a sunshiny day—happy and warm. Louise's drawing tells us how strong and furry her brown dog is. Jim loves red and orange, and he has arranged them well."

An attractive display of products in which the child has placed much sincere effort is essential in that this act of exhibiting a child's work tells him that he, as a person, is important, that his individual and unique achievements are respected and valued. All the children's work should be on display at different times during the year, and appropriate reinforcing comments and definitive discussion should be made about them.

As children produce art at a more conscious critical level, usually during the first grade, they may talk with the teacher in small groups or individually, verbalizing about their work, becoming more aware of the art elements and how to integrate them in their artistic configurations. Periodic discussions after art production periods aid the children in dealing more effectively and expressively with color, shape, line, contrast, rhythm, and all-over composition. In this way future discouragement, apathy, and frustration may be prevented. If teachers neglect to talk about the child's art in art terminology, it should not be assumed that the child will automatically develop in aesthetic language and awareness.

Using a positive and constructive approach that does not single out one child's work as "better" than others, the teacher should ask such directed questions as, "What is the best part of this painting? What shapes in Dan's picture tell us about his boat ride? How did Joe make us feel the coldness of a snowy day in his picture? What shapes are repeated in Helen's work and how does this make us feel?"

Art educators have frequently made statements as to the inadvisability of comparing one child's work to another's, using it as an example for others to copy. While harm can be done if emulation is the objective, this does not mean that a teacher should never choose one child's work for such positive and directed comments. These may refer to the use of ingenuity, praising it; the use of unique approaches and solutions; the imaginative use of materials; sensitive observations of things and events; enriching

of drawings and paintings with fine textural qualities and details; fine selection and expressive combination of colors; taking the initiative in suggesting ideas; the manner in which a child showed feeling in his work; etc. Such evaluative considerations are specific guideposts for young minds, and serve to aid them in the future, with added insight and understanding.

Checking on the Process and the Product

Over a period of time each child should be observed by the teacher as to evidence of individual progress and growth in the following areas:

1. Does the child show evidence of being visually aware and sensitive to differences and similarities in color, texture, shape, line, and form?
2. Does the child use art terminology to describe works of art and natural objects?
3. Does the child enjoy experimenting and trying different approaches with each art material?
4. Does he create with ease and fluency?
5. Does he change his symbols and images to suit the demands of the problem, material, or situation?
6. Does he persevere, with increasing duration?
7. Does he have unique and imaginative ideas?
8. Does he show resourcefulness in working with a combination of materials?
9. Does he display emotional qualities and feelings in his work?
10. Does he work independently, without need to imitate the work of other children?
11. Does he show self-confidence and eagerness in his art production?
12. Is he able to handle a number of tools and materials with an increasing degree of competence?
13. Does he use a variety of subject matter?
14. Does he produce works that show a unity of compositional elements and incorporate a variety of forms?
15. Is he able to cooperate in a group art task?
16. Does he work without bothering other children?
17. Does he enjoy performing art tasks and place value on them?
18. Does he frequently choose to work with art materials in a free-choice situation or outside the school?
19. Is the child significantly retarded or advanced in his art?
20. Does he show respect for art materials and cooperate at cleanup time?

Art has a body of knowledge and skills. Art requires thoughtful effort and hard work. Art requires practice and decision-making. Art requires the child's best performance in the realms of understanding, thinking, feeling, perceiving, and expressing with precision and beauty. These do not happen by chance. It is only through skillful teaching over the years that the very best can be brought from the children, and teachers should settle for no less.

The Role of Specific and Qualitative Encouragement

Supportive and encouraging remarks made by the teacher will work to bring out the best in children. The three occasions in which such encouragement can take place are during the initial motivation period, during the working process, and then later, in discussing the finished work. A teacher's specific comments have more meaning and offer more opportunity for the child's growth. "Louise, I am delighted to see how your curving lines are repeated," or "I am very pleased to see how much you enjoy painting

with red and yellow," are more specific than "That's nice." Precise statements during the working period may refer to product as well as process such as, "Jose, it makes me happy to see how much you enjoy making purple circles. I feel proud when I see how you are concentrating on applying that blue paint."

In talking with children the teacher can make some specific comments of encouragement and support. Instead of a vapid, 'That's nice, Liz,' or 'Good work, Sue,' the teacher should first look carefully at the work. The comments then may be directed to several content points:

1. The elements the child has used. 'You have used red in several places, Diane,' 'I like the blue and green colors that contrast with the big orange sun, Larry,'

2. One may comment on the art principles involved such as rhythm, balance, and the overall composition. 'You did a good job of repeating this shape, Jim. It gives your picture a sense of rhythm.' Or, 'These two small bright spots of red on this side of your picture help to balance the large dull blue on the other side.'

3. One can comment on the expressive quality. 'I feel happy when I see the warm colors in your painting, and I remember going to the circus last summer.' Or, 'Your picture make me remember a stormy night last October.'

4. One can refer to the inventiveness, ingenuity, and imagination shown in the child's work. 'Bob drew his horse different from anyone else's. It's almost running off the page.' Or 'Mary found two new ways to show people jumping rope.'

5. One can reinforce some desired behavior if a comment is made recognizing the length of time and effort the child has put into a work. 'Dean has worked for a whole hour on his picture. He is trying very hard to show us his treehouse.'

6. When a child has shown evidence of improved skill and control of the medium the teacher might express delight and approval. 'Laura painted her background color up very close to the house,' or, 'Jean really is doing a good job of making her crayon drawing dark and waxy.'

Notes

1. Swassing-Barbe Learning Modality Index, Zaner-Bloser, 612 No. Park St., Columbus, Ohio 43215
2. Betty Edwards, *Drawing on the Right Side of the Brain,* J. P. Tarcher, 9110 Sunset Blvd., Los Angeles, CA 90069, p. 40.
3. Elliot W. Eisner, *Educating Artistic Vision,* (New York: MacMillan Co., 1972), pp. 212–16.

7 The Teacher as Facilitator

The imporverishment of the imagination is more often the cause of difficulty in school learning than failure to master the mechanics of the three R's or the factual content of textbooks.

. . . Harry Broudy, THE ARTS AS BASIC EDUCATION

A Key Person

The teacher who is in charge of structuring and designing the young child's artistic encounters must investigate many avenues of skill development, of sensory refinement, of concept formation, and of emotional awareness, in order to develop to the fullest each child's inherent and unique potential. The teacher should value originality and recognize unique responses. The child whose confidence has been strengthened is able to resist stereotypes, to demonstrate flexibility, attain some measure of self-direction, and execute his art images with increasing skill, while using a variety of materials for his personalized expressions. The teacher must set the stage, arrange, plan for, and put into orbit many environments for the child's learning, expressing, and communicating.

Teachers of early childhood classrooms should know of the findings of the Goertzels and Torrance. The Goertzels studied the lives of 400 very eminent people of this century. They found that the childhood homes of almost all of these persons emphasized a love of learning, and that a strong drive toward intellectual or creative achievement was present in one or both parents. The family attitude of being "neutral" and "nondirective" was practically nonexistent. Three out of five of these people had disliked school, but the teachers they liked the most had been those who let them progress at their own pace, work in one area of special interest, and had challenged them to think.[1]

Torrance's research pointed to a child's creativity peaking at the second-grade level, then tending to be stifled by demands and pressures "to conform" from curriculum, peers, and teachers; thus a creative thinker is forced to adjust to the norm. Torrance also found that teachers tend to favor a child with a high IQ but with low creativity. His study described the creative child as one who seems to "play around" in school, is engaged in manipulative and exploratory activities; one who enjoys learning and is intuitive and imaginative, enjoying fantasy; one who is flexible, inventive, original, perceptive, and sensitive to problems. The creative student, he believes, is most often not identified as intellectually gifted.[2]

The influence of the teacher is a major one. By his or her positive attitude and example, the child becomes susceptible to new experiences, receptive to the many forms of art, judgmental in viewing, and skilled in forming tastes and making choices. Books and films having a high quality of illustrative material should be selected for special viewing. Exhibit corners in the room should display well-chosen and tastefully selected

art and craft objects as well as beautiful natural forms. The teacher should endeavor to keep the room attractive and inviting. Live plants, clean fish tanks, brightly colored furniture, and well-designed bulletin boards speak for themselves in contributing to a warm and happy atmosphere.

The teacher will find much value in keeping a "portfolio" of each child's work, putting in it from time to time dated drawings and paintings and cut-paper work that show progress, deviations, or regressions in the child's development. If the child has verbalized or named his work, it will be helpful to attach a notation to the drawing. Art is language for the child, and we can learn much about his personality and his ways of perceiving and feeling about the world through this cataloging technique.

The teacher should not draw for the young child nor ask him to follow a pattern or copy a drawing or prototype because, in so doing, the child's main thrust becomes that of pleasing the teacher. In attempting to imitate, the child will find the visualization meaningless and beyond his conceptual stage of development, and he will experience failure and frustration if he is unable to imitate. If he does imitate successfully, he is laying the groundwork for a dependent attitude for his future art production. It is wise for the teacher to be alert and quick to praise every sign of initiative on the part of the dependent child.

Contact with Parents

At the beginning of the school year the teacher should find occasion to send a letter home to the parents or meet with them in conference and explain the goals and behaviors to be expected in the child's art production. When drawings and paintings are taken home by the children, they should be received by understanding and appreciative parents if the artistic development at school is to be reinforced. A few words to the parents explaining what normal development is at that particular age level, will be helpful.

In addition, a few suggestions as to art materials and home environment for art may be made. Included should be reminders that:

1. Art stimulates the imagination and makes the child think more inventively. Art provides a healthy, natural and satisfying activity for the child now, and the habits thus begun in early childhood can last and flourish throughout his life.
2. Originality should be valued and independence encouraged rather than copying and imitative activities. The unique, the original, the novel solution to a problem, the unexpected, the humorous approach in expression—these qualities should be cherished and reinforced.
3. A place to keep his own collection of interesting objects will encourage the sharpening of the child's visual and tactile sensitivities and nourish his curiosity.
4. A place to work with drawing, modeling, constructing, cutting, and painting materials will encourage the ongoing and spontaneous flow of art production.
5. Trips to interesting places of all sorts in the community will give him experiences that will be reflected in his art work.
6. Trips to galleries and museums will establish a cultural habit that will continually enrich his life.
7. Special after-school and Saturday art classes are offered by universities, museums, and youth programs. Encourage the child's participation.
8. Visits to the school will enable the parents to be informed of the art program. Invite them to serve as art aides.
9. Sharing books with your child can explain about art—books that have color reproductions of paintings and sculpture and the like. Read with him and talk about the contents.

10. Displaying his work shows the interest and support of his family.
11. Coloring books and patterns destroy his ability to think for himself and foster stereotyped and meaningless responses.
12. Comparing his work with his brother's or sister's makes for negative feelings and attitudes.
13. Encouraging him to be resourceful with materials will develop his capacity to be inventive.
14. His art work is an indication of his personality. Respect it and endeavor to see his point of view.

Time: Regular and Frequent

Preschool and kindergarten children need daily encounters with art production.[3] Often, five or ten minutes is all the time required for them to engage in drawing, modeling, or cutting. As they grow older, their perseverance increases and they may be expected to work for longer periods of time. First graders should be expected to work twenty or thirty minutes on simple art tasks and longer periods on more complicated tasks that involve several steps to completion. Kindergartners and first-graders are ready to spend extended time periods working together on art tasks such as mural-making and construction activities. In so doing they spend time learning to respect another's point of view and see their own production contribute to the whole.

Art experiences can and should be repeated to be educationally valuable since children gain skills and insight and can delve deeper each successive time.

Since the creative aspects of art production involve an alert and vigorous mind, teachers would do well to schedule art periods early in the day when the child's ability to attend and remain "on task" are at a high level. Aesthetic sensitivity and art skills develop with use in the same way that skills in reading and mathematics progress—through frequent and regular episodes.

Materials: Suitable and Varied

Small muscles in early childhood are developing motor control rapidly, and art materials that provide the child with experiences in cutting, joining, applying, brushing, twisting, forming, adding, squeezing, rolling, pressing, printing, taping, and drawing are basic. Materials and processes introduced and used in early childhood must be on the child's level if he is expected to perform with minimal assistance from the adult. Small children *can* learn to cut both paper and fabric if they are supplied with good, high-quality scissors. Ball pens, soft lead pencils, small-size crayons, felt pens, oil pastels, small, medium, and large stiff-bristle brushes, tempera paint, glue, tape, clay, salt ceramics, staples, needles and yarn—all provide fertile soil in which the seeds of the young child's imagination may grow.

A lack of mastery in handling materials on the part of the young child may sometimes be due to the constant introduction of new materials each week, never allowing the child time to gain competency with any one material. Over a period of time the child will not have had enough in-depth experiences with one material and will not have become involved in seeking his own personal statement in that medium. The teacher who feels it is necessary to present a new "gimmick" every Friday afternoon is making the child novelty-oriented and is not providing for individual artistic growth in any one area.

This is not to say that variety in materials in not needed. After the initial exploratory and experimental period, the child may find that new material enables him to give form to a latent image. Through working with materials a number of times, a child learns which ones suit him best, what limitations and possibilities are characteristic of each. Through exploration and repeated practice with art materials the child develops self-sufficiency, visual literacy, and an encompassing awareness.

A classroom "art line" allows students to hang wet paintings or prints so that they will be out of the way as they dry. Large (5 gallon) ice cream cartons form a storage pyramid in the background.

Space: The Classroom as Studio and Gallery

There are three prevalent kinds of physical arrangements in a school which can be organized to provide an environment for art. First is the self-contained classroom in which all children are in the same grade and one teacher is responsible for all the experiences of the children. The school district should make available the services of an art consultant or resource person to aid the teacher in planning an art program or should provide a visiting art teacher. Second is the open or nongraded classroom, with a large number of children of several age groups working at their own levels of accomplishment and regrouping for various subjects. Third is the special school art room to which the children go at specified times during the week for art activities.

In preschool and kindergarten rooms, children may choose during activity periods to work in one of several spaces—one of which may be an art learning station. At other times, art tasks may be structured with small groups or perhaps the entire class working together.

Easy access to and immediate availability of art materials are imperative to a good art program. When art supplies and work spaces are convenient and neatly organized, the teacher will feel more relaxed and eager to provide a maximum number of art activities, and the children will be more stimulated to innovate, experiment, and participate. Four kinds of space within the classroom should be considered:

—Storage space for materials, tools, and supplies
—Space for projects not completed
—Space for displaying the children's finished work, both two- and three-dimensional
—Space for displaying interesting art-related objects

Teachers up-date teaching skills at in-service workshops. Ease of setting up tabletop painting activities is facilitated through the use of disposable palettes for mixing small amounts of tempera.

School stages and multi-purpose rooms can provide large spaces needed for group art projects. Students here are making kites which will be flown and then displayed on the curtains backing the stage.

Paint and brushes should be stored in cabinets or on shelves near the sink. Several large cans should be kept handy for storing brushes of various sizes. Different sizes, colors, and kinds of paper should be on shelves or in drawers within reach of the small child. Shallow plastic trays or dishpans with labels attached can be used to store felt pens, chalk, oil pastels, crayons, colored pencils, scissors, glue, and tape. Cardboard boxes, ice cream cartons or plastic dishpans should be labeled and filled with such materials as felt, fabric, yarn, and feathers.

Teachers often are ingenious in finding free materials from local businesses and industry and relish the challenge of finding new ways to use standard art materials. In displaying the children's art work in a classroom "gallery," it is advisable to display the work of the entire class or the work of small groups of children on a rotating basis that is understood by all. If teachers only put up pictures they consider "the best," this can signify a preference which might cause children to copy others or to become locked into repeating certain "successful" images in order to receive recognition. A child who is eager to please could easily become repetitious in his art expression. For the child whose work is never selected, the message is clear, and he can become easily discouraged with a resulting loss of confidence. At some time during the year after collecting art work in student portfolios, each child may select his or her favorite for an exhibit to be called "Portfolio Favorites" or "Artists' Choice."

There are usually opportunities for exhibiting student art work outside the classroom. Prints, paintings and drawings can be displayed in the principal's office or in the school office. Large art pieces show off best in spaces like the auditorium or cafeteria. Public libraries, airports, stores and other public buildings frequently are interested in displaying children's art. Museums and galleries sometimes sponsor shows of student art work, especially in March which is National Youth Art Month. Classrooms, schools or districts will sometimes compile a collection of student drawings and creative writing for publication. All efforts to feature a child's work communicate value and respect.

Art Learning Stations

An "Art Learning Station" is a small space that provides one or two students with a mini-environment for independent or semi-independent activity. With materials set up and visual and/or verbal instruction provided, the child is able to work with minimal supervision from the teacher thereby gaining confidence in his own ability to do things 'all by myself'. Some children feel more comfortable and free to experiment, fantasize and develop ideas and images in the quiet private atmosphere that an Art Learning Station makes available.

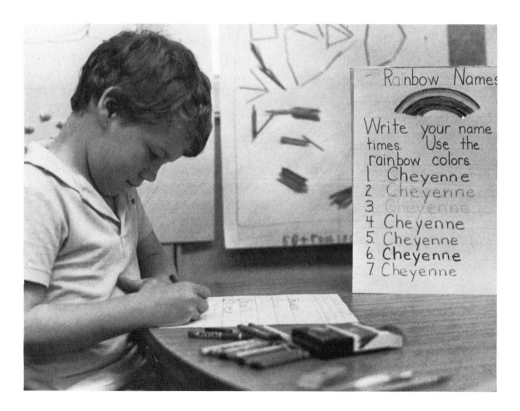

This portable center is placed on desk tops or tables for learning station session, and is then stored easily when the teacher has scheduled activities which require a more traditional classroom arrangement.

Learning stations make it possible to organize and use materials which are too small, too few, or too awkward for an entire class of children to use at one time.

As in any art activity stress in an Art Learning Station is placed on divergent and creative responses. At the same time the child is learning to follow simple directions in producing a final product. The learning station is basically designed to reinforce or extend a skill or concept which has been introduced by the teacher. To function productively, stations need to meet the following requirements:

1. Be attractive and enticing, offering the child ways to explore, investigate, and manipulate
2. Have well defined rules for its use, such as a limit on the number of students at the center at one time
3. Provide the supplies needed
4. Require few written directions for the primary child
5. Provide several directions in which the student may work to develop, reinforce, or extend learning
6. Contain a wide variety of multi-level activities that can be adjusted to the needs and abilities of individual children
7. Have several ways of doing the activities, such as listening, reading, observing, and/or manipulating
8. Include some self-correcting devices such as color coding, matching numbers or shapes, or puzzle matching
9. Provide a place for finished and unfinished activities
10. Be changed at regular intervals to coincide with curriculum changes and/or student interests.

For the most effective use of learning stations, it is essential that the teacher instruct students in the use of them. As each new station is developed, the teacher should explain the new concept to be reinforced. Stations need to be used as part of the daily program; they become an integral and effective part of curriculum planning as teachers recognize and utilize the variety of ways that learning can be reinforced.

Art Station Activities

A "See and Touch" station may have natural and man-made items for the children to investigate. The teacher may make up a game sheet in which numbered objects such as a stuffed owl, dried weeds, pressed flowers, dried skull of an animal, feathers, butterflies, colored Indian corn, shells, or a bird's nest are described in such terms as "rough and scratchy, crumbly, swirling, white, pointed, smooth, etc.," and the child must match the term with the object. This tactile station should sometimes have an arrangement of folk art items, such as a pottery bird from Mexico, a puppet or mask, a carved wooden lion from Africa, a piece of Eskimo soapstone sculpture, a Hopi Kachina, some carded wood, some brass bells, or some stone beads. A magnifying glass will provide an intriguing means of visual perception.

Some particularly appropriate art activites for learning centers include mixing colors; progressing from making simple shapes in modeling clay to pinch pots, clay animals, figures and shapes, providing a series of activities that reinforce basic clay techniques. Sample activities dealing with great works of art include making a collage after seeing some of those created by Picasso or Braque, or making a painting of dots (using daubers found in shoe repair shops) after viewing some of the works of the Impressionists. After the entire class has looked at portraits and self-portraits of great artists, students may draw a portrait of a classmate; drawing a self-portrait at a learning center further reinforces the concepts introduced in the classroom setting.

Color mixing using watercolor markers is the activity in this learning station. Students are allowed to select one of two art experiences (the other one in this particular center deals with paper sculpture).

The following are specific examples of Art Learning Stations that lend themselves to self-contained areas of instruction and that assist the child in making an individualized response to an art motivation.

String Starters: (Provide: string or yarn, scissors, glue, crayons, 9 × 12 paper)

1. Glue short piece of string to paper.
2. What does it make you think of? jump rope, fishing line, clothesline, tail of a fish, back of a camel, shoe of a giant?
3. Complete your picture with crayons.

Muffin Melter (Provide: muffin melter, see page 120–121, Q-tips, heavy paper, water colors and brush, India ink, masking tape)

1. Dip Q-tip in melted crayon.
2. Daub on heavy paper
3. Cover all the paper with crayon, or brush a water color wash over the uncovered paper, or brush India ink over the uncovered paper.

Warming Tray (Provide: warming tray, unwrapped wax crayons, paper, masking tape)

1. Tape paper to edges of tray.
2. Move crayon slowly on paper, letting it melt as it moves.
3. Add more colors to cover paper completely.
4. White, gold or another color may be blended on top of another color.

Catalog Clips (Provide: old catalog, scissors, paste, 9 × 12 paper, crayons or felt pens)

1. Cut out a face, shoe, pants, sweater, wheel, clock, or a lamp from the catalog.
2. Paste it on the paper.
3. Draw the rest of your picture.

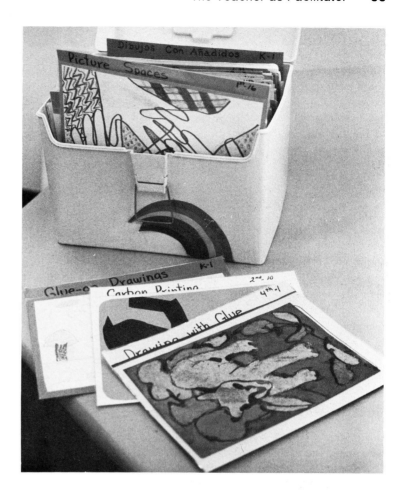

Art folders provide instructions, tips to teachers, and a space for a student example on the front. The size and format also make it easy to store in standard file drawers. Courtesy Chula Vista City School District.

Instructional Materials for Stations

Books (such as Addison Wesley's *Another Look* listed in Sources for Teaching Materials on page 228) can be cut apart and used in learning stations. Concepts found in this series such as "touching" and "not touching" shapes, or "curved" and "straight" lines in objects can be reinforced in a center by displaying parts of the books, enlarged pictures of the nonverbal symbols used in the lessons, and a series of photographs from magazines which show images in which objects are touching or not touching, straight or curved. If laminated, the children can mark on the materials with crayon, and the activities can be used over and over. Further reinforcement of the concept is possible through an activity such as having the child draw or paint a picture which shows the concept touching/not touching or straight/curved as seen in arrangements of objects in the immediate environment.

Teacher convenience is a primary consideration for the sequential art lessons used in the Chula Vista City School District in California.[4] Twenty art activities for each grade level have been developed in folder form, and the folders are color coded using spectrum colors. The folders are the size of regular file folders, and they easily fit in classroom file cabinets or portable file boxes. There is a blank on the front of each one for a student art example; the list of materials needed and simple directions are printed in the inside. Many illustrations make the directions easy to follow. Objectives, teacher hints, and information, and evaluation questions are printed on the back along with the art components to be emphasized in the lesson. Each grade level has sequential lessons in drawing, painting, printmaking, the elements of art, and three-dimensional

experiences. Since "extensions" or additional activities are often listed in the teacher's section on the back, the folders provide an excellent resource in setting up stations to reinforce concepts, knowledge, and skills.

As Ralph Voight points out, the learning station implies certain characteristics or behaviors on the part of the teacher, an enlarged learning environment, greater independence on the part of the learner, and revised physical arrangements in the classroom. He goes on to state that the learning center embodies the implementation of an idea which enables each child to grow at his own rate, in his own style, and to his uniquely personal potential.[4]

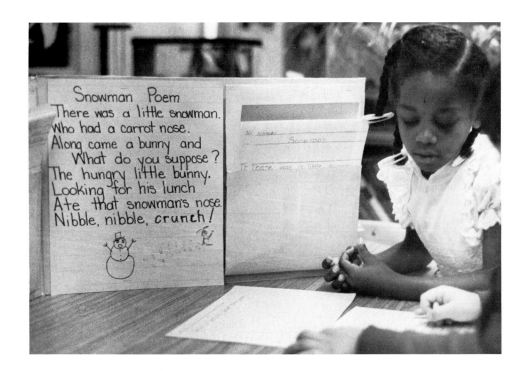

Simple directions, ample supplies, and a limit on the number of students using this learning station make it a comfortable space for independent activity.

Notes

1. Victor Goertzel and Mildred Goertzel, *Cradles of Eminence* (Boston: Little, Brown & Co., 1962), pp. 3–9.
2. Robert F. Biehler, *Psychology Applied to Teaching* (Boston: Houghton Mifflin Co., 1971), p. 248.
3. The Teacher's Edition of ART: MEANING, METHOD & MEDIA, a series of art textbooks for Grades One through Six, states that state departments of education across the nation tend to recommend about 100 minutes a week for art instruction.
4. Date Seymour Publications, P.O. Box 10888, Palo Alto, CA 94303.
5. Ralph Claude Voight, *Invitation to Learning: The Learning Center Handbook,* Washington, D.C.: Acropolis Books, Ltd., 1973), p. 2.

A

Set-ups for Art Learning Stations provide space for intense uninterrupted efforts for one or two children at a time.

A. String Starters aid divergent thinking.

B. Warming tray and crayons require student concentration while she searches for image formation.

C. Catalog Clips spark individual ideas for expression.

D. Templates, pens and water colors add up to animal shapes, trees, houses, monsters and designs.

B

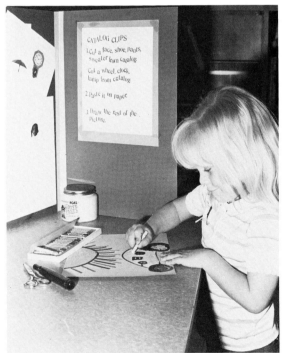

C

D

Drawing and Painting 8

Drawing: External Thinking

Human beings have engaged in drawing activities since the first rock pictographs were made many thousands of years ago. Early man drew on cave walls and on clay pots. Egyptians used limestone tablets and sheets of papyrus. Artists in the Middle Ages drew on parchment made from goatskin or sheepskin.

Drawing is basic to art. Drawings can be valid works of art in themselves or can be used in planning other works of art. Drawings by the old masters are treasured in museum collections, and many contemporary artists make sketches, figure and contour drawings, modeled renderings, and cartoons as their means of expression. They use charcoal, chalk, pastels, Conte crayons, pencils, and pens and ink.

Throughout history painting has been a mirror for man's feelings and ideas about his world. For many years, the development of civilization has been recorded by artists, and the many paintings by artists in countries all over the world tell us much about religion, national life, historic events, geography, and famous personages. Many activities that we engage in call upon us to clarify and develop an idea with a sketch. Drawing and thinking are often an all-at-once phenomenon making a graphic image an

Drawing improves with practice. By providing time, topics and materials, the teacher can help students to increase their skills.

extension of the mental process and helping to bring an idea into focus. Engineers, chemists, city planners, carpenters, surgeons, mechanics, and football coaches are but a few individuals who find a need to make useful and practical application of external thinking—that is, *drawing*.

Like other learned skills, drawing improves with practice. Many children and most adults seem to think that people are born knowing how to draw, and those who "can't" do it instinctively, never will learn. Like any other ability, some people show a little more aptitude in the beginning, and practice will increase the skill for anyone who takes the time to do it. Ten minutes of drawing every day will result in improved drawing skills, and the concentration or focusing on specific objects in the environment will increase perception as well. People who do sit-ups every day get better at them; people who draw every day will also improve.

Very young children approach drawing with great enthusiasm and spontaneity. Their marks are exciting to them. Motivation at this time need not dampen their aliveness, but directed observations can heighten their awareness. Sometimes children (and adults) look without seeing. Examination is fleeting and cursory. By carefully examining lines, shapes, colors and textures of objects, a child can develop his perceptions. The more details he perceives, the more details he is likely to draw, and the more differentiated his visual configurations will become.

Exploring Images

There are three ways to develop an image in drawing—from memory, from looking at objects in the real world, and from the imagination. Frequently, children are asked to draw or paint objects of which they have only dim memories, and the results are disappointing. When asked to draw a person or object that has had great influence in a child's life, the results are usually more detailed and may show exaggeration which reveals some emotional significance to the young artist. A neighbor who is very frightening may appear large and menacing in the drawing while the child's self image is small and practically hidden. A friendly dog may appear to be all tongue, and a piano player has dozens of fingers on each hand.

A, B and C. These three drawings, all done by first grade students in the same class, show the wide variety of creative expression possible even when the subject matter is the same.

A

B

C

Drawing objects in the real world is one of the best ways to increase visual perception and discrimination. Without making the child feel inadequate, an adult can reinforce and direct observation of details. As an experiment, ask the students to draw a leaf. Once completed, give each child several leaves; ask him to rub each one between his fingers. Some leaves have smooth edges while others have serrated "saw-tooth" edges. Leaves are different shades of green, and some are yellow, gold or red. Ask children to look at the shape of each leaf, its veins and stem. After observing leaves, ask the children to draw a leaf. Increased sensory interaction with the environment leads to increased awareness and realistic depiction of objects.

While drawing real objects increases perception and eye-hand coordination, sometimes an artist may want to go beyond reality to create images that exist nowhere in the real world. Drawing from the imagination can result in delightful and highly original scenes that exist only in the child's mind.

When Children Draw

Children begin drawing very early in life when they first trace a finger through spilled oatmeal, move a stick on the surface of sand, or make a few crayon or chalk marks on a wall. It is exciting, indeed, to discover that the kinetic activity of moving one's hand when it is holding a crayon can leave a mark on a paper!

To draw is to depict forms with lines; it is to pull or move a drawing instrument in a direction that will cause it to make marks. The best tools for children to use are felt pens, crayons, oil pastels, ball-point pens, chalk, and soft lead pencils. Most drawing instruments are small-tipped, and these almost always require a small piece of paper; conversely, thick chalk is an excellent medium for drawing huge life-size figures, animals, and houses on the sidewalk or on a large piece of paper.

Drawing plays an especially vital role in the young child's artistic development, because it is during early childhood that he needs to see very clearly the images and symbols that he is making and not have them drip or run together, as they do when he works only with paint. He can use drawing tools to make outlines and details; it is at this time that his perceptual explorations are leading him towards finding and recording all sorts of things that are of fundamental importance in his development of concepts. The more details he perceives, the more details he is likely to draw, and the more highly differentiated his visual configurations will become.

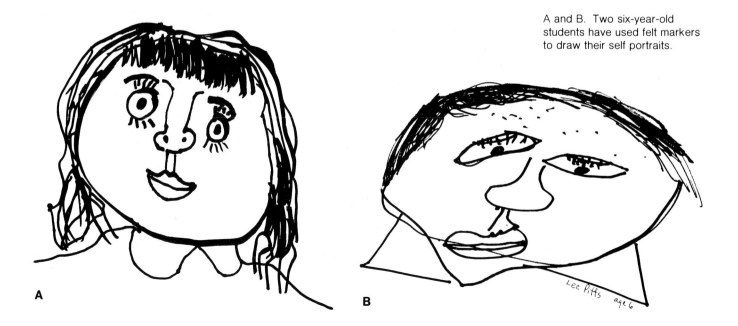

A and B. Two six-year-old students have used felt markers to draw their self portraits.

A

B

Thick, round-topped crayons are frustrating for small children to use. At a time when they are perceiving and refining visual forms and details, small crayons will better suit their needs. A thick crayon in the hand of a five-year-old child is equivalent, in proportion, to a broomstick-size crayon in an adult's hand, making it difficult for him to grasp and to control its direction. The child will find it much easier to draw small details such as fingernails, shoelaces, and teeth which he may desire to do but cannot do with thick crayons. While slender crayons may tend to break more easily than thick ones, no child should ever be so cautioned about the use of his crayons as to cause him to become intimidated and fearful of using them. If one of our objectives in the education of young children is that they become more perceptive in relation to visual details and better able to make distinctions and differentiations, we must provide them with the kind of art materials that encourage definitive drawing activities. Small-size crayons, pencils, and felt pens do just that.

When Children Paint

In early childhood art programs, painting should play a constant and integral part. Tempera is the most functional and popular paint for young children to use. It should be purchased in liquid form in plastic containers with squeeze tops that make for easy dispensing. Not only is the squeeze top convenient, it is economical in that only the amount to be used needs to be squeezed out at one time—usually about a spoonful—thus eliminating left-overs when tin cans, muffin pans, and milk cartons are left half-filled to dry up and be wasted.

If the paints are too thick, they should be thinned by stirring in a little water; however, tempera should be used in a creamy opaque consistency, as too much water makes it transparent and runny. Paper for painting activities should be heavy enough so that it does not tear when it becomes wet with paint. Flat and round stiff-bristle brushes in small, medium, and large sizes should be plentiful, since the exclusive use of big, wide brushes encourages the smearing and stroking of paint rather than the making of images and the painting of sensitive forms and details.

This student feels comfortable and enjoys working on large paintings at an easel. The important thing in a classroom is to set up a variety of painting experiences for children so that they are able to experiment with many approaches and techniques.

At Easels

Most preschools and kindergartens have several easels available for on-going painting activities. This is a convenient method for children; however since the paper is attached to the easel at the top and hangs vertically, paint tends to drip and run down if it is at all thin and watery. Children need to learn to put the brush back in the same color to avoid getting the brush or the paint supply muddy. They need to learn to wipe each side of the brush on the inside edge of the paint container to avoid dripping and having excess paint on the brush.

Skill-Oriented Painting

In addition to on-going easel painting opportunities, activities which are more precisely skill-oriented and motivationally directed can be set up and structured by making use of newspaper-covered desks, tables and floor space. Each child should have a disposable palette for holding several spoonfuls of thick tempera paint and upon which he can mix two or more colors together. This disposable palette may be either a piece of waxed paper, a styrofoam egg carton, or an old magazine whose top pages may be torn off and thrown away at the end of the painting period. By avoiding the use of tin cans or small milk cartons or muffin tins, which are often used for tempera containers, loathesome and time-consuming clean-up activities are shortened and less paint is wasted. Each child should have a clean damp rag (old bath towels torn in twelve-inch squares) or a small sponge for wiping his brush clean between colors. An old shirt worn backwards or a vinyl apron should be worn to protect clothing. A large-sized plastic garbage bag with a hole cut for the child's head and two holes cut for his arms makes an excellent slip-on protective smock. Brushes should be washed in warm sudsy water and rinsed at the end of the painting period and then stored, bristles up, in a large can or plastic container.

A styrofoam egg carton provides places to mix paint. If needed, the lid can be closed and the paints stored over-night (the students can write their names on the lids in pencil). When finished, all cartons can be discarded in a large plastic bag for easy disposal.

What Skills Can Be Expected

After very young children have had a number of initial exploratory experiences with one or two colors of paint, they should be given some instruction in the handling of brushes and paint. They should begin to know and demonstrate proficiency in

1. using fingers and not the fist to hold the brush
2. using the tip of the brush and being able to make thick and thin lines and strokes and avoiding scrubbing with the brush.
3. using a large flat brush for large areas and smaller narrow brushes for details and for painting close to another painted area
4. using chalk occasionally for preliminary sketching before applying the paint
5. letting a color dry on the paper before applying details either on top of it or too close to it in order to prevent smearing
6. learning to mix colors on their disposable palettes: adding a little bit of a color to white to make a tint; adding a little bit of black to a color to make a shade; mixing a little of the color's complement to a color to dull it (blue-orange; red-green; yellow-violet); mixing any two primary colors to obtain a secondary color (red + yellow = orange; blue + yellow = green; blue + red = purple)
7. wiping the brush clean on a wet rag before using it for another color
8. completing a painting by covering the entire surface of the paper with paint, giving consideration to composition, adding patterns, small details, etc.
9. washing brushes in warm sudsy water when finished, and storing them in a designated container; cleaning up work area.

Pouring spouts on commercial paints and a cardboard container (which once held bottles of tonic water) form a unit which is easily carried and distributed to students.

Size, Design, Color

A distorted conception, prevalent for a number of years, has been instrumental in forcing the young child to make only large paintings and to use only thick, wide brushes. What benefits are reaped when we provide small fingers and hands with only supersize art materials? Some children may feel threatened and overpowered by large blank sheets of paper, and find themselves unable to manage, delineate, and control the wide strokes that a large brush forces them to make. Children should have opportunities to use both large and small paper; they should have available to them all sizes of brushes so that they can make a decision and select those which best suit their needs, thus developing skill and mastery in using them.

The teacher's guidance in setting up many painting experiences for the children will greatly enhance the variety of approaches that the class may take. For instance, giving the children colored paper to paint on will enable them to see new relationships between colors and the unifying effect of the background. Premixing colors occasionally for the children will encourage them to try mixing colors themselves. Pastels, blended tones, grayed colors, gold, silver, magenta, peach, and lime are not used frequently, and their introduction will arouse the children's interest and cause them to think of new subject matter to use for picture-making.

Older children will profit from having a piece of scrap paper handy to try out brushstrokes, brush sizes, color mixing. They can also work together in planning, sketching, and executing a mural on a large piece of paper, with each child painting several items individually.

The painting tools of the child artist include the working elements of design, one of the most important of which is color, since it also incorporates and reflects both the cognitive and the affective domains in the child's growth and attitudes. Children live in a world of color. They see it in flowers, in clothing, in cars, in rain puddles on oil-slick streets, in animals' fur and birds' feathers, in sunsets, in paintings, and in people's eyes and hair. Color can make us feel happy or sad, warm or cool; and the colors children use in their paintings and drawings often reflect this quality.

We usually think of a color in association with familiar things, and as very young children begin to paint and draw, they slowly develop this color-object relationship.

A and B. Preliminary drawings with chalk or crayon enable children to plan and develop paintings that include overlapping and details.

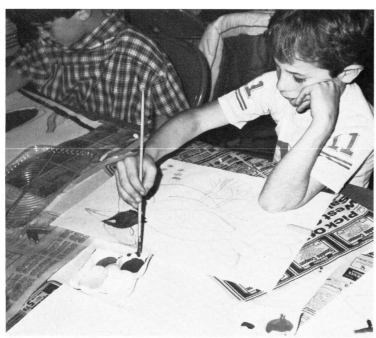

A

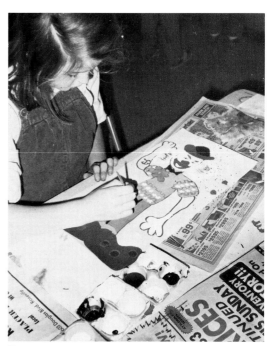

B

Since fire is red and yellow, these colors are thought of as warm. Sky and water are green, violet and blue and these are usually thought of as cool colors. Children like to have favorite colors, and they usually choose bright, intense hues.

If children compare the green leaves of the budding willow tree with the green leaves of the stalwart oak, if they look at the blue summer sky mirrored in a lake and the blue-gray sky above city buildings, they develop a more refined awareness of color's delicate or intense differences.

Color wheels are available for purchase, or they may be made. Children may choose two opposite colors for a painting, adding black and white to each color for tints and shades, then mixing the two colors in varying amounts to achieve dulled colors. Analogous colors, or those adjacent to each other on the wheel, may be selected for a warm or a cool picture. Children may mix equal amounts of colored baker's clay, choosing colors that are opposite on the wheel, or two primary colors, to see what happens. Clear plastic cups or glasses may be filled with water and food colors dropped in to see the colors mix.

A and B. "From above" theme stimulates child to imagine himself looking down from a hot air balloon and to paint the landscape, mixing colors for fields, rivers, trees, houses and fences.

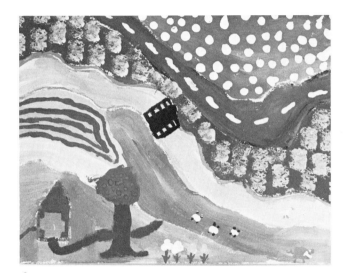

A

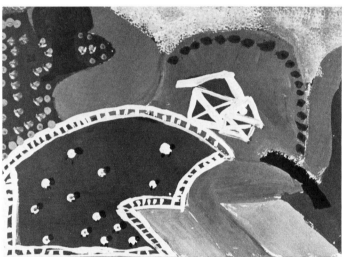

B

A serious look at a commercially produced color wheel can be part of child's learning experiences in relation to understanding primary and secondary colors.

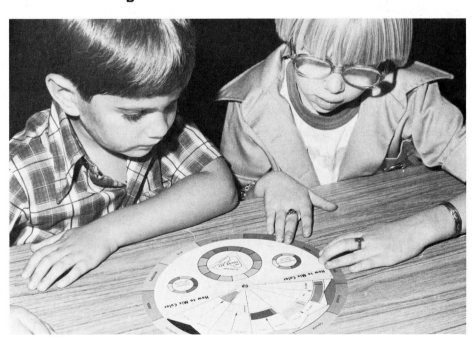

Accordian-pleated cardboard forms a holder for crayons so that they will not roll off the desk.

Crayons and Oil Pastels

Probably the most familiar medium for childhood art is the wax crayon with its glowing, vibrant colors. However this waxy effect is not often realized when children only use it as a medium for line drawing. They should be encouraged to bear down hard enough on the crayon, applying sufficient pressure to achieve the rich waxy look typical of this medium. First graders can be shown some of the rich possibilities and encouraged to explore using crayons. They can draw their ideas lightly on white or manila paper with a yellow crayon, making changes and corrections as they desire, and then color in the areas solidly. They should not use a pencil for preliminary drawing when using crayons, as the sharp point of the pencil is suitable for small details that cannot be covered or colored with the blunter, softer tips of the wax crayons. They can try drawing on colored paper and discovering how the vibrant tones of the crayons look against red, brown, or green paper. The large crayon boxes containing many colors can prove exciting due to the many shades, tints, and dulled colors available. Children will benefit from having a thick pad of newspapers under their drawing paper since this surface is more conducive to such work than the hard desk or table top. Older children should be encouraged to imagine their entire drawing on the paper before they begin the actual drawing, to think of background areas and spaces around the objects, and to plan for their utilizations. The children should be reminded that repeating the same color or shape or texture several places in their drawing will give it unity, and that dark colors used next to light hues give it contrast. Water color washes may be applied over finished crayon drawings.

Oil pastels offer a type of drawing/painting combination experience for young children. They are available in rich glowing colors and are softer than wax crayons. They should be applied boldly, and the children should press down hard enough to achieve the brilliant effect typical of this medium. They are especially vibrant when applied to colored paper, and children should be encouraged to let some of the background color show through between the objects. They are somewhat akin to oil paint in that a light color or white oil pastel may be applied on top of another color. Oil

pastels are especially successful when used as a resist technique in which the child makes a drawing, preferably using the lighter colors and then applying water colors or India ink to the background areas.

Resist Techniques

Many substances can be used to resist other materials and preserve a design or picture. Oil or wax and water-based paints are frequently used, although tempera and ink are also possible. The basis for resist techniques is the incompatibility of two materials.

Wax Resist

An introductory experience in wax resist can utilize paraffin or white or yellow crayons to make a "secret drawing" for a classmate. Clear or white marks on white paper (or yellow marks on yellow paper) are like a coded message. Once the drawings are completed, students are to exchange them and brush on a coat of watercolors or thinned tempera paint. The drawing will appear magically as contrasting colors of paint are applied.

Subsequent wax resist activities can involve the students in drawing with many colors of crayon and applying thin paint over the entire surface. Holiday themes lend themselves to this technique, and a drawing of Santa on the roof or a haunted house becomes even more effective when a coat of black or dark blue is applied. Blue and green washes of paint over an underwater scene reinforce the illusion of water, and heavily patterned crayon designs increase in boldness and impact when paint is applied afterward. Encourage children to apply the crayon heavily, otherwise the paint will cover the drawing. Be sure to point out that it is the wax that keeps the water and paint from coloring the paper; the wax "protects" or "resists" the porous paper. If there is not enough crayon, if the waxy surface is too thin and sparse, the paint will soak into the paper and hide the crayon marks. Several layers of newspaper or a piece of window screening beneath the paper will help with the heavy application of crayon or wax. Oil pastels are more easily applied, and tempera, watercolors, or India ink applied as a last step will make a particularly effective background for the finished art work.

Paint Resist

Thick, creamy tempera paint applied to colored construction paper forms the basis for this resist technique. When the paint is thoroughly dry, a coating of India Ink is brushed over the entire surface of the picture. Where the paper is exposed, the ink blackens the area. The painted lines and spaces prevent the ink from soaking into the paper in those particular spots. Temporarily, the ink blackens the outer "skin" or surface of dried paint, and the original painting will seemingly disappear.

After the India ink is thoroughly dry, the entire art work is gently washed with water. Depending on the quality of the paper, it is usually a good idea to place a cookie sheet or some other flat surface under the paper to act as a support and to prevent tearing. As the water soaks into the dried tempera, the paint partially dissolves, lifting away much of the pigment as well as most of the ink that dried on the painted surfaces. The result is an interesting textured design with the colors of the paper and paints combined in an antiqued effect against solid black.

The simplified version of this process is to use only white paint on colored construction paper. The effect is very bold and striking, and is particularly suited for portraits of people. Introducing several colors allows a more complex subject: tropical fish and birds are very colorful and are excellent as subject matter. Children will need to

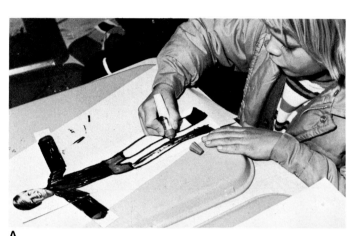

A

B

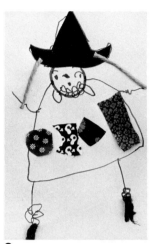

C

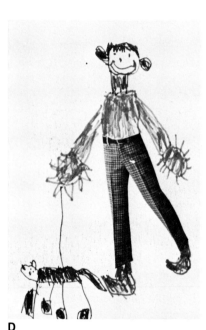

D

E

F

G

H

I

J

K

L

A. Photographs of heads clipped from a catalog were glued to twelve-inch strips of lightweight poster board, and shorter strips were added for arms. The children drew the bodies and clothing with felt pens.

B and C. Five-year-old children showed great diversity of form concept when they drew witches using precut hats as visual starters. Felt pens, yarn, and fabric scraps were used to complete the drawings.

D. A pair of pants was the glued-on starter for five-year-old boy's drawing of himself walking his dog.

E. Each child in the first grade had a photograph of his own face, and was highly motivated to draw himself in this assembled mural.

F. Four seeds glued to the drawing paper motivated this drawing of roots and flowers by a five-year-old child.

G. and H. Flags glued to drawing paper suggested soldiers to one kindergarten child, and racing cars to another.

I, J. K, and L. Short pieces of yarn were shaped by one five-year-old child into a monster; shorter pieces into swings for a group of performers by another; the roof of a house by another; and ocean waves near a lighthouse by another.

use tints (colors with white added to them), either mixing them or using pre-blended paints for their art work. The use of tints creates greater contrast to the ink.

A second resist technique involving tempera also involves the student in painting a colorful picture as a starting point. Contrasting colors of crayon are applied over each area of the dried painting; a wet sponge is applied to the surface until the underlying tempera paints begins to flake off. The result will be a mottled, textural picture in which the residual crayon will accent the seemingly weathered tempera tones that remain.

Glue-it-on Drawings

Most young children produce drawings frequently and with fluency, but a few children show little interest in drawing, probably due to a lack of confidence in their own ability. Both types of youngsters will respond with enthusiasm to the "idea starter" type of drawing motivation. This art task suggests to the child a specific focal point and directs his thinking to the innovative possibilities upon which he may elaborate, enrich, and even deviate from his schema.

In glue-it-on drawings the basic concept is that of attaching one item to a piece of drawing paper and using that object as a visual point of departure for the child to begin making a picture.

Clothing and Faces

Gluing on cut-out faces or one item of clothing, such as a sweater, slacks, shoes, or hat, which has been clipped from a magazine or catalog is especially conducive to developing the child's concept of the human figure. The teacher or the child may glue the clipped photograph of a single item of clothing to a piece of drawing paper, then the subsequent discussion should deal with what the person who is wearing that particular article of clothing might be doing—running down a hill, walking a dog, playing ball, skiing, pulling a wagon, sweeping a floor, jumping rope, painting a building. The motivation should then lead the child's thinking to the environment that would be appropriate, i.e., where the figure might be—on the street, in a garden, at the zoo, on a mountain—and who else might be with the person. Next, the children should use crayons, pencils, felt pens, or oil pastels to complete the drawing.

Yarn

Each child is given a short length of yarn to place on the paper in a curve, circle, zigzag, line, angle, and so on. The motivational discussion should cause the child to wonder what the yarn suggests to him. Could it be the string of a kite, a fishing pole held by a man in a boat, the outline of an elephant's back, the top of a building, a clown's head, the peak of a mountain, a jump rope, the antennae of a butterfly—or what? Then the children glue the yarn to the paper and complete the picture with drawing materials.

Seeds

The children should each have a paper with four or five flat beans or large seeds glued on it. The motivation should focus on the roots, stems, and parts of plants. Bring in a flower or weed that has been pulled up so that the children can examine it closely and touch its roots, stem, leaves, flowers, and seed pods. Talk about how the shapes of leaves and plants differ, then direct the children's attention to all the colors that flowers take. The children will then be ready to design their own imaginary plants, drawing the roots below the ground, growing down from the glued-on seeds, and the stems, leaves, flowers, and seed pods growing upward above the ground from the seeds.

Flags

Very small paper flags mounted on short wooden sticks may be purchased in variety stores. They are brightly colored and come in assorted designs. When they are glued to a drawing paper, the children may discuss where they have seen flags flying and who carries flags. One child should demonstrate how a real flag is held—how the elbow is bent—and how the flag flies high above the child's head. The children will remember seeing flags on buildings, on boats, on flagpoles, at fairs, and carried by horseback riders in parades. Then they will be eager to draw a picture with a flag in it, adding appropriate figures and environmental details.

Murals

In the mural "There Was an Old Woman" shown here, first-grade children were given actual photographs, about four inches high, of their own faces. These photographs were cut out and glued to a piece of twelve-by-eighteen-inch drawing paper. Then, using felt pens and scraps of colored paper and fabric, the children drew and cut out the rest of their own bodies and clothing. The completed figures were then cut out of the drawing paper and assembled on a bulletin board, which in this case was covered with a piece of yellow felt. Several children painted and cut out a shoe house, a few flowers, and the title.

Not only did the figure concepts become more detailed and elaborate, but an intense awareness of drawing a person was experienced, due to the fact that their own faces were serving as the focal points. By grouping the finished figures around a central item and using a unifying theme, the whole group of children enjoyed working together on a class art project.

Here are some related mural topics for a group of young children to create, using either their own portraits or some photos of heads clipped from catalogs and magazines as glued-on starters:

—A castle filled with kings and queens
—An office building where many people work
—A super rocket with space travelers in compartments
—An ocean liner with many tourists in the cabins
—People walking through the jungle on trails
—Children getting on the school bus
—Children playing games on the playground

In all of these motivational topics, each child draws himself and some of the environment that is needed for the completed mural. Each item is individually drawn and cut out, then all the parts are assembled on the background. For a permanent mural the parts may be glued in place. Pins should be used if the children wish to disassemble the mural later and retain their own individual work.

Tall and Wide, Round and Square

How to provide situations which will help children break through stereotyped expression and move on to less rigid and more sensitive realms is a challenge for teachers. Through appropriate and stimulating motivations, we can endeavor to keep children's thinking dynamic, their schemata enriched, and their imagery varied and flexible.

Paper for drawing and painting that departs from the usual twelve-by-eighteen-inch size challenges the child to make new visual configurations. If crayons, felt pens, or pencils are used instead of paint, the paper should be fairly small. Tall and wide pieces of paper as well as round and square sheets encourage him to adapt his form concepts to that shape of paper, adding details and configurations that fit the new proportions and shapes.

A

B

C

Teachers may suggest to children suitable topics that are adaptable to a particular given shape. Here are some subjects that match unusual paper shapes:

Tall Paper

—High-rise building with people looking out the windows
—Church with steeple
—Clowns on a ladder
—Tree full of squirrels
—Girl in a tree swing
—A castle tower and a princess
—Jake, the Giant

—A spaceship with an astronaut
—A skinny man with boots and hat
—A giraffe or ostrich
—Acrobats on a unicycle
—Raccoons climbing a tree
—Man on stilts
—Tall bird

Wide Paper

—A submarine, interior
—A long train
—A bus full of people
—People waiting in line for tickets
—Racing horses
—Dancers on a stage
—Chickens on a fence
—An alligator

—The most beautiful caterpillar in the world
—A candy-making machine
—Floating on water
—Things that crawl
—Camel caravan
—Store fronts

A, B, and C. Drawing tall giants and skinny people requires the child to stretch his concept of the human figure to fit a long, narrow piece of paper.

D, E, F, and G. Round paper from a dentist's office served for these circular representations by kindergarten children.

H and I. Vigorous drawings of a truck and a train by five-year-old children are aesthetically adapted to long, narrow paper.

J and K. Tall rocket and tall apartment buildings were painted by kindergartners.

D

E

F

G

H

I

J

K

Round Paper

—Children playing farmer in the dell
—Swimming in a pool
—Fishing in a round lake
—Children playing jacks or marbles
—A butterfly
—A flying carpet

—A magic wheel
—A clown's face
—Mother cat nursing kittens
—My friend, the sun
—A coiled snake
—Circus ring
—Pond full of ducks

Square Paper

—Eating at a picnic table
—Inside a magic box or radio
—A mechanical snail
—A lion's face growling
—A grasshopper or ant
—Sitting in a chair

—Bird in a cage
—Bug on a big flower
—A comet or shooting star
—A very fat man
—Looking down on a city block
—Baseball game

Drawing with Glue

A thick line oozing from a spout and flowing onto paper has great appeal for children, and provides an interesting medium for them. In this activity, the child draws with pencils first until his picture or design is pleasing to him. A large, thick primary pencil is probably best since it will discourage too many little details which are difficult to make with glue. If a child wishes to make a free-form design with glue directly on the paper, this is certainly an acceptable solution to the lesson.

When dry, the glue lines will be transparent and will be raised above the surface of the paper. This provides an opportunity to use tempera or watercolors to paint the areas within the lines. The glue will protect the paper beneath it, and the lines will appear to be white.

Designs created in glue provide a foundation for a multi-media work of art. Once dry, the white glue becomes transparent and forms a raised surface which adds interest to the drawing.

A variation of this is to draw with glue on black paper. When the glue is dry, chalk can be applied to the areas within the transparent glue lines. The chalk should be pushed with a fingertip into the spaces next to the lines. The transparent glue will cause the black paper to show through as black lines. The chalk will have a muted quality since the black paper will dull the colors.

Still another variation is to add black India ink to the glue (two parts glue to one part ink is a good combination) and place the mixture in a plastic squeeze bottle. When used to make lines on white paper, the glue stands out, dark and bold. Watercolors or brightly colored tempera paints can be used to complete the work, and the permanency of the India ink allows the glue to dry waterproof. If watercolors are used, the intense black line against the transparent color gives the work a stained glass effect. Art reproductions showing the works of Rouault, Pollock, Klee, Calder or Miro will help develop appreciation for the use of the black lines in art while introducing students to the styles of great artists.

Sand Drawings

After drawing with glue, it is also possible to add colored sand while the glue is wet. Sand can be easily colored; add water to dampen the sand, add a few drops of food coloring, shake or stir to blend the color, and then put the sand on a flat surface to dry (the drying procedure can be speeded up by placing the sand in a warm oven).

Once sand has been sprinkled over the wet glue lines, the design should be set aside until the glue has dried. Excess sand can be removed by tipping and shaking the design over newspaper; the sand can be returned to the container for later use. Soap powder, salt or rice can be used in place of sand.

This activity introduces texture to a work of art. Encourage students to rub their fingers gently over their drawings and feel the lines and shapes with their eyes closed. A comparison of these drawings (actual texture which can be felt) to pictures in magazines (visual texture which can be seen but not felt) can extend the concept.

The audience happily watches the aquatic show in this bleach drawing on purple paper. After the bleach dried, a felt marker was used by the second grade student to add details.

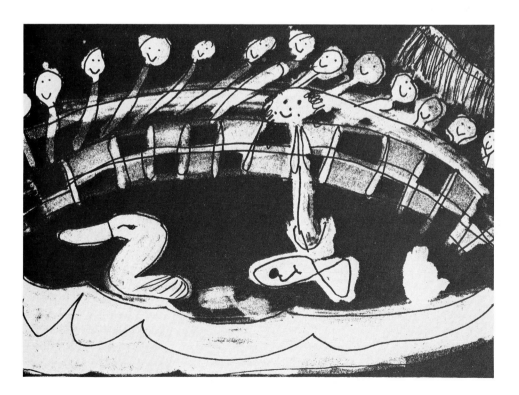

Reverse Paintings

In this process, the child experiences a kind of magic as he/she draws on colored paper with a Q-tip dipped in bleach. Newspapers should be spread on the table or floor before each child is given a cap from a soda bottle filled with a small amount of laundry bleach. By dipping the absorbent end of the Q-tip in the bleach and then marking on the colored paper, he/she will see the magic begin to work as the color changes to white in every area where the bleach touches the paper, the reverse of the usual manner of drawing or painting where black or colored lines appear on white paper.

Lines, dots, and entire shapes may be rubbed with the bleach-soaked Q-tip to make representational images, designs, and words. Colored construction paper, Astrobright paper, and tissue paper all bleach out satisfactorily. If tissue paper is used, it should be backed with a piece of white paper before mounting it to reinforce the effectiveness of the white areas. Or it may be mounted with a thin strip of cardboard or wood across the top and bottom to make a small banner through which the light can shine since tissue paper is translucent.

If colored construction paper or Astrobright paper is used, the child may add more details after the paper is dry by drawing on it with black or colored crayons or felt pens in a mixed media approach.

Painting with Melted Wax

When artists paint with melted wax, it is called *encaustic*. An easy way to translate this brightly colored technique for very young children is by making a special crayon melter.

For this you will need an empty ditto fluid can, a muffin tin with small cups, an electric cord with a light socket on one end, a 150 or 200 watt light bulb, and a piece of lumber to attach to the bottom to prevent the tabletop from being scorched. An

Child dips Q-tip in soda bottle cap that holds laundry bleach and then makes reverse painting on colored tissue paper.

A

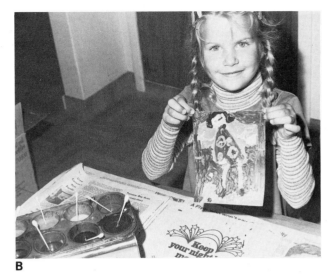

B

A. Shiny colors can be spread easily on card stock when applied with Q-tip from cups holding melted crayons.

B. Small encaustic painting done with melted crayons was completed by 7-year-old who concentrated on schematic theme and background design.

opening should be cut in the broad side of the can, the cord inserted through the pour-top opening, the wooden piece nailed to the bottom, and the light bulb attached to the scoket. Then the muffin tin should be placed in the cut-out opening and screwed in place. Old broken pieces of wax crayons should then have the paper removed and be placed in each cup, along with a small piece of paraffin to make for smoother brushing. The heat from the bulb will melt the crayons. Q-tips may be used by the child for painting. A small piece of card stock, such as old manila folders, makes an excellent surface for the child to use for his work. A color may be applied to an area and in a few seconds it cools and hardens, then another color may be applied on top of it for details, or a color placed next to it. The entire background may be filled with the melted crayons, or water colors or India ink may be brushed on. The wax hardens rather quickly on the Q-tip, so that the child will need to stand close to the crayon melter and keep dipping his tool into the melted wax in order to achieve the waxy, luminous encaustic effect and to avoid a 'dry brush' appearance. A small size of heavy paper or card stock about 5 × 8 inches is best to use, as it takes a bit of time to complete this sort of painting.

Though children will have their own ideas for encaustic paintings, they may benefit from the stimulation of seeing a butterfly collection or listening to a visual image-provoking record such as Puff, the Magic Dragon, or hearing a motivation having to do with nursery rhymes or fairy tales.

Drawing on a Warming Tray

A warming tray used for serving food may be used for making crayon drawings. A piece of paper should be taped to the top and bottom edge of the tray so that the child need not hold onto it while he is drawing. Paper wrappings should be removed from the crayons. The child then draws directly on the paper, moving his crayon slowly enough to allow for the flow-melting action that the heat causes. These trays do not usually get hot enough to cause any burned fingers. The results are rich and waxy. Colors may be placed adjacent to each other, and the entire surface of the paper should be covered.

Batik: Plausible, Pleasing, and Painless

Just how the batik process began is not known, but it probably originated in Indonesia and spread to Europe and other countries before finally achieving a high degree of development as an art form in India. Basically, batik is a process whereby

A small piece of paper is taped to a warming tray and child creates melted crayon drawing by moving crayons slowly over the surface. Entire paper may be covered with crayons or background areas may be brushed with India ink or water colors.

An electric fry pan with several layers of heavy aluminum foil can be safely used to melt paraffin for batiking. The thermostat on the pan maintains the wax at an even temperature well below the burning point, and the foil protects the pan's surface as well as providing insulation between the heat source and the cans of wax.

wax or paste is applied to fabric in a decorative manner for the purpose of resisting the dye which is applied later. One of the main characteristics of batik is the spiderweb effect achieved when the wax hardens and cracks and the dye penetrates into the fibers in thin lines. In more complicated batiks, the fabric is waxed and dyed several times, creating fantastic color and design patterns due to overlapping and color blending.

In adapting the rather complex batik process for use with young children, teachers will find the techniques described here to be replete with artistic possibilities, yet simple and safe enough to be used in the classroom. All the materials may be purchased in local stores.

A. Paste flows smoothly from squeeze bottle as the child makes a drawing on a taped-down piece of cotton muslin.

B. Food dye contrasts sharply to the white areas that were protected by the paste. Intense watercolor washes may be used in place of the food colors.

Paste Batik

The first batik to be described is the "paste" method. This technique does not involve using wax or dipping the fabric in a dye bath. It is somewhat related to a Japanese dye process called Sarasa. It is also akin to a resist technique used in Africa called 'adire eleko', in which the design is painted on the cloth with a starch called 'lafun', which is made from cassava flour. Later, when the fabric is dry the starch is flaked off the cloth and the fabric is dipped in the dye again to reduce the contrast.

These Japanese and African techniques can be greatly simplified for use with young children by using a paste mixture made of ordinary store ingredients. Paste is used instead of melted wax for the purpose of protecting the fabric from the dye, which is applied later. Wherever the paste is squeezed onto the cloth, the fabric will be white when the piece is finished. The paste should be mixed until there are no lumps. A blender will do the job efficiently and quickly. You may need to double or triple the recipe for large groups of children. The proportions are the following:

1/2 cup of flour
1/2 cup of water
2 teaspoons of alum (spice rack in grocery store)

Each child needs a small piece of 100% cotton bleached or unbleached muslin that has not been laundered or treated with perma-press. This piece of material should be about eight by ten inches in size, and should be taped down to a piece of corrugated cardboard.

This paste is placed in plastic squeeze bottles such as those used for dispensing mustard and ketchup. A half dozen or so bottles are all that are needed for a class if the children take turns drawing their pictures. The child makes the design by holding the bottle perpendicularly and squeezing it to create and maintain a smooth flow of the paste onto the fabric. He draws his entire picture in this manner, making lines, dots, and solid masses, and then leaves it to dry overnight. The next day the dye is brushed over the entire picture, the dried paste resisting the color and leaving the fabric underneath it white.

Paste food colors, available from cake decorating supply stores, or water colors should be mixed with water in clean, shallow tin cans such as empty tuna and cat-food cans. These do not tip over as easily as taller cans do. A small amount of this very intense dye should be stirred into the water to make a rich hue, because the colors, once on the fabric, dry lighter than they appear to be when they are wet. Several colors may be brushed into separate areas of the same picture, as in applying red for the roof, brown for the tree trunk, yellow for a flower, and blue for the background. The fabric is left to dry thoroughly, and then the paste is chipped and rubbed off with the fingers, revealing the white picture underneath.

The fabric may be trimmed neatly, ironed to press out the wrinkles, and mounted. Batik pictures also make attractive greeting cards when they are glued to a folded piece of colored paper.

For a group project, tape a length of the muslin to a large piece of corrugated cardboard, perhaps a piece about 3 × 5 feet in size. Each child may squeeze on his figure or animal, perhaps on several base lines that have been applied beforehand.

Drawn Batiks

In the second batik variation, the child draws his design with water-soluble felt pens on Dippity Dye paper or on a piece of white muslin that has been taped to a piece of corrugated cardboard. He may use as many colors and shapes as he wishes. The second step consists of applying melted wax to cover all the outlines of the objects in the drawing.

A

B

C

D

A. Child draws on fabric or Dippity Dye paper with water soluble felt pens before applying wax.

B. Wax melts in a can that stands in a foil-covered electric pan. Here a boy covers his felt-pen drawing with wax before he brushes the dye on the unwaxed portions of the fabric.

C. Diluted food coloring is brushed over entire picture.

D. When wax is removed by ironing, the drawn batik is finished.

Wax should be melted and kept at 250 degrees in a deep-fat fryer or in a can standing in a foil-lined electric pan. Dipping a small stiff-bristle brush into the hot wax, the child quickly applies it to his fabric or paper, working rapidly to prevent the wax from cooling on the brush and hardening so much that it does not penetrate and protect the fibers from the dye.

After he has completely covered all the felt pen lines in his picture with wax, he is ready to brush on washes made of diluted paste food colors. All the background areas that are not colored with felt pens should be covered with dye, and the wax will serve to protect the edges of the drawn forms.

The cloth or paper should then be allowed to dry thoroughly before being ironed between several thicknesses of newspaper to remove the wax.

Wax melts easily and safely in foil-lined electric skillet to enable children to experience batik process.

This kindergarten batik was drawn on muslin. The bright colors of the drawing were preserved by wax before the piece was dipped in an orange cold-water dye.

Simplified Batik

After completing a drawing on butcher paper with many colorful crayons, the paper is soaked in water and crumpled into a ball. After uncrumpling the paper, the students flatten it and blot off excess water. Using a wet brush, each child can apply watercolors or diluted tempera over the surface. Because the color will be more intense in the creased areas of the paper where the fibers have been broken down, the finished drawing will have the cracked effect of a wax batik.

Peepface Figures

Appeal to the young child's sense of humor and you have a ready-to-go motivation for painting the human figure. Provide him with cardboard panels with cut-out peepholes, and you will stimulate his sense of the dramatic and illusory. Not only will the children delight in this comical art task, but they will expand and enrich their cognitive awareness of the human form.

Large pieces of corrugated cardboard are discarded after mattresses and refrigerators have been shipped in them. A single narrow panel is sufficient for one figure, while a longer panel works well for a "living mural." Small ovals just the size of a child's face should be cut very close to the top so that the children can peep through them. Two smaller holes cut on both sides, either halfway up or near the top, can serve as openings for the child's hands. Placing such hand holes up high requires the child to extend the figure's arm up or bend its elbow to reach the opening. He may wish to place a flower or some object near the opening for the hand to pretend to "hold" as it projects through the opening.

The panels should be placed flat on the floor or on several desks or table tops while the children sketch their figures. Chalk rather than pencil enables the child to draw freely without fear of making a mistake, since he may quickly rub off any area he wishes to change. Chalk is closely related to brushstrokes, and the child will be able to use it to draw details and decorative elements that are easily transposed to paint.

A supply of tempera in both pure and blended colors will enable the child to predetermine which parts of his figures will be which colors. He should be reminded to paint the large areas first, using a large flat brush. Smaller areas, edges, and details should be painted with a small stiff flat bristle brush. Paint should be dry before a color is placed next to it or a detail painted on top of it. The children will enjoy painting the background on the panel and adding suitable environmental details.

For an imaginative extension of peepface figures, provide the children with horizontal and vertical panels with cutout holes for animal paintings. The silly appeal of having one's own face growling from a lion's body, or one's own mouth pretending to nibble leaves from atop a giraffe's neck would be an irresistible invitation for even the most timid young painter to become involved.

Colored Chalk

Large areas of paper can be covered easily with colored chalk. Young children respond readily to its bright vibrant tones. Since chalk is dusty, smudgy, and sometimes frustrating for young children to handle, two options are available to facilitate its use. Be sure to use colored chalk that is manufactured for use on paper, not chalk boards.

Method 1

Soak the chalk in water for about 30 seconds and then drain it on a paper towel. Pour about two spoonfuls of liquid starch in a jar lid or small container. Dip the tip of a piece of chalk in the starch and apply it to the paper. Keep dipping the chalk in the starch as needed to keep it marking and flowing in a smooth velvety manner. The youngest children will draw directly onto the paper with the starch-dipped chalk, but first and second graders and older children may prefer drawing their ideas first with a piece of dry chalk or perhaps a thick black felt pen and then applying the colors.

Method 2

Pour about a tablespoon of thick white tempera paint into a jar lid, small container, or onto a piece of waxed paper or foil. Dip the tip of the colored chalk in the paint and make marks on the paper. This technique is especially effective on black or dark colored paper.

A. Three chalk-drawn figures are being painted by these eight-year-old children. Long arm on middle figure is reaching up to catch a bird painted close to the hand hole.

B. Two boys are using tempera tubes rather than brushes to paint their peepface figure. Note whimsical muscles on figure's arms.

C. Girl uses small brush to paint background near her figure's hair.

D. Some panels may have a half circle cut along the top edge where the child may place his chin instead of looking through the oval-shaped hole.

E. When the peepface figures are finished, the children will enjoy taking pictures of each other looking through the openings.

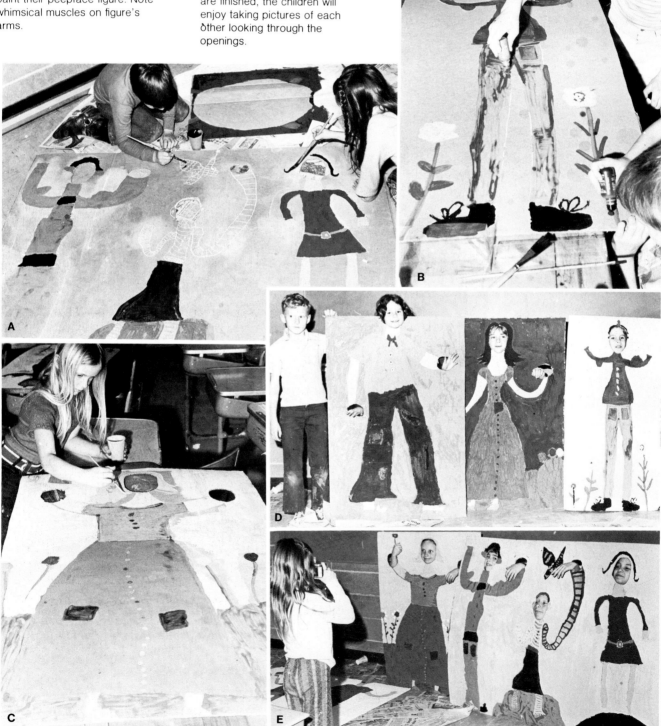

Both the starch and paint techniques dry quickly, and the colors do not readily dust or rub off the finished pictures.

Theme Motivators

As mentioned previously, art can be stimulated by the introduction of topics or themes as motivators. Some examples of themes which appeal to young children are:

An animal I've touched
The circus parade
Playing at the park
Trucks, trains and trolleys
Forest friends
Carousels and roller coasters
Boots and umbrellas
My family, my home
Portrait of my pet
A trip to . . .
Bugs and butterflies
The toy store

A and B. City buildings were drawn and colored with chalk/ starch colors after much visual analysis of real and photographed city scenes.

A

B

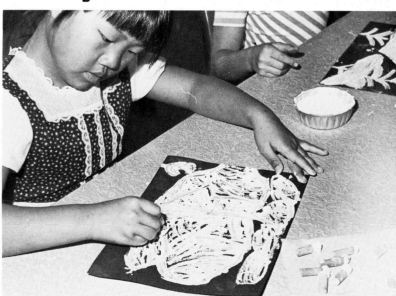

Colored chalk dipped in white tempera makes dramatically toned marks on black paper.

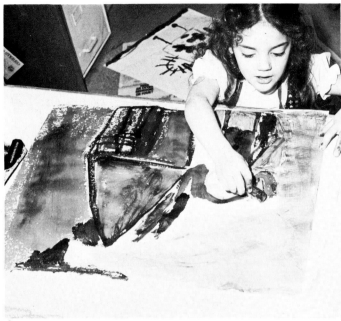

A

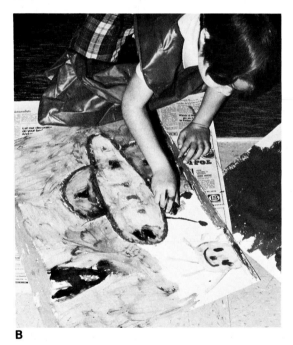

B

A. Kindergarten girl enjoys seeing vibrant tones of starch-dipped chalk on her house-figure picture.

B. Kindergarten boy uses bright yellow and warm orange tones for his butterfly-sun picture.

Introducing topics which call upon actual or imagined experiences can encourage language development as well as enliven the art lesson.

A live animal or a classmate dressed in a hat can ignite the imagination of children. A box of old clothes, a vest, hats, an umbrella or a cane, a cape or a cardboard crown are all props which can be stored in a closet and pulled out for use by student models. After experiencing painting or drawing lessons based on themes, children can better appreciate the various ways in which great artists depict subject matter such as kings, cowboys and clowns. In this way, there is a natural flow from actual art production to art heritage and the valuing of art.

One color plus black and white made for a limited palette and encouraged this Kindergarten child to mix colors in order to complete his tempera self-portrait.

Assignment Interpretations

A truly "successful" art lesson can be identified by the number of different interpretations of the assignment; every child should have his own unique set of mental images and experiences to bring to the activity, and this should be reflected in the diversity of the art work. Another criteria in establishing the value of a lesson in drawing or painting is how each child feels about his work of art and about himself as a creative person.

While enjoying the physical sensations of painting or drawing, a very young child may not make an effort to create an image that looks realistic. Even when children have started to develop pictures of objects in their environment, they do not necessarily draw things the way they look to adults, nor are the colors realistic or imitative. The art of young children has a distinct character and is dominated by the vision of the world as they feel it and understand it to be. Many adults who are not familiar with the art of young children will frequently ask "What is it?" This question implies that art must "look like" something and that the child has failed in some way. It's quite possible that the child was happily experimenting with lines or color. It's also possible that the picture reflects the child's perception of something important in his world. In either case, "What is it?" creates a barrier between the child/artist and the adult/critic.

Tearing, Cutting and Pasting 9

Why and How to Tear

For very young children, scissors can be frustrating, but they enjoy tearing paper. Torn paper activities can help develop visual motor perception, increase the ability to control finger muscles, and enlarge the child's awareness of shapes, sizes, and proportion.

Before starting art activities which require paper tearing, it might be a good idea for the children to simply practice tearing. After tearing strips and shapes, children who are experiencing some difficulty can continue the activity by tearing pieces of paper out of old magazines, paper scraps, or old phone books. Directions might include tearing the paper in half, tearing a strip from one edge, tearing a big shape, tearing a little shape out of the middle of the big shape, tearing tiny bits and skinny strips. Children can learn to control the torn edge by moving their fingers inch by inch as they tear. Encourage them to use the "pinching fingers" to tear; another technique is to place the forefinger on the paper and tear it by pulling it up and against the finger.

Torn Paper People

Art can be used to motivate and reinforce learning in other subject matter. For example, in studying the human body in science, very young children are able to understand that the body bends in certain places. Usually, these places have names like

"Two people in action" is the theme of this lesson which uses torn construction paper pieces.

"elbow," "waist," "wrist," "knee," "ankle." There are sixteen body parts and fifteen major places where the body bends. Discuss this with children and use student volunteers to point out the head, neck, chest, upper arm, lower arm, hands, hips, thighs, calves, feet. Have the children tear pieces of paper to represent the body parts; start with the head which is one of the hardest pieces to tear since it is oval-shaped. The piece that represents the head will determine the proportion of the other 15 rounded rectangles that make up the remainder of the human figure.

Once all the pieces have been torn, have the students arrange the pieces on another paper to show a person in action. You can mention various sports, games, work activities. Do not pass out paste until the children have arranged the pieces several times to show a lot of action. Allow the students to paste the pieces down and add some details with pencils or crayons. Older children will be able to add a second person in another color of paper. The torn paper people can be made in different sizes and placed higher or lower on the paper or so that they overlap in order to show perspective.

As a follow-up activity, ask the children what the person or people are saying while they are participating in the activity. For older children, this extension of the art lesson can go into creative writing activities or the introduction to dialogue and quotation marks.

Cutting Paper

Learning to control scissors may need some practice for children who are experiencing difficulties. Ask the child to blow a puff of air and pretend that he is cutting the air into little pieces. Cutting clay or small foam pieces also offers exercise in cutting skills. Provide old magazines and sales catalogs and have children cut out favorite things—foods, clothes, animals. Draw spirals on very thin paper plates so that when children cut on the line, they will end up with a coil. When colored and patterned, this can make an interesting mobile. Children who have mastered cutting skills can be introduced to simple paper sculpture techniques such as fringing, scoring and curling paper.

A and B. Body parts of figures were assembled in action position, pasted down, and then dressed in colored paper clothing.

A

B

A

B

A. Very young children can begin to learn scissors skills if they are provided with a good pair that readily cuts both paper and fabric.

B. Cutting and taping colored paper into sculptural forms involves skills in forming, joining, and relating three-dimensional shapes.

Cutting Skills

Children who develop cutting and pasting skills early in their lives will create more exciting and perceptive art objects. The teacher should provide the children with good quality scissors in order to prevent initial cutting experiences from being frustrating and failure-oriented. A lack of good scissors and appropriate materials will impede the development of the child's aesthetic growth, and later, when he reaches the symbol stage and is eager to depict the human figure, animals, plants, buildings, and such, his lack of cutting and pasting experiences will have stunted his development of the proper skills. He will tend to be handicapped in his ability to communicate visual images in cut paper.

The teacher should be knowledgeable and specific as to what goals and behaviors are to be achieved in cutting and pasting with paper and fabric. Preschool and kindergarten children should have time, space, and supplies available daily for them to cut and paste. They should know not to run with scissors in their hands and to walk with them holding the tips down.

Children who are still scribbling probably will not cut recognizable objects; rather, they will be content to experiment and cut for the sake of cutting. This is good practice and should be encouraged.

Pasting Skills

The teacher should stress the importance of not using too much paste. Many times, paste is applied in globs, and the result is a piece of art work that is lumpy and unsightly. Encourage students to apply paste evenly to the backs of paper with their fingers; the paste should be a thin, shiny coat that covers the entire surface, not just one spot in the middle. Use old magazines or phone books for paste-applying surfaces. When a clean surface is needed, all the child needs to do is turn a page. A damp sponge nearby to wipe sticky fingers eliminates some of the frustration of handling small pieces of paper.

An alternative to paste is to mix equal parts of white glue and liquid starch and to brush the mixture on the reverse side of the piece of paper to be attached.

When the children begin to cut realistic symbols, the teacher can then introduce more advanced skills—how to add details and smaller parts on top of other things; how to fold the paper over and cut out an interior hole or shape; how to make multiple images by cutting two or three papers at one time; how to make a symmetrical shape by folding and cutting the open edges.

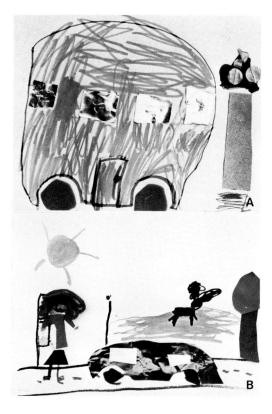

A and B. The children may choose to cut out only some parts of a touch picture. They complete the picture with felt pens or crayons.

C. All the parts of a touch picture can be cut from textured materials. Children enjoy closing their eyes when they examine each other's pictures.

Children should be encouraged to cut freely into paper, avoiding drawing the shapes with pencil ahead of time, as this makes for tiny, cramped details that are difficult to cut out. The teacher should discuss the kinds of shapes the children are cutting, referring to them as straight, curved, thin, jagged, or smooth. Children should be given the opportunity to use shiny paper, dull paper, textured paper, as well as fabric and felt.

When children have developed sufficient skills with scissors and paste, they should be given motivational topics for picture-making. They will enjoy combining their efforts to make cut-paper murals, with each child making several figures, flowers, bugs, and buildings, then assembling them with pins on the background until a final arrangement is decided upon. Making stand-up figures from oak tag for dioramas is a skill-building task for young children, as is also decorating boxes and wood constructions with cut-paper decorations.

Collage Pictures

"Hands off" and "Do not touch" are frequently heard admonitions that run counter to the natural human inclination to explore the world around us through our sense of touch. Smoothly polished wood, shining brass, bumpy fabric, soft fur, gritty sand—all invite the hands to feel, to sense differences, and to enjoy a multitude of aesthetic qualities. Children need to develop their capacity to differentiate between textures and to enjoy the sensory experiences of associating different textures and surfaces with different objects.

When children draw, paint, model, and cut out pictures, they are usually more involved with shapes, colors, and lines than they are with texture. In the art task of making touch pictures, the young child is called upon to think primarily of his world in terms of its physical "feel" or surface quality.

The children should all have the opportunity to handle and compare a number of materials and to talk about whether they are soft, rough, smooth, spongy, shiny, slick, furry, and so on. They begin to think of things that the materials remind them of, and then they are ready to make a touch picture.

Collage scarecrows made of fabric scraps were adhered to background by third grade student before adding environment with oil pastels.

Children who begin cutting and pasting from their earliest school days and who continue to have frequent opportunities to practice will arrive at third grade with highly developed skills as demonstrated by these renditions of "Trains."

Velour-surfaced paper may suggest kittens to children. Sheet sponge may suggest undersea plants; shiny foil paper, the flashing colored fish. Sandpaper and felt could be an Indian tent, a tree trunk, or ground. Yarn and fabric may become clothing or hair. Corduroy could be the walls of a house; leather scraps could be a horse or cow.

Before a child pastes down the parts of his picture he should be encouraged to try moving the various parts around and possibly discover a more pleasing arrangement; or perhaps to repeat some shapes to give his picture more unity and to add other textures to enrich the overall quality of the concept he is trying to convey.

Zigzag Books

The pages of a zigzag book flow in a continuous progression from front to back and serve to tell a sequential story; or they become a focus for a cluster of connected concepts. The children should choose a topic and make up their story line together, with each child cutting out one picture for the series of episodes that are needed to tell the tale.

The book which the children are holding in the photograph below tells the story of "Silly Dilly the Clown," who had a dog named Billy. Each page of the book tells of one event in which Billy went searching at the circus for his lost master, asking first the balloon man, then the thin man, the popcorn seller, the bareback rider, and so on, if they had seen Silly Dilly. The dog, made of felt, "traveled" from page to page with the aid of the storyteller, creating the necessary suspense leading to a happy ending on the last page.

A blank zigzag book should be made of sturdy cardboard so that it may be folded and unfolded a number of times, as the children will enjoy looking at the pictures over and over and giving a visual and oral presentation to another class. Mat board should be cut in pieces about eight-by-ten or nine-by-twelve inches for the pages. These pieces

A. Zigzag books are sturdy receptacles for composite group ideas. They promote sequential thinking about events, or they may unify many concepts having to do with a single theme.

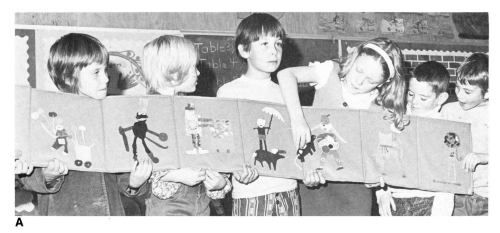

A

B. Six-year-old children thought about what their life ambitions were and how they would look as adults, and then made a zigzag book called "When We Grow Up."

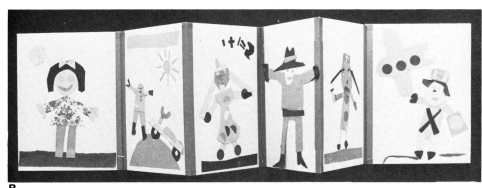

B

should be fastened at the sides with masking tape or plastic tape on both front and back so that the pages will fold up in an accordion-like manner from either end.

After the children have decided on a title and a story, each child chooses an episode that he would like to depict. Fabric, felt, yarn, and various kinds of colored and textured paper may be cut and combined for individual pictures. If each child arranges his cutouts on a piece of background paper the same size and shape as the pages in the book, he will find that they fit the dimensions of the page when he transfers the pieces to the book.

After arranging his pictures he may use paste or glue to fasten down the cutout pieces. Several children should cut out letters to spell out the title.

Oral communication and creative writing skills may be integrated with the art task of making a zigzag book. The children will be proud of their individual contributions and enjoy taking turns telling and retelling the stories and looking at the illustrations.

Topics of a type that would suggest story lines for making zigzag books include the following:

The street where Tom lives	A book about birds
Things that are round	An airplane named Harry
The crocodile who couldn't find his dinner	The adventures of a unicorn
	Favorite nursery rhymes
Rainbows and colors	Dinosaurs and long ago
Rockets and space people	Textures to touch
Our families	

Corrugated Paper Crowns

The very young child can be a king or queen for a number of days when he proudly wears a brightly colored and gaily ornamented crown of his own making.

Corrugated paper serves as a sturdy base for these headpieces, and upon them the children may glue, tape, and staple all sorts of decorative materials. This paper comes in rolls in a variety of colors and is available from office and school supply houses. A strip about twenty-one inches long may be stapled to a longer piece of colored paper of the same length and then overlapped at the back and stapled to fit the individual child's head. This added piece of construction paper elevates the height of the crown, giving the child more space to decorate. The child may cut the top of his crown in points, curves, fringe, or in whatever manner he may choose.

With a rich supply of such things as discarded gift-wrap ribbons, colored paper and yarn, the children are ready to begin using scissors, glue, tape, and staplers. The child can create projecting decorations by adding feathers, soda straws, and pipe cleaners, and he can make moving parts with fringed paper and crepe-paper streamers. Foil paper, gold and silver stars, and alphabet stick-ons will add sparkle and shine. Folding colored paper and cutting several shapes at the same time will encourage the child to make a repeated motif. Buttons and beads with one side flat enough to hold a bit of glue will add interesting design accents. A pile of egg carton bumps may be painted with tempera and glued on for fake diamonds, emeralds, and rubies.

When they have finished, the new kings and queens may parade in a grand procession or rule their kingdoms seated on thrones. They may happily act out stories and imagine themselves in their new roles as grand monarchs.

A

B

A. These preschool children are developing their cutting and gluing skills when they add both two- and three-dimensional decorations to their crowns.

B. Young children love to wear headpieces, and when they can make bright crowns all by themselves, they treasure them highly and wear them for all sorts of pretend play.

Pass-it-on Pictures

Gamelike in approach, pass-it-on pictures require the child to be adaptable and quick in his thinking with respect to cutting out images freely from colored paper.

Each child should have a piece of white or black construction paper, about nine-by-twelve inches in size, and an assortment of colored paper and glue or gummed colored paper. The class should be instructed in the rules of the game. Each child must cut out one shape from his collection of colored paper, glue it anywhere he chooses to the background, and at a given signal (two minutes is usually sufficient) pass it on to the youngster sitting next to him. At this signal he will also receive a paper from his neighbor. He must quickly decide what the shape reminds him of, and how he can add to it to make the picture progress. This passing-on continues for about fifteen or so turns, with each child adding a part to each picture for a composite finished arrangement.

The children are quick to find humor and suspense in observing what happens to the picture that each of them started and seeing how their friends changed and enriched it as the game progressed. They will want to play it several times and will find that practice increases their skill and ability to see novel configurations in shapes. They should make titles for the finished pictures and let their imagination dictate directions for unexpected and whimsical results.

Crayon Rubbings

In recent years a number of people have enjoyed making brass rubbings on tombs in England and India, and for years children have amused themselves watching magical pictures appear when they place a piece of paper over a coin and rub it with a pencil. Crayon rubbings are made in somewhat the same manner—only an original cut-out design or picture is made by the child himself prior to making the rubbing.

Basic materials that are necessary are several sheets of typing paper, scissors, masking tape, and a black wax crayon, preferably thick and with the paper removed. Tag board, index cards, or manila folders—all slightly stiff and heavier than typing paper—are best to use for the cut shapes. The teacher should demonstrate the overall process so that the child understands that the rubbing and not the actual cut picture is the finished product. First the child cuts out the shapes for his picture or design, using simple shapes that overlap for the different parts. He may choose to make his own portrait with one large oval shape for the face and then cut the features separately and paste them in place. Or he may make an animal, bird, fish, car, airplane, or any other object, cutting all the parts separately; i.e., the body of the dog is cut out and the legs, neck, tail and head are cut and placed in proper positions. Paste should be used very sparingly, applying a tiny dot in a strategic position and smearing it thinly as paste blobs are highly visible on the finished rubbing. Two or three layers of cut shapes are maximum. An interesting result can be obtained by making short snips in a shape and then folding them over to create perhaps the tailfeathers of a bird or fish. Stripes may be placed on a tiger and polka dots on a clown. Children will enjoy using a hole punch for a few accents and details.

When the child has finished his cut-out picture, a piece of typing paper should be placed on top of it, making a 'sandwich' of: the bottom sheet, the cut-out work, and the top sheet. Masking tape should be used to hold the corners in place and avoid any

A and B. Pipe-smoking funny man and a motor boat grew piece by piece as children each added to the arrangements.

A B

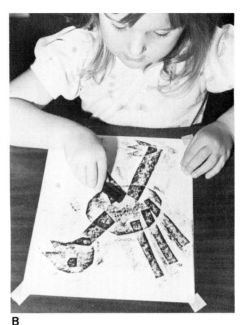

A. Cut paper shapes are arranged on paper background as preparation for crayon rubbing.

B. A piece of typing paper is placed on top and corners taped to prevent sliding. Flat side of black crayon is rubbed over surface to bring out the impression of paper shapes beneath.

A **B**

slipping. A thick folded section of newspaper should serve as a pad for the 'sandwich'. A much better result is obtained if the rubbing is done on this pad rather than on the hard surface of the desk or table.

Then using the black crayon on its side, the child should stand up while making the rubbing. He/she should rub very softly at first, making short strokes on the surface of the paper until he/she 'finds' his cut picture. When the edges are ascertained, he/she should begin rubbing harder and harder in the same short strokes rather than rubbing back and forth, emphasizing the edges and making the images stand out in contrast with the background.

Sometimes it is interesting to make the first rubbing of a horse or whatever object has been made, lift the top paper, move it over an inch or so, and make another rubbing overlapping the first one. The second rubbing should probably be made lighter than the first one and will appear to be behind it. The image may be repeated several times to create a "school of fish, flock of birds, fleet of ships, herd of cows, etc."

The class may work together on a group project to create a mural on a long piece of butcher paper. Each child cuts and assembles a house for 'Houses on our street.' Other topics could be: 'Circus time, Our pets, Our trip to the zoo, Sea full of fish and mermaids, Our faces, Cars and trucks, etc.

Tissue Paper Collages

Making collages with colored tissue paper provides young children with a good opportunity to improve their skills in cutting freely and boldly with their scissors. The many bright colors of tissue paper with the wide range of tints and shades of one color are visually stimulating.

Instruction should begin with the children having six small pieces of tissue for practicing specific cuts. The first challenge should be to take a piece of paper and try making all large curving cuts. The second piece of paper should be used to make all straight and jagged cuts. The third piece of tissue should be folded in half and the child told to cut out a large shape from it, thereby discovering that he has made two of the same shape from it. The next cut requires the child to fold a piece of paper in half, keeping the folded edge in his left hand and making a shape by starting his cut at the bottom and exiting his cut at the top. When he unfolds the paper, he will have made

Brush is used with liquid starch
to adhere colored tissue to
white paper. Black lines may be
added to collage before or after
for details.

a symmetrical cut. A fifth piece of paper should be folded in half and then in fourths and four shapes made all at once. These multiple cuts are useful later for making such things as wheels for a train, petals on flowers, or windows for a castle. The last piece of paper should be used to try tearing a shape. This is best accomplished by holding the finger tips close together and remembering to 'pinch and tear'.

After the children gain confidence in freely cutting, they are ready to start making a collage. They should look through their practice cuts and see what images might emerge from the scraps. They may suddenly discover an alligator's head, part of a rocket, or an elephant's trunk and then be eager to complete the picture with some more cut shapes.

A small amount of liquid starch should be poured into a jar lid or other small container. The child then dips a small clean brush into the starch and applies a small amount of it onto a piece of white drawing paper. He/she then places a piece of tissue on the starch-brushed area and brushes a little more starch on top of it. Most of the colors of tissue paper do not 'bleed' with liquid starch, but if they do, a minimal amount of brushing will reduce this effect. More pieces of paper are applied to the collage, overlapping shapes to achieve differences in light and dark and interesting patterns. The entire background may be quickly covered by cutting or tearing a number of small pieces of tissue and using them to fill in around the objects in the collage in a mosaic-like manner. If the brush is wet with starch, it can be used to pick up each small piece and position it on the paper. Wrinkles in the tissue paper enhance the collage effect and provide textural interest.

When the collage is dry, the child may want to add some details with a black pen. Collages may be ironed when they are dry to flatten the paper before it is mounted.

A variation of collage-making is made possible by having the child draw the picture first with a few strong black crayon lines and then covering the paper with pieces of tissue in the approximate shapes that were made with the crayon. No attempt should be made to cut the tissue shapes of the house of the lion's body, or whatever it is the child has made exactly the same as the crayon drawing. It is the essence of collage making to have a cut and torn paper appearance along with the visually delightful overlapping of shapes.

Cut-paper Assembled Murals

Mural making with cut paper using an assembled technique is highly appropriate for early childhood. Large pieces of colored banner paper should serve as background materials. This paper comes in rolls in a number of brilliant colors. It may be cut to assemble the background areas, or it may be torn. For instance, the ground area will be lowest and may have a torn edge along the top for a horizon faced against a contrasting color for the sky. The space set aside for the ocean might have torn edges where it meets the sand. The jagged mountain peaks could be cut and all the pieces of paper pasted together or attached on the backside with masking tape.

The background composition should be in keeping with the child's spatial concept development. That is, if children are beginning to draw on a base line in their own individual drawings, they will understand a mural background composed of a long piece of yellow paper with a strip of green paper attached to the bottom portion. The base line concept can be expanded to form a multiple base line arrangement, and several colors of the banner paper may be cut or torn to serve as layers for these base lines. Base lines can be curved or bent. If the subject matter theme calls for a street, river, or road, the mixed plane and elevation concept will be understood as a spatial arrangement. That is, the street, river, or road may be depicted as if one is looking down on it, while the houses, trees, cars and people may be perpendicular to it and seen as if viewed at eye-level. A small committee of children may help the teacher in preparing the background ahead of time, deciding which areas will be sky, which ground, where the lake, ocean, streets, and mountains will be, cutting and tearing the paper accordingly.

The background for the mural is then placed on a large table or on the floor so that as the children finish items they may place them on the mural and rearrange them until the final gluing-down occurs. Let's say the topic selected is "our Neighborhood." Children can name items that should be included, such as the grocery store, school, church, barber shop, fire station, motel, trailer park, apartment house, policeman, fire truck, radio station, trucks, cars, bicyclists, stop signs, park and play equipment, lamp post, airplane, sun, helicopter. Each child chooses which item he will make, and there should be a discussion of scale. Generally speaking, the average cut paper mural will require that the children make items about the size of their own hands. A very large building or elephant may be two-hands high, and a dog may be only as large as the palm of the child's hand.

The children each make their chosen item from cut paper, preparing all details and decorations with cut paper, with no details being made with pencil. They should have a choice of colors and kinds of paper. Usually the teacher will find it useful to cut a number of pieces of colored paper into small size pieces, say 6 x 9 inches and 4 x 5 inches or smaller, so that the children may conveniently make their selections. Scrap boxes of paper come in handy, too.

When the children finish, they bring their items to the prepared background and begin the assembly. The largest items are placed first, and effort is made to have a center of interest and then place the other items in eye-leading lines and unifying positions, with colors and shapes repeated to create a cohesive and related arrangement. Items may be moved and shifted and additional shapes made, until the class agrees on a final composition. Then the items should be adhered to the background with paste or glue. White glue may be diluted with starch, about equal parts of each, for a smooth flat finish. The use of too much glue or paste applied in untidy blobs makes for a messy finished mural.

Topics that are especially successful with cut paper murals are those that include a large number of people, animals, plants and objects. These include such themes as: the zoo, the circus, Noah's Ark, the farm, the Pied Piper, nursery rhymes, fairy tales, on the playground, at the seashore, dinosaurs and dragons, Paul Bunyan, the parade, etc.

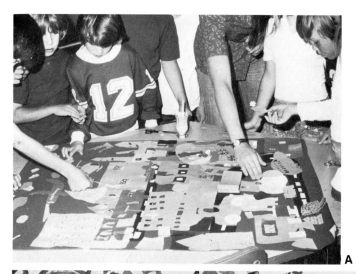

A. Fun in final assembly of cut paper mural is shared after children complete work on individual parts.

B. Assembled mural from Glendale, Ca., utilizes kindergarten class's ideas expressed with cut paper and tempera paint and is arranged on three baselines.

C. Bi-lingual mural from Glendale, Ca., kindergarten class is arranged on a curved baseline with thought given to design of surrounding areas.

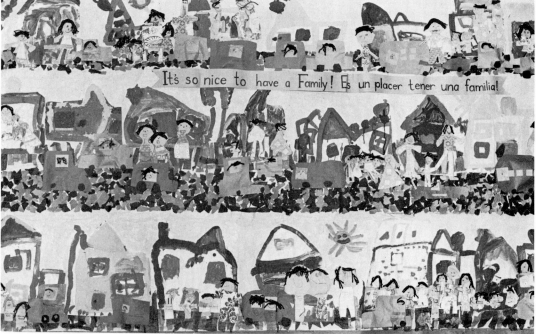

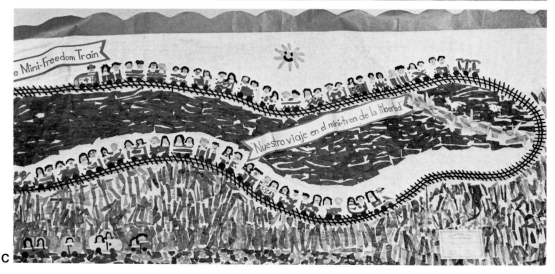

A set of rubber alphabet stamps offers opportunities to foster language development with the child's cut paper skills. A cut paper mural may be made and the rubber stamps used to print phrases about the objects featured. Words or sentences may be used.

Each member of a second grade class made a cut paper person, himself or his best friend doing what he did best, then fastened it to the mural background and applied two or three stamped words. "Pat jumps rope," "Sue rides horses," "Bob hits balls," "Jim runs," were some of the phrases that were stamped in a pleasing arrangement around the figures. The words became a part of the design, since they were combined to create an interesting arrangement.

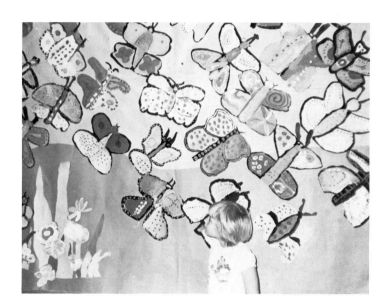

"Butterflies on the Wing" swoop upward together in this assembled mural created by first grade children. Each butterfly was painted with tempera, cut out, and adhered to the background in the area above the painted flower garden.

Printmaking 10

Relief Prints

Printmaking is filled with surprises and suspense. One is never quite sure what the finished product will look like until the magic moment when the block is pressed or stamped on the paper. Children are intrigued with the step-by-step process leading up to the moment when their prints are completed. Equally fascinating is the rhythmical element inherent in repeating a single design many times to make all-over patterns, as is sometimes done with gadget printing, potato printing and other small relief prints. A relief print is the result of applying ink or paint to a raised surface and pressing it onto paper.

Relief printmaking involves three steps before the product is completed. First comes the making of the relief image, whether it is cut on a potato, made from insulation tape, or pressed onto a meat tray. This block or plate is then inked with a brayer, pressed on a pad saturated with paint or ink, or brushed with paint, and then pressed onto a piece of paper.

Relief prints may be printed on all sorts of paper, white or colored. If printing ink is used, it is best to use paper other than construction paper due to its high absorbency. Colored ink or paint as well as black opens the door to a variety of printed effects. A white print on dark paper is quite different in appearance from a black or dark print on light paper. If oil base block printing ink is used, designs may be printed on cotton fabric.

A print may be made singly and mounted. A print may be repeated a number of times to create a patterned effect. Each child can make a print of an insect, car, or house, for instance from his own block and then all the children can print theirs as a group on a large piece of butcher paper to create a mural. Suitable topics for muralmaking themes include the following:

Insects and flowers in a garden
Cars and trucks on the highway
Groups of animals in a jungle, zoo, or farm
Mermaids and sea life
Astronauts and spaceships
Rows of houses and stores

Other group projects involving printmaking include printing calendar illustrations, making notepaper, greeting cards, and program covers. All-over patterns resulting from printmaking can be used for notebook covers, covering boxes and tin cans, bookbinding, wrapping paper, etc.

Throughout the year children should make all kinds of prints. Each time they will be intrigued with the surprise that awaits them in the viewing of the final product, and will discover that the design possibilities in printmaking are unlimited.

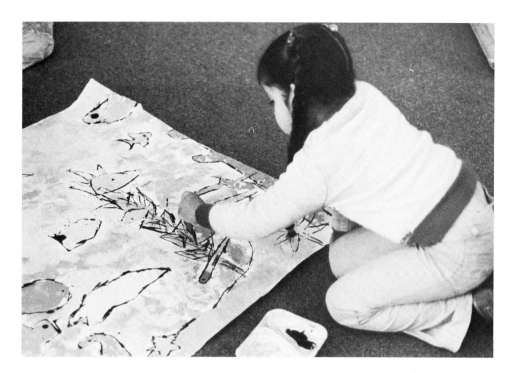

A student puts the finishing touches on a group mural. After studying fish, students cut fish shapes out of tagboard, painted them, and printed the fish on a large piece of butcher paper. "Sand" and "water" were printed with pieces of sponge tipped in tempera. Detail lines were added with pieces of cardboard whose edges were dipped in dark colored paint.

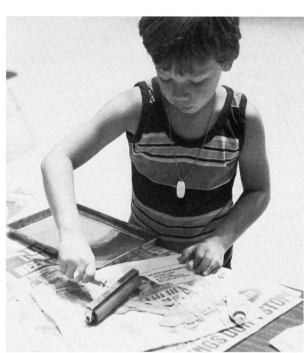

A brayer is used to roll ink evenly over the block or plate as the student prepares to pull a print.

Potato Prints

Several ways to begin exploring printmaking are available through the use of potato prints. An oval, oblong, or round shape is created when the potato is cut in half, and this shape can be used 'as is' by the youngest child. The cut half should be placed on paper toweling for a few minutes to absorb moisture. It is then pressed onto a paint-saturated pad before pressing it onto paper. To make a suitable pad, take about six layers of paper towels, moisten them with water, and place them in an aluminum pie

A

B

A and B. Oval shape of a potato print was impetus for these "Family Portrait" drawings, done with oil pastels. Final step was brushing thinned tempera wash on background.

tin or on a cookie sheet. Then pour about a teaspoon of liquid tempera on the center of the pad and use a brush to spread it evenly on an area about the size of the potato. Each time the child makes a print, he will need to press the potato onto the pad. More paint will need to be added occasionally. The child may either repeat the potato shape a number of times randomly, or in rows to make an orderly regular over-all pattern. When the paint is dry, he may use another color of paint and stamp some more shapes on top of the first ones.

Instead of using a paint-saturated stamp pad, the child may apply tempera to the cut surface of the potato with a brush. He will need to apply more paint with the brush each time he makes a print.

An alternative medium to use in making potato prints is water colors. A brush may be used to cover the surface of the potato before making the print. A few drops of water on each color in the water color tray will soften the pigments and make them easier to use. Since water colors are transparent, as opposed to the opaqueness of tempera, a lovely overlapping effect can be achieved by using several different colors of water colors and applying them after the first prints have dried for a few minutes.

Another way to use the basic shape of a potato print is to have the child print a number of potato shapes and after they dry, let their shapes suggest forms for him to use in drawing the rest of the picture; i.e., the shapes may be heads of people and only need to have the child draw their bodies with crayons. Or the shapes might be wheels on a car, centers for flowers, or the bodies of birds or insects.

After children have mastered the above printing process with potatoes, they can use a paper clip to carve out a design from the flat cut surface of the potato half. By making a few gouges, lines, and simple shapes, a pleasing image can result. Design possibilities are further extended by altering the basic oval or oblong shape of the potato by trimming the sides to create squares, triangles, rectangles, or other geometric shapes. A few gouges with the paper clip can transform the shape into a design motif or a realistic form such as a little house, boat, space ship, etc.

Felt Prints

Scraps of felt can be used also in creating the relief block for printing. Older children will want to plan their design first by making sketches. Younger children who are still having problems controlling their scissors can use precut felt shapes or scraps left from other projects.

The felt pieces are arranged and glued to a piece of cardboard. The design could also be made from pieces of inner tube although this material may not be readily available. Sturdy, sharp scissors are necessary for cutting either material.

Once the glued pieces have dried, ink can be rolled on the surface with a brayer, paper placed on top and the back rubbed gently with fingertips.

Clay Prints

Either plasticine or water-based clay can be used to make a print. A chunk of moist clay can be flattened on one side by hitting it against a flat desk top. A design can be carved out using a pencil point, plastic forks and knives, large nails or the edge of a piece of cardboard. The decorated side can either be painted or pressed into a paint pad (as described above) and then printed.

Insulation Tape Prints

Rolls of dense insulation tape with peel-off paper on its adhesive side is available at hardware stores. This product is about ¼″ thick and is easily cut with a scissors. Small design motifs can be created by adhering small cut pieces to a small block of wood or a piece of corrugated cardboard. The interest span of the very youngest child can be maintained since the entire process takes but a few minutes.

Office stamp pads should be liberally covered with stamp pad ink. By having one stamp pad in each color—black, red, blue, green, and purple, the child has a wider range of design possibilities. The child presses his block with the design on it onto the stamp pad and then onto his piece of paper. He can relate the process to the print his finger makes when he presses it on a stamp pad, and to the print his shoe makes in the snow, or the pattern a car tire leaves in the mud. By repeating his motif over and over, he begins to understand the meaning of the terms, 'repeat print, rhythm, and all-over pattern.' A very simple design made with only a few bits of tape takes on a new importance and assumes interesting relationships when it is repeated over and over again, very close together a number of times, especially if a second design on another block is used alternately with a second color of ink.

A. Child presses block onto well-inked office stamp pad each time before printing it on paper.

B. Flocks of birds, schools of fish, crowds of people, and herds of animals are achieved by each child printing his design a number of times on multi-colored paper background. Each child attaches pieces of insulation tape to piece of corrugated cardboard to make his design.

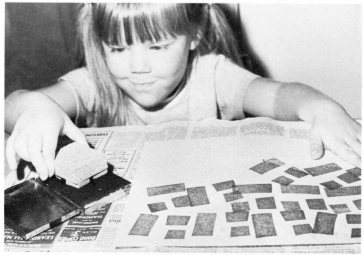

A

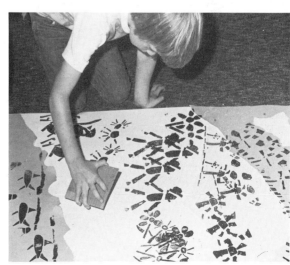

B

Meat Tray Prints

Making a print with a plastic meat tray is an easy task for young children, and they will want to repeat it a number of times, trying out new images and forms as their concepts expand.

Each child will need a clean tray of the kind that butchers use to pack meat. This tray should have the curved sides trimmed off on a paper cutter. Then the child draws his picture on it with a pencil, pressing down rather firmly to imprint deep grooves. It is simple to make a line drawing this way, but if the child wishes to make a solid shape, he will need to press down evenly in or even cut thru the tray and remove an area. All the lines and places that are pushed down or removed will show up as the color of the paper upon which the plate is printed. All the areas that are left standing will print the color of the ink that is used. Children should be encouraged to achieve a balance of light and dark areas.

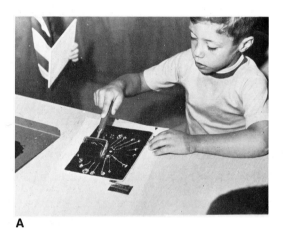

A

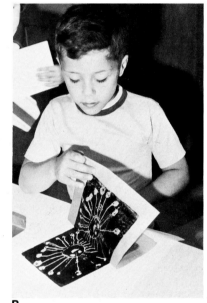

B

C

D

E

A. Kindergarten child rolls water-base ink on his meat tray with a brayer. Paper is carefully place on top of the tray and rubbed with the fingers to assure an even printing.

B. Paper is pulled off the meat tray, and the print appears.

C, D, and E. Since they are mostly linear, these prints have a strong appeal for the very young child. They offer avenues for the development of his conceptual symbols.

For variety, the children should be encouraged to be innovative with their pencils and create dots, close-together lines, and other textured motifs, as well as thin lines and wide, curved lines and straight, large shapes and small.

After the drawing has been completed on the tray, it is ready to be inked and printed. Black or colored water-base inks may be rolled with a brayer onto a baking sheet or a metal or plastic tray. Then the child should use the brayer to cover his meat tray design with ink. A piece of typing paper or colored Astrobrite paper cut a little larger than the meat tray should be placed carefully on top of it and gentle pressure applied with the fingers to assure an even printing. The paper is then pulled off, and the finished print is left to dry before being matted for display. Construction paper is too absorbent for use with printing ink.

Any number of prints may be made; however, the tray will need to be re-inked each time it is printed. Children will be interested in seeing the different effects they can create by changing the color of the ink as well as the color of the paper upon which their prints are made. To create an unusual effect, a piece of paper of another color may be cut and pasted onto the background paper before making the print. For instance, a strip of green paper could be pasted onto the lower portion of a print in which grass was important, or a circle of yellow could be placed in the area where the sun will appear in the print.

Carbon Paper Prints

Used or inexpensive carbon paper may be used for a print making experience for young children. They may cut out shapes from the carbon paper and make a simple picture. The print that results is black and silhouette-like. To begin, the child should cut out and arrange the different parts for his picture on top of a piece of typing paper, carbon side down. Shapes may overlap. The elephant, or whatever his subject matter happens to be, may be made in several pieces—the body, legs, head. Then another piece of paper is placed on top of the carbon paper and it is ironed. When the carbon paper is removed the shapes from the cut-out carbon paper will have transferred to the bottom paper.

A and B. Carbon paper is cut and placed, carbon side down, on a piece of plain paper. Second piece of paper is placed on top and quickly ironed to make carbon paper design transfer to bottom sheet. Carbon paper shapes are then lifted off and discarded.

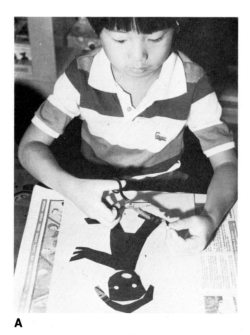

A

B

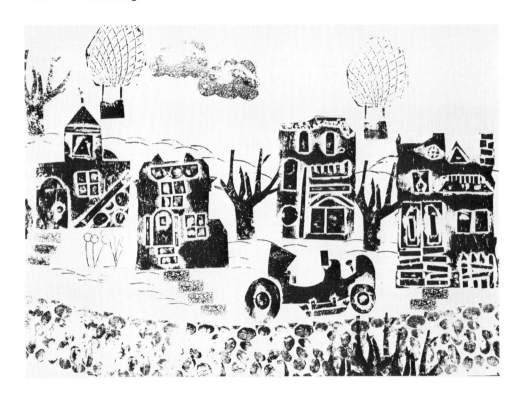

Each child made a house, tree, or car for this "card print" mural. Pieces are printed separately, several times, on a long piece of butcher paper. A piece of waxed paper covers the inked card to keep background and fingers clean while print is being pressed and carefully rubbed on its backside.

A

B

Card Prints

If young children have had enough experience in cutting paper, they will have developed the skills needed to put together a card print.

Using a five-by-eight-inch file card for the background and another file card, piece of tagboard, or discarded manila folder from which to cut his designs, each child prepares a picture from which a final print will be made.

Parts of an animal such as the ears, wings, legs, and such, may be cut separately and glued down on top of other pieces. The edges of the cutout shapes create a white outline on the finished print. When all the parts of the picture have been cut, the child may wish to rearrange them a bit, add other shapes, or alter some of them.

The printing ink is rolled onto the brayer from the inked tray or sheet, and the image is given a good coating of ink before printing it on white paper or colored Astrobright paper.

A. Cutting and designing skills as well as the know-how of printing are involved when young children make card prints.

B. Dark and light contrast sharply in card prints. The elephant and lion print was made by a five-year-old child.

Gadget Prints and Paper Shapes

As a starting point and focus for this art task, the children will need an assortment of circles, squares, rectangles, and long strips of colored paper. From these they may choose one or more to glue down to a piece of paper. When they have made their selection and chosen where they will place their shapes, they are ready to use gadget prints to complete their compositions.

Small blocks and sticks of wood, corks, erasers, jar lids, and edges of cardboard strips are easy-to-handle shapes which offer endless possibilities in design. Gently pressing them on the paper towel pad that is soaked with tempera each time before they are stamped makes a neat print on the child's paper. Children will be eager to repeat them and combine them in all sorts of configurations relative to the colored paper shapes.

A long strip of paper may suggest to one child a stem of a flower, or to another child a tree trunk; a rectangular piece might connote the shape of a car, airplane, wagon, torso of a person, or the body of an animal or bird. A circle might help them focus on a plant design, a lady bug, a wheel, a clown's head, a turtle, or a beaming sun face. Whatever the pre-cut geometric shapes suggest is then ready to be enhanced and embellished and made more complete with simple gadget prints.

Monoprints

When artists enter their original prints for a show, many times the rules indicate that they cannot enter a monoprint (a print that can only be made one time). Some people, therefore, do not consider a monoprint a "true" print. Actually, most monoprint techniques are closer to drawing or painting than printmaking, but the ability to pass pigment from one surface to another is a major element of printmaking, and in this respect, the monoprint qualifies.

Transfer Print

A simple monoprint can be made by painting a picture or design on a piece of paper and pressing another piece of paper on top while the paint is still wet. A design made in finger paints can be transferred by pressing another piece of paper on top of the wet original. Sometimes, the picture or design is made in finger paints which have been applied evenly to a cookie sheet. After using fists, fingers and palms to create a design so that the shiny surface of the pan shows through, the student lays a sheet of newsprint paper on the surface of the paint and smooths the back of the paper with clean palms. The design is transferred to the paper, and the finger paints can be smoothed out to make another design.

Carbon Paper

Another procedure for creating a monoprint requires carbon paper. After drawing a picture or design on paper with colored chalk, carbon paper is placed face down on the chalked surface. By rubbing a hand over the back of the carbon paper, the chalk will transfer to the dark shiny surface. Spraying with fixative or clear spray is necessary to keep the print from smearing.

Tempera Print

A similar technique can be used to make a tempera print. Once a chalk design or drawing has been completed (the chalk must be applied heavily), another piece of paper is coated evenly with white tempera paint. While the tempera is still wet, the chalk drawing is placed face down in the paint. The child rubs the back of the paper with fingers and hand and separates the two papers before they dry. Two pictures will result—the chalk will have merged with the paint on one paper and some will be left on the original drawing. Although two pictures are in existence, only one is a print. As in other printing processes, the design on the print is reversed or backwards from the original. For this reason, discourage children from using letters or numbers in their art work.

11 Modeling, Shaping, and Constructing

A Child's Three-Dimensional World

The child's world of living, moving, and playing is largely in space, that is, it is three-dimensional. Consequently, the task of modeling, shaping, and constructing visual images is a natural channel through which the child's concepts of form become richer, more detailed, and interrelated. If *only* painting and drawing activities are experienced, the child is constantly forced to contrive and translate roundness, depth, spatial relations, and texture into the limitations and confines of a flat plane. This is a complicated and advanced task. However, his representation of form and his conceptual knowledge of three-dimensional forms can more effectively be developed and dealt with by using three-dimensional materials. In working thus, the child uses both hands and, in a more real and true-to-life manner, clarifies and relates all that he knows and feels about natural forms.

All children, and especially those who do not as readily express their ideas with paint or crayons, can derive pleasure and valuable experiences from manipulation of three-dimensional materials. With an emphasis on inventive use of materials, the teacher may develop skills in making puppets, masks, animals, and sculpture. By alternating experiences between two and three dimensional materials, both are enriched and related concepts are made evident.

To construct means to combine materials in a three-dimensional way. The objects made may or may not be realistic, but the things structured should be joined together in such a way that they are stable and hold together. The pieces may stand on the floor or hang from the ceiling or on the wall. Young children can work with many construction materials and find them challenging and interesting. They can learn to tape and glue. Preschoolers and kindergartners can learn to pound nails and saw small pieces of wood. The children can discover for themselves that such familiar objects as newspapers, boxes, tape, paste, wood scraps, and paint can be manipulated and combined to create all manner of three-dimensional objects. They will need only a minimum of assistance in their work and will often enjoy collaborating in pairs so that one child may hold while the other child tapes or glues.

Young children need to review many times their three-dimensional concepts, as their perceptions and knowledge increase and unfold with repeated experiences. The ease and appeal of modeling and constructing activities will route their discoveries toward success-bound avenues.

When he manipulates a pliable modeling medium, he is able to make changes in his work rapidly, feel the roundness, the depth, the overall wholeness of a figure, head, or animal, and through this tactile intake he can refine, better understand, and communicate his knowledge of physical forms. His continually increasing knowledge of three-dimensional forms will interact with his two-dimensional drawing skills to prevent the rigid fixation of a stereotyped schema.

Preschool and kindergarten children will probably spend a good deal of time in manipulating any modeling material they are given. They will enjoy pounding, rolling, squeezing, making coils and balls, and imprinting objects into the material. They should not be pushed into making recognizable objects until they are ready to do so naturally. However, if they have many opportunities to play with the material, their growth will proceed rapidly, and representative symbols will begin to emerge.

When children are ready to make use of some techniques, the teacher may show them how to moisten two bits of the material to make them stick together; how to roll out and cut pieces with a dull knife; how to make textures and pinch out details.

First-graders and older children will enjoy the challenge of a specific motivation or topic after they have passed through the earlier experimental stage of manipulating a modeling material. They can work creatively within a given framework and will benefit from new areas of exploration and expanded ideas.

Students in a second-third grade combination class had a robot parade after constructing unique robots from objects found at home.

A. Ceramic animals and people from folk cultures demonstrate construction techniques of slab, coil, pinch pot, and texturing.

B. Replica of 4000-year-old Egyptian ceramic hippo gives children tactile experiences as well as visual in first step on road to aesthetic awareness.

A

B

Clay Construction

Two kinds of clay are commonly used in schools—the water-base kind that hardens and is usually fired in a kiln, and the oil-base variety that is reusable and never dries out. The oil-base type is called plasticine and is suitable for young children to use over and over again. The objects made with plasticine are generally tossed back into a container and are not kept by the children. However, the even consistency makes it a good material for manipulation, and it provides an opportunity for children to learn some basic skills in modeling and forming.

How to Roll

Very small children will spend some time pounding, pinching, mashing, and rolling the clay. The teacher should demonstrate how to roll a small ball of clay about the size of a lemon; this can be done in two ways: one by rolling a lump of clay between the palms and the other by rolling the clay between one palm and a table top. Large brown paper bags or pieces of canvas or denim make excellent reuseable work surfaces for clay. Newspapers should not be used since the oil from the ink can be worked into the surface of the clay.

How to Coil

Another introductory activity in manipulating clay is making a coil. Like the ball, it can be formed by rolling a lump of clay on a surface with the palm. Once the coil starts to lengthen, the palms of both hands can be used. Young children are often quite content to roll coils of clay for no particular purpose.

How to Slab

The third technique to learn is rolling clay out to make a slab. The brown paper sack or canvas is a good surface; doweling that is 1½ to 2 inches in diameter and cut into one-foot lengths can be used to roll the clay. Again, the flat of the hand is used to roll the doweling over the clay until it is the desired thickness.

Squeezing, pinching, manipulating clay—young children need frequent opportunities for coordinating muscular activities and perception.

Once a child can make a slab, it is easy to cut it into pieces to make wind chimes, to fold it over and press the edges to make a weed pot, or to square it off to make a tile. To add texture, the clay can be rolled between pieces of burlap, a weed or pieces of rice can be rolled into the surface, or texture can be added by stamping objects like wire whisks or forks into the clay while it is soft.

A

A, B, and C. Two pieces of clay are rolled into balls, flattened, and stamped with fired clay stamps. A weed or flower holder is formed when the two pieces are joined.

B

C

The Pinch Pot

Once a child has progressed to this stage of clay manipulation, the pinch pot is the next technique to be learned since it forms the basis of other techniques and activities.

The teacher may demonstrate by holding a rounded ball of clay in one hand and inserting the thumb of the other hand into the center. By pinching and rotating the ball, it will slowly become rounded and hollow like a small pot. Care will need to be taken to make the sides of an even thickness. The pinchpot can actually be left as a small pot or vase, or additional parts can be added such as a handle or little legs.

Once pieces of clay are joined, problems occur. Frequently, children merely press pieces together, and this results in the parts separating. Although many ceramics books recommend scoring and something called "slip" (a solution of water and clay about the consistency of very thick cream), this is not necessary. An old toothbrush dipped into water and rubbed on an area of the clay provides moisture and a roughened surface; when two surfaces are treated in this way and joined together firmly, the resulting juncture will keep the pieces together through handling and firing.

If two pinch pots are made and the edges roughened and joined, a hollow ball will be formed. In order to keep the round shape, a piece of crumpled newspaper can be placed inside before the two halves are put together. Newspaper, rice, dried weeds, anything combustible added to the clay, will end up as a few ashes after the firing.

A word of caution: be sure the child has inserted a pencil through the side of the hollow ball created by the two pinch pots. The air pressure inside the ball and outside the ball must be the same or the clay will explode in the kiln. A good "rule of thumb" to remember is that anything bigger in diameter than an adult thumb should be hollowed out (a pencil can be inserted into an extraordinarily thick coil, for example); anything hollowed out must have an escape path to allow for the free flow of air.

Pinch Pot Structures

A hollow ball created by the joining of two pinch pots can be made into a person, an animal, a monster or imaginary creature. Legs, beaks, tentacles, wings, horns, heads and other appendages can be added using the toothbrush technique. "Hair" can be

This second grade student is adding "fur" or "hair" that has been made with a garlic press. A toothbrush dipped in water roughens the surface so that the clay pieces can be securely attached.

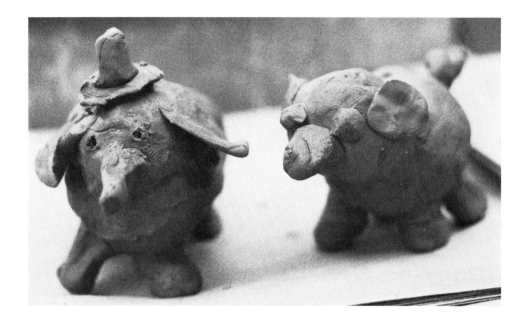

Two clay animals made from pinchpots by kindergarten students are ready to be fired. Holes have been poked into the hollow balls in order to let the steam escape and prevent the pieces from exploding in the kiln.

made by forcing clay pellets through a garlic press; texture can be added with a variety of tools such as old combs, forks, nails, scissors, patches of burlap or wire screening.

Clay construction can also be experienced by joining slabs, by winding coils into shapes, by adding coils to slabs or to pinch pots. The possibilities are limited only by the child's imagination and skills.

Drying and Firing the Clay

Clay pieces should be allowed to dry slowly. If the atmosphere is too hot and dry, they may crack. Plastic bags or milk cartons with one end removed can be placed over drying clay pieces to slow down the process. Dampened paper towels are sometimes needed in very dry conditions.

When clay pieces are dry, they are called greenware; in this state they are very fragile. Once the pieces have been fired in a kiln, they are referred to as bisque and are much more sturdy. After the bisque firing, a glaze can be applied. Glaze is a solution which looks drab; it is usually difficult to convince children that the glaze will turn into a bright interesting color once it is fired again. Sample disks which have been painted with glaze and fired are useful in demonstrating what colors are available. Once the glaze has been painted on, the bisqueware will need to be fired again. Alternate finishes which don't require a second firing include: staining with shoe polish or an antiquing stain (available from a ceramic supply store), painting the clay piece with acrylics, or leaving the natural color and spraying with a clear spray or polymer medium. Still another finishing technique requires applying a mixture of brown and black tempera which is later rinsed off, leaving dark stains in the lower indentations. Red clay can be especially attractive when its natural color is intensified by rubbing stains into the crevices and coating with a clear shiny liquid polymer or spray.

Recipes for Additional Media

Three additional types of media are suggested for modelling and construction activities. They all make satisfying finished projects. They are:

1. salt ceramic
2. baker's clay
3. food forms—candy clay, modeled cookies, bread, graham crackers, and fruit and vegetables

Glaze is being brushed on this bisque-fired animal. The bowls in the foreground have been glazed and fired to show the actual color of the glazes they each contain.

A. Bread-dough doll from Ecuador is delicately made with much colorful detailing added. Such examples are made with materials similar to those children use, and they are fascinated when they see work from a faraway land.

B. Clay figures by contemporary artists show much of the decoration and exaggerated forms that young children find easy to relate to and understand.

C. Clay wolf shows seven-year-old child's highly developed skill in handling the material. Teachers need to demonstrate techniques for making arms, legs, feet, and ears adhere.

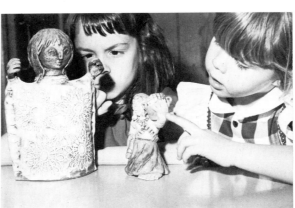

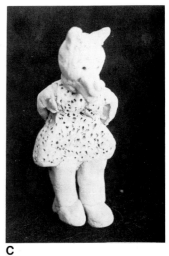

A **B** **C**

All are easy to use in the classroom and only require materials purhased from the grocery store.

Salt Ceramic

One batch makes a ball about the size of a large orange. Each child should have one batch for most projects. Food color (preferably the highly concentrated paste food

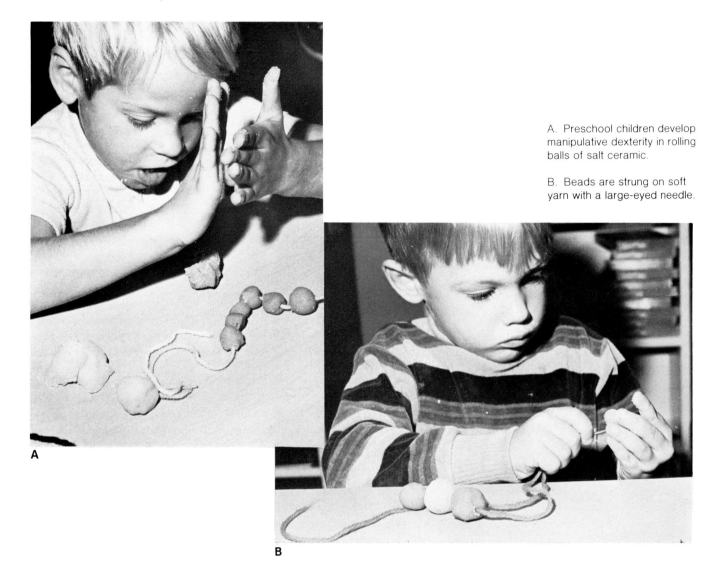

A. Preschool children develop manipulative dexterity in rolling balls of salt ceramic.

B. Beads are strung on soft yarn with a large-eyed needle.

A

B

colors) or liquid tempera may be mixed into the water, or the batch may be left white. Salt is much cheaper if it is purchased in five-pound boxes rather than in one-pound boxes.

 1 cup of salt
 ½ cup of cornstarch
 ¾ cup of water

Stir these three ingredients together in a pan and then cook the mixture over medium heat, stirring constantly with a wooden spoon until it thickens into a big blob. Remove from the heat and place the mixture on a piece of foil. When it cools a bit, knead it thoroughly. If it must be kept a short while before using, it should be kneaded again to make it soft and pliable. It dries to a rock hardness without being baked. Finished objects are inedible and may be brushed or sprayed with a clear glaze. Wire, cloves, feathers and such objects may be imbedded in salt ceramic while it is soft.

Baker's Clay

> 1 cup of salt
> 4 cups of flour
> 1½ cups of water
>
> Optional: ⅓ to ½ cup of liquid tempera

Mix these ingredients thoroughly by hand, adding a little more water if necessary. Knead about five minutes until dough is soft and pliable. Do not mix ahead of time as this clay loses its springiness and resiliency if stored. In addition, it often becomes too sticky to use. Items made with colored dough are best left to air dry. Items made from uncolored plain dough may be baked an hour or two on foil-covered baking sheets in a 300 degree oven till nicely browned and hard all the way through. Thick, large pieces will require a longer time than small flat objects. If a browner color is desired, increase the heat in the oven.

Beads and Pendants

Children begin very early to roll bits of any modeling material in the palms of their hands to make small balls. They also learn to coordinate hand and eye in stringing all sorts of beads. By combining these two manipulative skills, very young children can make their own necklaces.

You will need a number of blunt needles with large enough eyes to accommodate soft yarn. Given a length of this yarn about eighteen inches long, the child pinches off pieces of colored salt ceramic or baker's clay, rolls them in balls, and pushes the needle and yarn gently through the centers. Some children will be interested in the more advanced skill and challenge of alternating colors or sizes of beads—such as one red and then one yellow, or one large and then two small beads. Whatever planned or random combination is made, the necklaces are easy to make and attractive to wear; making them holds the attention of very young children for quite some time.

The finished strings of beads should be placed on foil and dried thoroughly for several days. They should be turned over gently to insure that they dry evenly on all sides. When completely hard, they are ready for the child to wear.

Young children will enjoy modeling salt ceramic or baker's clay to create handsome yarn-hung pendants, regardless of whether they themselves wear them or share them with friends.

To make a necklace, each child needs a length of thick yarn about thirty inches long with a two-inch strip of felt folded over in the center of the yarn. This felt forms the base upon which the child will later glue his pendant. Four or five batches of salt

A. Tabs of folded-over tape form the base for attaching modeled salt ceramic pendants.

B. Kindergarten children enjoyed creating these butterfly and flower pendants.

A

B

ceramic or baker's clay in strongly contrasting colors will be sufficient for an average class. If white salt ceramic or baker's clay is used, the pieces may be painted by using small brushes with watercolor or tempera when they are dry.

The child may roll coils, small balls, and make pinched and formed shapes to place upon the basic flat shape that he has pressed down on the felt tab. These small decorative bits of salt ceramic or baker's clay may need to be lightly moistened to make them stay in place. If they fall off in drying, they may be glued back in place later. A pencil and other small tools will be useful in creating small dots and pressed-in textures.

Such simple forms as flowers, bugs, butterflies, turtles, elephants, airplanes, and faces lend themselves well as motifs; or abstract designs may be created.

The pendants will dry hard in a few days. They should be turned frequently in order for them to dry thoroughly and evenly. A clear acrylic glaze gives added shine to the finished pieces.

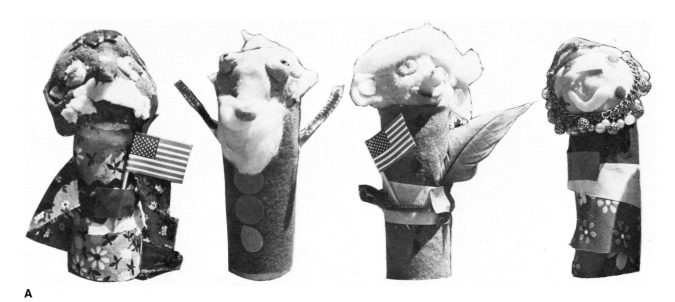

A

B C

A. Six-year-old children showed much originality and diversity of form when they made these salt-head figures. Colored salt ceramic made it possible for them to model contrastng facial features.

B and C. Young children enjoy the challenge of finding appropriate scraps of materials to use in adorning their figures after the salt heads are hardened. Glue and tape are suitable adhesives.

Salt Sculpture

A cardboard tube or an empty frozen juice can and a large lump of salt ceramic are the basic materials for these salt-head figures. In order to keep the figure from being top-heavy, the tube itself should be filled with salt ceramic and the head modeled right on top of it. Each child will need a large lump of salt ceramic and several small pieces of other colors for adding the facial features, unless he wishes to paint the head when it is dry.

If the children have used salt ceramic before, they will probably need only be reminded of the necessity for kneading it before they begin work and of how to moisten rolls and balls of the material to make them adhere as facial details. Toothpicks may be helpful in making added parts stick to the base. The teacher should point out that exaggerated or oversized features project well from a distance.

After several days the salt heads and the salt ceramic inside the tubes will be dry, and the figures are ready to be finished. By using glue to attach yarn, rope or cotton for hair and beards, and felt, colored paper, and fabric for garments, and pipe cleaners or sheet sponge for arms, and braid, feathers, and other scrap materials, the salt-head figures may be completed.

Children should be encouraged to make a definite character, perhaps one from a favorite story, or from a television show. It may be real or make-believe, human or animal. Figures may also be used in dioramas.

Baker's Clay Murals and Other Projects

Baker's clay murals provide for a rich experience and an aesthetic product in the early childhood classroom. These murals are considered a group project, with each child in the class contributing at least one item to the composition. Many topics are suitable for these large panels or murals. Any theme is appropriate in which there are a number of items for the children to form and shape individually and then assemble on the prepared background. The photograph shows large murals made by early childhood classes in Glendale, Ca. The kindergarteners modeled themselves, and the small schemas—each about the height of a child's hand—were arranged on a multiple base line background. First graders used the theme of "The Park Across the Street." Second graders made "Our Neighborhood," and the third graders depicted "Our Trip to the Beach."

To prepare for a baker's clay mural project, you need to obtain a ¾ or ⅝ inch thick piece of particle board or plywood. This should then be covered with chicken wire and some thin flat boards painted and nailed on the sides for the frame. Finished murals are heavy; two sturdy screw eyes and a wire across the back will enable the panel to be hung later. Baker's clay should be mixed in the desired colors for the background, yellow, for instance, for the ground area and turquoise for the sky. If a river, street, lake or mountains are to be included they should be arranged at this time. The background clay should be slightly softer than the clay that will be used for modeling, to enable you to roll it out with ease. To begin forming the background, break off small amounts of the clay and 'knuckle' it onto the board. When a large area is covered, it should be rolled smooth with a rolling pin. A general rule to remember is that one full batch of dough generally covers about one square foot of background. It should be rolled to a thickness of about ½ inch—enough to cover the chicken wire. If the dough on the background is too thin, too many cracks will form as it dries. After the background is finished, the board should be covered with a large sheet of plastic (from the dry cleaner's, or a large garbage bag) to keep the mural from becoming too dry before all the children's creations are put in place.

Usually the clay to be used by the children for forming the items for the mural may be mixed in half batches to avoid wasteful leftovers. It is important to put plenty of liquid tempera into the water when you mix the dough so the colors will be bright and intense in the finished piece.

After a general discussion as to what the theme of the mural is, what objects are to be made and what sizes they should be, the children may select what they wish to make. A detail on page 167d was made by more than 1000 boys and girls for the Department of Motor Vehicles building in Sacramento, Ca. Each of the twelve panels was ten feet high and two feet wide. The general theme was "Highways and Byways of Sacramento," with each panel focusing on a scene such as Sutter's Fort, Lake Folsom, Airports, Agriculture, State Fair, Gold Discovery Days, or Fairy Tale Town. As each panel developed, the children came up with fresh, innovative ideas for additional items, until at the end of each day the panel glowed with spontaneous bursts of people, cars, buildings, hawks, sun bathers, fireworks, bikes, and blimps.

The children should choose small lumps of the baker's clay in as many colors as they will need from the supply table. They should work on a paper towel at their tables or desks. The finished form can be easily lifted from the paper towel and later put in place on the background. A dishpan full of tools for cutting, imprinting, and rolling the clay will be useful.

The children who finish first should keep their items on the paper towel and cover them with a sheet of plastic to prevent their drying out before they are placed on the background. It is best not to begin assembly until all the children have finished, in order to determine how many large objects there are, how many small, etc. Generally speaking, the largest items should be placed first, with thought given to making a pleasing and cohesive composition. Sometimes a street or path may be added to unify the objects. A garlic press with very small holes helps considerably at this point, since green clay of various shades may be pressed through and a toothpick used to cut off small clumps of 'grass.' This grass may then be placed under the feet of each figure or at the bases of houses. This tends to tie them all together in a unifying way, while at the same time keeping the objects from having a 'floating in air' appearance. A spray bottle filled with water should be used when assembly begins, with the background receiving a light spray of water before each item is placed on it. This serves as 'glue.'

When the mural is finished, it should be left to dry, preferably in a dry warm room. It may take several weeks for it to become thoroughly dry, and during this time the colors will appear to fade and look very flat and unattractive. However, when the mural is absolutely hard and dry any of several finishes may be applied, and the colors will recover their previous brilliance. The best finish to use is a brush-on resin. Envirotex or any of several brands on the market will suffice. This resin comes in a two-bottle package, the liquid in one of the bottles serving as a catalyst for the other. A small amount of each liquid, about one or two ounces, should be poured in equal amounts into a clean tuna can and stirred about a minute according to directions on the bottles. Then it should be quickly brushed on the mural. One coat is sufficient, not only to bring back the colors, but to give it a high gloss coat, glass-like in its appearance. Other finishes such as spray-on clear acrylics, clear varnish and lacquer will bring back the color, but they require a great number of coats to achieve sufficient shine or glaze.

Topics that work especially well for baker's clay murals are similar to those for cut paper murals—Nursery Rhymes, Fairy Tales, Aesop's Fables, Seasons, Birds and Butterflies, Our Town, The Zoo, Scarecrows and Farms, Factory We Visited, Boat Harbor, the Circus Parade, Flower Garden, and All about Us.

The children also enjoy making small individual panels, covering little pieces of thin plywood with the clay, then adding their own designs. Chickenwire is not needed for these small panels, but it is advisable to hammer in about four or five short nails to help hold the clay on as it dries.

Teachers find that spelling out a word or phrase with baker's clay adds a tactile quality and third dimension to their bulletin boards. The clay may be rolled out, the letters cut, and imprints or decorations added. Similarly, ropes or coils of clay may be made and the letters formed from twisted or braided pieces. Or small balls and cut out shapes may be pressed into the letters after they have been formed from thick ropes

of the clay. Colored dough is especially pleasing to use for baker's clay letters. A paper clip or a U-shaped piece of wire should be inserted in the tops of the letters so they may be hung later. Children enjoy forming the letters of their own names with baker's clay. The added sensory dimension of feeling the shape of an 'A' aids the child in learning to recognize letters and to write words.

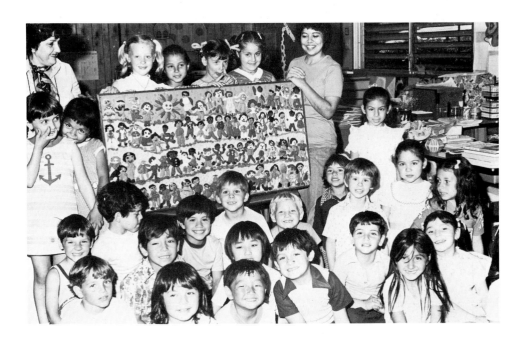

Kindergarten classes in Glendale, Ca., school modeled themselves and placed the schemas in a joined-hands position on four baselines for this large baker's clay mural.

A. Title on baker's clay mural can be made with balls and ropes of dough.

B. This baker's clay tool is pressed into rainbow on a mural to add star-like imprints for textural accents.

C. Green baker's clay was pushed through a garlic press and a toothpick used to implant 'grass' to mural background for a baseline effect.

D. 'Farm Life' is theme for this ten-foot tall baker's clay panel. Orchards, barns, scarecrows, farmers, fields, and trucks are arranged on a textured multi-colored background.

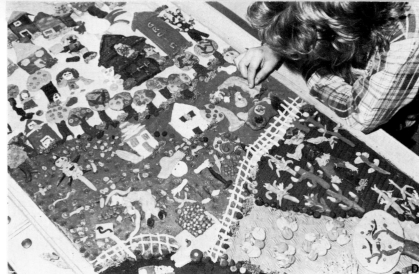

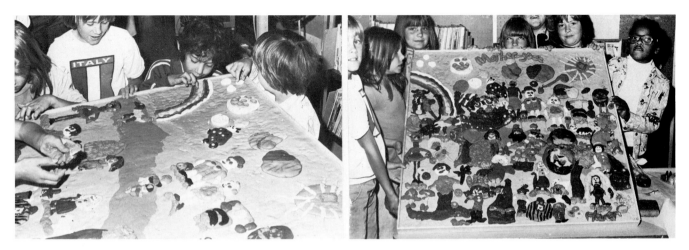

Assembly begins on baker's clay covered panel as children complete small animals, human figures, and other objects needed for theme. Complete panel is proudly displayed. Each child contributed one or more figures related to "Mother Goose."

Edible Art

Bread dough, candy clay, and cookie dough as modeling materials will probably find their happiest and most appropriate uses at holiday times and on special occasions when children need to have outlets to express creatively the gaiety of the season. (The section on Celebrations lists a number of exemplary topics which would be suitable for use in stimulating the children's thinking when they begin modeling with any of these three food forms.)

Cookies and Bread, the Baker's Art by Ilse Johnson and Nika S. Hazelton, is a magnificent pictorial collection of work done by both folk artists and contemporary artists from around the world. Children will enjoy looking through this book with the teacher to see what adult artists from many lands have done with a few basic ingredients, to embellish and enrich the human experience.

Whichever edible art form is made by the children—whether the modeling material is colored, light, dark, spiced, or plain—bread, candy and cookies are all delightful adjuncts to festive occasions and furnish the child inventive ways to say things about the world in which he lives—a very human part of which should be filled with fantasy, fact, and fun!

Bread Sculpture

Bread made from various grains and shaped in a variety of forms has long been a basic element in mankind's diet. Who knows what adult (or child) first thought of shaping decorative forms while kneading, squeezing, or playing with soft, pliable bread dough? Bread has often been a part of symbolic rituals, and many a baker with an artist's sense of three-dimensional form and design has used the unbaked dough to express aspects of the human spirit. A small child responds immediately when handed a small lump of soft bread dough. He senses its plasticity, and his hands respond to its tactile appeal.

It is debatable whether the Chinese or Egyptians were the first to make bread. Long long ago the Chinese knew about fermentation and steaming. It is believed that about 5,000 years ago a king's baker in Egypt made dough and forgot about it. The wild yeast cells settled on it and when the dough was baked, it rose high and light. By luck he saved part of the dough and used it to make more. Loaves of Egyptian bread baked thousands of years ago are now in museums. For many years people thought bread rose by magic until Louis Pasteur found in 1859 that yeast was a live plant. Scientists tell us that 400 tiny yeast cells can be placed on the head of a pin. The Romans had their apprentices wear gloves and gauze masks to prevent sweat and bad

breath from affecting the dough. They often baked bread in artistic shapes; if a poet was the guest of honor, the bread was baked in a shape of a lyre, while weddings called for bread shaped like joined rings.

Children can derive some understanding of one phase of Mexican culture by modeling bread-dough forms around Halloween time, since there exist parallels and common areas of both serious and humorous feelings at this time. Every year in Mexico, November 2 is celebrated as the Day of the Dead, and it is an occasion for the blending of the Christian All Souls' Day and a pre-Hispanic feast day. Many toys and different kinds of food are made in the shapes of skulls, skeletons, and masks and are sold in the markets. When families gather for a festive meal, they set up an altar with candles and flowers. A special bread called Pan de Muertos (Bread of the Dead) is offered, in the belief that the souls of dead people will return and enjoy eating it. The cemeteries at this time are gathering places for families and friends to meet and decorate the graves.

The children should also know a bit of the history and folklore behind some of the symbols we in the United States associate with Halloween because they relate, to some extent, to Mexico's Day of the Dead. They will be interested in learning that long ago the Celtic Druids celebrated, on October 31, a rite that was called the Festival of Samas (who was lord of death). At that time, the souls of all evil-doers who had been condemned to inhabit the bodies of animals were gathered together, the black cat being particularly prominent. Later, Christianity displaced this Festival with a Vigil of All Saints which came to be known as Halloween, or hallowed evening. Through the years people have held this to be a time when evil spirits come out into the open. Witchcraft and returning souls are given equal prominence. The ever-popular jack-o'-lantern is Irish and Scottish in origin. One legend tells that it was named after a man named Jack who was condemned to roam the earth with his lantern after he was barred from heaven for his stinginess and from hell for playing too many practical jokes on the devil. In the 1600s, the Irish peasants decided October 31 would be a good date to celebrate the good works of St. Columba, a missionary who converted Scotland. So they made the rounds seeking donations to buy meat for a feast, prosperity being assured for generous donors, and threats being made against stingy persons. Thus, trick-or-treating was born!

This type of historical and cultural information can serve as an introduction to bread sculpture near the Halloween season. Children may choose to model cats, skulls, bones, skeletons, mummies, jack-o'-lanterns, spiders, witches, broomsticks, pots of magic brew, ghosts, goblins, and bats from the soft dough. At other times of the year they might make funny faces, masks, suns, animals, birds, and people of various kinds.

Puppets that one can eat may also be made with bread dough. The form should be about the size of a child's hand, with all the features and decorations attached. A length of dowel stick, about twelve inches long is inserted in the finished puppet before it goes into the oven. The child may choose to make just the head or face of a puppet, and a show may be staged when the bread puppets have cooled—before the children gobble them up!

One batch of the following recipe will make one large bread sculpture about the size of a baking sheet, or it may be divided into four or five pieces for smaller sculptures. Children should make their pieces directly on a lightly sprayed or greased baking sheet, as trying to lift and move the forms after they are completed is difficult. The dough may be formed into sculpture by cutting, rolling coils, pinching, and squeezing. Bodies may be made in several separate parts and a tiny bit of water applied as 'glue' if the child has used so much flour that his pieces of dough won't stick together. Children will enjoy using almonds, pumpkin seeds, and sunflower seeds for eyes, noses, and other small decorative details. For a shiny golden glaze, beat an egg with two teaspoons of water and use a pastry brush to coat the modeled form before placing it in the 400 degree oven. A scissors may be used to make a number of little snips after the glaze

has been applied. This creates a texture that may be used for fish scales, sheep's wool, alligator skin, and similar surfaces. Poppy seeds and sesame seeds can be sprinkled over the egg glaze for accent areas.

The odor of fresh bread baking either in a classroom oven or one in the school kitchen is truly memorable!

Bread Recipe

 1 cup of water
 1 teaspoon of sugar or honey
 1 tablespoon or 1 package of dry yeast

Let these three ingredients stand in a bowl until the yeast softens—two or three minutes. Then add one cup of flour and stir vigorously with a large spoon. Beat until smooth and add one tablespoon of oil and one teaspoon of salt and one more cup of flour. For a dark dough to contrast with white dough, whole wheat flour, wheat germ or bran may be substituted for a portion of the white flour. Beating the batter thoroughly makes for a lighter and tastier loaf of bread. Pour the thick batter onto a floured board and add more flour slowly as you knead the dough, keeping a coating of flour on the dough. Fold the dough into a lump and push it firmly away from you with the heels of your hands. Knead for about five minutes, until it is smooth and elastic and no longer sticks to your hands. The kneading process is finished when the dough is smooth and satiny, and when a finger poked in the dough bounces back. Do not add too much flour to the dough or a stiff heavy dough will result. Let the dough rise for about 45 minutes in an oiled bowl. Cover the bowl with a clean towel and set it in a warm place. Then punch the dough down and work it into a smooth ball. Divide the dough into portions for use in various parts of the bread sculpture or for different children to use. When sculptures are completed, let them rise in a warm place for about 30 minutes. Then bake them for about 15 to 20 minutes in the lower third of a preheated 400 degree oven. Large forms may take longer. The bread should be golden brown and baked through. Let the sculpture cool on a rack.

Bread dough should be kneaded until it is smooth and elastic. It should bounce back when a finger is pressed into it.

A and B. Bread dough is soft, pliable, and fun to form into skeletons, bats, cats, owls, and witches at Halloween. Any holiday would be an appropriate time to let the children make their own interpretations of characteristic symbols in bread dough. It bakes quickly to a golden crust.

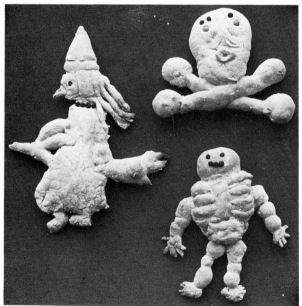

A

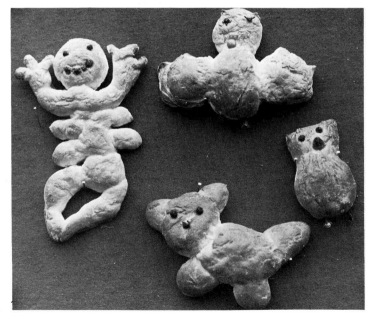

B

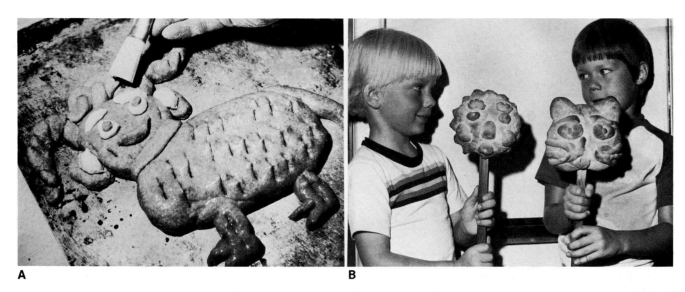

A **B**

A. Egg and water glaze is brushed over bread sculpture before baking to create a shiny glaze.

B. These youngsters can have their puppets and eat them too. Made of edible bread dough, the puppets are brushed with an egg glaze and baked on a wooden stick.

Graham Cracker Constructions

With a few tasty ingredients, the children can have an exciting experience constructing things with graham crackers. Basically, there are two kinds of structures they may make: first, there are two-dimensional items. These are made on a piece of waxed paper or on a cardboard that has been covered with contact paper or plastic wrap. A large sheet of corrugated cardboard can serve as a base for a semi-flat or bas-relief object. Second are three-dimensional objects. These require a piece of corrugated cardboard that has been covered with waxed paper or colored contact paper. An option is to cover the cardboard with colored paper, then protect it with a covering of clear plastic wrap.

Graham crackers may be gently sawed in smaller rectangles and triangles with a serrated knife. Vanilla wafers may also be cut in half-circles with this sort of knife. These shapes are then moved around until the bird, man, or dog or whatever form the child wants to make, is assembled. A life-saver or perhaps a gumdrop may be added for a mouth, eyes, etc. Frosting glue should be used to attach the separate pieces of crackers and vanilla wafers together.

Three-dimensional items are a little more difficult to make, and it is sometimes advisable to have two or three children work together. Such items as houses, trains, cars, and castles can be made in this manner. The easiest way to begin is to 'glue' two crackers together at a right angle, then attach them to the cardboard base with a little more frosting. In a few minutes the 'glue' will set and harden enough so that the other crackers may be added to the construction. If too many pieces are added too quickly, before the 'glue' has had time to set up, the entire construction may collapse. Assorted hard candies may be stuck on for decorations. Graham cracker constructions will keep well in a dry place. Fairy tale castles, boats, animals, trains and other such objects may be grouped together for a diorama.

Frosting Glue Recipe

3 egg whites
1 box of powdered sugar
⅓ teaspoon of salt
1 tablespoon of lemon juice

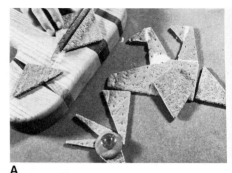 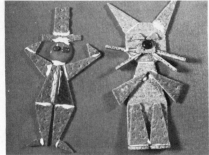 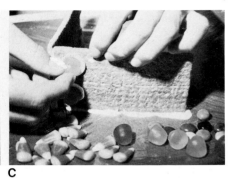

A B C

Lightly beat together the egg whites, four tablespoons of the powdered sugar, and salt with an electric mixer. As the mixture thickens, add the remainder of the powdered sugar, and then the lemon juice. Beat until it holds its shape and stands in stiff peaks. Food color may be added. Do not beat in a plastic bowl, and do not store in the re- frigerator. Mix only as needed.

A. Two-dimensional constructions are made by 'sawing' graham crackers with serrated knife and using frosting glue to attach pieces together on a flat surface.

B. Frosting glue holds together cut-up shapes of graham crackers to form these two edible characters.

Candy Clay

The happy art task of modeling and shaping with candy clay enriches the child's form concept, in that the nature of the material produces a result similar to that of drawing in three dimensions—the products will tend to be somewhat flat. It is inad- visable to try to make animals, people, or plants that stand upright. Paste food colors will dye the candy clay to bright and irresistible hues, and each child should have mar- ble-sized balls of several colors. The children should work with clean hands on freshly scoured desks on a piece of paper towel. Candy clay designs may be placed on a plain graham cracker or one that has been covered with buttercream frosting. Children will also enjoy decorating frosted cup cakes for special occasions. A large sheet cake pro- vides an area in which all the children may contribute. The approach to decorating such a cake with candy clay is that of making an assembled mural, with each child making one item about as tall as his finger, and placing it on the frosted cake. Themes for cake murals might be 'Mary, Mary, How Does Your Garden Grow?', Nursery rhymes, At the Circus, Butterfly Land, All of Us Standing in Rows, A Favorite Story, Silly Pets, Robots and Astronauts.

C. Beginning of graham crackers house stands upright on base and colorful candies are attached with frosting glue.

D. Frosted graham crackers are decorated with candy clay.

E. Colored candy clay can be modeled in any number of decorative shapes and placed on top of frosted cupcakes.

The recipe for candy clay may be mixed in the classroom by several of the stu- dents, or if very young children are using it, an adult or older child may mix it ahead of time and store it in plastic bags. Once mixed it is not sticky to the hands. A small amount goes a long way, and the final products are delicious!

Candy Clay Recipe

⅓ cup of butter or margarine
⅓ cup of light corn syrup
½ teaspoon of salt
1 teaspoon of vanilla
1 pound box of powdered sugar
Food coloring

Blend the first four ingredients and then mix in one pound of powdered sugar. Knead till smooth. Add more powdered sugar if necessary to make a nonsticky, pliable clay. Divide in small portions and mix in food colors.

D

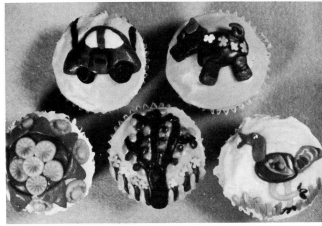

E

Buttercream Frosting Recipe

 1 box of powdered sugar
 ¼ teaspoon of salt
 ¼ cup of milk
 1 teaspoon of vanilla
 ⅓ cup of butter or margarine

Combine the ingredients and beat with an electric mixer until smooth and creamy. It should spread very smoothly to make a neat surface on which to decorate with the candy clay. If it is too stiff, beat in a few more spoonfuls of milk.

Modeled Cookies

The making of cookies is closely related, from the plasticity standpoint and in range of motivational topics, to what is applicable for use with candy clay. Candy clay is ready to be admired and/or eaten as soon as it is modeled, but the cookies require baking in an oven.

The cookies shown here were rolled, shaped, and decorated by the children on small pieces of waxed paper which later were carefully placed on baking sheets. By using both a dark and light dough, together with some light dough that had been colored with food dyes, the children were able to provide contrasting elements for their cookies. By having several garlic presses handy, they could squeeze dough through them for stringy hair, tails, manes, beards, and grass. Cake decors, colored sugar, or any sort of edible nonmelting decorations could be added by the child to the forms and symbols before baking.

Besides being eaten, cookies can be used for tree decorations, bulletin board displays, and gift-wrap ornaments. Cookies can be mounted on a felt or fabric-covered piece of cardboard and hung on the wall.

Dark Cooky Recipe

⅓ cup of shortening or margarine	2 teaspoons of soda
1 cup of packed light brown sugar	1 teaspoon of salt
1½ cups of light molasses	½ teaspoon of cinnamon
⅔ cup of water	¼ teaspoon of nutmeg
6 cups of sifted flour	¼ teaspoon of ginger

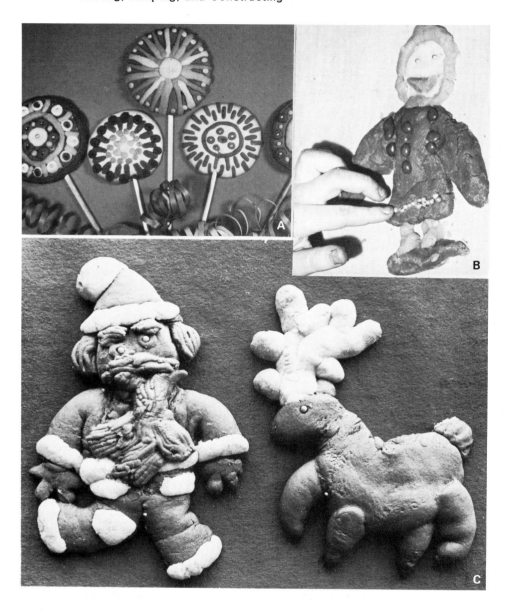

A. 'Lollipops' are made from dark cookie dough and light dough that has been tinted with food colors. Sticks are added before baking.

B. Colored cookie dough in the form of an angel has silver decors added before baking.

C. Dark and light cookie dough became a dancing Santa and an elegant reindeer. Beard, hair, and eyebrows were formed from threads of cookie dough that had been pushed through a garlic press.

Mix shortening or margarine, sugar, and molasses. Add water and stir. Mix flour, soda, salt, and spices and beat gradually into the wet mixture. Add a little more flour if necessary to make a pliable non-sticky dough. Refrigerate for at least an hour. Bake on waxed paper at 350 degrees for fifteen minutes or more, depending upon thickness and size of cookies.

Light Cooky Recipe

⅔ cup of margarine
¾ cup of white sugar
1 teaspoon of vanilla
1 egg

4 teaspoons of milk
2 cups of sifted flour
1½ teaspoons of baking powder
¼ teaspoon of salt

Cream margarine, sugar, and vanilla. Add egg. Beat until light and fluffy. Stir in milk. Sift together flour, baking powder, and salt and blend into creamed mixture. Chill one hour. Divide and knead in paste food colors. Bake on waxed paper at 350 degrees for ten to fifteen minutes, depending upon thickness and size of cookies. When cookies have cooled slightly, remove from the baking sheet and cool on wire racks.

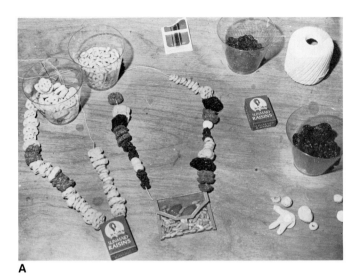

A

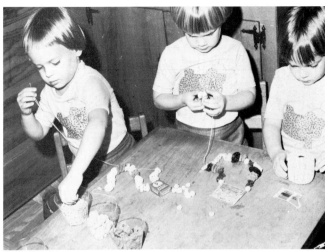

B

A. Beads for the edible necklaces are made with dried cereal and fruit and a special dough made of gelatin and powdered sugar. Pendants may be made of seed and nut-filled plastic envelopes, boxes of raisins, or they may be modeled with the colored bead dough.

B. Pre-schoolers prepare for nature walk by making wearable snack of dried fruit and cereal.

Edible Jewelry

Not only can very young children make their necklaces, but they can eat them too. Stringing the various items is good training in manipulative skills, and deciding the order for large/small, dark/light, and rough/smooth items calls for counting and decision-making as to the arrangement. A large-eyed needle with a sharp point and some light-weight crochet thread will be needed for each child. Then the collected food items should be placed in bowls for the children to make their selections. These may include: Cheerios, Cracklin' Bran, Apple Jacks, Honeycomb, (or any dry cereal that has a hole in the center), raisins, prunes, dried apricots or any dried fruit, beef jerky, and gum drops.

In the middle of the necklace, the child should place a pendant. This pendant may be a tiny box of raisins, or he may make a 'survival' pouch from a clear piece of vinyl purchased by the yard from variety stores. Colored masking tape is used to put this little envelope together and it is then filled with sunflower seeds, nuts, raisins, etc.

Fruit and Vegetable Assemblage

Materials needed for this nutritious art project may include such items as these plus any others that are in season or readily available: apples, oranges, potatoes, celery, carrots, lemons, lettuce, radishes, mushrooms, parsley, small squash, jicama, green beans, pumpkin seeds, nuts, lunch meat, cheese, grapes, cucumbers, pretzels, pickles, alfalfa sprouts, cloves, tiny marshmallows, etc. You will also need some toothpicks and waxed paper or paper towels for each child's desk or table area. The teacher should cut and slice the carrots, celery, or other items so that they are ready for the children to select from and use. Small hors d'ouevre or aspic cutters may be used to cut interesting shapes from slices of carrots, celery, turnips and the like.

A batch or two of Peanut Butter Clay will come in handy also, in that it can be used to help attach small items to other parts, along with the toothpicks.

Peanut Butter Clay Recipe

½ cup of peanut butter
½ cup of honey
1 cup of powdered milk
Knead until smooth

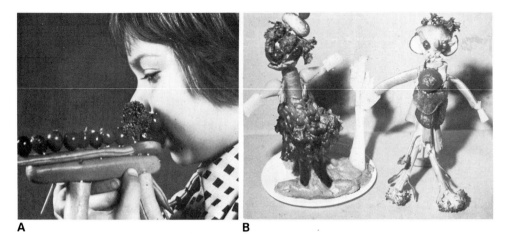

A

B

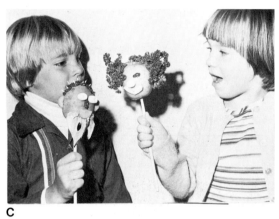

C

A. Olives, parsley, carrot slices, a wiener and green beans are put together with toothpicks in an animal-like form for vegetable assemblage treat.

B. Stand-up characters are made from fruit, vegetables, toothpicks and peanut butter clay.

C. Wooden chopsticks are inserted in potato, (left) and orange, (right) to hold edible puppets. Toothpicks are used to secure raisins, slices of carrots, tiny marshmallows, parsley hair and dried fruit.

Puppets: A puppet that can be eaten is fun for young children to make. The 'head' is selected from the assembled items—potato, apple, lemon, carrot, etc., and a wooden chopstick inserted inside it for the handle. Then toothpicks and Peanut Butter Clay may be used to adhere the features to the shape that was used for the head.

Other Edibles: Give each child a wooden meat skewer and let him select from the bowls of cut-up edibles and arrange the pieces on his skewer. The filled sticks are then placed into half a cabbage head for an attractive edible 'floral' arrangement.

Another assemblage project calls for each child to have a small paper plate for creating a special arrangement. Using lettuce of various sorts for a background, he may choose to make a face, perhaps with a halved pear serving as the foundation. Or he may want to make an attractive design of cheese cubes, halved grapes and pretzel rings. Another delectable edible is the 'stand-up construction.' Animals may be made with a carrot section body, toothpick and grape legs and a radish head. A racing car may be made from a zucchini with stuffed olive headlights and carrot slice wheels.

Whatever the assemblage, children can learn a great deal about delicious nutrition and even more about structure, good design and adhering separate parts . . . and at the same time have a tasty treat.

Wadded Paper Creatures

A stack of newspapers, a roll of masking tape, some corks, cut-up dowel sticks, cardboard tubes, and wheat paste are all that is needed to start young imaginations working. The lumpy bumpy creatures shown here were all brought into being by six-

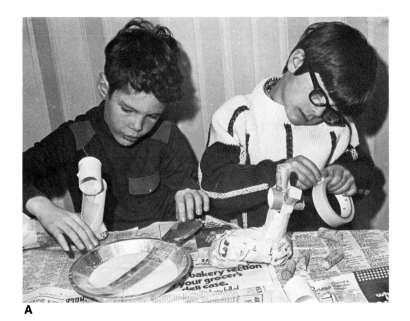

A

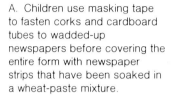

A. Children use masking tape to fasten corks and cardboard tubes to wadded-up newspapers before covering the entire form with newspaper strips that have been soaked in a wheat-paste mixture.

B. Contrasting colors are added for decoration when the base coat of paint is dry.

C. Q-tips dipped in paint are handy for children to use when making small dots.

D. Yarn, pipe cleaners, felt, feathers, and all sorts of scrap materials may be glued on the animal for final embellishment.

E. By cutting cardboard tubes in half lengthwise, a six-year-old girl fashioned tall ears for her wadded-up rabbit.

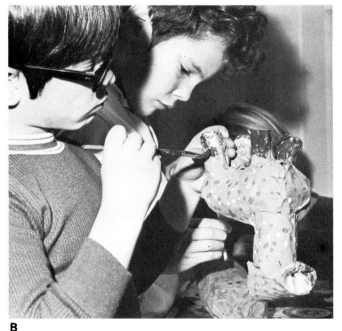

B

C

D

E

year-old children. The materials are common and inexpensive, and the process provides channels for a wide range of responses by each child.

To make a mammal, bird, fish, or reptile, a large sheet of newspaper is wadded up by the child into an oblong, round, or egg shape. A few strips of masking tape should then be used to hold the wad firmly together. Corks, a short piece of wood, and cut-up pieces of cardboard tubes are taped in place for legs, ears, tails, heads, and horns. After all the parts are secured with more masking tape, the whole form is covered with newspaper strips and then a final top layer of paper towel strips dipped in a wheat paste mixture.

Wheat paste should be mixed with water to a smooth, thick consistency. Several children can share a pie pan of paste while they are dipping short strips of newspaper in it. The strips may be cut quickly beforehand on the paper cutter (by the teacher) into approximately one-inch widths. The short strips should be thoroughly soaked and covered on both sides with the paste. Excess paste should then be wiped off before applying the strip to cover the animal. A number of strips will be needed to cover up the wadded form completely. The children should be encouraged to smooth out the strips with their fingers until the animal is neat and even on the surface. It is then left to dry thoroughly, usually for several days.

While the animal is drying, the children will enjoy thinking about how they are going to decorate their new friends—what colors of paint they will use and what things they may choose to glue onto them, such as cotton, wool, or feathers. Then, using tempera that is smooth and opaque, the children should paint their animals with a base color. After this coat is dry, they may add the features and decorative stripes, dots, and so on, with small stiff brushes and cotton-tipped swabs. They may glue on a rope tail, button or thumbtack eyes, a yarn mane or hair, felt or sponge ears. If a shiny glaze is desired, the entire creature may be coated with a clear acrylic spray when it is dry.

Boxy Constructions

Instead of using wadded-up newspapers as a base, small boxes and cardboard tubes may be combined and fastened together with masking tape. These adapt themselves well to forming cars, fire engines, streetcars, trains, trucks, planes, boats, space-

A few small boxes, cardboard containers, and tubes are stacked, combined, and taped together by the children to become cars, gliders, boats, and moon ships.

A

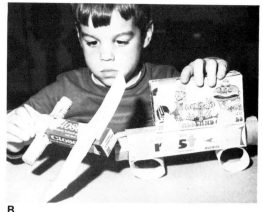

B

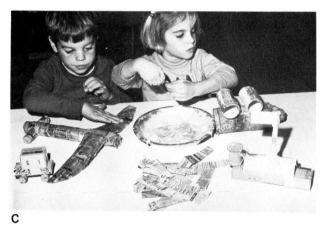

C

D

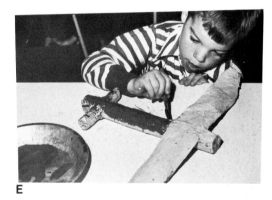

E

A and B. Kindergarten boy contemplates how he will paint his cars and plane after they have been covered with paste-soaked strips of paper towels.

C. Creamy smooth wheat paste is used to coat newspaper strips before covering the boxy conveyances with them.

D. Popsicle stick is taped on top of this boat to hold a cardboard flag.

E. Several colors of tempera and both large and small stiff brushes are needed to paint the boxy conveyances after the wheat paste has dried.

ships, submarines, and the like. Cardboard tubes and thick dowel sticks may be cut up for wheels and smokestacks. Short sticks may be taped on for sailboat masts, propeller, and airplane wings.

When all the parts are securely taped in place, the entire form is covered with a layer of newspaper or paper towel strips that have been dipped in wheat paste. This serves both to hold all the parts together and to provide a smooth surface for the child to paint upon.

When the vehicle dries, the child is ready to paint it with tempera. After a base coat of color has been applied and has dried, he will want to add windows, doors, wheels, and contrasting trim of all sorts, using small stiff-bristled brushes. Boats will need portholes, cabins, and flags. Planes may have emblems and numbers painted or glued on. Photographs of faces clipped from magazines can be glued onto the windows.

Early childhood teachers participate in an in-service class and learn technique of covering boxes and cartons with wheat paste and newspapers to create life-sized animal forms.

Small boxlike conveyances appeal to young children because their forms are familiar and their size is such that children can cope with them. The concept is three-dimensional design, yet two-dimensional decorative elements also are involved.

Boxy Beings

A group project using large cardboard cartons, carpet tubes, and round ice cream cartons can result in large animals for the classroom. To make one of these creatures, assemble the boxes and separate parts using wide strips of butcher tape. Wads of newspapers should be attached with strips of newspapers dipped in a mixture of wheat paste. In this manner rounded forms can be built up and the general contours of the animal formed. All the children can participate in this phase of the project. It will take quite a bit of time and quite a few pieces of newspapers to develop a fat hippo, lion, bear or giraffe. When the animal is completely dry, the children will enjoy painting it with tempera, or it may be taken outside and spray painted. A coat of clear varnish or shellac will give it a finished look. Usually these animals, especially if a few pieces of lumber are included in their framework, are strong enough to hold a child on their backs. One teacher made a number of 'saddlebags' for the hippo her class made, then filled them with task cards and books for the children's convenience. No matter how the boxy beings are used in the classroom, both making them and having them for friends later are exciting experiences for young children.

Wood Scraps and Glue

If spread on the floor where small hands can poke, pick up, and handle them, wood scraps in a multitude of shapes and sizes will cause the young child to conjure and imagine, to relate and design, to think in terms of height, width, depth, and weight. What can he make with them by using only glue and tape as adhesives? How can he decorate and finish his work?

Construction projects of this nature offer both boys and girls excellent three dimensional experiences. Through handling and becoming sensitive to form, the children will find in the wood scraps shapes that may suggest to them the body of a bird, the

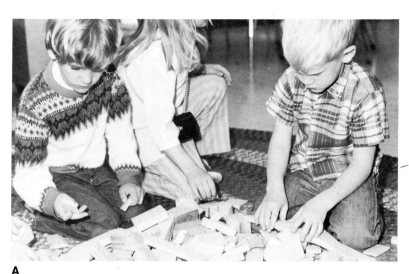

A

B

A. Children should see, feel, and study wood shapes carefully as they make selections for their glued-together constructions.

B. A piece of masking tape is helpful in holding several wood scraps in place until the glue dries.

basic shape for a truck, boat, or plane, the legs or arms for a figure, the trunks for a grove of trees, or the parts for a building or abstract composition.

Cabinet shops and construction companies discard odds and ends of wood scraps. If these pieces are too large for the child to handle easily, they should be cut into smaller odd shapes, triangles, squares, and rectangles. A few flat boards and Masonite sheets will be helpful to use as bases upon which some of the children may glue their constructions.

In adhering wood pieces, it is advisable to inform the children that a small amount of glue will dry and hold two wood pieces together rather quickly, whereas a large puddle of glue will require a long time to dry. Masking tape will hold them in position while they are drying. When the objects are completed and the glue is dry, the children may wish to paint them and add various kinds of decorations. Bits of fabric, feathers, pipe cleaners, and photographs of faces clipped from magazines may be cut out and glued on the construction.

Bas-reliefs may be made with wood scraps, too. For this art task, a flat piece of Masonite or thin plywood is used for the background, and the wood pieces are glued down flat in an arrangement. The children could be presented with the problem of designing a "Funny Machine" or a "Mechanical Animal." Thick yarn might be used along with the wood pieces if a linear element is needed, and the finished work may be painted with watercolors, tempera, or sprayed all one color.

A. Bird assembled by a kindergarten child was embellished with paint and feathers. Structure is glued to Masonite base.

B. Boat by a kindergarten child had basic form and structure.

A

B

Masks and Maskmaking

Children today most commonly associate the making and wearing of masks with Halloween. The tradition of wearing masks on the last day of October began long ago in ancient Gaul and Britain. The druids and priests thought that witches, demons and the spirits of dead people came back to earth for this one night of the year. The druids lit bonfires to drive these bad spirits away, and they protected themselves by offering them good things to eat, by disguising themselves by wearing masks so that the evil spirits would think that the druids belonged to their own group and would not harm them.

Protection is one reason for wearing masks, but other cultures have also used them in order to scare away intruders, to appease their gods, or for momentarily being another personality. Frequently in primitive cultures, masks are worn in rituals and are used when dancing. Indians in the Southwest and Mexico still use masks today as a part of their dances, celebrations and religious rituals. In Japan, Kabuki theatre still uses masks as an integral part of the drama.

Although we most frequently think of masks as dramatic and part of some celebration, modern-day masks are frequently utilitarian and are most often used for protection. Examples of useful masks would be those of the deep-sea diver, the catcher in baseball, the bee keeper, the surgeon, the astronaut, the welder, the goalie, the fireman and the skier.

Many ceremonial masks have exaggerated features, repetitive design elements, and use decorative materials such as paint or dyes, feathers, beads, bones, shells, hair and fur. Primitive masks are usually symmetrical and often emphasize a mood or capture the personality of a spiritual creature through exaggerated and distorted parts. The craftsmen often heighten the all-over effect by using repeated lines and shapes to make the dominant features stand out. Authentic folk art masks of other cultures are frequently found in museums and are particularly interesting to young children. Photographs, reference books, films and filmstrips are useful ways to bring masks into the classroom if real masks are not available.

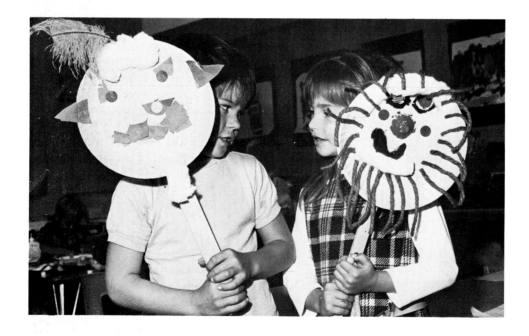

Paper plate faces on sticks can be masks or puppets.

Corrugated paper forms the
foundation of this simple mask
with yarn and construction
paper used to represent hair
and facial features.

Found Object Masks

In most cultures, people used materials from their environment to create masks. For that reason, some masks are made of wood, some are made of woven fibers, and some are metal. Decorative items vary from region to region depending on the objects to be found.

To reinforce this concept, provide an oval piece of cardboard for each child. It can be scored down the center and folded back to better fit the face and should have peek holes poked in places so that a child can see through it. The children are to collect things from their environment that they can use to make an interesting mask. The collection period should last several days or a week. On mask-making day, children can select from their collections of found objects which ones they want to use to decorate their masks. Found object masks have such things as shells, bottle caps, steel wool, beans, parts of pinecones, paperclips, keys, coins, leaves, pebbles, plastic utensils, feathers, cloth, buttons, lace or rickrack, yarn, parts of engines or motors, nails or screws, bolts, wire, and a wide variety of everyday objects from the environment. These objects can be glued into place for facial features as well as patterns and textures. A discussion can follow to determine which object or material was most frequently used, which was the most unusual, the most imaginative.

Sack Masks

Large brown paper sacks can form the base of masks which not only cover the face but the entire head. Large eye holes, a flap for the nose, and sections cut out on the sides for the shoulders relieve children's feelings of claustrophobia. Large (five-gallon) ice cream containers also make good foundations for masks that cover the entire head.

These students in a special education class enjoy their sack costumes. Their teacher made the oversize sacks out of various colors of butcher paper, and the students added facial features and other details with marking pens.

Paper sculpture techniques are used in making this mask from torn, cut, scored and curled paper. The base of the mask is part of a stocking that has been stretched over a frame made of cardboard and wire from a coat hanger.

To decorate or embellish the sack masks, paper cutting or tempera paint techniques can be used. This particular lesson can also introduce or reinforce knowledge about color, line and texture. Encourage students to use limited colors (only one or two colors), warm colors (red, yellow orange), cool colors (blue, green, purple), or neutral colors (brown, beige, black, gray). Lines can be thick or thin, curved or straight, long, short or broken. Texture can be actual (objects glued to the surface) or visual (small repeated lines or shapes which give the appearance of texture; these can be cut from photographs in magazines or drawn and painted on by students). Actual texture can also be added with various fibers used as hair.

Stocking Masks

Nylon stockings can be stretched over a wire frame to form the foundation of a mask that is easy to see through and offers great flexibility for decoration. The wire frame can be made by older children or adults by using a wire hanger that has a cardboard tube at the base. The tube is removed and used as a handle, and the wire is straightened, formed into an oval, and the ends stuck into the tube handle. Knee high nylon stockings are a perfect length to stretch over the wire frame, but other stockings or pantyhose can be cut in lengths and tied off.

Once the frame is assembled, the child can use yarn, torn or cut paper, plastic tape, buttons and other sewing materials to create features, hair, hats or crowns, collars, and jewelry. Possible themes might include characters from favorite books, someone in uniform, a person from history, or birds and beasts. After the masks have been completed, children can participate in a "Who am I?" session in which they wear their masks and give clues; other children can ask questions that must be answered by "yes" or "no" in an attempt to guess who each mask represents.

A simple mask is formed from folded paper. Half of the face was painted on one side of the fold and transferred to the other half while the paint was still wet.

Paper Masks

Half or full masks can be cut from construction paper; slits and tucks will help it to fit around the face. Sidebands of paper can be attached above each ear to hold the mask in place. Paper can be cut, curled, torn and pasted into place to add interesting features.

Paper plates can also be used as masks with features and decorations glued, painted or drawn on the surface.

A symmetrical mask can be constructed by folding a piece of paper or thin cardboard in half and cutting it into an oval or other facelike shape. The paper or cardboard should have a slick surface (finger paint paper or heavy butcher paper would be suitable) so that it does not absorb paint easily. Have students paint half of a face on one side of the fold line; there should be one eye, one eyebrow, half a nose and half a mouth. When the paper is refolded, the painted features will transfer to the other half, making a mirror image of the original painted features. Designs can be painted and duplicated in this way, or students may want to add asymmetrical lines and decorations with paint or crayons.

Strips of paper dipped in a starch-glue-water solution can be used to build up layers for a papier mâché mask. The paper should be porous (newspaper or newsprint is good) and torn into pieces or strips less than an inch wide. For the best results, the layers should alternate in direction. A metal bowl turned upside down can be used to form the mask. Students can also use heavy aluminum foil which has been pressed and molded to their own faces; the basic facial form can be preserved by placing wads of newspaper beneath the foil so that it will keep its shape while the strips of paper are applied. Three or four layers of paper strips should be used.

The last layer of papier mâché should be plain white. Once dry, the mask can be painted with thick, creamy tempera. When completely dry, clear spray, polymer gloss medium or shellac can be added for a shiny finish.

Puppet People 12

Puppets are three-dimensional small-scale representations of people and animals. They are directly controlled by the child's hand, both when he designs them and later when he makes them talk and move as animated creatures. They may even be extensions of his own personality, disguised somewhat in paper, paint, and cloth.

The puppet's exact origin is unknown. There are people who believe that the Egyptians invented puppets, yet some of the first were made along the Ganges River in India. Oriental countries have a long tradition of puppetry, and the ancient Greeks even had puppet theaters. Roman puppet performances were held in homes and public places, and traveled as road shows. Italy is well known for its puppetry, and in the Middle Ages Italian puppeteers took their portable theaters to France, Spain, Germany, and England. When young children make puppets they are not only enjoying a playful art activity, but are joining in a long historical line of make-believe, laughter, tears, and high adventure.

Contrived and assembled stages for puppet and marionette shows can be made from corrugated cardboard or plywood. They should be sturdy and large enough to accommodate several children at one time. Youngsters enjoy decorating them and making backdrops. A table turned on its side may be used as a makeshift puppet stage.

Paper Puppets

The young child delights in playing with puppets, and when he can make one quickly and easily to suit his own fancy, his pleasure is enhanced.

Flat Stick Puppets

Probably the simplest puppet for the very young child to make is the flat stick puppet. Any child who is drawing figures and animals can make one by simply cutting

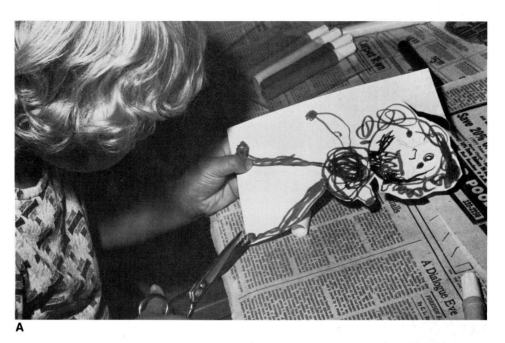

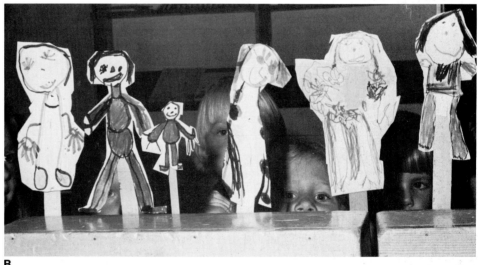

A. Kindergartener draws schema with felt pens on stiff paper and cuts it out for making a stick puppet.

B. Variety of symbols for people is evidenced in these stick puppets as kindergarteners position themselves behind improvised stage made of building blocks

out his drawing and gluing or stapling it to a flat stick of wood. He may find it fun to glue on bits of fabric or felt for items of clothing. By sitting below the level of the table top or behind an improvised puppet stage made from a cardboard carton or large blocks, he can hold onto the stick and make his puppet move and talk.

Lollipop Puppets

The teacher should have available for the children an assortment of pieces of corrugated cardboard—rectangles, circles, and ovals. Then the children can staple a short flat stick, such as a tongue depressor, onto the piece of cardboard. The cardboard may be painted by the child or a group of circles may be spray-painted ahead of time in a variety of colors. Then the child makes selections from an assortment of yarn, buttons, macaroni, colored paper, felt, and paint, and creates a face, gluing on hair, a nose and other features. The children will enjoy naming their brightly colored puppets—Gooney Gumdrop, Larry Licorice, Hairy Jerry, Nosey Rosey, etc.

Paper Plate Puppets

Paper plates are inexpensive; they come in white and a variety of colors. Thin paper plates can be folded in half to form the mouth of a simple puppet. A hand strap will need to be stapled or glued on to the top half of the plate. The puppet is manipulated by placing the hand through the strap and the thumb under the bottom of the plate. A tongue, teeth, eyes, whiskers, nose, hair, and other details can be added with glue or by stapling.

Another type of paper plate puppet is very versatile in that it can double as a mask by cutting eyeholes at the proper places. A short, flat stick of wood is stapled and glued to the back side of the plate, and the child is ready to start. By attaching the stick between two plates which are glued together, a two-faced puppet is possible. The puppet can be either human or animal in form. A tableful of interesting supplies and scrap materials is a necessity. Such things might include yarn, feathers, buttons, stick-on dots, tape, colored or metallic papers, egg carton bumps, paint, cloth, scraps of felt or fur, and corrugated paper. If the group has just enjoyed a favorite fairy story or folk tale, the children may wish to create characters to act it out, or they may make a puppet of their own choice.

Folded Paper Puppets

The next three puppet forms are all made by folding colored construction paper in a basic shape and directing the child to add features and clothing in a manner he chooses.

Fold-over Puppet This puppet form is made by folding a piece of nine-by-twelve-inch colored construction paper vertically, then stapling the top and open side. The top is folded over about three or four inches, and the child's hand is inserted in the open end of the tube. Next the child uses cut paper, yarn, felt pens, or whatever he chooses, to create the face and body of his puppet. He should remember to add some hair, ears, or whatever decorative details he may wish, to the back side also.

A simplified fold-over puppet can be made from small paper lunch sacks; the bottom of the sack becomes the puppet's face, and the natural fold of the sack forms the mouth of the puppet.

M-fold Puppet This type of puppet is also made from a folded piece of nine-by-twelve-inch colored paper. This sheet is folded vertically and the open side stapled. Then it is folded in half and the two ends folded back again in an **M**-shape. The fingers and thumb are then inserted in the pockets in the back side, and the puppet's mouth opens and closes as the hand moves. Colored-paper eyes, teeth, ears, whiskers, tongue, and so on, are glued, taped and stapled in place.

Cootie-Catcher Puppet To make this puppet, the child starts with a nine-or twelve-inch square of paper. This is folded diagonally twice to find the center and then each

A. Heads bob up and down on fold-over puppets.

B. **M**—Fold puppets offer many channels for the resourceful use of scrap materials.

C. Moving, dangling, and projecting parts aid these puppets in being viewed and manipulated.

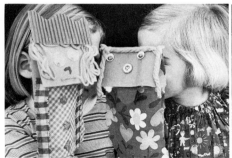

A

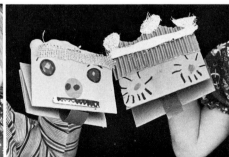

B

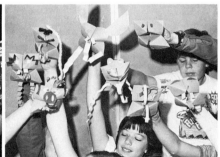

C

corner is folded to the center. The entire piece is then turned over and the corners on the back side folded to the center point. The piece is then folded in half from both directions. By inserting his fingers in the back openings, the child opens and closes the puppet's mouth. The talking mouth may be stapled together to keep it from splitting as the child opens and closes it. Eyes, ears, eyelashes, tongue, teeth, and beards may be attached.

These four puppet forms involve skills in folding, stapling, cutting, gluing, attaching, and overall designing. The puppets are completed quickly and have a very low frustration point for the young child. In a few minutes he is ready to move into the world of fantasy and relate to his new talking friend. The techniques may be repeated often, with every child making a different form of puppet each time.

Stuffed Paper-Bag Puppets

Stuffing a small paper bag with a wad of newspaper and turning it into a delightful puppet by using bits of discarded materials and paint, gives the young child a new friend to play with and talk to, while also rewarding him with a good feeling of personal accomplishment. A scrap box filled with a variety of yarn, fabric, felt, feath-

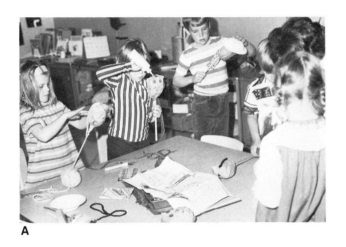
A

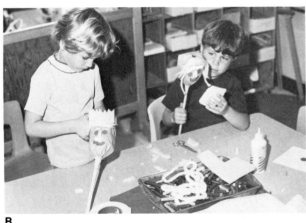
B

A. Kindergarten children learn to handle glue, scissors, and all sorts of scrap materials when they make stuffed-bag puppets.

B. Simple materials make for a success-oriented art task; thick yarn, stick-on dots, and meat trays are easy for young hands to handle.

C. Paper bowl hat covers this puppet's yarn-covered head.

D. Masking tape wrapped around a scrap of fabric at the neck serves to hold the puppet's garment in place.

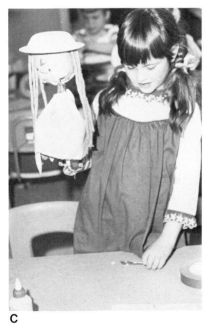
C

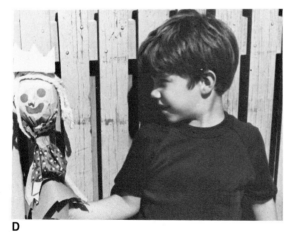
D

ers, pipe cleaners, buttons, will prove to be a valuable aid in generating ideas and approaches in design. Paint, brushes, tape, glue, and staplers should be accessible.

Number-one-size paper bags are available at hardware and variety stores. Being rather small they are easier for small hands to handle than larger bags. First, wad a piece of newspaper around the end of a short wooden stick and wrap pieces of masking tape around the wad in such a way as to hold it firmly in place on the stick. This wad is then inserted into a paper bag, and a piece of masking tape is wound around the base of the bag at the puppet's neck.

Before children begin to work they should be directed to think in detail about the differences in facial features and the great variety of forms that they may imagine and create to represent eyes, eyebrows, lashes, noses, mouths, teeth, ears, beards, and such. Hair, hats, crowns, horns, simple clothing, and arms may be cut from colored paper, yarn, and scrap materials. A piece of fabric, tissue, or crepe paper may be gathered up and taped around the stick at the base of the bag to serve as a garment. Arms and legs may be attached with a stapler. Egg carton bumps, fringed paper, and stick-on dots will help the child think in terms of exaggerating and projecting the features, and making use of decorative details. Adding objects that move, bounce, sparkle, and shine will aid in making the puppet visible from a distance.

The children will enjoy making their puppets talk and move about while performing in an impromptu show, whether the story line they use is taken from a popular story, nursery rhyme, or is one of their own invention.

Sock Puppets

Every household usually ends up with a few odd or mismatched socks. These can be used as the foundation for a sock puppet. Pull the sock over a hand with the heel over the thumb to form a mouth. The child can make a fist and make the puppet talk by moving his fingers. Ears can be formed by shaping and pulling part of the sock out from the side or top of the puppet head; the ears will need to have rubber bands or elastic hair bands wrapped around the base to hold them in place.

Rickrack, yarn, lace, buttons, beads, felt or rug scraps can be used to decorate the puppet.

Box Puppets

Basically, a box puppet foundation consists of two small boxes taped together with gummed paper or masking tape. The boxes are arranged so that when they are opened out, using the tape as a hinge, the sides rest together and the open ends of the boxes both face in the same direction. The boxes form the jaws of the puppet and the open ends provide spaces into which the puppet maker can fit his hand to manipulate the puppet's mouth. Individual cereal boxes or half pint milk cartons are the right sizes for puppetmaking.

Although each box puppet begins with the same basic shape, imaginative decorations give each one an individual personality all its own. Cardboard ears, wire or twine whiskers, candy cups cut and used for eye lashes, eyes formed from the cups of pressed fiber egg cartons, features and designs created from yarn, string, paint or felt markers all work well in adding details. Teeth, tongues, and fangs can be cut or torn from paper and added to the mouth formed by the two boxes. A handkerchief or scrap of cloth can be wrapped around the wrist and the part of the hand that shows when the puppet maker is manipulating the puppet.

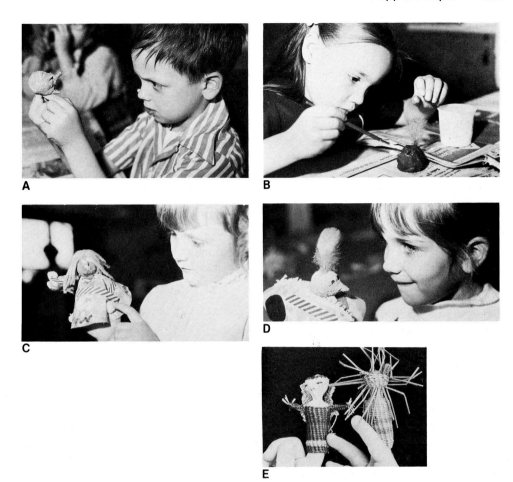

A. Ball of instant papier-mâché is formed over the child's finger into a tiny puppet head. Chin, nose, and eyebrows project in an exaggerated manner.

B. Feather was imbedded in salt ceramic bird's head when it was being modeled. Paint is brushed over entire head after it is hardened.

C. Yarn was glued on this painted head to complete the finger-puppet's decoration.

D. Circle of cloth is poked up inside the puppet's head to cover the child's hand.

E. The smallness of finger puppets appeals to children, and they enjoy seeing those made by others. These woven puppets were made in Ecuador.

Finger Puppets

Tiniest of all, finger puppets are particularly appealing to the very young child. They are charming and adaptable to all sorts of play activities.

The two materials that work best for these small modeled puppet heads are instant papier-mâché and salt ceramic. Instant papier-mâché comes in pound bags and is a dry, powdery substance that must be mixed with water and kneaded to a pliable consistency.

The child takes a small wad of either of these doughlike materials and sticks his finger inside it to create a hole. This opening enables the child to hold the completed puppet on his finger, and it should be made a little larger than the child's finger, since the cloth garment will be glued inside it with enough space left for the child's finger.

The child should model a simple face, pinching out a nose, ears, chin, and such, and adding tiny lumps for other features. He may use a pencil or small tool to impress and imprint details. After several days' drying time, the child paints the head with tempera, giving the entire outside of the head a base coat of one color, which is left to dry before painting on top of it and adding features and decorations. Colored salt ceramic requires no paint. Yarn, felt, cotton, wool, or other materials may be glued on for hair, hats, beards, and the like.

The garment is made from a small circle of cloth upon which the child may draw designs with felt pens and glue on rickrack, buttons, pom-poms, beads, and ribbons.

When the garment and head are both complete, a bit of glue should be dropped in the opening of the puppet's head and the center of the garment poked into it. After the glue is dry, the child may insert his finger into the puppet's head.

Clay can also be used to make finger puppets. Plasticine is temporary but provides many colors while the water-based clay needs to be fired but is more permanent. The clay can be squeezed around fingers; the features, hair, clothing can be pinched out or scratched into the surface. This technique of pulling the details out of the clay prevents problems with joining, of having poorly attached pieces fall off. Even very young children are able to squeeze and pinch characteristics into their finger puppet.

Finger puppets can also be made out of fingers which have been cut off a glove. Old rubber gloves, ski gloves, or children's knitted gloves can be used. The child can decorate by sewing or gluing on thread, yarn, buttons, feathers, felt or fur to make the facial features, hair, a beak, whiskers, a mane, topknot, hat, crown, or anything else needed to create an interesting puppet.

Stick Puppets

Tongue-depressor Puppets

Either baker's clay or salt ceramic is suitable for children to use in forming small heads and attaching them to tongue depressors. If salt ceramic is used, several colors are needed so that the child can create facial features of contrasting colors. If baker's

A

B

A. Kindergartner adds a flag to the pipecleaner arm of her tongue-depressor puppet.

B, C, and D. Tongue-depressor puppets are as different as the five-year-old children who created them.

E. Baker's clay gives crusty wrinkled faces to these two witches. Children added clothing and wool hair after the puppets were baked in an oven.

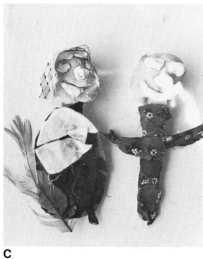

C

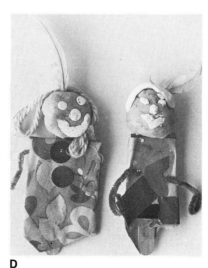

D

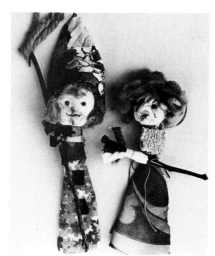

E

clay is used, the head on the stick must be baked in a 350-degree oven until it is thoroughly hard and lightly browned. It is important that the finished pieces be covered with plastic wrap until they are baked, as the salt in the baker's clay tends to dry rapidly, making cracks and leaving a rather unattractive surface.

These puppets, being small, are particularly suitable for the very young children to make. They may add peppercorns and cloves or bits of macaroni for eyes and teeth. Hair, hats, and ears may be attached with a bit of glue after the heads are either dry or baked, and scraps of fabric may be attached to the tongue depressor at the neck by using a short length of masking tape or plastic tape. The availability of a good assortment of scrap materials makes for unique creations. A stapler will come in handy for attaching decorative details to the garment.

Tongue-depressor puppets can be completed quickly so the children will enjoy making several of them. The kindergarten children who created the examples shown here made entire families.

Salt Ceramic on a Stick

Stick puppets with heads modeled of salt ceramic offer young children a wide design latitude, with the opportunity of depicting facial features in three dimensions. Each child will need a small lump of salt ceramic for the basic head shape and several small pieces of other colors of the modeling material for details. For instance, the basic head shape might be green, and the child could add a yellow nose, red eyes, and a

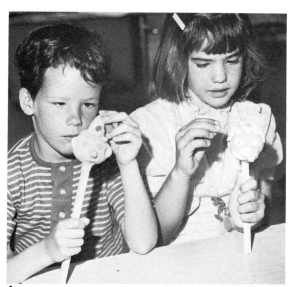

A

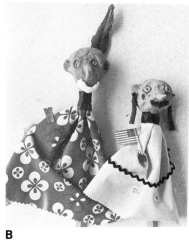

B

A. Salt ceramic heads are modeled on top of a short stick.

B. Tape is used for attaching wrap-around garments on stick puppets.

C. Contrasting colors of salt ceramic were added by this six-year-old girl to accent the features on her puppet's face.

D. Projecting features make for interesting profiles on these two puppets.

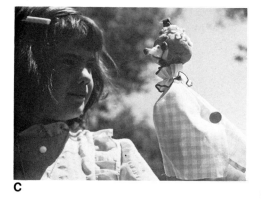

C

D

white beard. Although salt ceramic may be painted when it is dry, the use of brightly colored dough eliminates the need for this step. One recipe of the salt ceramic mixture should make enough modeling material for three to four children.

The teacher should demonstrate how to place the salt ceramic on top of the nine- or ten-inch stick of wood. To make it pliable and plastic the dough should be kneaded for a few minutes before using. The children can pinch it, roll it in coils or into small balls, and use pencils and small gadgets to imprint textures.

Feathers, toothpicks, pipe cleaners, macaroni, buttons, nails, and other such articles, may be placed in the dough while it is pliable, and rope, yarn, and fabric may be glued to the dried piece. Several days are required for the heads to dry thoroughly.

A square of fabric may be gathered or pleated, then attached to the neck of the puppet with masking tape or colored plastic tape. Braid, lace, rickrack, felt scraps, or ruffles may be attached to the garment with glue or needle and thread.

Puppet Situations

The successful puppetmaking experience will result in a diversity of colorful and interesting characters, each with its own unique personality. In addition to the puppet's head and facial features, the addition of fangs, horns, beaks, pigtails and other interesting details can emphasize the puppet's character. Props such as caps, hats, helmets, crowns, shawls, or even miniature masks can also be added for interest. Children should have many opportunities to play with their puppets either through plays or speech-making activities. Create situations for the puppets and ask the child to fit the voice to it; a few sample situations might include:

a parent scolding a misbehaving child
a burglar making excuses to a policeman
grandmother calling on the telephone
a waitress in a restaurant
a sleepy animal in the zoo
a child making cookies
a caterpillar about to make a cocoon
a puppy waiting for his dinner
a bird building a nest
an argument on the playground
getting ready for a birthday party
late for school

Once the artistic creation is complete, a child's creativity and imagination can continue to be stimulated with activities which develop language skills and cognitive ability.

13 Fabric and Fiber

Working with fabric and fiber is a simple, direct technique which encourages spontaneity and fosters skills in cutting, gluing, stitching, weaving, and designing—both in picture-making activities and in craft objects. Fabric is an exciting tactile material for young children to see and handle. It comes in an endless variety of colors, prints, and textures. It lends itself well to both individual and group projects.

Fabric and felt should be collected and stored in a number of labeled cardboard boxes, cartons, or plastic pans. Pieces may be sorted by color to make it easier for the children to find the kind of scrap they need. Having an iron available to press the fabric before the children begin cutting will make it easier for them to work. In like manner, yarn should be wound loosely into balls from the skeins and kept sorted by color in boxes or cartons.

Good sharp scissors are necessary when working with fabric and felt if children are to be expected to learn to cut with a degree of skill. The ordinary scissors for paper that are usually found in classrooms are inadequate if the child is to have a success-oriented experience.

In becoming acquainted with fibers, the children should begin to develop a basic knowledge, vocabulary, and understanding of the process of weaving and be able to warp and weave, making simple objects using several different elementary techniques, looms, and yarn.

Banners and Flags

Banners are beautiful, bold, and direct, and their production makes for exciting encounters with art for young children. When a group of boys and girls work together on a banner, a large space is available for them in which they may organize their visual and emotional experiences. Each child can actively participate in designing, cutting, pinning, and attaching the parts to the background, either with a fabric adhesive or by sewing them with simple running stitches.

Today, banners and flags enjoy a special role in our lives. They are elegant and exciting, adding richness and meaning to various occasions. Many professional artists are busy designing both these exciting art forms; and one finds these banners in gallery exhibits, museums, churches, and at fairs.

When young children make banners, they have a part in carrying on a fine tradition. Extensive use of banners and wall-hangings was made during the Middle Ages, this practice originating in Rome during the period of military conquest. They were carried into battle to differentiate military groups. Heraldic flags helped identify a friend or enemy, since the metal helmet and armor made recognition impossible. Standards were the personal flags of rulers, while small streamers and long ribbonlike flags were carried by troops. During the Crusades both flags and banners were used by nobles and kings. Standards were used at an earlier time in Egypt and the Near East. Merchant and craft guilds in the Middle Ages had banners to identify themselves, and through the ages countries have used flags.

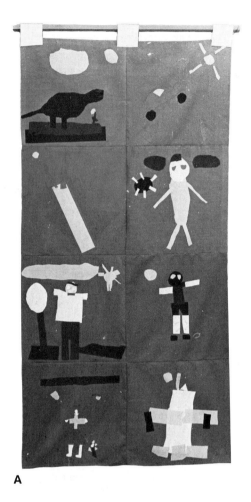

A

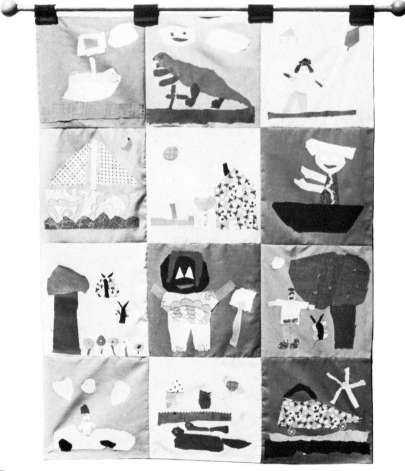

B

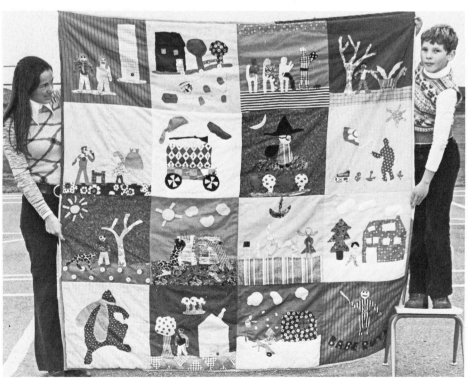

C

A. Red and purple squares in checkerboard arrangement make up this banner by six-year-old children. Iron-on fabric was used for instant applique technique.

B. Applique banner made by first-grade children is made of red, yellow, and orange squares. Cutouts were adhered quickly with fabric adhesive.

C. Sixteen third-grade children combined efforts for this large, lined, patchwork banner. Children attached their cut-out shapes with running stitches. Each square represents a favorite book.

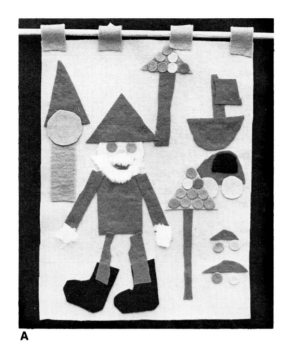

A

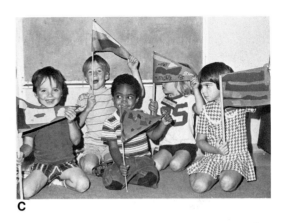

C

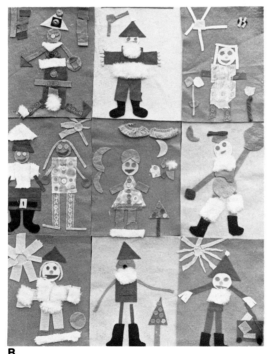

B

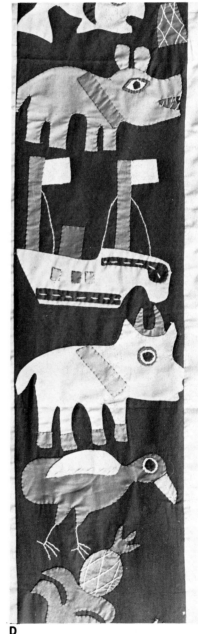

D

A. Small individual banner made by a five-year-old child is hung by felt tabs from a short dowel stick.

B. Kindergartners made Santa and His Helpers banner, using felt on felt and a bit of fake fur for textural emphasis. Banner was later disassembled in order for each child to retain his panel.

C. Preschoolers delight in playing with flags they made with felt, fabric scraps, and short sticks of wood.

D. Colorful applique banners from Africa are living history books in that they tell of heroic deeds of a powerful dynasty of eleven kings who ruled for many years in what is now Dahomey. They appeal to the eye and heart of the viewer through their simplicity and boldness.

Banners and flags are in themselves a celebration in line, shape, color, and texture. They may be highly decorative with a unifying theme; they may be a culmination of a group's thoughts and feelings about an idea or an aspect of life; they convey a message, an emotion, a story. Whatever it is the group wishes to achieve, a banner should present its message or thought in a clear, effective display which is easily viewed from a distance. The project should utilize shapes, colors, and textures that will contrast, reach out to communicate and delight all who see the finished product. Words and phrases may be used to clarify and enrich the general theme. Sobo is a fabric adhesive that dries soft and flexible. Ordinary white glue dries stiff and hard on fabric and felt. While first and second graders are able to pin their designs together and use a simple running stitch to hold the pieces in place, pre-schoolers and kindergartners should use Sobo.

Banners may be made from many kinds of fabrics—in solid colors and in bright stripes and prints. Buttons, beads, lace, rickrack, braid, tiny mirrors and mylar may be added to the designs. Yarn is sometimes used together with the fabric for linear details and for writing words. Both sides of felt banners may be used for designs.

Patchwork banners are recommended for group projects. Each child makes one square for the all-over configuration, then all the squares are stitched together or adhered to a large felt or fabric backing. If regular fabric is used, it may be hemmed or bound with tape. No hemming is necessary when felt is used. These banners may hang in the room or school office for a number of weeks, then be dismantled in such a way that each child can retain his individual section.

Young children as they begin cutting fabric may need to have someone who will demonstrate a few techniques for using scissors; e.g., how to hold the scissors; how to fold the fabric to cut out a small opening for an eye or similar small spot; how to fold the fabric to cut several objects of the same shape at once; how to snip fringe; and how to fold and cut a symmetrical shape. They should be encouraged to create figures in parts—cutting the body, legs, arms, hair, hands, and boots out of separate pieces of fabric. It is always better to have the children cut freely into the material rather than to draw their designs on it with a pencil. As in cut-paper work, spontaneous cutting results in freer shapes that are more natural and uncramped than those that are drawn with a pencil.

After cutting their designs, the children should look at their work and decide on any changes or additions which might be made, any colors or shapes that might be repeated to give unity and interest and accent to the whole design, and any objects which might be modified, rearranged, or enriched with more details.

The top of the banner may be attached to a wooden stick or a metal rod by adding short straps of felt or fabric or by folding over several inches of the top and stitching it in place, leaving a narrow opening for the rod to slip through. Wooden balls or screw-on finials may add adornment to the ends of this supporting pole.

The bottom of the banner may have lead weights attached to make it hang evenly. Lightweight banners may need lining, although this is seldom necessary. Some banners have a rod or stick inserted through a hem in the bottom. A felt banner may be cut in a scallop or other decorative manner with fringe and tassels, or ribbons attached.

Banners may hang flat against the wall, from a ceiling or beam, or be placed in a freestanding holder on the floor. Swinging wall brackets will hold banners out from the wall, and of course banners may be carried in a procession or parade.

Older children will enjoy the challenge of designing a room flag or a school flag perhaps featuring the initials or name of their school, their class motto, their team emblem, or some other simple motif. Heavy canvas is a good backing to use for outdoor flags, and the edges should be hemmed before the flag is placed on a pole or holder.

Occasions for making banners and flags are virtually endless. They may be created to welcome parents and friends to an Open House, to say "Thank you" to the PTA for some project they have given to the school, to celebrate a special event or a

change of season, to make a school picnic or musical performance more festive, or to wave in the wind at a school athletic event.

Banners and flags are colorful, graceful, charming, and a joy to have in and around school. Have the children make them and rotate them. Let the banners be a culmination point—tying together new experiences and concepts. Employ banners to motivate and point the way to new learnings.

Stuffed Stuff

Drawing with felt pens on fabric or Dippity Dye paper takes on an added dimension when the figures are stitched to a backing, and stuffed. The result is a type of soft sculpture. It may be an individual production or an assembled group mural. When this sort of three-dimensional mural is disassembled for the child to keep and take home, the individual parts are complete, and a satisfying feeling of accomplishment is achieved by each child.

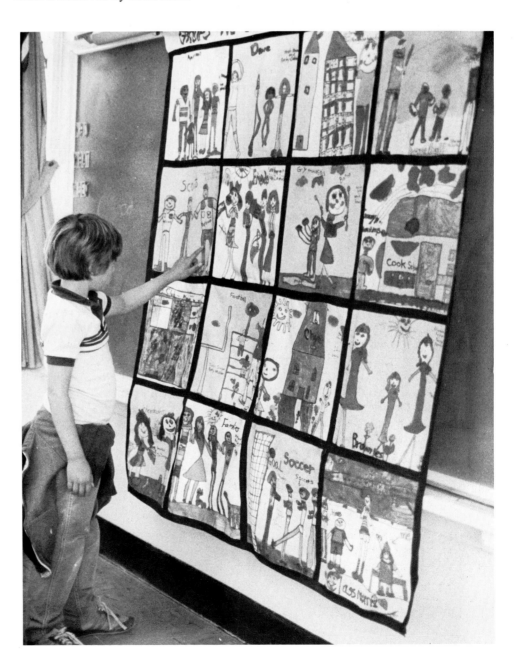

Permanent markers were used to make drawings on squares of muslin, and the squares were sewn together to make a quilt. The theme for this project was "Groups I belong to" which the students were studying in social studies. Courtesy of Judy Parker, Chula Vista City School District.

Cotton muslin and Dippity Dye paper are inexpensive and provide a good base upon which the children may draw. If felt pens are used, the children should have an old magazine or several thicknesses of newspapers to put under the fabric or paper in order to protect the table or desk from ink stains.

After the children complete their drawings on fabric, the figures are placed on another piece of fabric and the two pieces stitched together on the sewing machine, with a few inches left open on one edge. It is easier to sew the two pieces together on the right side and then to trim the raw edges with a pinking shears than it is to sew them on the wrong side and to turn them inside out. The forms will look neater if they are pressed before being stuffed. Polyester, available in pound bags, old nylon stockings, fine sawdust, or plastic bags are suitable stuffing materials. Small children can be taught a simple running stitch to use in sewing up the openings, or a sewing machine may be used. Objects made on Dippity Dye paper may be stapled, glued, or stitched before stuffing.

It is advisable to have the children work with a fairly small piece of fabric or paper. In the case of the caterpillar shown here, each child was given a circle approximately seven inches in diameter, except for one child, who received a ten-inch circle with which he designed the head. The children decided to add pointed pieces of felt to each segment. Pipe cleaners and feathers were added to the face for antennae.

The first-grade children who drew themselves for the Balloon Parade had their choice of several sizes of fabric pieces. They were urged to use the entire height of the material for their figures. The stuffed figures were assembled on colored paper, and then a bit of bright yarn with a name balloon was attached to the hand of each figure.

The Butterfly Tree was done by a group of six-year-old children using felt pens. The variety in the all-over designs and colors used is seen in each child's unique shapes and decorative details. The children perched their stuffed butterflies in a colorful swarm on a many-branched tree.

The City Skyline mural was drawn and assembled by seven-year-old children who had just completed a unit on City Neighborhoods and had studied the many kinds of buildings that make up a city. They had looked in detail at the shapes, sizes, and kinds of architecture—churches, factories, schools, apartment buildings, offices, and so on.

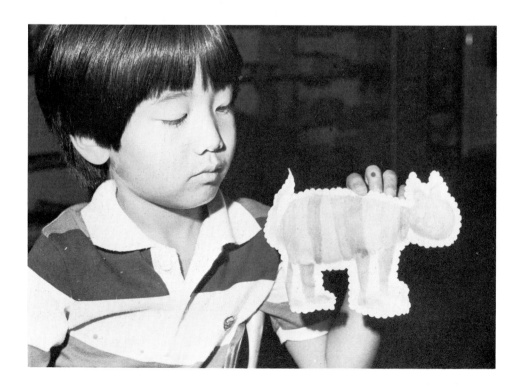

Fabric crayons were used on paper, and the design ironed onto synthetic fabric to create this stuffed animal. Edges were trimmed with a scalloping scissors after stitching and stuffing.

A. Caterpillar is made of individual circles of fabric and colored with oil pastels. Each child designed one section.

B. Kindergarten children introduced themselves for Open House by drawing figures with felt pens and assembling the stuffed forms with name balloons on colored paper background.

C. Butterfly Tree was made by first-grade children using felt pens on white fabric. When it was disassembled, each child retained his own contribution

D. Six-year-old girl draws butterfly freely on fabric, and fills in areas with felt pens.

This type of soft sculpture offers a rich potential of creative tasks for young children. Backgrounds for murals may be made from cut paper, burlap, felt, chalk, or paint. With each child drawing one or two elements for the total concept, the entire class feels the pride of group effort, yet individual expression is paramount within the whole configuration. Children will enjoy exploring the following topics for Stuffed Stuff murals:

Birds in a bush
An airport
A boat harbor
Houses on a hill
On our playground
Witches and goblins

Easter eggs hidden in the flowers
Dancing around the Maypole
Children flying kites
Below the waves
Zoo parade
Birds, Bugs, Bees, Butterflies and Blossoms

E. City Skyline is seven feet long and epitomized a study of urban architecture. Buildings show great diversity of shape and exterior ornamentation. Car, plane, sun, and clouds unify all-over design.

A

B

C

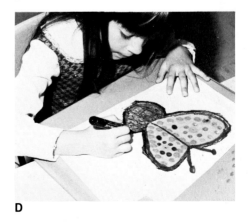

D

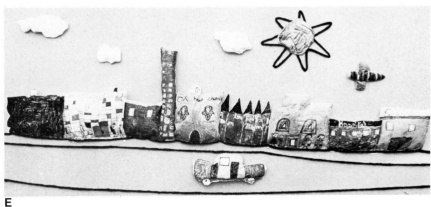

E

A **B**

C

A. Each child's drawing, done with special fabric crayons, is cut out and ironed onto synthetic fabric.

B. Drawing is lifted from fabric after being ironed.

C. Kindergarteners display group project after all the drawings have been transferred to fabric.

RUNNING

Plain

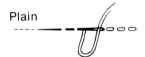

COUCHING

Single

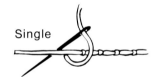

CHAIN

Plain

CROSS

Diagrams courtesy Lily Mills, Shelby, N.C.

Fabric Crayons

Fabric crayons resembling regular crayons have appeared on the market recently. The student makes a drawing on a piece of typing paper with them and then the paper is placed, crayoned side down, on a piece of 100% polyester fabric or pellon. A piece of typing paper should be placed on top of it while it is being ironed, with the iron set at 'cotton.' (The top paper protects the fabric from the high heat which is necessary to transfer the crayon.) Wall hangings made by a large group of children can be prepared by having each child draw a small building, figure, flower, animal, and then ironing it onto the fabric in a pleasing and related arrangement. Individual projects such as fabric pictures, pincushions, tree ornaments and pillows can be made. Small squares of fabric may be mounted on heavy paper for greeting cards. Fabric crayons are quite useful for making Stuffed Stuff, in that the fabric can then be sewed to a piece of felt or other fabric as a backing, stuffing placed inside, and the edges pinked or scalloped or just cut with a plain scissors. Since these crayon marks are permanent when applied to polyester fabric, the teacher may enjoy having a garment made for her/himself, each child drawing a small design and transferring it to the material before it is sewn together.

Stitchery—Basic Beginnings

Learning to express ideas in media other than crayons and paint is an important part of artistic growth in early childhood. Stitchery should be introduced at this time by giving each child a small piece of natural or colored burlap about ten or twelve inches square, some yarn, and a large-eyed blunt needle. The teacher should pull threads in the burlap to assure straightness when cutting it, then he/she should either use masking tape folded around all four sides, or run a zigzag machine stitch around the

A

B

A. Chain stitched picture made by Peruvian child is examined by kindergartener.

B. Stitchery from Colombia embodies symbols for houses, trees and spatial concepts that are comprehensible to young children.

edges, to prevent the child from unraveling it as he works. Burlap is best sprayed with starch and ironed before the child uses it. An embroidery hoop or a wooden stretcher frame will help the young child control his stitches, although this is not absolutely necessary.

If you plan on incorporating some appliqué work with assorted fabrics and felt, you will need some thread and regular size needles. Blunt needles cannot be used for piercing through fabric and felt, but they easily penetrate the loosely woven burlap. Children will want new pieces of cloth frequently, especially when they are just beginning stitchery, and therefore it is useful to have plenty of pieces cut and available, along with short cut pieces of colored yarn.

The first stitches of pre-schoolers will probably be mostly straight stitches arranged in a random fashion. The size and number of stitches will vary, since the child's attention span is quite short. Gradually the child becomes aware that he can consciously make his needle go up and down, right and left. He is not sewing a recognizable object at this stage. It is enough that he is learning to control his hands and fingers. By age four he may begin naming what he has stitched, either before or after he has made it. Five-year-olds are eager to begin gaining more skill with the needle, and this is a good time to extend their vocabulary with color and texture words. Enthoven[1] suggests that inspiration for a five-year-old could come from 'taking a walk with stitches,' and to think of stitches walking quietly, running suddenly, going along a straight road, a curving road, turning left, skipping, taking long and short steps. Two people could go on the walk with a second color for the second person.

Six, seven, and eight-year-olds are ready to learn more about specific stitches if they have had previous experiences with needle and thread. A sample of a few basic stitches made by the teacher and mounted in a display area will encourage children to advance another step in mastering a variety of stitches. Children can also invent their own stitches or variations of the basic ones. Four basic stitches are: 1. the running stitch, a basic in and out movement with the needle and yarn. The stitches on the top surface of the burlap may be tiny and the ones on the underneath long or vice versa, or they may all be somewhat the same size. Several rows of running stitches may be placed closely together to create a special effect. 2. the chain stitch is very useful for filling areas, and children may want to choose chaining to make a border entirely around the perimeters of their burlap. 3. Cross stitch 4. Couching. This stitch is very good for outlining and making borders. A piece of yarn is placed on the burlap in the desired linear configuration and secured with a few pins. Then another piece of yarn or embroidery floss is used to stitch it down. (See diagrams)

A problem frequently encountered by young children doing stitchery is that of pulling the needle off the thread as they pull upwards. Enthoven suggests 'anchoring' the needle by threading it and drawing out a tail about four inches long. Hold the middle of the needle in the right hand with the long end of the thread in the left. Split the yarn exactly in two with the point of the needle at a place about the length of the needle. Push the needle through with your right hand and pick it up and pull it completely through the split yarn. Hold the short end to be sure it is not also pulled through the split yarn, and the needle will be firmly anchored. Knotting the end of the yarn is accomplished by wrapping it around the index finger of the right hand three times, twisting it between the finger and thumb pulling it off, and then sliding it between thumb and index finger to the end. Threading the needle is easier if the child will bend the tip of the yarn over, squeeze the loop tightly between his thumb and index finger and ease it through the large-eyed needle.

While some of the technical needs of children during stitchery may seem cumbersome the problems can be solved by working with small groups of children at one time rather than the whole class. Several parents or intermediate age children can be available to aid in threading needles and securing the end of the yarn when the child finishes. Children often enjoy helping each other when a new stitch is introduced. The size of the fabric should be fairly small, so that it won't take so long to finish it, at least before the child's patience and interest die. Perfection in stitches should not be the primary aim in early childhood. The process should be relaxing and pleasurable, with emphasis on spontaneity, inventiveness and stimulating the child to want to continue developing his stitchery skills on through the grades. A stitchery once started can be something that the children can pick up and work on during their free time.

Some children like to stitch directly on the cloth in a spontaneous manner. Such children proceed in a 'doodling' manner and let a design evolve, or else they have a preconceived idea of just what it is they want to create. Sometimes children may wish to make a preliminary drawing with crayons or cut paper. They may then cut out the main shapes, transfer them to the burlap, and secure them in place with pins. Next they may stitch around the shapes, remove their patterns and fill in details with additional colors and stitches of yarn. Some children may choose to make their drawing in chalk on the burlap before they begin to stitch. It is also prudent to save some of the children's drawings and have them use these as ideas for their stitcheries.

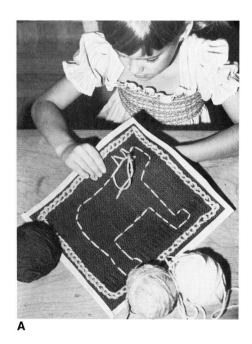

A

B

A. Masking tape keeps edges from fraying while child works on burlap. Here, a chain stitch was used for a border while the animal was outlined with a running stitch. Child completes French knot for an eye.

B. Couching was used as outline for face with felt eyes and mouth attached with a running stitch and a chain stitched nose added. Some children prefer embroidery hoops or wooden stretcher frame to hold their fabric while they work.

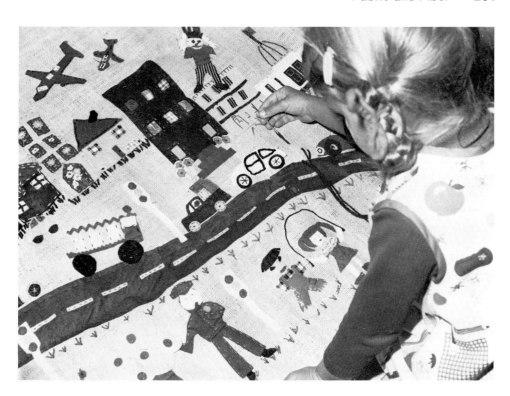

Large burlap mural may be a group project incorporating felt applique and four basic stitches.

Subject matter can be drawn from the world of flowers, insects, animals, trees, butterflies, favorite stories, the sun, rockets, special holidays, poems, songs. An entire class may like to make alphabet squares, with each child selecting an alphabet letter and making an object to illustrate that letter. Later all the squares may be stitched together for a wall hanging. A large group stitchery is fun to make; a piece of burlap about three by six feet may be securely stapled to a wooden frame with the children taking turns working on it, adding both applique and stitchery to represent houses, trees, people, etc., perhaps on a multiple base line background. The edges of pieces of fabric for applique need not be turned under by young children; rather they may simply be fastened to the background with a running stitch.

Introduction to Weaving

Weaving is the process by which fibers—yarn, string, and thread—are interlaced. It is an ancient craft, the basic principles of which have not changed through the ages. As long as 30,000 years ago cavemen mastered the weaving of simple baskets with straw, reed, and other natural materials. Later these prehistoric people wove with fibers and made cloth.

Young children can use a number of simple looms to create woven items for both utilitarian and decorative purposes. They will find the over-and-under process fascinating and will be delighted with their new skills. Even the youngest children are able to learn the terminology of weaving, and their finger muscles will develop dexterity and control as they become sensitive to color, texture, and the elements of design.

By examining the woven artifacts of other times and cultures as well as the works of contemporary craftsmen, young children will come to value woven forms as genuine creative expressions.

Paper Weaving

As an introduction to the weaving process, very young children will find this activity easy to do and understand. Provide each child with a weaving unit made from construction paper. The base is a piece of twelve by eighteen inch construction paper or tagboard. There are four strips stapled to the base at one end; the strips are three inches wide and eighteen inches long. Two of the strips should be of light colored paper and the other two should be of dark colored paper. These long strips, stapled at one end, become the warp of the weaving. The four strips should be attached to the base so they alternate: one dark, one light, one dark, one light.

Each child has a weaving unit and eight strips of black paper cut so that they are two inches wide and twelve inches long. To operate the weaving unit, each child will first pick up both the dark colored strips in one hand. He then will push in the black horizontal strip (the weft) with the other hand. Once the horizontal strip is in place, have the child drop the dark colored strips, pick up the two light colored strips, and push in a new black horizontal strip. This is repeated over and over again until all eight of the black weft strips have been used and the weaving is complete. Staple the outside two warp strips so that they are attached to the last weft strip and to the base piece. Other loose ends can be pasted by the children.

This weaving method can also be used to teach the alphabet, numbers, or color families. For example, the horizontal strips (warp) could all be white and marked with letters or names of colors or numbers (Arabic or Roman). Directions to children could be to pick up numbers one and three, or two and four; a child might be asked to identify a word and pick up the strips that have the words red and purple or blue and orange on them.

More horizontal strips could be added by making the strips only two inches wide (this would allow six strips to be stapled to the twelve-inch base piece). Colored strips can be used which are color related so that children pick up first all the warm colors, then all the cool colors. Older children could number the strips and weave using the odd numbered and then the even numbered strips.

Advanced Paper Weaving

Again, a loom or base piece for the weaving is made from construction paper. The size will vary according to the size of a magazine picture selected by the child. The picture will need to be trimmed so that it is a square or a rectangle. The construction paper should be the same width as the picture but will need to be four or five inches longer than the picture.

To make the construction paper into the loom, the child will start at the bottom and make several cuts to within 1½ inches of the top; a light pencil line drawn across the paper at the inch-and-a-half spot will help children remember to stop. The width of the strips being cut by the students can vary according to their age, ability and dexterity. The weaving is most effective if the strips are less than a half inch wide, but this is only possible with older students.

When each child is ready to weave, he should cut one crosswise (horizontal) strip from the top of his picture and weave the strip before cutting the next one. This will eliminate confusion. The picture strip will be woven over and under the construction paper strips. When a second strip is cut from the top of the picture, it should be woven so that is the opposite of the first one; every place that the first strip went over, the second one should go under. The converse is also true: every place the first strip went under the construction paper, the second strip will go over it. This over-under-over pattern is the foundation of all weaving.

When complete, an interesting effect is created by the image woven into the piece. Pictures cut from magazines like *National Geographic* are particularly good for use in this project since the pictures are colorful and the paper is sturdy.

Weaving on Hardboard and Cardboard Looms

A loom for practicing the over-and-under process may be made from a piece of vinyl, about 8 × 10 inches. Vertical slashes about an inch apart should extend to about a half-inch from the top and bottom. Pieces of thick cotton roving should be cut about 12 inches long. The child should use his/her fingers and weave each piece of the roving across the vinyl loom, alternating the over-and-under process on the second piece of roving.

A piece of weft yarn used in weaving may be likened to a worm that is crawling over and under, over and under the warp strings on the loom. After one weft has been woven across the loom, the second one is put in place by going under and over alternating warps, opposite to the preceding row, to create the woven effect. After a short time practicing, the child will be ready to transfer his/her new skills to a small cardboard or hardboard loom.

To construct such a loom, a thick piece of corrugated cardboard may be cut in an 8 × 10″ shape, and scissors used to cut ¼ inch or ½ notches along the upper and lower ends. However, hardboard or Masonite is much more durable and can be used over and over again for weaving projects. Small strips of wood may be glued near the top and bottom to lift the warp strings from the background. This makes it much easier for the child to use his fingers or a needle to weave the weft back and forth across the loom. This loom is made from a small piece of hardboard about 8 × 10 inches. Notches at the top and bottom are cut with a bandsaw about ¼ inch apart. A parent who owns such a saw might be enlisted to make a number of these looms, an easy task if a stack of pieces of Masonite are taped together and the notches all cut at once on the bandsaw.

To warp the loom, any kind of non-stretchy yarn or string should be used. An end of the string should be attached to the back of the loom with a piece of masking tape. Then the string should be wound around and around the loom, fitting the string into each notch top and bottom. When all the notches are covered, the end of the warp string should be tied to the end of the string that was taped to the back of the loom at the beginning. The youngest children should be given pre-cut lengths of yarn, called wefts, to weave with. This enables them to put each piece of yarn over and under the warps separately and not have to go back and forth with a long single weft string. The lengths should be cut about three or four inches wider than the width of the loom, and the loose ends will project or hang down the sides.

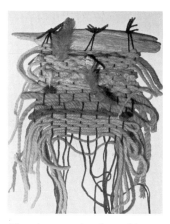

Weaving on a hardboard loom with weft threaded on a needle is an enjoyable task challenging the child's ingenuity and skill. When woven piece is finished, the warp threads should be cut from the loom and the piece attached to a piece of wood at the top.

A. Cardboard loom is strung with warp, and short pieces of yarn are woven back and forth with the fingers.

B. Striped mats were made on cardboard looms by eight-year-old children and stitched together for a wall-hanging.

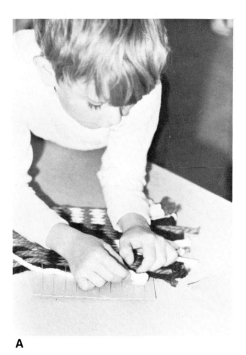

A

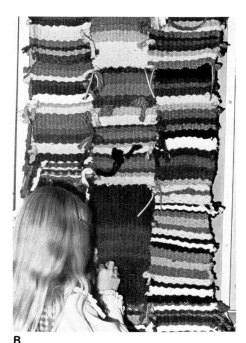

B

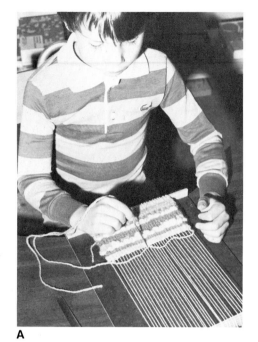

A

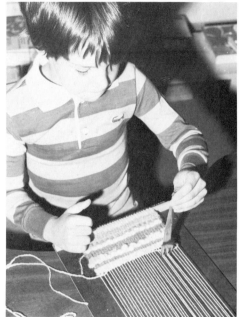

B

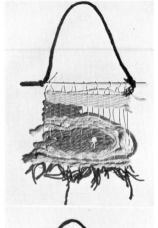

C

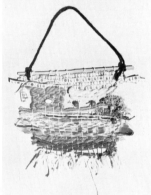

D

E

F

A and B. Weft yarn is woven over and under across warps and then 'bubbled' downward in several places with a needle (left) before being packed neatly with a comb or fork (right). This helps prevent hourglass or pulled-in effect on sides of finished piece.

C and D. Straw, braid, and lichen as well as yarn were woven into the warp strings on cardboard looms by six-year-old children. Fringe tied on the bottom and a dowel through the top added finishing details.

E and F. Baker's clay beads, feathers, and other decorative objects may be added to finished woven piece in a balanced or assymetrical arrangement.

Mistakes on the board loom are easy to correct by simply pulling out the weft. After the children have mastered the over and under process, they may thread a longer length of yarn on a large-eyed blunt needle and use this as shuttle to take the yarn over and under, and back and forth in alternating rows across the warp strings. Different colors, textures, and thicknesses of yarn enable the child to create his own design in his woven piece. He may arrange thick and thin stripes and alternate rows of different colors. The weft may be pulled up between each set of warp strings to create raised loops, adding a different thickness to the woven piece. The weft may be placed across the warps in a curved line, and then the spaces created filled in with different colors of yarn. The child may choose not to weave all the way across the warps each time; rather he may weave a column of eight or ten warp strings with one color and another column of four or five strings, thereby giving him more latitude in designing his woven piece.

Probably the greatest problem the child will encounter in weaving on a board loom is how to avoid the 'hourglass' effect, that is having his woven piece of fabric become pulled-in and narrow in the middle. To avoid this a demonstration should be given in which the teacher weaves a piece of yarn across the the loom several times. Each time across the needle should be used to 'bubble' the weft downward; that is, the yarn should not be pulled tightly across the warp strings, and the needle should be used

to push the weft downward in about four or five places. Then the fingers, a wide-toothed comb, or a table fork should be used to pack the weaving tightly in place. Also a small loop should be left on each side of the woven piece every time the weft goes back and forth.

A pick-up stick may be used also to speed up the weaving process. This is a flat stick of wood, perhaps a ruler, that is woven in and out across the warp strings and left in place. Then each time the weaver desires to go from left to right with the needle and yarn, he lifts the ruler upright. This creates a 'shed' in which every other warp string is lifted. The pick-up stick on this simple board loom can only be used when going in one direction. When returning in the other direction, the over and under process must be accomplished with the blunt needle. The pick-up stick is also very useful for packing the weft tightly in place. Generally speaking, the wefts will completely cover the warp strings in the finished woven piece.

When the piece is finished, scissors are used to cut the warps across the backside of the loom. Then the warp strings should be tied together in small groups with over-hand knots to keep the weaving from coming unraveled. Additional clumps of yarn may be tied to the bottom of the woven piece to make fringes. The top may be mounted by stapling it onto a stick of wood. Woven pieces may also be made into mats and purses as well as wall hangings.

An attractive holder for dried flowers or pencils can be made from a flat piece of weaving after it has been cut off the board loom. The two sides of this flat piece should be brought together, forming a hollow cylinder, then stitched up. The bottom warps can all be tied together in a single overhand knot, or a large bead might be threaded onto all of them. The top warps can each be threaded on a needle and woven back inside the piece. After a loop has been attached to the top, the little tube can be hung on the wall and filled with dried weeds, flowers, or pencils.

Soda Straw Weaving

One of the simplest techniques to use to begin teaching young weavers is that of using a few soda straws and almost any kind of yarn. The finished product is a band or strap, and this band can be used for belts, headbands, hat bands, purse straps, etc. It may also be made into a most attractive pencil or dried flower holder or napkin ring.

Each child will need four or five soda straws, preferably the large plastic kind. Snip off about two inches from each one. Next, determine how long you wish the finished piece to be, add twelve inches to it for tying, then cut one piece this length for each straw. It is best to use rather heavy yarn for threading through the straws as this

A. Yarn is moved in and out around soda straws, back and forth, and woven area is then moved downward gradually onto the yarn that is extending downward from the bottom of the straws.

B. Completed pouch for dried flowers was made by folding over soda straw weaving, stitching up sides and adding a loop at the top for hanging.

A

B

gives more body to the finished item. These pieces of yarn are called 'warps.' One piece of yarn is then threaded into each straw and several knots tied in the top of each one to form a large 'bead' that will keep the yarn from pulling down into the straw. The loose ends, at the bottom ends of the straws, are then tied into one overhand knot.

Using a ball of yarn, tie a knot onto the middle of one of the straws. Then using an over and under weaving technique, move the yarn in and out around the straws, going back and forth. Soon you will have several inches of the straws covered with the woven yarn, and you are ready to gently slide the woven part downward on the straws and continue weaving. As the straws continue to fill, push the woven part downward, and soon the woven band will be transferred onto the yarn that is hanging out of the lower ends of the straws. Continue weaving until the desired length is obtained. Then snip off the knotted 'beads' at the top of the straws and carefully pull the straws upward and out, leaving the warp yarns that were inside the straws inside the woven band. Next, cut the yarn you were weaving with, leaving a piece about six inches long; thread this onto a large-eyed needle and insert it up inside the woven piece so that it won't come unravelled. Do the same with the yarn at the other end. The warp strings may be tied one to another or threaded back inside the woven band. To make a pencil or dried flower pouch, weave a band about twelve inches long, then fold up a little less than half of the lower portion and sew up the sides with a matching piece of yarn. The small flap that is left at the top can be used for attaching a loop for hanging the pouch to the wall.

Rug Pictures

Two traditional rug-making techniques lend themselves well to invention and exploration for very young children. A minimum of space and equipment is required, yet the results are beautiful, and the process quickly learned. Making a large rug picture is a sustained task for a group of children since it will take a number of weeks for them to complete it. Several children may work on it at one time, and each child will enjoy seeing his efforts add to the color patterns appearing in the cut pile.

Canvas mesh or scrim for the backing may be purchased in most department stores and yarn shops. It comes in widths of about thirty-six inches and should have 3½ or 4 holes to the inch. A realistic and appropriate length to buy for a class project would be about three-fourths of a yard. It should be covered on the cut edges with masking tape to keep it from coming undone as the work progresses. Either acrylic, Orlon, or rayon-cotton blended rug yarns may be used for rug pictures. These are inexpensive and available in a wide range of colors. The skeins should be loosely wound in balls to prevent them from becoming tangled.

In talking with the children as they work on design ideas for a rug picture, teachers should point out that due to the nature of the yarn and pile, the motif should be kept bold and simple, without too many small details.

Two techniques are recommended in transferring the child's design to the canvas backing. In the first, each child paints a picture with tempera on paper the same size and shape as the canvas. The class may vote upon its choice, and the picture is then placed on a table with the mesh on top of it. Next, several children draw the outline on the mesh with felt pens of matching colors. When the different areas are filled in with felt pens, the children will know where to hook or tie knots with the different colors of yarn.

The second method for transferring a design to canvas is to have each child make a small drawing. These drawings are then placed one at a time in an opaque projector and viewed on a piece of white paper that is the exact size of the piece of canvas mesh. By moving the projector back and forth the teacher can reduce or enlarge the image as desired to make it fit the shape of the paper. The class may then decide which design it will choose, or perhaps they may select parts of several different drawings to combine

within one composition. The mesh should then be taped over the paper, and several children may draw the design on it with felt pens, being careful not to stand in the way of the beams of light coming from the projector.

Two ways of filling in the areas with pile are described here, and small groups may be instructed at one time in how to use either the latch hook or how to tie rya knots. These children may in turn teach their peers, until all the class has learned the technique. Hooking and knotting are no more complicated for young children to learn than shoelace tying.

Latch hooks may be purchased in department stores or yarn shops. A latch hook is a small tool with a hinged latch that opens and closes to hold and pull the yarn before releasing it in a neat knot. The yarn is cut before it is used, and the cut length determines the height of the pile. Usually about 2½ inches is a workable length for finishing up with a pile about one inch high.

To make the precut pieces of yarn, wrap the yarn a number of times, without stretching it, around a piece of cardboard 2½ inches wide. Then wrap a rubber band around the middle of the cardboard to hold the yarn in place; snip along the top and bottom with a scissors. These short pieces should be kept sorted by color in boxes or plastic bags. The children should work on a table and try to hook across the canvas, starting at the bottom and working up so that the pile will fall evenly and in the same direction. However, they may enjoy filling in areas of the rug solidly in one color and completing the background later.

The rya knot is formed like the Ghiordes knot that is used in Oriental rugs, and the resulting short pile that it makes is called *flossa,* which is Scandinavian in origin. It is tied with a large-eyed needle. When a row of knots is completed, the row above it should be tied in every other hole to those knots of the preceding row. It is better to work from the bottom up so that the knots are all tied in the same direction and the pile falls evenly.

When the rug picture is finished, a narrow flat piece of wood may be attached to the top to make it easy to hang. A class might like to present the finished work to the school office for all the children and teachers to enjoy.

Notes

1. Jacqueline Enthoven. *Stitchery for Children.* Van Nostrand Reinhold, New York, 1968.

A. Fold a piece of cut yarn in half behind the latch. Then push the hook down through the first hole, under the horizontal threads of the canvas, and up through the hole directly above. The hinged latch will fall open.

B. Then, holding both ends of the yarn in the fingers, pull them around in front of the latch under the hook. Pull the hook toward you until the latch closes. Then let go of the loose ends.

C. Continue pulling the hook until the loose ends have passed through the looped yarn, thus completing the knot.

D. Give the ends of the yarn a tug to tighten the knot.

E. Each child may make a small square, hooking or tying the yarn in a simple design of his own creation. When all the squares are completed, they may be whipped together on the reverse side to make a large patchwork rug picture.

A

B C D

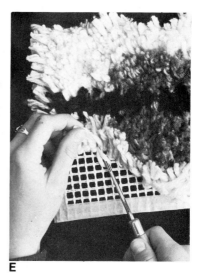

E

B

A

C

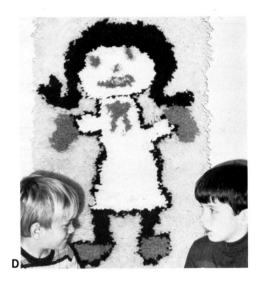

D

E **F** **G**

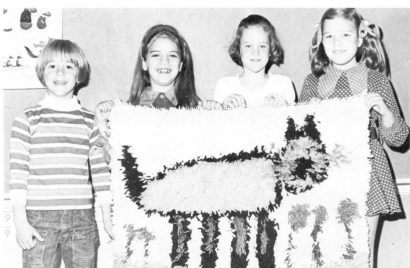

H

A. Canvas mesh may be placed on top of a child's drawing or painting, and the picture drawn on it with felt pens.

B. A small drawing of Cat with Flowers is being enlarged by an opaque projector, while a six-year-old girl traces the images on the canvas mesh with felt pens.

C. Six-year-old children enjoy the challenge of latch-hooking and delight in seeing their individual work contribute to the group production.

D. The entire class of first-grade children worked on this two-by-three foot rug picture.

E. For the rya knot, a length of yarn about two feet long should be cut and threaded through the eye of the needle. Then the needle is poked down through a hole in the mesh, leaving a one-inch tail of yarn sticking up. A short piece of inch-wide cardboard will be helpful in measuring the length of this tail.

F. Then, holding onto this tail with the left hand, poke the needle back through the mesh immediately to the right of the hole where the tail is sticking out. Pull the yarn up. Then poke the needle down in the hole immediately to the left of the hole where the tail is, leaving a loop about as big as your finger.

G. Now poke the needle up through the same hole where the tail is, coming out below that loop you just left. Pull both tails to the same one-inch length as measured against the cardboard, and snip them with a scissors.

H. Six-year-old youngsters are justifiably proud of their rya knotted rug picture.

14 Celebrations

Seasons and holidays throughout the year offer exciting art-experience opportunities for young children. However, the celebration concept can be abused if it is thought of only as a time to decorate the classroom with thirty tired lookalike turkeys, Santa Clauses, cupids, or Easter bunnies. Patterns and copy work rob the child of the chance to express his own feelings and thoughts in unique ways. They become obstacles to his self-confidence and destroy his ability to respond imaginatively, joyously, and flexibly in a new situation.

The human need to celebrate and make an event festive is universal. It has been perpetuated and fostered by both young and old throughout all eras of history. For children it can manifest itself in a variety of creative activities. Their feelings about celebrations and their awareness of each holiday's meaning can be proclaimed when they draw, paint, cut, model, and construct with art materials. Four approaches to eliminating stereotyped depictions of holiday subjects, while at the same time encouraging children to celebrate special days with original and unique art expression are suggested here.

Familiar with a New Twist

Placing holiday subjects in personalized settings or observing them in an incongruous or humorous activity will humanize a holiday or arouse the child's sense of humor and cause his imagination to rush in a new direction.

The following list of topics for painting, drawing, cutting and gluing, print-making, modeling, and constructing, incorporates familiar cultural symbols for the month of December and is typical of this specific method of encouraging both imaginative and cognitive/affective responses:

A very fancy winter sun, snowflake, or star
Cherub rocking on a crescent moon or riding on a comet
Santa dancing, skiing, or playing a violin
Elf with a goat or riding a sled
Boy with a *dreydl*
Reindeer with bells on his antlers
Lighting candles on our Menorah
Angel dancing or playing a guitar, banjo, trumpet
Rocking horse, rocking lion, or rocking reindeer
Boy or girl drummer
Toy soldier blowing a horn
Mouse with holly
Elephant with a horn
My dove of peace
Quails in a bush
King or queen with a glorious crown
Alligator with a Christmas bird on his back
Raggedy Ann or Andy with a balloon

Backgrounds and Origins

Delving into resource material for historical background and origins of a holiday will give children insight and a fresh approach to incorporate in their visual imagery.

The following description of how Valentine's Day came to be gives us a number of motivations for art tasks. People long ago felt, loved, and thought the same as we do, and children find it easy to identify with these human drives and emotions and to make aesthetic responses.

It is believed that Valentine's Day had its beginnings in a Roman festival called Lupercalia when the men wore hearts pinned to their sleeves, on which were the names of girls who would be their partners during the celebration. Sometimes the couple exchanged presents—gloves or jewelry. In later times, a day honoring Saint Valentine preserved some of the old customs. Seventeenth-century maidens ate hard-boiled eggs and pinned five bay leaves to their pillows before going to sleep on Valentine's Eve in the belief that this would make them dream of their future husband.

In 1415 the Duke of Orleans was imprisoned in the Tower of London. He wrote love poems or "valentines" to his wife in France; it is believed that these were the first Valentines. Sweethearts in the seventeenth and eighteenth centuries exchanged hand-made cards trimmed with paper hearts and real lace. During the Civil War Valentine cards became popular in the United States. Satin ribbons, mother-of-pearl ornaments, and spun glass trimmed these elaborate cards.

Here is a list of themes for Valentine art tasks. These topics will stimulate original and personal art productions incorporating historical and sometimes whimsical comments about February 14.

> Roman men wearing hearts on their sleeves
> Seventeenth-century maiden dreaming of her future husband
> The Duke of Orleans in the Tower of London
> Civil War soldier giving a Valentine to his sweetheart
> Cupid shooting a bow and heart-tipped arrows
> Mermaid with a loving heart
> Lion with a heart of gold
> A house made of hearts and flowers
> An automobile with heart-shaped tires
> Valentine bugs and butterflies in a Valentine flower garden
> The most beautiful and loving heart in the world
> Love birds and love bugs
> Cupid with a daisy
> The Queen or King of Hearts

Festivals and Processions

Preparing for and participating in a festival will have much meaning and memorable enjoyment for the children when the focal activities are related to a particular holiday or event.

Parades have often been held and still are held as parts of folk festivals; they are characterized by a good deal of ritual and tradition. Such occasions as harvest, seasonal changes, or the re-enactment of historical or religious events are celebrated. Such is the innate human need that is satisfied by these folk festivals and parades that they are found the world over. Sweden's Midsummer Eve festivities, Belgium's Procession of Penitents, Japan's Shinto festival, China's New Year festivities, Munich's Oktoberfest, the Mummer's Parade in Philadelphia, the Pueblo Indian's Corn Dance, and the Rose Bowl Parade are examples.

The early childhood classroom can also stir the spirit and imagination by including parades as activities. Children love parades—big ones, small ones, serious ones

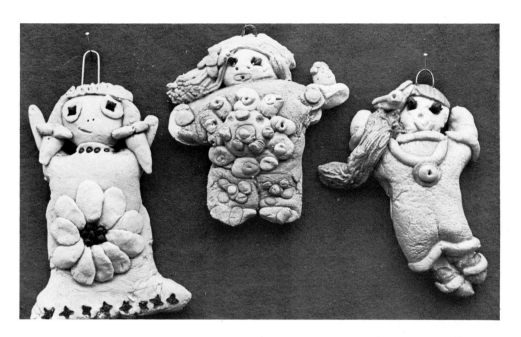

Dancing Angels are modeled of baker's clay for holiday decorations.

Parents assist at Palo Alto, CA's Wing Ding, an all-day celebration, to enable young children to each take home a special silk screen banner commemorating the annual event.

and funny ones. They love the music, the color, the costumes. And they especially love to be in a parade. A parade can be structured around almost any event. It can be small, casual, and impromptu such as marching to a drumbeat to visit another classroom with all the children wearing their newly-finished paper crowns or carrying paper plate puppets on sticks. A parade can help the children appreciate and remember a special event such as wearing a box or ice cream carton helmet for Space Day. The children may wish to carry decorated balloons and make reverse painting banners on brightly colored pieces of tissue paper, then move in a procession to celebrate the lives of Jacob Grimm and Hans Christian Andersen, tellers of fairy tales. All parades must have some central theme, some organization, pattern or arrangement, some aspect of rhythm, and certainly color and spectacle.

The Coming of Spring

The celebration of the Vernal Equinox or the Coming of Spring can be made resplendent by the combined participation and efforts of several grade levels. A procession and a short program complete with banners, simple costumes and headgear, flags, music, dances, food, poems, and stories can involve all the children in all of the arts.

Music, Banners, Dances, Costumes

In keeping with the spirit of spring, children can embellish long cardboard tubes for make-believe horns and trumpets. Paper plates may be painted and mounted on sticks with crepe-paper streamers attached to trail in the breeze. Short cardboard tubes with waxed paper wrapped around the ends become kazoos for the children to decorate and hum into. Aluminum pie pans taped together with pebbles inside make a satisfying rattling noise. Narrow strips of fabric or crepe paper tied to the ends of sticks serve as streamers to wave. Large felt banners to celebrate the three spring months can be mounted, carried on poles, and incorporate symbols and words associated with the customs and historical proclamations of spring.

A Maypole dance can be staged around a tether pole or around a long stick imbedded in a bucket of sand. Long crepe-paper or fabric streamers should be attached to the top of the pole, with each child grasping the end of one strip. Each child then faces another child, and they walk around the pole, going over and under and carrying their streamers in what becomes a woven wrapping at the top of the pole. Very young children will enjoy the simpler version—holding a streamer, walking around and around the pole in follow-the-leader fashion.

Large-size paper bags from the grocery store can be quickly converted into costumes for celebrations and imaginative play activities. At the same time they provide young children with an opportunity to develop their painting and designing skills.

A large hole should be cut in the bottom of the bag for the head opening and small holes in the sides for the arms to go through. The edges of these holes should be covered with masking tape for reinforcement to prevent them from tearing when the child puts on or removes his costume.

Kindergarten class participates in Lion Dance in celebration of Chinese New Year.

Designs and pictures may be applied with paint and brushes or with paint from a tube. The children should be encouraged to make designs on the sides and backs of their costumes after the paint is dry on the front. Older children will enjoy gluing on paper fringe, egg carton bumps, and other shiny and textured materials in combination with their painted areas and designs.

Folded paper hats and crowns, crepe-paper headbands and sashes can be made and worn by the children for the procession. They will enjoy singing a few songs about spring and perhaps hearing a poem written by several of the older children in honor of the First Day of Spring. The children will of course be eager to eat cookies, candy, or bread that they have made in symbolic spring forms.

In designing banners and in making special drawings and paintings for an art exhibit, the children will need to know the story of spring. Such information from books and films as the following will provide helpful resource data for all sorts of stimulating art productions.

Mini-celebrations

Consideration of some not-so-familiar days as possible vehicles for mini-celebrations provides many occasions for creative merrymaking and significant festivities. An interesting story or film about some historical first or important event will suggest to children ideas for all sorts of art tasks—mural-making, painting, cookies, dioramas, living pictures, construction activities, kite making, and puppet shows, to name but a few. In like manner, when birthdays of famous people are solemnized or celebrated at school, children are able to identify more closely with and appreciate those men and women who made important contributions to our lives.

Here is a sampling of noteworthy birthdays and events:

Sep. 15	Native American Day
Sep. 26	Johnny Appleseed's birthday
Oct. 2	Gandhi's birthday
Oct. 3	Universal Children's Day Celebration (Write to: US Committee for UNICEF, 331 E. 38th St., New York, NY 10016)
Oct. 10	Opera Day, (Verdi's birthday)
Oct. 20	Circus Day (Barnum Circus opened in 1873.)
Oct. 25	Picasso's birthday
Nov. 6	Basketball Day (game invented by James Naismith in 1891)
Nov. 9	Smokey Bear Day
Nov. 24	Pinocchio Day
Dec. 3	Gilbert Stuart's birthday
Dec. 16	Beethoven's birthday
Jan. 4	Louis Braille's birthday
Jan. 5	George Washington Carver Day
Jan. 9	First Balloon Flight in America, 1793
Jan. 31	Anna Pavlova's birthday
Feb. 15	Susan B. Anthony Day
Feb. 20	Buffy Sainte-Marie, American Indian singer, wrote song for Brotherhood Week
Feb. 24	Winslow Homer's birthday
Feb. 26	Buffalo Bill's birthday
Mar. 3	Dolls' Day in Japan
Mar. 6	Michelangelo's birthday
Mar. 7	Luther Burbank's birthday
Mar. 10	Harriet Tubman's death
Mar. 13	Uncle Sam Day (Date of first cartoon showing our national symbol as a character
Mar. 22	Marcel Marceau's birthday
Mar. 26	Robert Frost's birthday
Mar. 30	Van Gogh's birthday

Apr. 8	Buddha's birthday, flower festival in Japan
Apr. 12	Imogen Cunningham's birthday
Apr. 13	Thomas Jefferson's birthday
Apr. 26	Audubon's birthday
May 2	Leonardo da Vinci's birthday
May 3	Solar energy day, "Sun Day"
May 6	Penny Black's birthday (world's first postage stamp, Great Britain)
May 23	Mary Cassatt's birthday
June 2	Martha Washington's birthday

Celebrating with Gifts

Throughout the school year there are a number of celebrations when children want to give a present to a relative or friend.

Unfortunately, holidays and gifts are frequently excuses for dictated art, when teachers feel pressure to plan a project which will please parents and result in a product

A. Pennants, crowns, and a Maypole made colorful additions to the Coming of Spring festivities in which preschoolers through third-graders participated.

B. Felt banners incorporating springtime activities were draped on a pole and carried in lead positions in the procession.

C. Imaginative musical instruments, individually designed hats, balloons, and paper butterfly costumes contributed to an awareness of the changing season and the warm sunny days to come.

D. Kindergarteners designed a many-legged caterpillar with cardboard boxes to represent the concept of new life in the springtime.

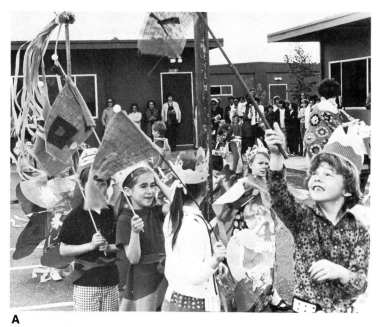

A

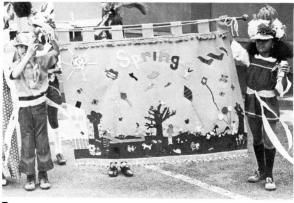

B

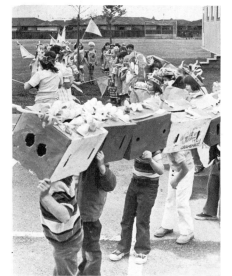

C

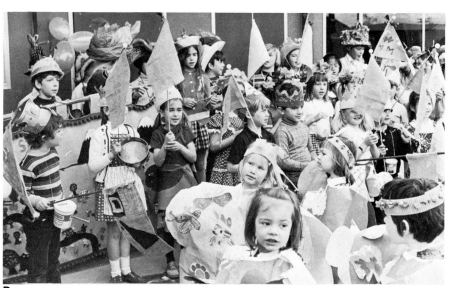

D

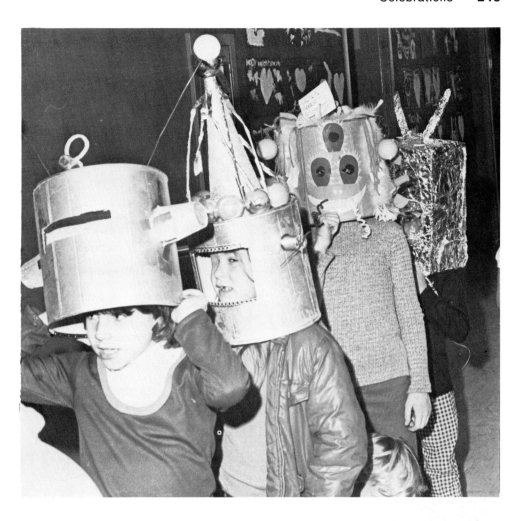

Space Day was celebrated by all the second-grade classes after they had studied the planetary system and man's explorations into space. A special space-food luncheon was prepared, and each child created his own helmet for the afternoon parade held to honor the brave men who were the first explorers in spaceships.

that is a guaranteed success. Many holiday arts and crafts books feature projects with patterns and finished products that can only be made one way, following step-by-step directions given by the adult. Little creativity or personal involvement is required, and the child frequently is given a message that what he does on his own is inadequate. It is essential that the child not become secondary to the product or gift he makes. For this reason, it would be educationally advisable to use as gifts some of the art work that the child has produced during the regular instructional lessons.

With the foregoing philosophy as background, the following tasks are presented for gift time. All of them are designed to result in an aesthetic product that is conceived and designed by the child to incorporate his skills of drawing, modeling, cutting, and assembling.

Portfolio Gifts

If the teacher has been collecting the child's art work in a portfolio, a painting can be selected and be attractively mounted as a gift. Interesting parts of drawings can be cut to fit the fronts of inexpensive note paper. Greeting cards can be drawn, painted or printed. Arrangements of dried weeds can be placed in a child's pinch pot or hanging weed pot. Fabric projects such as batiks, stitchery or fabric crayon designs can be made into pillows, stuffed animals, or pin cushions. Children can paint or draw self-portraits as gifts for parents or grandparents. They can decorate and bake cookies as a class project for one of the holidays. They can create a collage of materials related to the holiday. Children can make mosaics out of holiday-related materials such as

A

B

C

A and B. Mirrors and clown make-up prepare student for commemorating Barnum's first circus performance in 1873.

C. Kindergartener's painting of a clown was made more detailed and aesthetically whole by child's experience of applying make-up to his own face.

pumpkin seeds or colored egg shells or herbs and spices associated with holiday cooking. The finest gift that a child can give is what truly comes from within; for this reason, it is best to utilize art activities which require creativity and imagination and not all-just-alike products as gifts at holiday time.

Calendars

A happy and colorful drawing, painting, or cut-paper picture which a child has made and of which he is particularly proud, or perhaps one that he especially creates for the occasion, may be mounted and made into an enchanting and useful calendar. Such calendars are a suitable gift project for preschoolers as well as older children, because the art work itself depends entirely upon the imagination and maturity of the individual child.

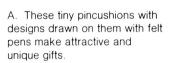

A. These tiny pincushions with designs drawn on them with felt pens make attractive and unique gifts.

B. A small funnel is helpful in filling pincushions with fine sawdust. Side opening is then stitched together and the pincushion is finished.

A

B

The child's picture should be attached to a contrasting piece of construction paper, colored tag, or poster board. Small printed calendars are available in stationery stores and variety shops. They are inexpensive and have a gummed backing, making it easy for the young child to fasten one onto the bottom of the frame or mat.

The child may wish to replace the picture he had made on his parents' calendar during the year, changing it to one that will fit the season or tell about an event that month. In such an instance the teacher may see fit to stack eleven sheets of paper of the same size under the top picture and staple them all to the backing, so that as the months pass the child may create a new picture for each of the eleven sheets.

By thus putting the child's art on permanent display, adults show their valuing and appreciation of the child's own ideas. Since the art work is original with each child, no two gift calendars will ever be alike.

Bookmarks

Useful and decorative, bookmarks involve drawing, or cutting and gluing, with felt and fabric. Burlap stripping may be purchased by the yard in hobby and craft stores, while felt and pellon are available in fabric shops. Felt and pellon should be cut in strips two or three inches wide and seven or eight inches long.

Children may snip out designs from assorted scraps of felt and fabric, then use glue or fabric adhesive to attach the pieces to the burlap or felt background strips. They may choose to make a realistic representation or an abstract design. Before they begin cutting, the children will benefit from thinking about things they know about which are tall, long, or thin that would fit the narrow shape of a bookmark. Such suggestions might include a long-necked bird, a clown on stilts, an alligator, a fish, a mermaid, a tall building, a train, a skinny man or woman, a girl jumping rope, or a boy holding a balloon. Children should be encouraged to think in terms of adapting their design motif to the narrow shape.

The bottom of felt or burlap may be slashed diagonally, cut pointed, curved, fringed, or finished in whatever manner the child may choose. A hole punch may be used to make openings to tie on yarn loops for fringe.

Weed and Candle Holders

Young children love to work with baker's clay, rolling it in balls, coils, squeezing, poking, and imprinting it with any small gadget that is handy. A natural outgrowth of this play activity is the making of dried weed and candle holders. Children may gather

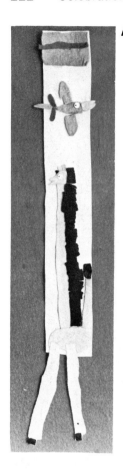

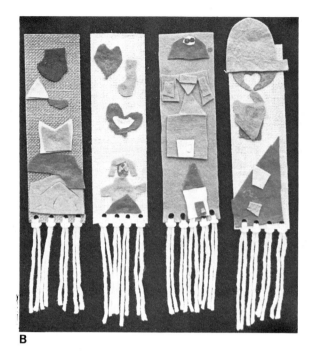

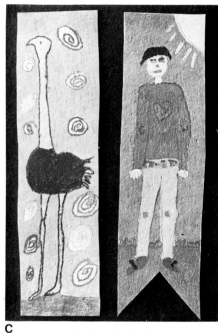

A. Giraffe with fringed mane and a beady-eyed bird were designed by six-year-old child to fit a long, narrow felt bookmark.

B. These bookmarks were made by four- and five-year-old children who cut out felt shapes and glued them to burlap strips.

C. Pellon and felt pens were used for these drawn bookmarks.

small dried weeds on a nature walk, or a small bunch of straw flowers may be purchased. These come in earth tones and bright colors and contrast nicely with the soft tan and gold shades produced when the baker's clay comes out of the oven.

The child should model and work with his holder on a small piece of aluminum foil. This makes it easy to lift the finished piece onto a baking sheet and place it in the oven. Cloves and peppercorns make good design motifs for the young child to use to imbed in a linear or grouped arrangement. The candles and stems of the flowers may be stuck into the clay while it is being modeled, the flowers remaining through the baking process and the candles being removed beforehand and glued back in place later.

The lump of baker's clay that the child uses for his holder should be about the size of a lemon; it will require a slow baking period until it is thoroughly hard and dry all the way through. This may take several hours at 300 or 325 degrees. Colored baker's clay may be used for making weed and candle holders and is best left to air-dry.

Mounted Baker's Clay Pictures

After young children have had several experiences with baker's clay, they should be ready to make a bas-relief picture with either plain or colored clay. Small pieces of plywood or hardboard may be utilized as backgrounds for these three-dimensional arrangements. Since baker's clay lends itself to making flat objects rather than to stand-up sculpture, the animals, birds, or whatever the child makes are quite adaptable to this art task.

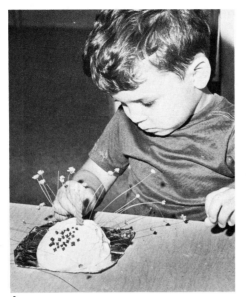

A

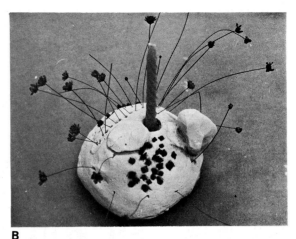

B

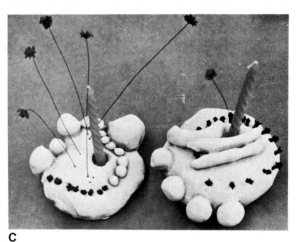

C

A. Preschool boy finds it intriguing to imbed dried flower stems into baker's clay. Very young children enjoy participating in this art task and are proud of their products.

B and C. Small balls and coils of clay as well as cloves, candles, and straw flowers are combined by young children for these attractive table ornaments.

While the child is modeling the colored baker's clay he should think in terms of the total arrangement, grouping and relating two or three forms on his board. Materials such as macaroni, toothpicks, peppercorns, and beads may be imbedded into the clay for details and contrast. Also, pencils, screws, spoons, and small gadgets may be used to imprint texture and details. A garlic press will produce stringy threads of dough which may be used for hair, manes, clothing details, or grass.

The modeled pieces should be left to dry on the pieces of wood, or small pieces may be baked on foil and later glued to wood or felt-covered corrugated cardboard. The child may add bits of moss, dried flowers, weeds, and such objects to unify and relate the modeled parts. A piece of jute or heavy yarn wrapped around the edges of the board makes an attractive frame. After drying or baking, the picture should be sprayed with clear acrylic or brushed with resin to bring back the color and create a shiny finish. Small ring-hanging devices are available in hardware and variety stores, and these should be glued to the back of the wood piece before it is gift wrapped and taken home.

Plastic Plates

For a very inexpensive price attractive plastic plates can be made directly from children's drawings. The process requires a package of round paper blanks that are the exact size of the finished plate. The children draw on the round paper with water-soluble felt pens. The manufacturer stresses the importance of keeping the paper free of grit, oily hands and dirt. The circles are then sent in to the manufacturer who trans-

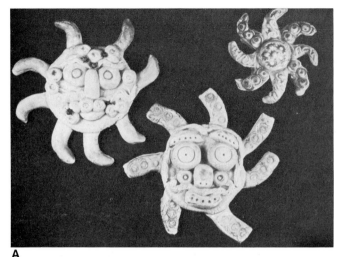

A

B

C

D

A. Sun faces made of baker's clay are decorated with coils and balls of dough and are imprinted with various tools.

B. Small plywood panel is covered with baker's clay picture.

C. Smiling Lion by seven-year-old child has shaggy mane and stands in a flower bed of lichen and dried weeds.

D. Happy Angel is mounted on calico-covered cardboard and has a red ribbon tied on top of its head.

fers the designs to sturdy plastic plates which are non-breakable and dish-washer proof. The children should work out their ideas for their plates on another piece of round paper first. By carefully placing the round paper blank on top of it and securing it with masking tape in several places around the edges, they can redraw their own design. Also available from the same company are paper blanks upon which designs may be drawn for plastic mugs.

Decorating Paper for Gift Wraps

Very young children are captivated by the old Japanese technique of folding and dipping paper in dye. They will want to make several sheets of this decorative wrapping paper because no two ever come out of the dye baths looking exactly alike. Two and three dips in the dye baths create merged and blended tones, while the pleasing repetition of colored shapes results from the way in which the paper was folded before it was dipped in the dye.

Plastic plates with the child's own drawing permanently applied make excellent creative gifts.

The paper should be folded in an accordion-like manner as illustrated on page 226, and the resulting packet should not be too thick, or the dyes won't penetrate to the center. A paper folded very small will produce small patterns, while a larger fold will create larger patterns. Special paper called Dippity Dye is available from art supply sources. This paper is absorbent, has a rice paper appearance, but is quite inexpensive.

Dye baths may be made from paste food colors since these colors come in a large assortment of tones, and are highly concentrated. The paste should be mixed with a small amount of water in a small bowl, sour cream carton, or tuna can. The color should be rather intense since the wet paper dries to a lighter tint.

The folded packet of paper should be dipped in the dye bath one corner or side at a time and lifted out when the desired amount of color has been absorbed by the paper. Children will quickly learn how to control the spread of the color by the length of time they leave it in the dye. The dyed packet should then be squeezed with the fingers, letting the excess color drip back in the dye and forcing the color evenly through the layers of paper. The packet is then dipped in another color which should be darker than the first—either by dunking a corner or side that was not dipped before, or by redipping the tip of a corner or edge that was dipped before and removing it before the dye completely covers the first color. After the packet is squeezed thoroughly, it may be carefully unfolded and placed on newspapers to dry.

The brightly patterned paper may be pressed with an iron and used for gift wraps, stationery trims, program covers, greeting cards, or for covering cartons, boxes, cans, books, and notebooks.

Making Paper for Greeting Cards

What would the world be like without paper, and what would art be like if there were no paper upon which and with which to create?

A man named Ts'ai Lun invented paper making in 105 A.D., in China. The process was kept secret for many years, but was finally introduced into Europe in the 12th Century, and by the 15th Century was used widely. The Arabs had learned about it and taken it to North Africa, whence it was carried across the Mediterranean to Europe. The first paper mill was started in Philadelphia in 1690, but until the 1850's most paper was made by hand.

Paper is made from cellulose, which comes only from plant or vegetable fibers. Today most paper is made of wood pulp in large mills; but old newspapers, wrapping paper, typing paper, paper towels, magazine pages, and advertising flyers may be broken down into pulp again and turned into clean new sheets of paper to be used for craft projects, greeting cards, or other types of art work. The paper-making process, greatly simplified, can be duplicated in the classroom and the resulting product made into greeting cards for a special occasion. Printing and drawing techniques can be used to illustrate the card. In order to make paper, a food blender is needed to make the pulp. The jar should be filled about ⅔ full of water, and to this about one cup of paper that has been torn in half-inch pieces slowly added. Let it blend thoroughly after you have added all the scraps. You may use separate colored sections of newspapers, comic sections, or any of the types of paper mentioned above.

You may experiment by adding such fibers as grass clippings, corn husks, dried leaves, rose petals, onion skins, hair, feathers, or any stringy vegetable matter finely cut up. Blend this until you have a pulpy mush which is called 'slurry.' You may choose to boil this pulp for about ten minutes to get better paper, although this is not necessary. You may make jars of different colors of pulp and use several colors for one sheet of paper by arranging them in an interesting design upon which you may later use ink or paint to create a design, picture, or words. You may add fabric dyes to the pulp. One tablespoon of instant laundry starch in two cups of water will provide a sizing and may be mixed in with the slurry if desired.

A

B

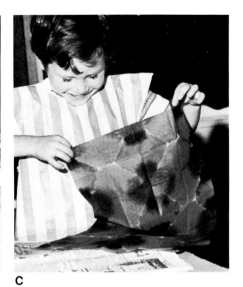
C

A. Preschooler folds Dippity Dye paper in triangular accordion fold prior to dipping it in diluted food color.

B. Corners or entire sides of the folded paper may be immersed in dye and removed when the desired amount of color has been absorbed.

C. Magic moment comes when child unfolds the paper and discovers the lovely pattern he has created.

D. Paper may be folded in several ways before dipping and redipping it in dye baths.

D

A technique suitable for young children to use in making paper is suggested. A small piece of fine screening material, about 8 × 10 inches should be attached to a wood frame. The child holds the screen over an empty plastic dishpan and uses a plastic cup or tin can to dip up the slurry and pour it over the screen, distributing it as evenly as possible. He may choose to use only one color of pulp. Or he may pour yellow pulp in one area and blue in another, thereby creating an arrangement for later adding a drawing with ink or paint. At this time he may choose from bits of yarn, ferns, jute, butterfly wings, etc., and place them on top of the slurry on the screen.

The slurry need not be placed in a regular rectangular shape on the screen. Children sometimes enjoy making a face or animal with different colors of slurry and leaving the outside shape of the paper the shape of the face or animal. When the child is through pouring pulp through the screen, he should lay a Handiwipe or dry newspapers on top of it and squeeze out the water as evenly as possible, pressing from the center out. The screen is then turned over onto a stack of newspapers with the Handiwipe on the bottom. The screen may now be carefully lifted off, leaving the Handiwipe on top of the newspapers. The hand-made paper should be ironed until it is as dry as possible and then peeled off the Handiwipe.

You can laminate two sheets of different colors of handmade paper together for a two-toned effect, placing the second sheet from the screen directly onto the first while both are still very wet, and then ironing them.

Children will be better able to appreciate Ts'ai Lun's original invention in the second century, if they have an experience in making their own paper for that special greeting card.

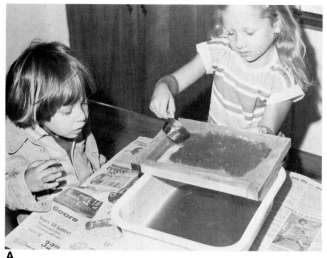

A

B

A. Slurry is poured through screen leaving fibers in layer on top as first step in making paper.

B. After Handiwipe is placed on top of screen, child exerts gentle pressure to squeeze out excess water.

Sources for Teaching Materials

In the following list of materials for teaching art heritage and aesthetic awareness, teachers will find packaged programs, units, and resources to use in taking young children on exciting ventures into the study of our cultural background in art. Also included are places to which one may send for catalogs of films, filmstrips, slides, books, fine reproductions and small study prints, three-dimensional replicas, and postcards of great works of art.

1. *ADDISON WESLEY PUBLISHING CO.,* Innovative Division, 2725 Sand Hill Road, Menlo Park, CA 94025. "Another Look: A Program in Visual Awareness" by Mary Ross Townley is a three-level art program for young children designed to teach skills that will make it easier for students to express themselves creatively. It is a totally non-reading program at 3 levels; each level has 16 units. It includes reproductions of works of art in a large-sized student booklet, with one teachers' guide. This is a broad program in which children are asked to cut, paste, classify, discuss how illustrations relate to each other and to real objects and ideas; to take pictures, to sculpt, to act out forms and words, and to play games based on unit themes.

2. *ALVA MUSEUM REPLICAS, INC.,* 30–30 Northern Blvd., Long Island City, New York, N.Y. 11101. Fine quality replicas of ancient and modern works of art.

3. *AMERICAN BOOK CO.,* 7625 Empire Dr., Florence, Kentucky 41042. "Teaching through Art," a multipurpose art print program designed by Robert J. Saunders for the elementary school. Series A, B, and C each contains twenty prints and a teacher's manual explaining how to extend the lesson. Lesson plans for each print provide description and interpretation of the painting and some background information on the artist. "Looking Exercises" guide the child's first encounter with a painting; "Learning Exercises" develop concepts and cognitive skills; "Extension Activities" use the painting as a point of departure for developing ideas and skills. Also from the American Book Co. is *History of Art for Young People* by H. W. Janson, an excellent source book for teachers' reference.

4. *AMERICAN LIBRARY COLOR SLIDE CO., Inc.,* P.O. Box 5810, Grand Central Station, New York, N.Y. 10017. Over 75,000 slides of great works of art which are available with catalog numbers or (for a little extra money) fully labeled with explicit data including the artist, title, dates, media and source.

5. *ART EDUCATION INC.,* Blauvelt, New York 10913. An art appreciation print program consisting of mounted and varnished prints and an adjustable frame with a complete kit of teacher commentaries and materials. Prepared by Olive Riley and Eileen Lomasney. Also available are Multi-visuals, twenty-four color reproductions mounted on heavy card stock, with exciting images from various sources.

6. *ARTEX PRINTS, INC.,* Box 70, Westport, Conn. 06880. Several sizes of inexpensive small reproductions, including sets of 3½ × 4½ inches for primary level.

7. *AUSTIN PRODUCTIONS, INC.,* 815 Grundy Avenue, Holbrook, N.Y. 11741. Sculpture reproductions include Oriental, Egyptian, and African pieces as well as reproductions of works of Michaelangelo, Rodin, Modigliani, Picasso, Renoir, Durer, Degas, Brancusi, Miro, and Giacometti.

8. *BENEFIC/CORONADO PUBLISHERS,* 1250 Sixth Avenue, San Diego, CA 92101. For grades one through six, a series of text books for students, with special teacher editions called "Meaning, Method, and Media." Each book is organized in six learning task areas, and is a comprehensive art program for learning to preceive, learning the language art, learning about artists, criticizing and judging art, how to use art tools and materials, and how to build artistic abilities. The authors are Guy Hubbard and Mary J. Rouse.

9. *W. S. BENSON & COMPANY,* P. O. Box 1866, Austin, Texas 78767. *Art and the Creative Teacher* by Kelly Fearing, et al., a resource book for the elementary classroom teacher with little or no formal art training; described as "a museum without walls," it contains 180 full color and 280 black and white reproductions.

10. *BFA,* 2211 Michigan Avenue, Santa Monica, CA 90406. A number of films and filmstrips, *The Discovering* series lists Color, Composition in Art, Creative Pattern, Dark and Light, Form in Art, Harmony in Art, Ideas for Art, Line, Perspective and Texture.

11. *BOWMAR,* 4563 Colorado Avenue, Los Angeles, CA 90039. Catalog lists "Artworlds," a series of programs including filmstrips, records, or audio cassettes, large color posters, child art reproductions, and an illustrated teacher's guide for commentary and classroom activities. Twelve sets are listed under Visual Awareness, Self Awareness, and Visual Expression. Designed by Dotty and Harvey Mandlin.

12. *CEMREL INC.,* Aesthetic Education Programs, The Viking Press, 625 Madison Avenue, New York, N.Y. 10022. Available in forty packages for the program, each representing ten hours of instruction in the following areas: Aesthetics in the Physical World, Aesthetics and Art Elements, and Aesthetics and the Creative Process.

13. *CHILDCRAFT EDUCATION CORP.,* 200 Kilmer Road, Edison, New Jersey 08817. Offers a variety of perceptual games.

14. *CORONET INSTRUCTIONAL MEDIA,* 65 East South Water Street, Chicago, Illinois. 60601. Films on Art for Beginners: Fun with Lines, Color; Color Everywhere; Red, Yellow, Blue; Creating with Color, Creating with Shapes, Creating with Textures.

15. *CREATIVE PLAYTHINGS,* Princeton, New Jersey 08540. Lists a number of perceptual games and toys.

16. *CREATIVE PUBLICATIONS,* P.O. Box 10328, Palo Alto, CA 94303. Catalog lists books, posters, games, etc., that are art-math related.

17. *DAVIS PUBLICATIONS, INC.,* GFB Printers Building, Worcester, MA 01608. Series of books edited by Gerald F. Brommer, developed to stimulate visual awareness and creativity. Titles include *Line, Color and Value, Shape and Form,* and *Texture.*

18. *DOUBLEDAY AND COMPANY, INC.,* 561 Franklin Avenue, Garden City, N.Y. 11530. Ernest Raboff has written a series "Art for Children" which includes books with information and reproductions of art by Van Gogh, Gauguin, Rembrandt, Picasso, Raphael, Chagall, Lee, Da Vinci, Toulouse-Lautrec, and Renoir.

19. *EDUCATIONAL DIMENSIONS,* Box 126, Stamford, Conn. 06904. Catalog lists collections of filmstrips and slides on painting, sculpture, American artists, masks, and the major crafts and their place in the history of man.

20. *ENCYCLOPEDIA BRITTANICA EDUCATIONAL CORP.,* 425 N. Michigan Avenue, Chicago, Ill. 60611. Films on What is Art?, Color, Form, Light and Dark, Line and Texture.

21. *FINE ARTS PUBLICATIONS,* 1346 Chapel Street, New Haven, CT 06511. Multi-media art units on the Tempo of Mexico and American Indian Arts. Also, an excellent Bookbox on the Magic of Color, containing 30 copies of a leaflet explaining primary and secondary colors, and relating them to fine art. Also, *All About Art,* a good book for teacher reference.

22. *GIANT PHOTO,* Box 406, Rockford, Ill. 61105. Extensive listing of inexpensive color reproductions of great works of art in two sizes, 8×10 and 16×20 inches.

23. *HARCOURT, BRACE JOVANOVICH, INC.,* Center for the Study of Instruction, Polk and Geary, San Francisco, CA 94109. Excellent series of textbooks for early childhood called *Self Expression and Conduct: The Humanities.* Also filmstrips, records, boxes, activity cards. Incorporates all the arts.

24. HARRY N. ABRAMS, INC., 110 East 59th Street, New York, N.Y. 10022. Extensive listing of art reproductions.

25. *HESTER AND ASSOCIATES,* 11422 Harry Hines Blvd., Suite 212, Dallas, Tex. 75229. Series of filmloops for motivation and perceptual awareness.

26. *LAMBERT STUDIOS, INC.,* 910 N. La Cienega Boulevard, Los Angeles, CA 90069. Extensive listing of large and small reproductions and cards.

27. *LOCAL SOURCES,* museum shops, local bookstores, local art stores. Look for postcards, books, booklets, catalogs, calendars, advertising flyers, etc.

28. *MACMILLAN COMPANY,* 866 Third Avenue, New York, N.Y. 10022, and *HARPER-ROW PUBLISHERS,* 10 East 53rd Street, New York, N.Y. 10022. Author Shirley Glubok has developed a series of books on the art of various cultural groups; sample titles include *The Art of the Southwest Indian, Art of Ancient Rome, Art of Egypt.*

29. *MAKING FRIENDS WITH GREAT WORKS OF ART,* 20975 Bandera Street, Woodland Hills, CA 91364. An art appreciation kit which includes 73 full color reproductions and a 330-page curriculum. The program, described as a "three-year perpetuating art appreciation program" is designed primarily for grades 4–6. It is multi-cultural and inter-disciplinary, and a Spanish edition is also available.

30. *METROPOLITAN MUSEUM OF ART,* 255 Gracie Station, New York, N.Y. 10028. Catalog lists postcards, reproductions, replicas, booklets for students, etc.

31. *MUSEUM COLLECTIONS,* Box 999, Radio City Station, New York, N.Y. 10019. Also 140 Greenwich Avenue, Greenwich, Conn. 06830. Catalog of sculpture, jewelry, and artifact replicas.

32. *MUSEUM OF MODERN ART,* 11 West 53rd Street, New York, N.Y. 10019. Catalog lists postcards, slides, books, games, etc.

33. *NASCO ARTS AND CRAFTS,* 901 Janesville Avenue, Ft. Atkinson, Wis. 53538 or 1524 Princeton Avenue, Modesto, CA 95352. Catalog lists reproductions, slide sets, and filmstrips on a variety of topics.

34. *NATIONAL ART EDUCATION ASSOCIATION,* 1916 Association Drive, Reston, VA. Set of 6×9 inch colored reproductions of famous works of art. Also extensive listing of association publications on art programs.

35. *NATIONAL GALLERY OF ART,* Washington, D.C. 20565. Through the Extension Service Loan Program, as listed in their catalog: slides, records, films, special publications, and traveling exhibits are available to any school free of charge except for transportation costs. The catalog of reproductions lists items for sale including reproductions, color postcards, sculpture and jewelry replicas, and a number of materials especially designed for school use such as slides and filmstrips.

36. *NEW YORK GRAPHIC SOCIETY,* 140 Greenwich Avenue, Greenwich, Conn. 06831. A collection of art reproductions in full color.

37. *NUT TREE, NUT TREE,* Ca. 95688. Large color reproductions by contemporary California artists.

38. *PENN PRINTS,* 221 Park Avenue South, New York, N.Y. 10003. Catalog of fine art color reproductions. Also, Penn Prints are available from Harlem Book Co., 22 Park Avenue South, New York, N.Y. 10003.

39. *PRENTICE HALL MEDIA,* 150 White Plains Road, Box 186, Tarrytown, N.Y. 10591. Filmstrips on The Creative Eye: What Can it Be?, Do You See What I See, and Can You See Me? Encourages K–3 child to look at things in a different way.

40. *PROTHMANN ASSOCIATES, INC.,* 650 Thomas Avenue, Baldwin, N.Y. 11510. "Art is Everywhere" and "The Eyes Have It" series of slides with text for second grade and up.

41. *SANDAK,* 4 East 48th Street, New York, N.Y. 10017. *Visual Sources for Learning* is a four-unit resource consisting of filmstrips, each containing 20 reproductions of art works. Produced by Flora and Jerome Hausman. Four major themes are: *Man and Society:* Portraits, Family, Work We Do, Recreation and Sport, Performers—Circus and Theater, Masks and Figurines, Costume and Fashion. *Forms from Nature:* Animals, Birds, Flowers and Foliage, Landscapes, Sun and Sea, Nightfall, and Weather. *Man-Made World:* The City, Bridges, The Machine, Everyday Forms and Objects, Words.

42. *SHOREWOOD,* 10 East 53rd Street, New York, N.Y. 10022. Catalog lists a large number of reproductions of the world's greatest masterpieces, coordinated with reference guides and display equipment. Special sets for K–2 and K–4. Prints, slides, films and correlated study guides that integrate the study of art with every area of the curriculum are available. Materials for creating an art gallery within the school are described.

43. *SOCIETY FOR VISUAL EDUCATION, INC.,* 1345 Diversey Parkway, Chicago, Ill. 60614. Over 100 great art reproductions, portfolio editions, and pocket library. The Singer Education Division of SVE catalog lists a number of sets of slides.

44. *STERLING EDUCATIONAL FILMS,* 241 E. 34th Street, New York, N.Y. Films on Hailstones and Halibut Bones, the Shape and Color Game, Seeing Like an Artist: Vegetables.

45. *SWRL: SOUTHWEST REGIONAL EDUCATION LABORATORY,* is a source of packaged materials for teaching art.

46. *U.S. POST OFFICE,* Sells $2 books, complete with a number of foreign and United States stamps centered around a specific theme, such as Masterworks, European Art. Companies that sell packages of stamps to collectors often have packets of stamps that feature the work of great artists.

47. *U.S. COMMITTEE FOR UNICEF,* 331 E. 38th Street, New York, N.Y. 10016. Variety of books, games and art from around the world.

48. *UNIVERSITY PRINTS,* 21 East Street, Winchester, Massachusetts 01890. Reproductions of 7,250 major works from pre-historic to contemporary in 5½ × 8 inch size. Complete catalog and sample prints for $2.00.

49. *WILTON ART APPRECIATION PROGRAM,* Reading & O'Reilly, Box 302 Wilton, CT 06897. Series of theme-based filmstrips/ cassettes on great works of art. (Landscapes, Still Lifes, Animals, American Folk Art, Portraits, etc.)

50. *WARREN SCHLOAT PRODUCTIONS, INC.,* Pleasantville, New York 10470. Catalog lists wide range of filmstrips including *Little Adventures in Art,* in which primary children will recognize the imaginative forms that familiar animals have taken in works of art from prehistoric cave paintings to contemporary works by Picasso and Calder. Filmstrips on UNICEF art introduce the child to lands and peoples of the world; *The Art of Seeing* series introduces the student to the language of visual perception and expression.

Bibliography

Books for teachers and children to enhance their understanding and enjoyment of art.

The 1973 Childcraft Annual: About Us. Chicago: Field Enterprises Educational Corp., 1973.

Alden, Caralla. *From Early American Paintbrushes: Colony to New Frontier.* New York: Parents' Magazine Press, 1971.

Andrew, Laye. *Creative Rubbings.* New York: Watson-Guptill Pub.,

Arnheim, Rudolf. *Visual Thinking.* London, England: Faber & Faber Limited, 1980.

Art Education: Elementary. Washington, D.C.: National Art Education Association, 1972.

American Council for Arts in Education. *Coming to Our Senses, The Significance of the Arts for American Education.* New York: McGraw Hill Book Co., 1977.

Atheneum Books. *Looking at Art: Faces, People at Home, People at Work.* New York.

Arts for the Gifted and Talented Grades 1–6. Sacramento, CA: California State Department of Education, 1981.

Baker, Rachael. *All About Art: An Introduction to the Basics of Art.* New Haven, Conn.: Fine Arts Publications, Inc.,

Baylor, Byrd. *When Clay Sings.* New York: Atheneum Public, 1972.

Brandwein, Paul F., Et al. *Self Expression and Conduct, The Humanities,* Textbook Series, K–6. New York: Harcourt, Brace, Jovanovich, Inc., 1974.

Brittain, W. Lambert. *Creativity, Art, and The Young Child.* New York: Macmillan Publishing Co., Inc., 1979.

Brommer, Gerald F. *Discovering Art History.* Worcester, Mass.: Davis Pub., 1981.

Campbell, Ann. *Paintings: How to Look at Great Art.* New York: Franklin Watts, Inc., 1978.

Chase, Alice Elizabeth. *Famous Paintings.* New York: Platt and Munk Publishers, 1962.

————. *Famous Artists.* New York: Platt and Munk Publishers, 1964.

Cherry, Clare. *Creative Art for The Developing Child: A Teacher's Handbook for Early Childhood Education.* Belmont, CA: Pitman Learning Inc., 1972.

Children's Crafts for Fun & Creativity for Ages 5–12. By editors of Sunset Books. Menlo Park, CA: Lane Publishing Co., 1976.

Cummings, Robert. *Just Look.* New York: Scribner's Sons, 1980.

————. *Just Imagine.* New York: Scribner's Sons, 1983.

Clark, Gilbert and Zimmerman, Enid. *Art/Design: Communicating Visually.* Blauvelt, New York: Art Education Inc., 1978.

Davidson, Rom, Et al. *The Learning Center Book: An Integrated Approach.* Pacific Palisades, CA: Goodyear Publishing Co., Inc., 1976.

Dimonstein, Geraldine. *Exploring the Arts With Children.* New York: Macmillan Publishing Co.,

Edwards, Betty. *Drawing on The Right Side of The Brain.* Boston, Mass.: J. P. Tarcher, Inc., Distributed by Houghton Mifflin Co., 1980.

Eisner, Elliott. *Educating Artistic Vision.* New York: Macmillan Co., 1972.

————, Ed. *Reading, The Arts and The Creation of Meaning.* The National Art Education Association, 1978.

Elements of Design Series: Selleck, Jack. *Line.* Gatto, Joseph. *Color and Value.* Brommer, Gerald. *Space.* Porter, A. W. *Shape and Form.* Horn, George. *Texture.* Worcester, Mass.: Davis Publications,

Enthoven, Jacqueline. *Stitchery for Children.* New York: Van Nostrand Reinhold Co., 1968.

Fearing, Kelly, Et al. *Art and The Creative Teacher.* Austin, Texas: W. S. Benson and Co., 1971.

————, Et al. *Helping Children See Art and Make Art,* 2 Volumes (Grades 1–3 and Grades 4–6). Austin, Texas: W. S. Benson and Co., 1982.

Fisher, Elaine. *Aesthetic Awareness and The Child.* Itasca, Illinois: F. E. Peacock Publishers, Inc., 1978.

Forte, Imogene and MacKenzie, Joy. *Nooks, Crannies, and Corners: Learning Centers for Creative Classrooms.* Nashville, Tennessee: Incentive, 1976.

Gaitskell, Chas. D. and Hurwitz, Al. *Children and Their Art.* New York: Harcourt, Brace, Jovanovich, Inc., 1982.

Gardner, Howard. *Art, Mind and Brain.* New York: Basic Books, Inc., 1982.

————. *Artful Scribbles.* New York: Basic Books, Inc., 1980.

Garritson, Jane. *Child Arts: Integrating Curriculum Through The Arts.* Menlo Park, CA: Addison Wesley Publishing Co., 1979.

Goldstein, Ernest. *Let's Get Lost in a Painting Series (Edward Hicks, The Peaceable Kingdom* and *Winslow Homer, The Gulf Stream).* Champaign, Illinois: Garrard Publishing Co., 1982. Future titles include *Klee: Fish Magic* and *Renoir: Girl With a Watering Can.*

Goodnow, Jacqueline. *Children Drawing.* Cambridge, Mass.: Harvard University Press, 1977.

Greenberg, Pearl. *Art and Ideas for Young People.* New York: Van Nostrand Reinhold Co.,

Gurski, Barbara, and Cote, Bernard. *Learning Center Guide.* Sunnyvale, CA: CTM Publishers, 1972.

Haskell, C. C. Art: *The Early Childhood Years.* Columbus, Ohio: Merrill, 1979.

Herberholz, Barbara and Herberholz, Don. *The Real Color Book.* 6730 Classic Place, Carmichael, CA: Art Media, Etc., 1982.

Herberholz, Donald and Alexander, Kay. *Developing Artistic and Perceptual Awareness.* Dubuque, Iowa: William C. Brown Publishers, 1985.

Hoban, Tana. *Shapes and Things.* New York: Macmillan Co., 1970.

Hoover, F. Louis. *Art Activities for The Very Young.* Worcester, Mass.: Davis Publications Inc., 1961 (10th printing).

Hubbard, Guy and Rouse, Mary. *ART: Meaning, Method, and Media.* Westchester, Illinois: Benefic Press, Grades 1–6 textbooks.

————. *Art for Elementary Classrooms.* Englewood Cliffs, New Jersey: Prentice-Hall, Inc.,

Hurwitz, Al. *The Gifted and Talented in Art.* Worcester, Mass.: Davis Publications, 1983.

Janson, H. W. *History of Art for Young People.* New York: American Book Co., 1971.

————. *The Story of Painting for Young People.* New York: Harry N. Abrams, Inc., 1959.

Jenkins, Peggy D. *Art for The Fun of It.* Englewood Cliffs, New Jersey: Spectrum Books, Prentice-Hall, Inc., 1980.

Johnson, Pauline. *Creating With Paper.* Seattle, Washington: University of Washington Press, 1975.

Kennedy, X. J. *Knock at a Star.* Boston, Mass.: Little, Brown and Company, 1982.

LaFarge, Oliver. *The American Indian.* Special Edition for Young Readers. New York: Golden Press, 1960.

Lasky, Lila and Mukerji, Rose. *Art: Basic for Young Children.* Washington, D.C.: National Association for the Education of Young Children, 1980.

Lerner Series (Mainline Book Co. 26953 Hayward Blvd. Hayward, CA, 94542.) *Cat in Art, Circuses and Fairs in Art, Self-Portraits, Kings & Queens,* etc.

Linderman, Marlene. *Art in the Elementary School: Drawing, Painting and Creating for the Classroom.* Dubuque, Iowa: William C. Brown Publishers, 1984.

Lindsay, Zaidee. *Art and The Handicapped Child.* New York: Van Nostrand Reinhold Co., 1972.

Lorrimar, Betty. *Creative Papier-Mache.* Cincinnati, Ohio: Watson-Guptill Publications,

Lorton, Mary Baratta. *Workjobs: Activity-Centered Learning for Early Childhood.* Menlo Park, CA: Addison-Wesley Publishing Co., 1978.

Lowenfeld, Viktor, and Brittain, W. Lambert. *Creative and Mental Growth.* New York: Macmillan Co., 1982.

Luca, Mark and Allen, Bonnie. *Teaching Gifted Children Art in Grades One Through Three.* Sacramento, CA: State Department of Education, 1974.

Mattil, Ed and Marzan, Betty. *Meaning in Children's Art.* Englewood Cliffs, New Jersey: Prentice-Hall, Inc., 1981.

McKim, Robert H. *Experiences in Visual Thinking.* Monterrey, CA: Brooks Cole Publishing Co., 1980.

Meilach, Dona. *Creating Art With Bread Dough.* New York: Crown Publishers, 1976.

Michael, John. *The Lowenfeld Lectures.* University Park, Pennsylvania: State University Press, 1982.

Munthe, Nelly. *Meet Matisse.* Boston, Mass.: Little Brown and Co.

Miralles, Jose M. *Famous Artists and Composers.* Mainline Book Co., P.O. Box 914, Bryn Mawr, Pa.

Ornstein, Robert. *The Psychology of Consciousness.* New York: Harcourt, 1977.

Peppin, Anthea. *The Usborne Story of Painting.* Tulsa, Oklahoma: Hayes Books,

Pickering, John M. *Visual Education in The Primary School.* New York: Watson-Guptill Publishers,

Pluckrose, Henry. *Creative Themes, A Book of Ideas for Teachers.* London: Evans Brothers,

Plummer, Gordon S. *Children's Art Judgment: A Curriculum for Elementary Art* Appreciation. Dubuque, Iowa: William C. Brown Publishers,

Raboff, Ernest. *Art for Children Series: Remington, Toulouse-Lautrec, Chagall, Picasso, Gauguin, Klee, Renoir, Van Gogh.* Garden City, N.Y. 11530: Doubleday & Co., Inc.

———. Artstart: *A Headstart on Art for Kids Series:* Includes *Chagall, Klee, Picasso.* Garden City, New York: Doubleday, 1982.

Raudsepp, Eugene and Hough, George. *Creative Growth Games.* New York: Harcourt, Brace and Jovanovich, Inc., 1977.

———. *More Creative Growth Games.* 1980.

Samuels, Mike and Samuels, Nancy. *Seeing With the Mind's Eye.* New York: Random House, 1975.

Schindef, Edith. *The Un-Coloring Book.* Los Angeles, CA: Media for Education, 13208 Washington Blvd.,

Shuker, Nancy. Arts in Education Partners. *Schools and Their Communities.* New York: Georgian Press,

Striker, Susan and Kimmel, Edward. *The Anti-Coloring Book.* Series of 12. New York: Holt, Rinehart and Winston, 1978.

Temko, Florence. *Paper: Folded, Cut, Sculptured.* New York: Collier Books, a division of Macmillan Publishing Co.,

Timmons, Virginia Gayheart. *Art Materials, Techniques, Ideas: A Resource Book for Teachers.* Worcester, Mass.: Davis Publications, 1974.

Townley, Mary. *Another Look* (3 levels for K–3). Menlo Park, CA: Addison Wesley Publishing Co., 1978.

Tritten, Gottfried. *Art Techniques for Children.* New York: Reinhold Publishers,

Uhlin, Donald. *Art for Exceptional Children.* Dubuque, Iowa: William C. Brown Publishers, 1979.

Visual and Performing Arts Framework, K–12. California State Dept. of Education, Sacramento, Ca.

Voight, Ralph Claude. *Invitation to Learning: The Learning Center Handbook.* Washington, D.C.: Acropolis Books, Ltd., 1974.

Wachowiak, Frank. *Emphasis Art.* New York: Thomas Y. Crowell Co., 1977.

Wankelman, Willard F., Wigg, Philip, and Wigg, Marietta. *A Handbook of Arts and Crafts for Elementary and Junior High School Teachers.* Dubuque, Iowa: Wm. C. Brown Publishers, 1982.

Weiss, Harvey. *How to Make Your Own Books.* New York: Thomas Y. Crowell Co., 1974.

Williamson, Ethie. *Baker's Clay.* New York: Van Nostrand Reinhold Co., 1976.

Wilt, Joy and Watson, Terre. *Look!* Waco, Texas: Creative Resources,

———. *Touch!* Waco, Texas: Creative Resources,

Wilson, Jean. *Weaving is Creative: Weaving is Fun: and Weaving is For Anyone.* New York: Van Nostrand Reinhold Co., 1967.

Winner, Ellen. *Invented Worlds, The Psychology of the Arts.* Cambridge, Mass.: Harvard University Press, 1982.

Wilson, Marjorie and Wilson, Brent. *Teaching Children to Draw: A Guide for Teachers and Parents.* Englewood Cliffs, New Jersey: Prentice-Hall, Inc., 1982.

Index

372.5044 H535e3

Herberholz, Barbara J.
 dn
Early childhood art /

 c1985.

Please remember that this is a library book,
and that it belongs only temporarily to each
person who uses it. Be considerate. Do
not write in this, or any, library book.